LOADED

Also by Dylan Jones

Magic

Faster Than a Cannonball

Shiny and New

Sweet Dreams

The Wichita Lineman

David Bowie

Mr. Mojo

Elvis Has Left the Building

The Eighties

When Ziggy Played Guitar

LOADED

The Life (and Afterlife) of the
VELVET UNDERGROUND

DYLAN JONES

GRAND
CENTRAL

New York Boston

Grand Central Publishing
Hachette Book Group
1290 Avenue of the Americas, New York, NY 10104
grandcentralpublishing.com
twitter.com/grandcentralpub

Originally published in 2023 by White Rabbit in the United Kingdom
First US edition: December 2023

Grand Central Publishing is a division of Hachette Book Group, Inc. The Grand Central Publishing name and logo is a trademark of Hachette Book Group, Inc.

The publisher is not responsible for websites (or their content) that are not owned by the publisher.

Grand Central Publishing books may be purchased in bulk for business, educational, or promotional use. For information, please contact your local bookseller or the Hachette Book Group Special Markets Department at special.markets@hbgusa.com.

Library of Congress Cataloging-in-Publication Data

Names: Jones, Dylan, 1960- author.
Title: Loaded : the life (and afterlife) of the Velvet Underground / Dylan Jones.
Description: New York : Grand Central, 2023. | Includes bibliographical references and index.
Identifiers: LCCN 2023026370 | ISBN 9781538756560 (hardcover) | ISBN 9781538756584 (ebook)
Subjects: LCSH: Velvet Underground (Musical group) | Velvet Underground (Musical group)—Interviews. | Rock music—United States—History and criticism. | Warhol, Andy, 1928-1987. | Rock musicians—United States—Interviews.
Classification: LCC ML421.V44 J66 2023 | DDC 782.42166092/2—dc23/eng/20230622
LC record available at https://lccn.loc.gov/2023026370

ISBNs: 9781538756560 (hardcover), 9781538756584 (ebook)

Printed in Canada

MRQ

Printing 1, 2023

For Haoui Montaug

"Haoui was impeccable. There was nothing one could say about Haoui that was short of full approval. Haoui was splendid."
—Danny Fields

CONTENTS

PREFACE

I got to know Lou Reed very briefly toward the end of his life, and on the surface, he appeared to be the very opposite of how he had been portrayed by the media for so many years. But by then he was physically beaten, and tired of fighting on so many different fronts, both physical and mental. What was the point of continually pretending to be difficult? When I met him, he was courteous, engaged, and completely aware of who he was and what he meant in the grand scheme of things. The old facade, perhaps, was collapsing.

In 2013 I had invited the poet of queer darkness to London to accept the Inspiration Award at *GQ*'s annual Men of the Year Awards—held with great fanfare, at that time, at the Royal Opera House, in Covent Garden every September—which I was then running, and which would turn out to be his last significant public appearance.

We had invited him to appear in May, four months before the ceremony, and almost immediately, Reed's wife Laurie Anderson gave an interview saying that he had recently been on the verge of death from a failing liver (brought on, obviously, from a stupendously successful parallel career of drug and alcohol abuse). He had just had a liver transplant, Anderson said, adding, "It's as serious as it gets. He was dying. You don't get it for fun."

He had been sick for a couple of years, first from Interferon treatments, a series of injections that treat hepatitis C that come with unpleasant side effects (and which John Cale had also actually taken back in the Eighties), then the cancer, accessorized with advancing diabetes. As

Anderson said, the pair "got good at hospitals." They tried to understand and digest what their teacher Mingyur Rinpoche said: "You need to try to master the ability to feel sad without actually being sad."

Remarkably, Reed's team said he was still intent on coming to London for our awards. He was, apparently, "actually looking forward to it." As someone in our office observed, he obviously wasn't going to be stopped by the mere fact of having someone else's organ in his body.

Had anything ever stopped Lou Reed?

However, just four weeks later he was readmitted to hospital to receive treatment for "severe hydration." Again, we were told that this wasn't going to stop him coming to town. "Happens to the best of us, I guess," said his publicist. "And we haven't lived his life, that's for sure."

Of that, there was certainly no doubt.

When Lou arrived at the awards that September, he looked unwell, but not desperately so. He appeared frail, but then he had just had two near-death experiences. The only sign that Lou wasn't perhaps as robust as he once was, was the handrail we had been asked to build for him, to help him with the climb up the modest number of steps to the stage. In its own very small way, this was quite shocking, to me at least—like watching Iggy Pop crowd surf on a yoga mat.

One of our senior writers was chaperoning one of the dozens of celebrity editors (from the likes of the *Telegraph*, *Vanity Fair*, the *Evening Standard*) who were there that night, and who couldn't believe that Reed was actually there. "It's an amazing line-up, just look at all these people," he said (and he was right—that night we were celebrating everyone from Michael Douglas, Emma Watson, Samuel L. Jackson, and Tom Ford to Justin Timberlake, Pharrell Williams, Noel Gallagher, and the Arctic Monkeys), "but I have to be honest, I just saw Lou Reed, and for me, he's the most exciting person in the room."

You could tell that pretty much everyone else at the Royal Opera House felt the same. That night, more of our guests appeared to shake his hand than anyone else. From what I remember, I think there was even a bear hug with Elton John.

At the podium, a melancholy but brisk Lou received the loudest cheer of the night.

"There's only one great occupation that can change the world," he said, looking up at the balcony, to a wall of waiting smart phones. "That's

real rock and roll. I believe to the bottom of my heart, to the last cell, that rock and roll can change everything. I'm a graduate of Warhol University, and I believe in the power of punk. And I believe—to this day—I want to blow it up."

Fifty-four days later, at the age of seventy-one, he was dead.

INTRODUCTION
THE LONG TAIL: 1964–2023

"During the Sixties, I think, people forgot what emotions were supposed to be. And I don't think they've ever remembered."
—*Andy Warhol*

It's August 23, 1970. A hot summer night, in the city where hot summer nights actually used to mean something, when long, desultory evenings were seriously sticky, claustrophobic, and close. Pre-air con close. *New York* close. For weeks now, the city had resembled something from a pulp thriller, all hot and frustrated in the daytime, and all noir and complicated at night. Manhattan was so hot it made you dizzy. So hot was it that some downtown tenants had taken to standing on chairs under their ceiling fans, having put towels under door slats to trap the cool air inside. When you went to Central Park, there were so many people sitting on the grass it looked as though a Sixties concert was about to start. New York felt as though it had had enough. Everyone was looking forward to the autumn, to the cold, to being at home, without having to resort to wandering the streets looking for somewhere cool and quiet.

The locale was 213 Park Avenue South, just around the corner from Gramercy Park, and a seven-minute walk from the iconic Flatiron Building. The Velvet Underground had just finished their second set at Max's Kansas City (they had closed that night with "Some Kinda Love" and "Lonesome Cowboy Bill," from their third and fourth albums, respectively), the chosen after-hours hang for anyone who thought they

were anyone in the increasingly incestuous New York music scene. Lou Reed, the group's peevish, leather-clad leader, was sitting in the dressing room, purposefully estranged from his bandmates, picking his teeth and thinking of the future.

But first he had to make a call. Using the club's rotary dial phone, Reed—still shaky from a forty-eight-hour speed binge, with sweat crawling over the skin beneath the tight curls above his sunglasses—called his parents in Long Island and asked them to come get him. He was twenty-eight years old, already a counter cultural hero, and yet he was ready to go home. He'd been at the downtown coal face for six long years now, and he was tired. He was quitting the Velvet Underground, and he was looking forward to going home. If his parents were going to come and get him, that is. Someone once said the Velvet Underground had helped Lou Reed feel less alone. But right now he didn't feel that way at all.

The orthodoxy of rebellion weaves through the history of rock and roll like a weary old leather-clad snake, while the surly outliers on pop's side ramp have always been its most intriguing elements. And there are few more intriguing artists than the Velvet Underground. Pop groups, like small countries, have a tendency to build identities on myth and fantasies. With the Velvet Underground, those myths are real. In fact, it is difficult to think of another band who were more formally concerned with catharsis than the original Velvets, a unit preternaturally devoted to transgression. For them, staking a claim for the avant-garde in the pop canon was not simply about altering the narrative but unraveling conceptions of what the avant-garde could be. It wasn't what anyone would call Outsider art, but it wasn't exactly inside the accepted beltway, either.

They were so different, they looked and sounded like a hoax. Their status is due in part to their identity as a prophecy as much as a celebration; because of their influence, there are many who have tried to sound like them, but there will never be anyone who really sounds like them. They came up with a template that could never be reinvented. Sure, it could be copied, but no one could ever again claim to have stumbled upon alt-noir, because the Velvets got there first.

They remain the original kings and queens of edge, the first major American rock group with a male and female line-up, a garage band who understood the importance of never smiling in photographs and wearing

sunglasses indoors. They invented a rock archetype (a look copied by everyone from Sid Vicious, Bobby Gillespie, and Chrissie Hynde to Bono, Kim Gordon, and Fall Out Boy), and are a pretty good illustration of how the particular becomes the universal.

They closed the gap between the popular and the esoteric, between the high and the low, between the left and the right. Unpack the last fifty years of pop and the broken fragments of the Velvet Underground are everywhere. Without them, Roxy Music wouldn't have happened ("In Every Dream Home a Heartache" is basically the Velvets plus lifestyle); without Lou Reed there is no Richard Hell, no Sex Pistols; without John Cale, no Nick Cave; without Nico—well, where do you start? Huge swathes of the past and present (and no doubt future) are the result of their unyielding presence—goth, emo, transgender punk. No VU, no Pulp (Jarvis Cocker's talking narratives owe more to "The Gift" than you might think), no steampunk, no Lacuna Coil, probably no Wet Leg.

Mark Twain was right: "History doesn't repeat itself, but it often rhymes."

The arc of an artist's career is no longer what it was. The Rolling Stones are no longer contextualized by their incendiary Sixties profile, their decadent Seventies heyday, nor their corporate late twentieth-century trajectory. Today we view the Stones as a parallel accompaniment to the story of post-war pop. Advertisements for their 2022 concerts didn't try to disguise their legacy; far from it, they positively reveled in it: "SIXTY" shouted all the marketing, making a virtue of their longevity. Similarly, the Velvet Underground can no longer be written about solely with reference to their original five-year existence (1965-1970), as their narrative and influence continues to this day, albeit much of it by proxy.

Which is what this book is all about, taking the Velvets' history right up to the present day.

* * * *

Loaded attempts to offer an alternative perspective on the life and work of the people involved in the Velvet Underground by seeking alternative voices, and by speaking to many of those not often included in the traditional narratives of their story, but who were right there in the mix, right there in the thick of it. The way stations remain the same, of course, but the ancillary testimonies hopefully create a new prism through which to view their tale. As this is a long-tail story, the tentacles

stretch out in many different directions, touching the unlikeliest of places. It is my hope that, by bringing the story up to date—literally, from then until now—the book creates its own narrative.

Told over a period of sixty dramatic years, this is an account of how a small, random group of people changed the culture without appearing to, creating an alternative reality that eventually became very real indeed.

It's also time to try and reframe Reed, if not exactly as a gentle soul, then certainly as a rather more nuanced personality than the one that has traditionally been painted. Over time he became such a cartoon that it was impossible to picture him as anything but a grumpy old barfly with peroxide hair and mirrored Foster Grants. After a while, you got what you expected with Reed, and if what you wanted was obstreperous Lou, he wouldn't disappoint. Not that he had many grounds for complaint: if he was often reduced to a cliché, it was one of his own making. He enjoyed being goaded and would perform to order. In 2000, asked by the Swedish writer Niklas Kallner if he held any personal prejudices, Reed responded thus: "I don't like journalists. I despise them, they're disgusting. With the exception of you. Mainly the English. They're pigs."

Reed was bigger than this, and smart people knew it. The bearbaiting tended only to be performed by the cynical, the desperate, or the gauche (it was Kallner's very first interview).

It is also time to acknowledge the enormous queer aspect of their work. The whole Factory experience was one of the first genuinely queer platforms of the post-war period—and certainly the first of the mass-mediated Sixties. Not that this was generally acknowledged at the time: Andy Warhol's queerness was disguised by critics as a kind of postmodern abstinence, a deliberate asexuality often used by bold-faced names, their media representatives, and by the media itself to camouflage homosexuality. His "Superstars," meanwhile (including Lou Reed), were portrayed as eccentric, damaged freaks. This masquerade was intended to dampen the truth of the matter, which was that the Factory was a hotbed of queer culture, queer behavior, and queer ideology. For years, Andy and his gang were relentlessly "degayed," something which seems preposterous now.

* * * *

The original band were a motley bunch: Lou Reed, a self-created malcontent from Long Island who had only recently recovered from electroshock treatment, and whose Kerouac-lite lyrics were a kind of rock and roll method writing; John Cale, a ridiculously gifted classical player from Wales who had interned with La Monte Young's Theatre of Eternal Music; Moe Tucker, a relatively androgynous drummer from Levittown who had perhaps the most idiosyncratic style of any percussionist in the Sixties; Sterling Morrison, a mild-mannered guitarist from Poughkeepsie who projected a weird sense of normality; and then there was Nico, born Christa Paffgen, an icily cosmopolitan German singer and model foisted on the band by their onetime manager, Andy Warhol.

The noise they made was a whirlwind of subversion that managed to epitomize the immortality of youth—with the Velvet Underground you could either live or die forever—while producing a blueprint that will be copied by teenage start-ups as long as they continue to manufacture guitars. Or sunglasses. Or black turtlenecks or Breton tops. Their look was a stylistic draft that has been as influential as any other in pop. It was all here: skinny jeans, plastic jackets, winklepickers. Black. Frowning. "They only seemed to come out at night," said Danny Fields. "They all wore black—black turtlenecks, pants, some leather. Their skins were light." The Velvets crystallized the idea of the genuinely bohemian, urban, narcissistic art school gang. Like Warhol, they glamorized fame while delineating it in the process. They were born in New York, were sucked into the art and drugs scenes, and were the pioneers of what we all now think of as "white cool." As James Wolcott once wrote in the *Village Voice*, "The Velvets and their progeny are all children of Dr. Caligari—pale-skinned adventurers of shadowy city streets."

But of course, they were so much more, and their influence only increases the further away we step from the Sixties. In the way that the Beatles are now more influential than at any time in their history, so are the Velvet Underground. Their vapors are all around us. Genet decadence. Down and dirty sex. European ennui. And that forever Warhol sheen.

The Sixties was a flowering of independence and imagination. And while for many the decade can be remembered by a Peter Max poster, for others it's the dissonant nightmare of "Sister Ray" (for them it probably won't come as any great surprise that the decade started

on a Friday). While they were powered by the enthusiasm of Andy Warhol—they were Andy's babies until Lou Reed suddenly decided they weren't—the VU very much had their own energy. If the Pop Art of the Sixties was defined by perpetual neatness, mechanical contrivance, and rationalized execution, the Velvets were a big old bomb going off every night they played. They were radical in a decade that demanded ironic contextualization. Counter-revolutionary during a time when revolution was almost a prerequisite. They blew stuff up just because there was no one to tell them they couldn't. Then they laughed about it (not that anyone ever caught their eyes smiling behind their shades—what Lou Reed called "girl watchers").

And they were special: "There weren't that many people in the Velvet Underground," says Warhol Superstar Mary Woronov.

I once asked Iggy Pop, another seminal proto punk, to write something about Lou Reed, and his words arrived almost before the phone call ended.

"As a young man starting out in music, I wanted to follow a path that had honesty and heart," said Iggy. "On that path, Lou Reed has been the bedrock beneath my feet, a beacon shining through the black night of crap. Those feelings of mine have not changed. Lou's always been for real to me, and never dull shit."

He had a "kind of buoyancy and flexibility," said Iggy, that made him so hard to imprison. He could do anything. He was one of the few guys who had been in the industry for so long, and yet still had a true feeling for the world around him, a way of connecting with the world.

"Most of the others," he said drily, "just end up singing in the mirror."

In Todd Haynes's 2021 documentary about the band, there is a scene in which Jonathan Richman, the architect of the Modern Lovers, recalls what seeing the Velvets was like, and how when a song finally ended there were five seconds of silence before the applause, because—in his words—the band had hypnotized the audience. "It doesn't happen a lot," says Haynes. "That moment of astonishment...certainly after first seeing *A Clockwork Orange* or *2001: A Space Odyssey*. When you witness something so complete, that so entirely uses its medium, and pushes buttons you don't understand. Those things you can't comprehend are what change society and change art, but you simply do not have an immediate reaction."

Our responses to the Velvet Underground are still going strong sixty years later.

* * * *

As befits many rock and roll stories, theirs is an inelegant journey, with a stuttering and inconclusive finale (if you can even call it that). The original, incendiary group lasted just over two years, while the latter period dominated by Lou Reed (which was equally unsuccessful) lasted much the same. Not only this, but their influence didn't really begin to be felt until the middle of the next decade, when punk was coming to the fore, and when critics, consumers, and artists were starting to understand the parallel underworld the Velvets had occupied. At the time, when they were operational, no one was really interested, especially toward the end. By the end of 1968, Warhol had gone, Nico had gone, Cale had gone (all fired by an increasingly megalomaniacal Reed), and most of the overtly transgressive elements associated with the group were in the past.

By the mid-Seventies, there was still a kind of fetishistic halo around the band, as there was around the likes of the Stooges, the MC5, the Flamin' Groovies, Big Star, the Modern Lovers, the New York Dolls, and various minor garage bands from the Sixties (the Standells, the Seeds, the Sonics, etc.)—anyone, in fact, who had presented a different narrative to the one espoused by the traditional music press and exemplified by the megalithic bands of the time, the so-called rock dinosaurs (who everyone loved, overtly or not) who were decried by the new generation of punks. Their legacy was also fighting with a clutch of fascinating, if not always successful, solo careers (not least, Warhol's, whose career was probably the most successful of all).

It's easy to forget that in the early Sixties, Warhol, and anyone in his orbit, was thought to be a "put-on," some kind of elaborate joke, orchestrated to hoodwink an emerging culture that was constantly unsure of itself. After all, as the Sixties was accelerating so quickly, who could tell what was real and what wasn't? The Velvet Underground were obviously no put-on, and yet the carapace around them was far less robust than anyone thought at the time.

Warhol's cultural prominence has hardly diminished in the decades since his death, in 1987, but then neither has the Velvet Underground's. Back then, the band were far from world famous, and if anything, were

actually the very inverse of that. However, the long tail of their influence is one of the most enduring in the rock canon.

In 2022, Mara Lieberman, the executive artistic director of Bated Breath Theater Company, based in Hartford, Connecticut, directed *Chasing Andy Warhol*, a theatrical tour through the East Village in which multiple actors played the artist simultaneously, alluding to his love for repeated images and various personas.

"Andy liked to take life and put a frame around it and say, 'Look, that's art,'" she said. "We go out in the streets of New York, and we put a frame around things and say, 'Look, that's art.'"

Exhibit A: The Velvet Underground.

DRAMATIS PERSONAE

Brett Anderson is the singer with Suede and the author of *Coal Black Mornings* and *Afternoons with the Blinds Drawn*.

Laurie Anderson made Lou Reed whole. They met in 1992 and were married from 2008 until Reed's death in 2013.

Ron Asheton played guitar successfully with the Stooges.

David Bailey rose to prominence in the Sixties as one of the most celebrated photographers of the time. He was the inspiration for the photographer played by David Hemmings in Michelangelo Antonioni's *Blow-Up*, in 1966. He knew and liked Andy Warhol, photographing him on numerous occasions and making an infamous television documentary about him.

Lester Bangs was often called America's greatest rock critic. He died at the age of thirty-three after self-medicating.

Devendra Banhart is the internationally renowned musician and visual artist. Considered a pioneer of the "freak folk" and "New Weird America" movements, Banhart has toured, performed, and collaborated with Vashti Bunyan, Yoko Ono, Os Mutantes, Swans, and Beck.

Roberta Bayley did the door at CBGB before becoming a photographer, shooting the first Ramones album cover.

Bill Bentley was a journalist with the *Austin Sun*.

Alex Bilmes has spent his life dedicated to men's magazines, working first for *GQ* and then successfully editing *Esquire*.

Rodney Bingenheimer is still the unofficial mayor of Sunset Strip. He is the host of the radio show *Rodney on the ROQ*, and was once the host of Rodney Bingenheimer's English Disco.

Leee Black Childers was assistant to Andy Warhol at the Factory between 1982 and 1984.

Sir Peter Blake remains the greatest British Pop artist.

Victor Bockris is an English-born but US-based journalist who had a long-term relationship with William Burroughs, Andy Warhol, and John Cale (whose autobiography he helped write).

Michael Bonner contributed to the *Uncut Ultimate Music Guide*.

Bono is 25 percent of U2, the percentage right at the front.

David Bowie immediately understood how important the Velvet Underground were, identifying the latent subversion in their work, as well as the collaborative possibilities. He would famously befriend Lou Reed, a mutually beneficial act that successfully reframed them both. Bowie died in 2016 in New York.

Dianne Brill was the face and body of New York during the Eighties. An iconic nightclub queen, for over a decade she was the queen of downtown. She was constantly accosted by young, busty blondes who had just moved into the city; they would come up to her and say, "I'm the new you." I interviewed her in May 2022, and she was just as effervescent as she was when I first met her in 1984.

Mick Brown is a features writer for the *Daily Telegraph*. I interviewed him in the newspaper's offices in February 2022, and he kept disappearing to update a live story.

Tina Brown was the editor of *Tatler, Vanity Fair*, the *New Yorker,* and *Talk*.

Stanley Buchthal is the producer of, among many other documentaries and movies, *The Andy Warhol Diaries*. He is also responsible for *Marina Abramovic: The Artist is Present, Peggy Guggenheim: Art Addict, Jean-Michel Basquiat: The Radiant Child, Paul Bowles: The Cage Door Is Always Open,* and *Love, Marilyn*.

Bebe Buell is a former model and *Playboy* Playmate who dated several rock stars in the Seventies. She began modeling at the age of seventeen and moved from her hometown of Portsmouth, Virginia, to New York City. It was there that she became embroiled in the CBGB scene, much to the annoyance of the nuns who were ostensibly looking after her.

David Byrne joined Chris Frantz's band in 1974. They soon became Talking Heads, and a staple of the New York punk scene. He wore a big suit and worked with Brian Eno.

John Cale has had one of the most enriching musical careers of the last fifty years, much of it below the radar. "The rules are whatever situation you're in at the moment," he said. "So if you want to change that or if you want to do something different—which is generally my tendency—you just try to find different ways of nudging it. You don't have to throw a spanner in the works. You can do it gently."

Jessamy Calkin is a senior editor at the *Daily Telegraph*.

David Cavanagh wrote for the *Uncut Ultimate Music Guide*.

Nick Cave played a prominent role in the post-punk movement, and has spent the decades since relentlessly experimenting.

Mark Cecil is a financier as well as the unofficial mayor of Mustique. One of the best-connected men in London.

Robert Chalmers is one of the greatest profile writers of his generation— or any other.

Barbara Charone is a legendary music PR.

Jarvis Cocker was the singer with Pulp before becoming a national treasure.

Bob Colacello wrote a review of Andy Warhol's *Trash*, on its release in 1970, which he hailed as a "great Roman Catholic masterpiece." Warhol liked it so much he made him the editor of *Interview*. He would soon become one of the artist's closest confidants.

Alice Cooper wants you to know that he isn't a nice guy anymore, even though he so plainly is.

Jayne County was formerly Wayne County, the singer with the Electric Chairs.

David Dalton is a writer and Warhol biographer.

Ray Davies is still a member of the Kinks, and one of the greatest song-writers Britain has ever produced.

Anthony DeCurtis is a critic and Lou Reed biographer.

Liz Derringer worked as a journalist for *Interview, Circus,* and CNN, among others.

Chris Difford is one half of the genius writing team in Squeeze.

Alan Edwards is the legendary chairman of the Outside Organisation, one of the most successful entertainment PR companies in Britain.

Tracey Emin rose to prominence as part of the YBAs in the early Nineties, and since then has become one of the most celebrated artists in the world. In 2020 she nearly died, having been diagnosed with squamous cell bladder cancer.

Syd Fablo is a blogger and John Cale expert.

Bryan Ferry invented Roxy Music.

Danny Fields is an American music legend who has touched the lives of everyone from Lou Reed, David Bowie, and Iggy Pop to Jim Morrison, the Ramones, and the MC5. The New York scene of the mid-Seventies simply wouldn't have happened without him.

Duggie Fields was one of Britain's greatest painters of the twentieth century.

Tony Fletcher wrote *All Hopped Up and Ready to Go: Music from the Streets of New York 1927-77*.

Ian Fortnam interviewed Lou Reed brilliantly for *Classic Rock*. His work has also appeared in the *NME, Uncut, Kerrang!, Vox*, the *Face*, and *Metal Hammer*.

Reeves Gabrels played guitar with David Bowie.

Bobby Gillespie is the prime mover behind Primal Scream. He was also the drummer in the Jesus and Mary Chain, using a style he appropriated from Moe Tucker.

Lizzy Goodman wrote *Meet Me in the Bathroom*.

Bob Gruen is one of the most famous rock and roll photographers, and took the iconic John Lennon "New York City" picture.

Catherine Guinness worked with Andy Warhol throughout the Seventies, accompanying him most nights to parties, openings, and dinners. For a while she had more face time with Warhol than anyone else in the Factory.

Valentine Guinness spent the summer of 1977 with Andy Warhol.

Duncan Hannah painted beautiful Hopperesque landscapes and portraits, many culled from adventure stories and classic films. He was a linch-pin of the New York downtown scene in the early Seventies, a rich seam he mined effortlessly for his memoir, *20th Century Boy*. He died in June 2022, just a month after being interviewed for this book in my house in London.

Keith Haring was an iconic graffiti artist who became one of the most important artists of the Eighties.

Bob Harris is the legendary British broadcaster.

Mary Harron is the celebrated Canadian journalist and filmmaker. Her movies include *I Shot Andy Warhol, American Psycho,* and *The Notorious Bettie Page.*

Deborah Harry sings with Blondie.

Nicky Haslam is one of Britain's most influential interior designers, while also finding time to be a fully committed socialite, cabaret singer, artist, book reviewer, art editor, memoirist, and literary editor. Smokes like the proverbial chimney.

Todd Haynes directed the 2021 documentary *The Velvet Underground.*

Richard Hell was an original member of Television, and was the visual prototype for what would become known as punk.

Tom Hibbert was the tip-top music journalist for *Q.*

Baby Jane Holzer was one of Warhol's Superstars.

Barney Hoskyns runs the online music journalism archive Rock's Backpages.

Mick Jagger is the singer with the Rolling Stones. He was a lifelong friend of Andy Warhol's.

Allan Jones is the author of *Can't Stand Up for Falling Down: Rock'n'Roll War Stories.*

Steve Jones played guitar in the Sex Pistols.

Lenny Kaye is the American guitarist, composer, and writer who is best known as a member of the Patti Smith Group.

Caleb Kennedy is a blogger and Velvet Underground aficionado.

Nick Kent is the mighty author of *The Dark Stuff, Apathy for the Devil,* and *The Unstable Boys.*

Young Kim is the Korean-American author of *A Year on Earth with Mr. Hell.*

Richard King is the author of *Brittle with Relics: A History of Wales, 1962–97.*

Tony King has been a confidant and creative muse for some of the world's greatest artists, including Elton John, Freddie Mercury, Mick Jagger, and John Lennon. At nineteen, he became the youngest promotion man of the time, looking after Roy Orbison, Brenda Lee, the Ronettes, and Phil Spector as well as Nico. King is a man who partied with the Beatles, who heard "Satisfaction" before anyone who wasn't a Rolling Stone, and who once thought nothing of

interrupting a stupefied David Bowie while he was taking cocaine in a Beverly Hills bathroom. He still receives a phone call from Elton John every day.

Phil Knox-Roberts is a British record company executive and owner of Dharma Records.

Gene Krell famously worked at Granny Takes a Trip, the legendary store in the Kings Road, before working with Vivienne Westwood and Malcolm McLaren. He was one of Condé Nast's most senior editorial staff members for over two decades.

Joe Kruppa was a teacher at the University of Texas.

Hanif Kureishi is the author of nine novels, five collections of essays, and over a dozen screenplays.

Oliver Landemain is a blogger and expert on the Velvet Underground.

Andrew Loog Oldham was nineteen years old when he signed the Rolling Stones to a management deal; his genius helped make them the band they became. Whereas Brian Epstein referred to the Beatles as "my popular music combo," Loog Oldham famously coined the headline, "Would you let your daughter sleep with a Rolling Stone?" In 1965, Oldham launched Immediate Records, working with the Small Faces, Chris Farlowe, John Mayall & the Bluesbreakers, Eric Clapton, Jeff Beck, and, of course, Nico.

Courtney Love is what a rock star is meant to act like. Wise beyond her years, she's the grande dame of grunge.

John Lydon was the singer with the Sex Pistols.

Tom Maxwell contributes to *Longreads*.

Gillian McCain co-wrote *Please Kill Me*.

Paul McGuinness steered U2 to international success, becoming one of the most successful managers in the entertainment industry.

Alastair McKay writes for the *Uncut Ultimate Music Guide*.

Kembrew McLeod wrote *The Downtown Pop Underground*.

Legs McNeil was the resident punk at *Punk* magazine.

Moby released *Play* in 1999. It has so far sold 12 million copies.

Haoui Montaug was, among other things, the legendary doorman of Hurrah, The Mudd Club, Danceteria, Studio 54 and the Palladium.

Sterling Morrison had the lowest profile of any member of the original Velvet Underground and yet was more than a vital cog in the dark machine.

Margaret Moser was an accomplished journalist who worked for the *Austin Chronicle*.

Jenni Muldaur is a singer as well as a longstanding family friend of Laurie Anderson and Lou Reed.

Kris Needs was the secretary of the Mott the Hoople fan club before becoming editor of *ZigZag*.

Stevie Nicks sings her heart out for Fleetwood Mac.

Nico was foisted upon an unsuspecting Velvet Underground at the tail end of 1965 by new manager Andy Warhol. She soon became an integral member, helping build a narrative that would help her launch an intermittent yet occasionally extraordinary solo career.

Jimmy Page was the most sought-after and prodigious session player in London during the Sixties, playing on hundreds of records by the likes of the Who, the Kinks, Donovan, Lulu, PJ Proby, Burt Bacharach, and Cliff Richard. In 1964 alone he worked on Marianne Faithfull's "As Tears Go By," the Nashville Teens' "Tobacco Road," The Rolling Stones' "Heart of Stone," Them's "Here Comes the Night," and Petula Clark's "Downtown." He even contributed to the incidental music on the Beatles' film *A Hard Day's Night*. He also worked with Nico. In 1966 he replaced Eric Clapton in the Yardbirds and then, when that ran its course, created the New Yardbirds, who almost immediately turned into Led Zeppelin.

Tony Parsons was one of the *NME*'s Hip Young Gunslingers.

Tom Pinnock writes for the *Uncut Ultimate Music Guide*.

Marco Pirroni made his first appearance onstage with Siouxsie and the Banshees at the 100 Club in September 1976. Future Sex Pistol Sid Vicious played drums. They were attempting to ape the Velvet Underground.

George Plimpton edited the *Paris Review* for half a century, until his death in 2003. Standing in the Paris Ritz, he saw Ernest Hemingway buy the second issue of the *Paris Review* at the hotel bookshop. Plimpton says it was the only time in fifty years he ever saw someone purchase a copy.

Iggy Pop was the original punk.

Robert Quine was a member of the Voidoids before playing guitar with Lou Reed.

Anka Radakovich wrote an excellent sex column in British *GQ* for a number of years.

Jim Radakovich is an artist based in New York.

Gary Raymond is a novelist, critic, and broadcaster, and is editor of *Wales Arts Review*.

Lou Reed always displayed an almost myopic creative passion. His singularity was the most important force in his artistic creations, even more so than his talent. This obsessive fastidiousness and pigheadedness made him a genuine cultural hero. Principally because he wanted to do things his way and his way alone. "I'm an artist, and that means I can be as egotistical as I want to be," he said, and there wasn't a scintilla of irony involved. Reed took artistic endeavor more seriously than almost anything else in his life, and considered the pursuit of a creative vision to be the most noble of callings. "Music should come crashing out of your speakers and grab you," he continued, "and the lyrics should challenge whatever preconceived notions the listener has."

Nick Rhodes is the keyboard player with, and de facto leader of, Duran Duran. Huge fan of the Velvet Underground.

Jonathan Richman became obsessed with the Velvet Underground in 1969, and probably saw them perform live more than anyone who wasn't in the band. He would go on to form the Modern Lovers, originally produced by John Cale, who was a huge fan of the band. Richman's intention was to simplify the Velvet's drone, creating his own naive avant-garde noise in the process.

Robert Risko is the brilliant illustrator who has worked for all the important US magazines, including *Interview*.

Chris Roberts is the author of the 2021 book *The Velvet Underground*.

John Robinson edits the *Uncut Ultimate Music Guide*.

Mick Rock was one of Lou Reed's very best friends.

Jude Rogers is the author of *The Sound of Being Human: How Music Shapes Our Lives*.

Henry Rollins was the mighty force behind Black Flag.

Paul Rothchild produced all but one of the Doors' albums.

Chris Salewicz started his career at the *NME*, a journey which saw him become one of the most important music journalists of the time.

Jon Savage is the author of *England's Dreaming: Sex Pistols and Punk Rock*, the definitive book about the period. Johnny Marr says, "It's a work that is not only the definitive account of the times and its subjects,

but one that has come to define the writer himself. Jon Savage literally wrote the book on punk, and that's some achievement. This is it."

Edie Sedgwick was an American actress and fashion model, a pixie known for being one of Andy Warhol's Superstars. She became known as "The Girl of the Year" in 1965 after starring in several of Warhol's short films. She was also dubbed an "It Girl," while *Vogue*, rushing to catch up, named her a "Youthquaker." She died of an overdose in 1971, at the age of twenty-eight.

Charles Shaar Murray is one of the greatest rock journalists of the Seventies and Eighties, and a long-standing expert on David Bowie and Lou Reed.

Siouxsie Sioux sings with the Banshees.

Geraldine Smith was a Warhol Superstar. She was discovered by the artist and Paul Morrissey in Max's Kansas City in 1966 and went on to star in *Flesh* with Joe Dallesandro in 1968. She turned down Warhol's next film, *Trash*, because she was worried about the title.

Patti Smith played many of her first gigs at CBGB. Her first album *Horses* was produced by John Cale.

Chris Stein was one of the main architects of Blondie.

Seymour Stein started Sire Records, signing the Ramones, Talking Heads, and Madonna. Oh, and Lou Reed, who made *New York* for the label.

Michael Stipe sang for years with R.E.M.

Chris Sullivan was one of the original Blitz Kids, and the man who—along with Ollie O'Donnell—invented the Wag Club. Decades before the dandy grew out his beard, called himself a hipster, and headed east to Hoxton, London's West End was a freewheeling den of rampant, raucous, and real postconformity. It was (and still is) the stomping ground of Sullivan. DJ, promoter, frontman, director, stylist, author, artist, documentarian, and journalist, he was the rake who made not having a job seem like so much hard work.

Chris Thomas has produced records by the Sex Pistols, Roxy Music, Pete Townshend, Pulp, Elton John, and John Cale.

Sherill Tippins wrote *Inside the Dream Palace: The Life and Times of New York's Legendary Chelsea Hotel*.

Stephen Trouss is a Velvet Underground expert who works for *Uncut*.

Moe Tucker was one of the most idiosyncratic drummers in the history of pop, and while she was no virtuoso, her style was not only a

vital component of the Velvet Underground, in the years since it has become increasingly influential.

Kurt Vile is an American singer, songwriter, multi-instrumentalist, and record producer. He was the former lead guitarist of the War on Drugs.

Tony Visconti is the ridiculously famous record producer who worked extensively with David Bowie.

Ben Volpeliere-Pierrot was the singer with Curiosity Killed the Cat.

Francis Whately directed *Andy Warhol's America* as well as a series of spectacular films about David Bowie.

Richard Williams worked for the *Melody Maker* before becoming head of A&R at Island Records, where he signed both John Cale and Nico.

Ellen Willis was the first pop music critic of the *New Yorker*, between 1968 and 1975.

Alex Winter starred in *Bill & Ted's Excellent Adventure*.

James Wolcott worked for both the *New Yorker* and *Vanity Fair* in their heyday.

Mary Woronov danced with the Velvet Underground at The Dom in the mid-Sixties and was a genuine Warhol Superstar (she appeared in *Chelsea Girls*). "Of all the girls at Andy Warhol's Factory, I was the butch one," she says. Interviewed at her local café in Los Angeles, she was as sharp and as profane as she always was.

Peter York is the renowned journalist, broadcaster, and management strategist, as well as the co-author of *The Sloane Ranger Handbook*.

James Young is the author of *Nico, Songs They Never Play on the Radio*.

Jan Younghusband has been responsible for more music documentaries than most filmmakers in the business, working with Channel 4, the BBC, and hundreds of independents.

Doug Yule came in for decades of unfair criticism since joining the Velvet Underground, but his story is crucial to the larger narrative.

Tony Zanetta performed in the stage production of Warhol's *Pork*.

Michael Zilkha launched ZE Records before making a fortune in renewable energy.

CHAPTER 1

WELCOME TO THE NEW CITY
1964

"If you want to write the story of the Velvet Underground, you have to begin far beyond any of the physical things that actually happened. You first have to look at New York City, the mother which spawned them, which gave them its inner fire, creating an umbilical attachment of emotion to a monstrous hulk of urban sprawl. You have to ride its subways, see it bustling and alive in the day, cold and haunted at night. And you have to love it, embrace and recognize its strange power, for there, if anywhere, you will find the roots."
—Lenny Kaye

To those taking notice, New York in 1964 was all about the future. The 1964 World's Fair was held in Flushing Meadow in Queens, on Long Island, and featured over 140 pavilions and 110 restaurants, representing 80 nations, 24 US states, and over 45 serious corporations. There were pools and fountains, a gigantic amusement park, and a furrowed-brow mission statement. Hailing itself as a "universal and international" exposition, the fair's theme was "Peace Through Understanding," dedicated to "Man's Achievement on a Shrinking Globe in an Expanding Universe."

Or, as the papers put it, tomorrow.

Also known as the future.

Masterminded by architect Philip Johnson, artist Donald De Lue, and no less an entertainer than Walt Disney, the fair was designed as something of a beacon of optimism and global unity, an exposition devoted to showcasing conceptual future technologies, along with Belgian waffles, the Ford Mustang, and a scale model of Manhattan's soon-to-be tallest building, the World Trade Center, of course. Gotham's master builder Robert Moses used the Fair as a platform for commercial exhibitors (why wouldn't he?) and so became embroiled in a civil rights controversy as activists decried the event's discriminatory hiring practices. And yet the Fair still dazzled, offering visitors both a temporary escape from political upheaval—a symbol of gaiety—and a nice day out.

Disney's corporate sponsor, General Electric, was intent on showing how society had progressed through the ages with electricity (why wouldn't they?). With seriously supercharged GE appliances on display, the attraction would specifically highlight the evolution of electricity in the home. Circular in form and divided into six equal segments, the carousel in which this show took place functioned as a giant doughnut that wheeled like a railroad car around a central, stationary stage. The six segments comprised an entry loading dock, a four-act show, and an exit dock. The show depicted a traditional American family living in their home in four different eras: the Gay Nineties—the world just before electricity was introduced—the Roaring Twenties, the Fabulous Forties, and finally, present-day—the Sixties. The show was hosted by the father, originally narrated by the iconic voice of Rex Allen. The audience would transition between acts to the tune of "There's a Great Big Beautiful Tomorrow," composed by the Sherman Brothers as a personal ode to the eternal optimist, Walt Disney. In an era filled with fears of atomic warfare and the Cuban Missile Crisis just two years before, Walt's optimistic outlook, as embodied by the "Carousel of Progress," was designed to give people hope for the future. And possibly encourage them to pay another visit to Disneyland.

There were performers wearing jetpacks, an audio-animatronic attempt at AI, and more concept cars than the 1964 Detroit Auto Show. As so many pavilions appeared to be built in mid-century modern style (heavily influenced by "googie" architecture, which was itself informed by car culture, jets, and the space age—all things the Fair was designed to celebrate), the whole thing felt like a theme park based on the animated sci-fi TV series The Jetsons. *In reality, the architecture was a cacophonous mix of different styles, sizes, and building types, ranging from a Ferris wheel in the shape of a tire, to an obviously faux Belgian village.*

How could this not be the future? Even the Beatles—an example of what the future looked like over in Europe—landed at the Fair's heliport for their concert at Shea Stadium.

The Fair had echoes of the International Geophysical Year, the global scientific project that ran from July 1957 to December 1958, which was designed as a series of collaborations between thirty thousand scientists from nearly seventy countries, sharing expertise, best practice, and a multitude of research prototypes in everything from transportation to fanciful white goods. These included solar-powered cities, a transatlantic rail tunnel, consumer space travel, construction of earth satellites and increased research in the Arctic and Antarctic polar regions, even the manufacture of Spandex jackets. At the time, President Eisenhower expressed his belief that "the most important result of the International Geophysical Year is that demonstration of the ability of peoples of all nations to work together harmoniously for the common good. I hope this can become common practice in other fields of human endeavor."

The millions of people who visited the Fair were confronted by a showcase of mid-twentieth-century American culture and technology, with a heavy, almost italicized emphasis on the Space Race. The two-acre United States Space Park was sponsored by NASA and the Department of Defense, and exhibits included a full-scale model of a Rocket Booster's aft skirt and five F-1 engines of a Saturn V, a Titan II booster, a Mercury capsule and a Thor-Delta rocket. There were models of a Gemini spacecraft, an Apollo command/service module, even some sexy weather satellites. If you came to the World's Fair you were left in no doubt that the Americans were going to conquer the universe, and that they were going to do it fast (which meant faster than the Russians).

There was acceleration all over. If you were the kind of person who spent their afternoons wandering around midtown Manhattan, and especially along East Forty-Seventh Street between Second and Third Avenue, just a five-minute walk from the United Nations, then you would have more than likely bumped into a different kind of future. Number 281 was the home of Andy Warhol's Factory, the original "Silver Factory" decorated with tinfoil, fractured mirrors, and silver paint (orchestrated by Warhol's friend Billy Name—né Billy Linich, which wasn't much of a name at all). Even the elevator and the toilet bowl were painted silver ("Silver was narcissism," said Warhol. "Mirrors were backed with silver"). A former hat factory, Warhol had found the place in November '63, and officially moved his professional headquarters to this powder-blue building at the corner of Lexington Avenue in January '64, along with his ever-growing

21

coterie of assistants, hangers-on, hustlers, speed freaks, drag queens, fag hags, on-off boyfriends, and random uptown/downtown socialites. The artist called them "Superstars," and they all thought they were. Over the next few years, Warhol would foster so many of them: Brigid Polk, Ultra Violet, Baby Jane Holzer, Viva, Ingrid Superstar, International Velvet, Billy Name, Ondine, Paul America, Nico, Candy Darling, Holly Woodlawn, and Jackie Curtis, among many others. Soon the best known, the crowning ornament, would be Edie Sedgwick, the sweet-faced and hapless rich girl who, in black tights, swinging earrings, and expensive sweaters, was often called upon to accompany Warhol to one of the many parties he went to each night. She, like all the others, was truly a Superstar, a ditzy emission of tarnished silver-gray cool.

These people were all gifted in the art of reinvention, an art that Warhol—himself a reinvention—didn't so much encourage as demand. But they were all up for the challenge (as Tom Wolfe wrote at the time, "One belongs to New York instantly, one belongs to it as much in five minutes as in five years"). In their kaleidoscopic realm, furnished like a space-age trailer park, they turned their lives into art, in much the same way Warhol was doing. The people who found their way to the Factory often had a kind of piss elegance—typically beautiful, but probably damaged or wandering. They called themselves the Mole People, tunnel dwellers in thrall to their weird king.

And assuming a filmic halo was everything.

"Do I look OK?" Viva (born Janet Susan Mary Hoffman to a prosperous Republican family) asked Warhol's technical director Paul Morrissey when she was preparing to meet some of the press at the Factory.

"Like a star," he replied grandly, knowing this was the only validation she needed.

Later, in her apartment, she told a reporter, "I have Andy now to think ahead and make decisions. I just do what he tells me to do. Andy has a certain mystique that makes you want to do things for him. Sometimes though when I think about Andy, I think he is just like Satan. He just gets you and you don't get away. I used to go everywhere by myself. Now I can't seem to go anywhere or make the simplest decision without Andy. He has such a hold on all of us. But I love it when they talk about Andy and Viva."

"They gave him his ghostly aura of power," wrote the Australian art critic Robert Hughes, whom Warhol hated so much. "He offered them absolution."

As Warhol—the Prince of Ether—said himself, "I approve of what everybody does. It must be right because somebody said it was right."

It was all the same to him. Completely understanding what the new decade could do for him, what the artist wanted above all was attention: for him there was no point in being shocking if there was no one around to be shocked. By surrounding himself with a collection of shocking, strange-looking extroverts, he was basically getting other people to work on his behalf.

His Superstars were encouraged to act out their fantasies in the safe space of patronage, although Warhol retained the right to film everything they did: drinking binges, stoned raps and confessions, sex (a lot of sex, often transgressive sex), or simply dressing up. They were a gang, of sorts, and when the "Factorians" went out they went out mob-handed, in packs of between ten and twenty people. When the Velvet Underground's John Cale started hanging out at the Factory, he would say that they didn't so much attend parties as invade them. Whether they were going to an art opening, a downtown cocktail bar, or—this year—a private screening of A Hard Day's Night *or* Dr. Strangelove, *they went* en masse.

"We were not at the show," Warhol liked to say. "We were *the show."*

"Warhol was always an observer, which means he never lost what an artist is—the one who can see what others might miss," said Ingrid Sischy, who would go on to edit Warhol's magazine Interview. *"He was probably such a consummate observer because he was a consummate outsider. Don't be fooled by the fact that you're always seeing pictures of him that made it look like he was a part of so many in-crowds."*

The introduction of Warhol and his acolytes and friends into New York society was like the introduction of electricity into machine technology. It raised the state of play to an entirely new magnitude. The sheer fact of Warhol, this supposedly weaselly little guy from the nothingness of Pittsburgh yet seamlessly present, here, in a thrumming metropolis, already king of the hill, was simply norm-defying: a thunderbolt out of the blue. He himself had come to New York from Pennsylvania in 1949, at the age of twenty-one (then known as Andrew Warhola, of Slovakian descent), keen to pursue a career in magazine illustration and advertising that would steadily develop into a genuinely transgressive new form of art that would go on to define the decade. His device was indulging the voyeur in his nature in the name of artistic experience. It had taken him some time, but by the early Sixties he not only knew what kind of art he was going to make, but he now understood how to make other people take notice of it, too. Jasper Johns and his boyfriend Robert Rauschenberg had already started painting familiar things like flags, targets, and maps, and Pop

Art was quickly emerging as a force on both sides of the Atlantic, and yet it would take Andy to popularize the movement, both by a celebration of the ordinary, and a radicalization of the transgressive. There was a new spirit in New York, it seemed, and even though Warhol was already in his mid-thirties, it was completely generational.

Andy Warhol (artist, and then some): I mean, I came to New York on a bus. And went with my portfolio to a magazine, and the lady just liked the things and said to come back when I got out of school, and that's how it started...I'd prefer to remain a mystery, I never like to give my background and, anyway, I make it all up different every time I'm asked. It's not just that it's part of my image not to tell everything, it's just that I forget what I said the day before and I have to make it all up again. I don't think I have an image, anyway, favorable or unfavorable.

Tony Fletcher (author): No other city undergoes such constant transformation with every new generation of immigrants; no other city can claim to be so powerfully driven by capitalism and yet so obsessed with community; no other city lures so many talented outsiders willing to risk total failure for such a small chance of success.

Danny Fields (manager, publicist, journalist): In the very early Sixties, in my neighborhood in Greenwich Village there were a few bars that had spectacularly interesting populations, and the most important was the San Remo at 93 MacDougal Street on the corner of Bleecker Street, which was the genesis of the first Factory. I had never seen anything like it. I'd just dropped out of Harvard Law School; I was twenty-one and my parents still lived in Queens. I went to see them once a week to wash my shirts. In the San Remo there were these crowds of here-we-are kids, almost as if we'd been wanting to meet each other all our lives. Then groups started to form identities. At the San Remo our table was the YJS, the Young Jewish Set. Then there was Andy, Ondine, and Billy Name at another table. Then there was a table called the Miseries, because they were all in black and gothic and gloomy. Jasper Johns was there, Robert Rauschenberg, Edward Albee, Frank O'Hara. Wonderful people. At the time there was an underground railway between New York and Harvard Square, which was very important, enriching, and fertile for San Remo,

and for the Factory. There was lots of two-way traffic. People like Edie Sedgwick came down and zapped into the existing community that Andy was building around him. It was wonderful, but when you're living in a golden age you don't know it. The Factory was inventing itself from little puddles and pools of people that had been in the San Remo. That's where it started, in this little bar. The start of the Sixties.

Kembrew McLeod (author): Warhol circulated among the artists, poets, theater people, and gay crowds that populated Greenwich Village bars such as Lenny's Hideaway, the San Remo, and the White Horse—which were central nodes in social networks that connected artists who worked in different mediums. The San Remo was a traditional village tavern with pressed-tin ceilings and wooden walls... There, playwrights Harry Koutoukas and Tom Eyen rubbed shoulders with eccentric characters like Ian Orlando MacBeth, who spoke in iambic pentameter, dressed in Shakespearean garb, and sometimes wore a live parrot on his shoulder. Warhol was more likely to be barely seen and not heard, quietly sitting at a table, observing.

Café Cino was another Village haunt that started to be used by the Factory crowd. It was also a hotbed of amphetamines, and syringes littered the hallway as though they were cigarette butts. The scenester Jim Fourratt remembers Ondine suggesting they go into the bathroom together. "I thought I was going to get a blow job, and he pulls out the biggest dick I've ever seen in my life, and then shoots up in it, with speed. I had never seen anything like it in my life. I was completely, AHHH! I must have been ashen." When Fourratt walked out, three regulars on the other side of the room burst out laughing; this had obviously happened many times before.

Geraldine Smith (actress): I adored the scene, as it was *the* scene. The most happening scene. And if you were involved with it, it was really something. New York at the time was absolutely amazing, and there will never be another time like that. Everything was great. There was money, everybody was up, it was the revolution of sex, drugs, and rock and roll. Everyone was just ecstatic about this new way of living. I guess you could compare Greenwich Village at the time to the Twenties. It was that exciting. Andy was responsible for so much of it, but the Beatles had

a lot to do with it. It all kind of fell in my lap. One day I was walking alone down the street in the Village and these people approached me, including a girlfriend of the Rolling Stone Bill Wyman called Francesca, and they asked me if I wanted to go and see the Beatles. I can't have been more than fifteen. I thought they were crazy, but they took me up to this penthouse in the Warwick Hotel, and the Beatles were all there, with Carole King and Brain Epstein and a few other girls, and we all ate steaks and smoked pot, and we were there until six o'clock in the morning. New York at the time was on fire.

Kembrew McLeod: When Beatlemania shook the city in 1964, its reverberations could be felt deep in the downtown underground.

Mary Woronov (actress, artist): New York was like two different places back then, and nobody from uptown went downtown, and if my parents had found out I was going down there they would have been horrified. At the time nobody went below Fourteenth Street. People were uptight about downtown, as it was this other world that no one really knew. Nobody went there. Literally nobody. Certainly not my parents. Downtown then was insane, because you'd go somewhere at three o'clock in the morning and some queen would come out in front of you and go "bleeaargh." It was all about self-expression. I liked it, as it was like nowhere I'd ever been before. At the time you could be thrown in jail for being gay, thrown in jail and fucked a lot, but it was dangerous being gay at the time, because it was secret. At the time my mother took a lot of pills. She was a very powerful woman, although my father didn't care about anything other than what kind of car he had. That cracked me up—"Oh Daddy, it's wonderful!" It was a Packard with a swan on the front. Also, he was fucking other women, something my mother never heard of or knew about. She didn't fuck at all. It was a useless thing for her because she just didn't fuck. Anyway, I was sent away to Cornell University, where I didn't learn a thing. Until I met Gerard Malanga.

Aged eighteen, Deborah Harry used to take a bus into the city from her parents' home in New Jersey, looking for excitement, looking for fun, looking for boys. Her favorite place to wander was Greenwich Village, "ingesting and digesting it all," staring at the beatniks, the "bohemians," and all the other

eager souls investigating downtown. "Art, music, theater, poetry, and the sense that everything was up for grabs, you just had to see what fit," she said. New York promised escape for a generation who probably wanted escape more than anything else. If the Fifties had brought economic prosperity and a presumption—ratified by a government assurance—that life was going to get better, their children wanted more. Those white suburbanites born after the war took their freedoms for granted, and naturally wanted more.

Mary Woronov: New York was starting to be crazy, and the Factory reflected that. In those early days the Factory was like some kind of medieval court of lunatics. We all pledged allegiance to the king—King Andy, but there were a lot of others around, too. Princes like Gerard Malanga, who was like Andy's Number Two. There was no accepted hierarchy, and yet there was only one person in charge. Weirdly Andy accepted the responsibility of all the insanity. I mean, he had created it.

Tracey Emin (artist): When I was at school, I used to imagine that I would go to New York by boat and when I walked down the gangplank Andy Warhol would be there waiting for me.

David Bailey (photographer): I went to New York in 1962 with Nicky Haslam and Jean Shrimpton, and then went back in 1964 with Mick Jagger, who was playing with the Stones downtown. New York was a very different place from London at the time. Almost immediately I met Andy, which seemed somehow preordained. Andy was the most positive person I'd ever met. He loved everything. To extremes. Anyone who could turn a Campbell's soup can into a superstar has got to be positive. He was an extraordinary person and was probably the coolest person I met when I first went to New York. I liked Gerard Malanga, but I wasn't sure about a lot of the people around him; I was very sure about Andy through, as I knew he was some kind of genius. Being in the Factory was actually like being on a Todd Browning film set—he'd directed *Freaks*—and lots of the people there were freaks for the sake of being freaks. I think some of them were genuine, like Candy Darling, who I met later, but a lot of them had just jumped on the freak bandwagon.

Nicky Haslam (designer, socialite): I went to New York with Jean Shrimpton and David Bailey in 1962 as I thought it might be fun. I'd been to New York lots as my mother had married an American, but I hadn't been since the Suez crisis in '56/'57. David suggested I go with him. *Vogue*'s Claire Rendlesham came with us, and she introduced me to Alex Liberman at Condé Nast. Alex asked me to come and work for *Vogue* in New York, and got me a Green Card. So I stayed in New York, but didn't go to *Vogue*, and went to *Show* instead. But I stayed at *Vogue* for a while, and one day I was in the shoe department, working for the lovely fat editor Kay Hayes. In came this nondescript boy with black jeans and a fringe—not blonde then—carrying lots of drawings of shoes. He also used to draw bottles of scent for the "turns," those bits of an article that turned to the back. And that was Andy Warhol. The number of his drawings I must have thrown away. Anyway, we became firm friends.

Danny Fields: The first time I properly met Andy was at a party in a fifth-floor apartment in a townhouse on East Seventy-Second Street, thrown by Peter Knoll, the Knoll furniture heir. There was a woman called Ivy Nicholson who was a crazy, deranged beauty, and was one of the first women Andy started to collect—one of his "let's portray beautiful women in agony" women. She was crawling across the floor at this party, disgracing herself, and she crawled over Andy, and she was begging him for attention, and he would sort of kick her, like you would an annoying dog, pushing her away. Then she went over to the window, picked up the sash, and leaned outside. And I jumped up and grabbed her, pulled her in by the waist and said, "Don't jump!" Then someone threw some tear gas, and as the place was evacuated, Andy said, "Why did you stop her? You should have let her jump." I thought, "Wow, here is the definition of cool. I saved a woman's life and Andy asked why." But then I found out she did this a lot, and this wasn't the first time she'd been at a party and threatened to throw herself out the window. It was my first time, but not hers. Andy's reaction was, "Let her jump already!" She'd been a big pain in the ass for him for a long time. In hindsight I should have let her jump.

The day I went to Peter Knoll's party, there was half a page of Campbell's soup cans in the *New York Times Magazine*. The gist was, "This has arrived." You know, this is someone who I'd seen in bars, who

you think might recognize you, but actually doesn't really care. And then he's in the *New York Times*. It was a big deal.

David Dalton (writer, biographer): The Factory became a magnet for brilliant speed freaks who simultaneously worshipped and trashed movie stars. This frame of mind created the alternating current that infuses Warhol's paintings of Liz, Elvis, Marilyn, Jackie, and Tab Hunter with such flashing ambivalence. If you compare Warhol's paintings of movie stars with, say, Bob Stanley's high-contrast images of rock stars like the Beatles, you see the difference at once. It's not simply that Warhol's silkscreened photographs impart a gritty authenticity to his images; it's the alternating energy of conflicting emotions—reverence and defilement—that gives these icons their unstable presence. This art and its consequent celebrity presented Warhol with a set of personal demands. The new style would ultimately require a new Andy, a new persona, with requisite entourage. The cool, hip, vaguely sinister "Drella" would displace—though not entirely replace—the earlier sweet and daffy Andy of the soup-can paintings.

Kembrew McLeod: The Factory began as a private world occupied mostly by Name, Malanga, and Warhol—a place to get work done, an artistic factory with a seemingly passive Warhol at the center.

By 1964, Warhol was already on his way to being the art world's most celebrated cause célèbre and had already had his rebellious stature reaffirmed by being banned from the World's Fair itself. Commissioned to produce something for the facade of the Fair's New York State Pavilion, the artist chose to enlarge mug shots of criminals. Warhol's gigantic mural was intended to hang on the outside of the Circarama, a circular cinema 100 feet in diameter. Intending to depict "something to do with New York" and taking direct inspiration from Marcel Duchamp's 1923 work Wanted, $2,000 Reward *(in which Duchamp put his own photograph on a wanted poster), Warhol impishly decided to print large-scale copies of images from a booklet published on February 1, 1962 by the NY Police Department, "The Thirteen Most Wanted," showing twenty-two head-and-shoulder mug shots of wanted men.*

Government officials quickly objected to the images and on April 16—two weeks before the fair was due to open—Philip Johnson told Warhol that he

must remove or replace the work within twenty-four hours. Fearing scandal, and panicking, officials painted over Warhol's mural, leaving only a large silver panel visible when the Fair opened.

Culturally, this was perhaps not so surprising, as the city government had spent the best part of the previous year "cleaning up" many of those venues that catered to the underground, attempting to close gay bars, coffee houses, and off-off-Broadway productions in a bid to gentrify New York's image before the opening of the Fair. A homage to dangerous felons was not exactly going to help.

For Warhol, this was just catnip publicity, just another example of the way in which he could outrage people and gain enormous media exposure simply by threatening to be conceptual. The Warhol exhibition that opened at the Stable Gallery in Manhattan on April 21 was in itself a concept. It was the first display of his three-dimensional grocery cartoon sculptures—boxes for Kellogg's Corn Flakes, Heinz ketchup, etc., as well as Brillo pads. The boxes didn't sell particularly well, but the exhibition predictably generated a tremendous amount of column inches. And Andy didn't care anyway, as his fame was already starting to travel. In February, the celebrated art dealer Ileana Sonnabend had mounted a show of Warhol's work in her ridiculously cool Paris premises, suddenly giving the artist an international foothold, and forcing domestic critics to take notice. Not just of Warhol, but of New York, too. Like the artist, the city was catalyzing the kinds of culture that had often only found solace in the shadows.

In the Factory, Warhol's army of assistants would organize his social life, help make his screen prints, and contribute to the unconscious collective that produced his movies. The most valued members of the Factory were those who supplied industrial-strength gossip. They would sit on the huge red curved sofa that Billy Name had found on the sidewalk opposite the YMCA. Outside the building, Warhol's life was considered a magnificent piece of performance art—whereas inside its confines he was thought of as more of a nutty (a favorite Warhol word) puppet-master, presiding over a culture of debauchery. One reporter called the Factory "a community center for eccentrics," while Andy was almost like an alternative Statue of Liberty, the patron saint of misfits. It was almost as if Warhol had lifted up Manhattan and sifted through the people left underneath.

The characters who hung out there usually had side projects, all the while paying Warhol due respect for bringing them all together. Often they would

come into the office at midday, when Andy would be finishing his silkscreen session at the other end of the floor with Gerard Malanga, his loyal accomplice. They were like Batman and Robin, with Gerard as Andy's ward, the Factory their dingy, silver clad Batcave (although unlike the Batcave, the "Factory" actually sounded rather sinister). There was always a new person with a slew of "the most interesting," "most radical," most whatever. There was constant movement, constant participation. Magic Markers were wielded onto drawing pads and Billy Name would be in the darkroom developing his photographs, Warhol holding court with famous faces doing nothing but staring uncomfortably into his camera, naked people popping pills to keep thin...loners clinging on to the vapors of others, in the hope of being acknowledged for the first time.

It was becoming almost too much of a scene, however, and there was very soon a sign outside: DO NOT ENTER UNLESS YOU ARE EXPECTED, which everyone ignored. Plenty of people would stop by to gawk, or hang out, or pop in just so they could say they'd been there. Sooner or later, you might bump into Rudolf Nureyev, Montgomery Clift, Tennessee Williams, Jane Fonda, Bob Dylan, Mick Jagger, Nicky Haslam, Jim Morrison, or William Burroughs. Notices were put up forbidding the use of drugs, but the habitués continued to plunge syringes into their veins and their backsides quite openly.

Paul Morrissey played father to the rest of the Factory bods, a pleasant, sensible man who took care of business. He was also one of the first there to sport black jeans and black turtleneck. Everything went young in '64, as the world acclimatized to the unprecedented success of the Beatles, and Anglophilia swept America. Rushing the other way was New York's Pop Art phenomenon, and the kinetic energy that appeared to be bubbling up from the streets of Manhattan. Suddenly people on both sides of the Atlantic were living in a culture defined by what everything looked like—with a thumping great soundtrack to boot.

Almost incidentally, Warhol had kick-started New York as an incubation chamber for daring and innovative experiments in both sexual expression and popular culture, encouraging thousands of young people to start using the city as a kind of streetwise finishing school. By dint of this, the city became a change agent. The island may have been in a process of protracted deterioration, as its post-war prosperity disintegrated, with factories closing, middle-class residents fleeing to the suburbs, political negligence, and rising crime, and yet culturally it was more than alive.

Danny Fields: My favorite people hung out at the Factory, and everything they did was my favorite thing. I couldn't believe how exciting the place was, as there was literally nothing else like it in New York. Everything moved so fast back then.

Mary Woronov: I remember my mother saying, when she saw the Rice Krispies packets or whatever they were, "See, I told you—he's not any good!"

Andy Warhol: I started repeating the same image because I liked the way the repetition changed the same image. Also, I felt at the time that people can look at and absorb more than one image at a time.

Danny Fields: One day at the Factory, Andy showed me some paintings of the Brillo boxes of the scouring pads my brother-in-law produced— when I suggested to my sister that she might like them she said that she'd seen so many of the real thing that she didn't need any paintings of them, thank you.

Richard King (author): John Cale always said the Factory ethos was about work. Work first, completely.

Mary Woronov: I met Gerard Malanga when he came to give a poetry reading at Cornell. I wouldn't call Gerard a boyfriend, but he took a liking to me and invited me to the Factory. He wore jewelry, had long hair, and had attitude galore. He was a big deal. I'd already been to the Factory on a Cornell-organized field trip but going back with Gerard was major. He started escorting me around downtown so I felt perfectly safe in his hands. One day Gerard said I should meet Andy and he walked me over to the freight elevator, pushed me in, and sent me up. When I got out, I was sat on a stool and they put all this camera equipment in front of me and then Andy came out and started filming me. Andy always stayed out in the staircase until he wanted to come in and see people. I didn't know what to do, so I started showing off. I didn't know what they wanted, and in the end Andy and everyone went away. I stayed there being filmed, which I guess is what they wanted. I was shocked when I found out later that some people used

the screen tests as an opening, a way into Andy's world or the movies, but I didn't, I suppose because I was so headstrong. I just sat there. I felt a bit used but then Andy came out and said I was very good, so I guess I was. He had just given me a compliment, and that apparently just didn't happen with Andy.

Jane Holzer (socialite): The first thing Andy said was, "Do you want to be in the movies?" And my thoughts were, "Well it beats the shit out of shopping at Bloomingdales every day."

Nicky Haslam: Jane Holzer and I were walking down Madison Avenue with David Bailey after I'd done that cover story with her for *Show* magazine and I saw Andy across the street. I waved at him and that's when they all met for the first time. Andy became obsessed with Jane, and we were in one of his films together, *Kiss*. Andy became a great friend. He was so inquiring, always wanting to know what was going on. I used to take him to grand parties, and I took him to one on Park Avenue one day and he always credited me with making him "smart." We'd go to all the gallery openings together. It seemed odd in the sense that it was different, but not in the sense of being unpleasant. It was a different world. There were the first drag queens, and people became a sort of gang and we went everywhere together.

David Bailey: On that trip we met everyone immediately. Miki Denhof was the art director of *Glamour* magazine, and through her we got to meet Andy, Baby Jane Holzer, the whole crowd that Andy was building around him. We were already exporting Swinging London, and actually I remember we found New York to be quite provincial. I told loads of people in New York about Mick, but a lot of them were scared of the Stones. I told *Glamour* to feature Mick—after they'd decided I was an expert on up-and-coming British bands—but they decided to feature the Dave Clark Five instead. Fucking fools.

I think I was rather disappointed with New York. I'd been looking at it in movies for years, so to go there was quite underwhelming. I was in love with New York as a mythical city of jazz—a jazz nirvana— and it actually wasn't like that at all. Even the hip people, even the Warhols, weren't as hip as the people in London. Because London was

just starting at the time. But you could feel there was a lot of energy in New York.

At the time Warhol wasn't really anybody, he'd only recently stopped drawing shoes for *Glamour*. I was only introduced to him because Miki Denhof thought my pictures looked a little like the things Andy was doing in his spare time. He'd just started the Elvis Presley silkscreens. He didn't even take the photographs! He only really started taking pictures when he started getting sued by the people who took the photographs he based his pictures on.

Andy didn't say very much at all, which is one of the smartest ideas he ever had. He was a philosopher really, although his reluctance to speak helped advertise that. He showed that a picture can be created without a lot of angst and effort. His art is easy to understand, which is why a rich person buys a Marilyn Monroe to signify that they've made it. It's all about status.

New York was rather odd. In London there were already lots of young people who were beginning to be successful—or at least there seemed to be a lot. But in New York there was no one. You never *met* anyone under the age of twenty-fire. And to be young and successful in New York, well, it just didn't happen. People there used to think we were weird because we weren't at school majoring in Domestic Science. People used to come up to you and say, "Are you a group?" The young men were all preppy, in their glasses and button-down shirts. They were very, very clean...

Mick Jagger (singer): The first time I met Andy was at Baby Jane Holzer's. It was our first party when we came to New York. Everyone was there.

Nicky Haslam: I gave an enormous party for the Rolling Stones. It was for the actress Jane Holzer's birthday, too, and Tom Wolfe described it in that weekend's paper as "The Party of the Year for the Girl of the Year." It was at Jerry Schatzberg's photographic studio and as a nod to our Englishness, everyone was dressed very Mod—I wore a ruffled white shirt and a tiger-skin waistcoat. Halfway through there was a roaring of motorcycles outside and in stormed a gang of Rockers. I'd arranged for leather-clad hulks from the local gay motorcycle gangs to "crash" the party. Quite a frisson. As dawn rose, Mick, Jane, Tom, and I went for

breakfast at the brasserie at the Seagram Building, a scene Tom captured in *The Kandy-Kolored Tangerine-Flake Streamline Baby.*

The all-girl band Goldie and the Gingerbreads played a one-hour set at the party, accompanied by Baby Jane, frugging enthusiastically in front of them, in her black velvet jumpsuit with its enormous bell-bottom pants, partnering with the actress Sally Kirkland, in her leopard-skin print dress.

At the party, all anyone could talk about was the Stones, or, more specifically, Mick Jagger, who they suspected had slightly exaggerated his working-class roots in order to win over the straitlaced New Yorkers. And it appeared to be working. Some in Warhol's circle—including Baby Jane—were sure the band's image had been manufactured, but the very act of reinvention was so very obviously cool, and played into the narrative of what was already starting to happen in Manhattan below Fourteenth Street that the Stones were treated as genuine disrupters.

And they were cute, even if they were dirty. Carol McDonald, the guitarist with the Gingerbreads, said, staring at their hair, "They must have worked on the grease. There's just too much grease to be casual."

To Andy, Jane Holzer was classy, epitomizing Park Avenue, haute couture, and all that he imagined about uptown. He knew she was high society, and yet she seemed to have an edge. Holzer's family had made its money in property in Florida, a lot of it in Miami and West Palm Beach, affording "Baby" Jane the opportunity to butterfly around in New York.

Profiling her for New York Magazine, *Tom Wolfe conjured up an essay that not only captured Holzer, it suggested a new kind of "something" was happening in New York, while creating a completely new way to contextualize it. In the piece, "The Girl of the Year," Wolfe depicts Holzer—already locally notorious for her big eyes, infectious enthusiasm, and voluminous halo of hair— attending a Rolling Stones concert at New York's Academy of Music: "Girls are reeling this way and that way in the aisle and through their huge black decal eyes, sagging with Tiger Tongue Lick Me brush-on eyelashes and black appliqués, sagging like display window Christmas trees, they keep staring at—her—Baby Jane—on the aisle." Here was a reimagined Manhattan, said Wolfe, a city that was changing due to the freedoms arising from the post-war economic boom. "Suddenly high art become very boring, such as grand opera and things of that sort," he said. "Andy Warhol used to like to take the old virtues and turn them upside down, [and] somebody like Jane Holzer is a*

perfect example in the area of society with a capital 'S.' She was a lovely young woman, but her loveliness came from excitement rather than perfect features or things of that sort. She thrived on excitement, she loved excitement and that just happened to fit the tenor of the age."

Nicky Haslam: The first Factory was a very hand-made affair with walls and pipes and cabinets roughly covered in silver foil. On the other hand, his mother's house where we went for dinner was extremely neat and bourgeois. One day after lunch we saw some nuns shoveling snow on the sidewalk. They were furious when Andy photographed them. He mumbled, "Gee, if I were a nun I'd love to be photographed."

Danny Fields: Well, Andy and me were all part of the same crowd. We hung out at the same bar in Greenwich Village, and we had the same friends. I mean, sure it happens in every city that has an alternative culture going on. Some of your friends will become extremely famous, some of them you will love very much, some of them will die before they should, some of them will keep being a pain in the ass for the rest of your life, but there you go. It's like *Middlemarch*, you know—it's just the whole universe there in one town.

Nicky Haslam: I did the first article on New York's new underground filmmakers in *Show* magazine. People like Taylor Meade would always come and film in my studio, on Nineteenth Street, and Andy used to come too, to watch.

Andy Warhol: The girls in California were probably prettier in a standard sense than the New York girls—blonder and in better health, I guess; but I still preferred the way the girls in New York looked—stranger and more neurotic. A girl always looked more beautiful and fragile when she was about to have a nervous breakdown.

Nicky Haslam: In a Bacofoil warehouse, cameras turned, Andy mumbled, hustlers humped.

Catherine Guinness (writer, socialite): Andy was always worried that he was running out of ideas, which is why he loved people with

ideas. He didn't have these great inspirations, he just wanted ideas for paintings that would sell. He didn't paint pictures of hammers and sickles and skulls, he painted them because he hoped they would sell. He wanted to paint pictures that people would buy. The people who did his canvas stretching often came up with good ideas. He was always very curious, inquisitive, and had a sort of childlike quality. He wasn't remotely jaded.

Nicky Haslam: A lot of the social mixing felt like it had been imported from London, this whole uptown-downtown thing, being interested in the lower class. London brought the modern look, although New York was already changing. I think we were thought of as fun folk. The Americans thought of us as "turns" [performers]. Music was changing, discos were changing, everything was becoming younger. We didn't know if it was a scene or not because we were part of it. I enjoyed being the English boy in New York, though, having Mick and Keith and the Stones to stay. You only had to have an English accent and you were considered to be exotic. We were streetwise more than anything. There was also no color bar in New York, and black and white were together, there was no problem.

Andy Warhol: Now and then, someone would accuse me of being evil—of letting people destroy themselves while I watched, just so I could film them or tape-record them. But I didn't think of myself as evil, just realistic.

David Bailey: The Americans came round to the Stones quite quickly, but a lot of that was due to Mick's sex appeal. The first time I took him to meet Warhol at Baby Jane Holzer's apartment, Mick sat down and stuck his feet up on her favorite lattice Chinese table. I thought, "She's not going to like that." But Mick could get away with anything because he had so much charm and made people want to please him. On our second trip to New York, I saw them play the Academy of Music down on Fourteenth Street—Warhol was there, Baby Jane Holzer, Shrimpton, Tom Wolfe… the band were like a small army that had recently invaded the island.

Mary Woronov: Instead of the pristine walls and bright lights of the other studios, Andy's Factory was dim and dirty-looking, as if it were

underground. The only light was reflected light coming off the tinfoil walls, making everything unreal and flickering.

Danny Fields: It's New York! There always has been, I don't know of any time that there hasn't been, and that's what a great city is supposed to do—is be a center for creative people. For me, when you're twenty, this is when it starts, so people are younger and braver. That's why everyone was here in the first place. They're here because the city itself was a magnet for people who lived in smaller cities, or couldn't find people that appreciated what they did or people to be friends with—there are all these things going on…It's New York!

Nicky Haslam: Andy was one of the most totally organized, practical, and astute beings I ever knew.

Liz Derringer (journalist): Andy was New York. He became the city. He became New York. The city just opened up for him. He could be a very quiet person, but he was always open and fun. He basically encouraged a lot of people, like he encouraged me. I have nothing but positive things to say about him because he was such a positive person. And his attitude was infectious.

David Bailey: I shot him a lot, maybe twenty times, but I'm not sure I ever properly caught him. He was always so protective of his image that it was almost impossible to permeate it. He was so particular and so introverted that you never got anything he didn't give everyone else. And of course all of this was deliberate. When I was photographing him, it felt like I was going after smoke. He'd just disappear right in front of you. Boom! You'd try to touch him, and he'd just evaporate in front of you. I liked him, but I'm not sure I ever properly knew him, I'm not sure he was ever actually there, not really. I'm not sure he was there for anyone. That was Andy, really.

Mick Brown (journalist): Billy Name would later vanish into his darkroom for more than a year, poring over the occult writings of Alice Bailey and Madame Blavatsky, and emerging after nightfall when everyone else had left, pallid and scabbed from vitamin D deficiency, brains fried by Methedrine.

To Lou Reed, Warhol's Factory would have been a foreign country in 1964. Despite attempting to reinvent himself at Syracuse University through loutish behavior, and by carefully tinkering with his personality, dressing like a bad boy and by taking and dealing drugs, this middle-class twenty-two-year-old graduated with honors in June with a BA in English. It was at Syracuse where Reed formulated the idea that rock and roll could genuinely serve as a medium for lyrics that addressed the same themes explored by the likes of Allen Ginsberg, William Burroughs, and Hubert Selby Jr. It was an almost myopic creative passion that allowed him to subjugate himself to a more bohemian way of looking at the world. His singularity was the most important force in his artistic creations, even more so than his talent. Principally because he wanted to do things his way and his way alone.

Reed took artistic endeavor more seriously than almost anything else in his life and considered the pursuit of a creative vision to be the most noble of callings.

"Music should come crashing out of your speakers and grab you," he continued, "and the lyrics should challenge whatever preconceived notions the listener has."

His point of difference, though, was an equally powerful desire to reflect reality, and the veracity of the earned experience.

"I think it's pretentious to create art just for the sake of stroking the artist's ego," he said. "How can anybody learn anything from an artwork when the piece of art only reflects the vanity of the artist, and not reality?"

Of course, it's implicit here that the only artist who could properly—accurately—reflect reality was Reed himself, which in a sense made it impossible to challenge his belief. His objectivity, being completely subjective, couldn't be countered, because there was no one who had had Reed's exact experience.

And there were probably many who were perfectly happy about that.

Reed's singularity started early, in his teens, and by the time he was at Syracuse in 1960, aged eighteen, he was already flailing at the world. One of the college's program directors, Katherine Griffin, concluded, "It was just Lou versus everybody else."

In some respect his teenage rebellion was boilerplate. He was born into a solid middle-class Jewish family in Long Island, his father an accountant, his mother a former beauty queen and doting housewife. The conformity of Fifties suburbia not only created a nation of eager, if passive consumers, it also created a generation of teenagers determined to push against this new

age of prosperity. Newly enfranchised and targeted by a record industry which understood that teens were consumers too, aspirational but downwardly mobile enthusiasts starting to ape the working class, borrowing from black style and devouring the Beats.

Reed wasn't just a disciple, he was an early adopter. He'd fallen in love with R&B (and in particular the legendary Johnny Ace) a good few years before Elvis Presley appeared, and at school was already aspiring to be a musician.

Lou Reed (musician): When I was in high school, we had a band called the Shades. Me and these two other guys. I wrote the songs and sang in the background. I wasn't up front. At the same time there was a group from East Meadow, Long Island, called the Bellnotes and they recorded a song called "I've Had It." "I've Had It" became a regional hit; my songs: nothing, zero. So then [radio DJ] Murray the K was supposed to play our song one night, but he was sick, and his replacement did. I actually heard my song on the radio when I was fourteen, my own song, once. That was it. And I received a royalty check for two dollars and forty-nine cents, and that was that.

His singularity was created in part by his parents' decision to subject him to electroshock treatment (the big new thing in the Fifties for straightening out delinquent kids). He was just seventeen and, like many of his peers and their hero James Dean—who, in Rebel Without a Cause, *pushed back against the confines of mainstream America—had turned into something of a problem case. He had alarming mood swings, was stridently sullen, and, more worryingly for his parents, had started to display what they thought were gay predilections. At the time, the homosexual was, along with the communist, the single most threatening, subversive character in American culture. So, after unsuccessfully sending their son to a psychiatrist, and encouraged by a local doctor, his parents requested he be given shock treatment. So, Reed was sent to Creedmoor State Psychiatric Hospital in Queens, for nonconvulsive electrotherapy, three times a week for eight weeks. Even though he was forever convinced the treatment was meant to "cure" him of any growing signs of homosexuality, a neighbor quoted in Victor Bockris's biography of Reed says his parents just wanted their rebellious, pop-obsessed son to behave. His circumstances were certainly extreme, but Reed was oblivious to the fact that teenagers are maybe not the most reliable guides on the subject of their parents.*

*Physically and emotionally brutalized by his treatment, the experience only accelerated a period of reinvention that not only saw him try to shed any evidence of his traditional middle-class background, but also encouraged a huge sense of entitled teenage injustice. A school friend says that the teenage Reed suffered from "shpilkes," a Yiddish expression for anxiety, and sudden nervous exhaustion. "He couldn't leave any situation alone or any scab unpicked."**

Lou Reed: They put the thing down your throat, so you don't swallow your tongue, and they put electrodes on your head. That's what was recommended to discourage homosexual feelings. The effect is that you lose your memory and become a vegetable. You can't read a book because you get to page seventeen and have to go right back to page one again.

Mary Woronov: Lou Reed was treated like an animal by his parents. Lou's parents were terrible to him. He dropped out of the fucking carriage, and they left him on the floor.

Mary Harron (journalist, filmmaker): Sterling [Morrison] told me that when Lou and he were at college, there was a huge army maneuver on camp, and someone in their room playing this wild, crazy guitar solo. And of course, it was Lou. He said you never knew what you were going to get with Lou, whether you'd get the smiling Lou, or the Lou on a new kind of drug. He would have these enthusiasms.

Lou Reed: I studied classical piano, and the minute I could play something I started writing new things. And I switched to guitar and did the same thing. And the nice thing about rock is, besides the fact that I was in love with it, anyone can play that. And to this day anyone can play a Lou Reed song. Anybody. It's the same essential chords, just various ways

* In the UK, aversion therapy was becoming all the rage among experimental psychiatrists, using electric shocks and nausea-inducing drugs to treat addictions and other unwanted behavior. John Barker, a psychiatrist who would soon start working at Shelton Hospital, a mental institution outside Shrewsbury, believed the right kind of therapy could be used to change behavior among everyone from speeding drivers to gluttonous eaters. He once treated a man who dressed up in his wife's clothes and was afraid of being prosecuted as a transvestite by making him stand on an electrified rubber mat—turning it on and shocking his feet and ankles while he put on the female clothes.

of looking at them. There is nothing special about it, and it only becomes special when I can't do it. When I can't do it, I'm very impressed by the person who can, and when I can do it, it means nothing. But I would write new things from the day I could play anything.

Reed seemed to start to enjoy his obvious differences, and while Lou Reed might have been a cliché, he was a cliché of his own making. At Syracuse he was taught by the charismatic poet Delmore Schwartz, and smoked pot, dropped acid, and took peyote, amphetamines, and Placidyl, a sedative (Schwartz convinced Reed he could become a great writer, even though the student went out of his way never to show him any work). His reinvention centered around his idea of being a literary bad boy, a kind of mordant pop Jack Kerouac. It was here that he had his first affairs with men. He dated women—and had a long-term girlfriend for a while whom he felt pretty serious about—but had affairs with men on the side, and he frequented the local gay bar, the Hayloft.

Lou Reed's complicated sexual history is one of his most important narratives, and would become a major contributor to the creative tension in his work. In a 1979 issue of Creem *magazine, he talks about his adolescence and early twenties, describing "trying to make yourself feel something toward women when you can't. I couldn't figure out what was wrong. I wanted to fix it up and make it OK. I figured if I sat around and thought about it, I could straighten it out."*

The musician and journalist Ezra Furman is a transgender woman who wrote a brilliant essay about Lou Reed, "Lou the Queer," in 2018.

Lou Reed is my favorite gay icon. Calling him that is a bit of an awkward fit, since he got married three times (to women) and can be heard on one of his live albums saying, "I'd rather have cancer than be a faggot." But he's a gay icon nonetheless, and it's his ambivalence and rebelliousness about those kinds of labels that makes him my favorite. Well, that, and the fact that he writes the best songs... I get the sense that Lou's homosexuality was deeply interwoven with his interest in music and art, as well as his aggressively alienating social presence. Finding himself surrounded by heterosexual jocks and threatened by the social power they held, he became an antagonistic iconoclast to survive. He turned what those around him saw as weaknesses—being gay, feminine, arty, and socially awkward—into weapons, and flaunted them.

She writes about Reed's constant flip-flopping between boys and girls, between men and women.

> *I'm compelled by the tug-of-war going on here, between the underground artsy lifestyle and the middle-class normalcy Reed's parents hoped he would find his way back to. It was also, I hardly need to point out, a battle between homo- and heterosexuality. I don't mean to suggest that Lou Reed felt guilty about his sexual relationships with other men, or his betrayal of his parents' hopes for him. But the freedom and instability of a life in art can compound the instability that comes with a rejection of the sexual behaviors the square world demands of us queers at every turn. We all know how much easier and less problematic it can seem to be heterosexual, and many of us achingly ask ourselves in dark moments if we wouldn't be better off learning how to fake our way through an institutionally sanctioned life as a straight cis-gendered Normal Person. If these thoughts still haunt the troubled queer in the twenty-first century, one can imagine how powerful a sway they must have held over a broke, uncertain twenty-something in the Sixties. On a bad week, anyway.*

At Syracuse, Reed also started experimenting in bands, one of which was called L.A. and the Eldorados, which included fellow student Richard Mishkin on piano and bass. "Lou and I really hit it off right from the beginning," he told Anthony DeCurtis. "But when I say 'hit it off'—you don't hit it off with Lou. You find commonality and deal with his bullshit."

Lou Reed: The first gigs I went to were in bars. The bands were just bar bands. I loved them, but then I had never really seen anything else, so they became the standard for me. I liked doo-wop too, and I started going to some of the Alan Freed package shows, with groups like the Moonglows. I really loved them too. But because most of what I saw was elemental, I started doing it myself, playing in different bar bands. A bar band seemed to be the very pinnacle of music.

Richard Mishkin (musician): Lou fashioned himself a rebel because he didn't fit in society the way a lot of people do. That was who he was. He clearly enjoyed being offensive and he always understood exactly what he was doing. He used to sing this song called "The Fuck Around

Blues." In 1961 or '62, people didn't stand up on a stage and do that. But Lou did. I thought it was perfectly OK until I realized that maybe the venue wasn't right. We'd lose gigs. People would get pissed off and throw beer at us. But we'd just change the name of the band and go back and play there again later.

Lou Reed: It didn't seem to make sense to just play a gig like anybody else. I thought there was an opportunity to do something genuinely different, something that had honesty and meaning.

Having got his English degree and having received a 1-Y draft classification because of his emotional and psychological problem (meaning he would only be called up for duty in the event of a national emergency or an outbreak of war), he was now free to explore pop. Which in the first instance was a job as a professional songwriter at Pickwick International, a budget record label in Long Island City, a section of Queens not far from Manhattan. He had already had some success with local bands in his area, and his ambitions stretched to writing as well as performing. He said it almost felt like a summer job, the kind of thing you do between one thing and another, although it would actually lead him to his first great collaborator.

Lou Reed: I was looking for a job and got a job as a staff songwriter at a real pittance. And it was great experience. It was just me and these three other guys writing essentially what would be called hack stuff. And a lot of that stuff has found its way onto bootlegs, amazingly enough. "Psycle Annie" is an example of that kind of thing, a hot-rod song. But there was one that I really liked that I wrote with one of those guys called "Love Can Make You Cry," and I've never been able to find a copy of that. That actually was a good song. I wrote another one: "Let the Wedding Bells Ring." The guy's got a car in high school, she wants to get married, he doesn't have enough money, so he enters a race, and gets killed. So, you know, they came in the room and said: "Write us twenty rock'n'roll death songs..." You know, "Tell Laura I Love Her," those kind of things. So, we did. And it was a great experience because you got to record them... The writing is nothing, but it's like training. I've only had two or three real jobs in my life. None of them lasted very long. But one of them was to file the burr off a nut in a factory, and that's what this was.

Pickwick was basically Reed's own pop factory, a suburban Brill Building, where he'd spend all day bashing out surfing songs, hot-rod songs, motorcycle songs, romantic ballads, whatever was required ("I was a poor man's Carole King," he said). One particularly macabre song, "Let the Wedding Bells Ring," ended with the hero dying in a car crash. Fundamentally a copycat company, Pickwick would churn out a string of records in whatever style was currently popular, until the fad disappeared. One day he wrote a gimmicky song called "The Ostrich" (inspired by a fashion revival of ostrich feathers) and then, because nobody told him not to, created a silly dance to go with it. Pickwick released it under the name The Primitives, and when Vogue, *in their finite wisdom, decided they wanted to photograph the band, the label decided they needed to hastily assemble one.*

Lou Reed: I didn't think I'd arrived at Pickwick International, but I enjoyed every minute of it. When I was one of the staff writers at Pickwick, I was charged with writing stuff that was like the stuff that was in the charts. Copying hits, basically. So every day I would churn out all these shitty songs that were just weird, pale imitations of things that were popular at the time. It was funny. They were pretty dreadful, actually, but they were timely, which was the point—I wrote loads of surf songs, automobile songs and Shangri-Las death songs—which were actually the kinda stuff I really loved. "Johnny Don't Surf," "Johnny Don't Drive," "Johnny Don't Do Anything." A lot of Johnny songs. It was actually great training for me, because I learned how to behave in a studio, and learned various shortcuts. I was obviously really into R&B and doo-wop and great rock and roll, but when I was at Pickwick, I was writing stuff that was very pop. I was writing kitsch, I guess, which in a sense freed me up to do the things that I really wanted to do. The things that I was working toward, the things I thought I might be able to do.

CHAPTER 2

THE BIRTH
OF THE COOL
1965

"I'm writing about real things. Real people. Real characters. You have to believe what I write about is true or you wouldn't pay any attention at all. Sometimes it's me, or a composite of me and other people. Sometimes it's not me at all."
—Lou Reed

The appearance in Vogue *resulted in a couple of requests for the Primitives to perform on TV, including* American Bandstand. *And so Pickwick started assembling them, much like the TV producers Bob Rafelson and Bert Schneider would a year later, when they started recruiting for the* Monkees. *One successful candidate for Lou Reed's imaginary band was a strange yet charismatic Welsh viola player called John Cale, a twenty-two-year-old avant-garde classical musician in the Theatre of Eternal Music, an ensemble put together by the minimalist composer La Monte Young. He was introduced to Reed by a Pickwick producer, Terry Phillips, who thought Cale was a pop musician because he had long hair. He asked Cale, Eternal Music cohort Tony Conrad, and another friend, the sculptor Walter de Maria, to form the band with Reed.*

"We thought it would be fun, and as a lark spent a couple of weekends playing the TV show and a few other East Coast gigs," says Cale. "Even though the record bombed, the experience of being in a rock band, however ersatz, gave Lou and me the opportunity to connect."

The son of a coal miner (a father who only spoke English) and a teacher (a mother who taught Welsh), Cale was born in the small Welsh rural pit village of Garnant, between Swansea and Carmarthen, in the Amman Valley, in 1942. Even then, the valley was at the center of the anthracite mining industry (it was called "the black diamond," the most valued form of coal mined in South Wales), an environment littered with chimney stacks, colliery towers, pitheads, and washeries, juxtaposed with fields of roaming livestock. Garnant, Pontamman, Gwaun-Cae-Gurwen, Brynamman, and Rhosamman were the villages of the valley, supporting a workforce that spent most of its life underground—according to the 1921 Census, the immediate area around Garnant contained a workforce sufficient for twenty mines. Tragedy was habitual: in 1884, seven men and three fourteen-year-old boys in Garnant fell to their deaths into the main local pit known as Pwll Perkins. The winch rope holding the cage that transported the miners to and from the coalface snapped; the families of the men and barely-men received no compensation. Here, death was punitive, even though the area boasted the finest coal in the world.

This was the world that Cale was destined to escape, helped by a mixture of talent, character, and a latent desire to flee. He began learning the piano at the age of seven, and developed into something of a prodigy: he played the local church organ, and the viola for the Welsh Youth Orchestra; his first original composition, "Toccata in the Style of Khachaturian," was recorded by the BBC when he was thirteen. When asked about his earliest memory, he said, "The first thing was my horror of Sunday. When Sunday comes around... There was a tortured way of hiding things. You weren't allowed to drink on a Sunday—but the chief constable would be having a pint, so nothing was ever what it seemed. It was tortuous."

His grandmother made life tough for him, as she really ruled the roost at home. What's more, she didn't like the fact his mother had married an uneducated miner who didn't speak Welsh. It made for a lot of tension. "I got the same treatment," says Cale. "Life was very uncomfortable because she banned the use of English in the house, and it left me unable to really talk to my father."

Consequently, Cale started to fantasize about escaping.

"The notion of New York as this twenty-four-hour society where you could work as long as you liked, stay up as long as you liked, was fascinating to me. So to end up in America had always been my aim, even before I got an offer to go there."

He started playing the organ at a precociously young age, and eventually decided to study viola. (He would later say that it is "the saddest instrument of all and, no matter how adept you get at it or no matter how fast you play it, you can't get away from the character of it.") While his parents hoped he'd become a doctor or a lawyer, in his late teens Cale became obsessed with contemporary classical music, in particular the works of John Cage, which he was able to obtain via inter-library loans from his local Workingmen's Library. Aiming to become a conductor, he enrolled in the music department at Goldsmith's College, but soon became disillusioned with the restrictive nature of the course. His finale at the college was a concert performance in 1963 of La Monte Young's "X for Henry Flynt," a piano piece to be played, not sitting down, with the fingers, but kneeling, with the elbows. He won a scholarship to the Eastman Conservatory at Tanglewood in Massachusetts, but he soon discovered New York.

There, he immersed himself in the burgeoning avant-garde scene, taking part in long-form experimental performances with John Cage; an eighteen-hour-long piano-playing marathon of Erik Satie's "Vexations" was one notable exercise. Through Cage, Cale was introduced to La Monte Young, another avant-garde artist with whom he once sustained a single note for days. After years of learning musical theory, Cale discovered he was keener on breaking the rules than adhering to them. Otherwise known as the "Dream Syndicate" (which also featured Tony Conrad, Angus MacLise, and Marian Zazeela), Young and Cale became embroiled in the most extreme form of atonal experimentation. Cale filed the bridge of his viola down, stringing the instrument with metal strings, and amplifying it. This allowed him to play four strings at once, and the result was "a great noise; it sounded pretty much like there was an aircraft in the room with you," says Cale—drone music.

As she says herself, sometime in early 1963, or even in late '62, the aspiring actress Amy Taubin found her way to the downtown loft where the Dream Syndicate were playing weekly concerts. She says the sound they produced was massive: "Tones sustained for impossible durations at impossible volumes, so that you felt as if you were inside the sound and that the connection between ear and brain was transformed." At the time, this musical onslaught shaped her aesthetic even more than the films she was involved with (she would work with Warhol, Ken Jacobs, Michael Snow, and Barbara Rubin—in '64 Rubin brought her to the Factory, where Warhol shot two screen tests of her and put her in a chapter of Couch, where she sat between two Superstars and very slowly ate a banana).

Mary Harron: John Cale contributed so much to the Velvet Underground soundscape, and they wouldn't have been what they were without him.

Bobby Gillespie (musician): Cale introduced modern compositional elements, like systems music. And Lou was hip enough to get it. The drones created tension. Plus, he had cheekbones. I think people were scared of him, as he had an edge. He had an intellectual edge as well. He was obviously quite hetero and working class as well. Cale was such a handsome guy. There's something about his character that's uncompromising. Flinty. He's certainly the best singer in the Velvet Underground. Or could have been.

Ed Vulliamy (journalist): I once asked John what the politics of the drone were, and he said, "How long can you walk with a stone in your shoe? Keep walking and you'll find out."

Jon Savage (journalist, author): In 1963, La Monte Young recorded "Sunday Morning Blues" with the Theatre of Eternal Music, which comprised Young on soprano sax, Marian Zazeela (voice), John Cale (violin), Tony Conrad (viola), and Angus MacLise (drums). MacLise played beatnik style, while Young improvised over the drones provided by the other three musicians. The result stands at a critical juncture between Near and Far Eastern music, contemporary Bohemianism, Minimalism, and the whole panoply of art rock that the VU would set in motion.

John Cale (musician): The viola is the saddest of all instruments, and no matter how fast you play you can't get away from the melancholy.

Jayne County (musician): John Cale made the sound of the Velvet Underground.

Lou Reed: I only hope that one day John will be recognized as...the Beethoven or something of his day. He knows so much about music, he's such a great musician. He's completely mad—but that's because he's Welsh.

Cale was intrigued by pure noise, but when Reed told him he had written "The Ostrich" by tuning all six guitar strings to one note, the possibilities of pop no

longer seemed so banal; this was effectively the same approach Cale had been exploring with Young.

"We did the TV show as the Primitives," says Cale. "We even did a few gigs. There was Lou, me, a friend called Tony Conrad, and Walter De Maria, a sculptor who also happened to play drums. It was obvious that nothing was really going to come of what we were doing, and Pickwick weren't really interested in the songs Lou was writing. He already had 'I'm Waiting for the Man' and 'Heroin' [which still sounded like folk songs]. But Pickwick were only interested in these crazy pop songs, cash-in stuff."

Cale begun to think there was an opportunity here to do something that was different from everything that was going on. He thought that if they combined Reed's literary side with Cale's classical training and what he'd been doing with La Monte, and wrap it all up with some rock and roll, fusing the furthest reaches of these propositions, it might take them somewhere no one else had been, and no one looked like they were going. He kept thinking about what Bob Dylan was up to, with these songs with fifteen or sixteen verses. He thought to himself: "We can do that, but let's bring in some of the stuff I've been exploring with La Monte, the drones and repetition, that's where we'll be different, and we'll do these songs and never repeat the same thing twice."

So Reed and Cale started collaborating with each other, socializing 24/7, and eventually, in the spring, moved in together (56 Ludlow Street, on the Lower East Side)—with Cale resisting Reed's amorous advances, but building a solid working relationship. Having decided to call their new project the Warlocks, they started looking for musical recruits. They were looking for another guitarist when, traveling on the subway, they literally bumped into a student Reed had known at Syracuse, Sterling Morrison, who was studying English Literature at City College. The Warlocks soon became the Falling Spikes, and then finally the Velvet Underground, after Michael Leigh's infamous 1963 paperback about "aberrant" sexual behavior.

John Cale: Growing up in Wales was a pretty Draconian experience with religion.

Chris Sullivan (DJ): John is from a part of Wales that is hard, rough, and surprisingly violent, where huge bar brawls and street fights are considered normal. To grow up as the son of a teacher, play the viola, and then be a child prodigy must have been hard work, and no mistake.

Richard King: Garnant is not an especially interesting place, but there was a sense that this person had gone on to do something quite exotic. He was very talented at a very young age and was part of a generation that was really encouraged to use their intelligence to get out. The cliché was, you're not to go down the pit. I think he had a very active imagination and wanted to get out anyway. He was Garnant's son. His mother was quite strict, he had gone to Goldsmith's, and there was that mass exodus through higher education. The schools in the mining communities were very good. The Miner's Institute and the Workers Education Association were wonderful things. There was an atmosphere of self-improvement through learning.

Lou Reed: I met Sterl in 1962, I think at college. We shared an interest in rock music and shared the same essential background—Long Island. He was staying on campus with a mutual friend, James Tucker, Maureen's older brother. We became friends almost instantly.

Maureen Tucker (musician): I'd known Sterling since I was ten and he was twelve. He was my brother's friend. By the time I was twelve, my brother didn't want to play cards with me anymore, but I became one of his group when I was seventeen or so. I remember Sterling then, those big, long legs sticking out across the living room floor and having to step over him to walk by.

Sterling Morrison (musician): I graduated high school with very high numbers and matching low esteem, for just about everything but music.

John Cale: I missed out in my teenage years. I led a sheltered life. I was practicing scales instead of playing football.

Sterling Morrison: Rock and roll consisted of Joey Dee and the Starlighters, guys who played the uptown clubs and had matching suits. We didn't have any of those things so we had no choice whatsoever of working on the Manhattan club scene. That was way beyond us, we just couldn't do it, any more than we could have gone to Las Vegas.

John Cale: The first time Lou played "Heroin" for me, it totally knocked me out. The words and the music were so raunchy and devastating.

What's more, Lou's songs fit perfectly with my concept of music. Lou had these songs where there was an element of character assassination going on. He had a strong identification with the characters he was portraying. It was method acting in song.

Both Reed and Cale were starting out in their careers, and both had a desire to push their respective envelopes. However, could they really work together? In these early days, it seemed to many who worked with them that Reed was the more commercial of the two, the one who had been in bands before, and who openly expressed a desire to be successful. But Cale also understood pop, he just wasn't sure if he liked it much. Weirdly, one man they both had enormous respect for was the Beach Boys' Brian Wilson, who was starting to create beautiful teen beach aural movies. "Will none of the powers-that-be realize what Brian Wilson did with the chords?" Reed would say. "Deftly taking from all sources, old rock, Four Freshmen, he got in his records a beautiful hybrid sound—'Let Him Run Wild,' 'Don't Worry Baby,' 'I Get Around,' 'Fun, Fun, Fun.'"

"What Brian came to mean was an ideal of innocence and naivety that went beyond teenage life and sprang fully developed songs—adult and childlike at the same time," said Cale. "There was something genuine in every lyric."

They both understood the inherent melancholy in Wilson's sweet tunes, a melancholy that would soon become apparent in the work of the Velvet Underground. Not that Reed's singing style owned anything to the Beach Boys. Far from it.

Nick Kent (journalist, author): The music Reed really loved was doo-wop and early rock and roll, because it's pure. And very simple. It's shallow, but there's a real purity to it. He kept returning to this music all his life. He talked about these records as though they were the *Mona Lisa*, these incredible works of art. He often tried to re-create that. However, his destiny was to completely smash that, all that purity and innocence. He made his living writing songs of experience. Nothing fits with Lou Reed.

Barney Hoskyns (journalist): It's almost as though Lou wasn't really a singer. It's almost *Sprechgesang*. He never attempts to really sing. From the word go, Lou Reed's approach to singing was very recitative. It's like,

"I can't even really be bothered to sing." He knew he was never going to be a great singer, and so I think it's interesting what he did with his voice, and in a way it's a great voice. So is Lou Reed even a rock and roll star? He said pompously once that he wasn't really sure that he had anything to do with rock and roll, because there was rock and roll and then there was Lou Reed. He was so self-regarding. He was cerebral and dry and sneering, even when he was being tender. He could never be a swaggering rock and roll frontman. He was an intellectual, a bohemian creative figure. He is a noir singer-songwriter.

Lou Reed: If I'd lopped out a lot of words I could have become very strict, but by leaving them in I had to do a lot of vocal things—things I could hear in my head but which were hard to do for real. I couldn't do an Al Green turn that takes up eight bars and makes everybody fall over dead, but I could embellish the verbal picture I was making. I could come off really smart like I planned all that, but that's essentially what went on. And when I wrote, I liked to break the rhythm a lot, because that was the way I heard it in my head.

In March, Andy Warhol attended various performances by the Fugs, some of which were at the Factory, supported by the Holy Modal Rounders. He was already starting to think that he needed some kind of rock band as part of his extended family, and had half-heartedly started looking around for one. The same month he filmed Vinyl, *his version of Anthony Burgess's book* A Clockwork Orange. *In the film, Gerard Malanga played a juvenile delinquent and danced to Martha and the Vandellas' "Nowhere to Run" while brandishing a whip. This would soon become his default behavior at clubs and gigs.*

Warhol didn't especially like pop, and was content to have the Shirelles on constantly in the Factory, playing slightly campy pop from the recent past. He liked the fact that pop was direct, and young, and punchy, but he didn't really understand it, nor did he think much of it was imbued with anything approaching "art." Fundamentally he liked the fact that it was immediate and constant. He also appeared not to mind listening to something dozens, sometimes hundreds of times. If he liked a record (usually something by a girl vocal group) he'd ask one of his assistants to keep playing it. After all, repetition was part of his professional DNA. When he said, "Every song has a memory; every song has the ability to make or break your heart, shut down the heart,

and open the eyes," Warhol wasn't talking about the Fugs, he was talking about the girl groups he liked to listen to on the radio.

He had actually already attempted to perform himself, with no great success. For a group show at the new Washington Gallery of Modern Art in 1963, he had even considered putting together an art garage band, consisting of Claes Oldenburg's wife Patty on lead vocals, drone king La Monte Young on saxophone, conceptualist Walter De Maria on drums, Jasper Johns on lyrics, with Warhol himself on backing vocals. Johns' song titles were more Warholian than Andy's pictures: "Movie Stars," "The Coca-Cola Song," "Hollywood," "The Alphabet Song."

John Cale: I don't think Andy liked any of the music, really...I don't think he liked music in general. I don't remember him ever listening. The Factory was full of [recordings of opera star] Maria Callas, but that was because a lot of friends that hung out there sang along with Maria Callas. He was there when we recorded the album, but he didn't say a word.

On 26 March, Andy met Edie Sedgwick for the first time, at a birthday party for Tennessee Williams. When he saw her, he sucked in his breath, and said, "Oh, she's so beautiful!" If "Baby" Jane Holzer had been the face of 1964, Warhol knew immediately he'd met the face of 1965. Only Edie Sedgwick could walk down the staircase at one of Warhol's museum openings, an ermine wrapped around her, leading two white Afghan hounds on black leashes with diamond collars.

For the rest of '65, Edie was the most glamorous girl in all New York, feted by fashion magazines, and admired all over Manhattan, by both the right and wrong people. And all the while she was on Warhol's arm, her latest catch, his latest flame. When Sedgwick introduced Warhol to her father, their meeting was not a success. While Andy thought Francis Sedgwick was the most handsome man he had ever seen, the Massachusetts blueblood said afterward, "Why, the guy's a screaming fag."

She probably wasn't listening, as Edie was already deep into drugs, both fast and slow. As the Vogue *editor Diana Vreeland said, "Edie was after life, and sometimes life doesn't come fast enough."*

Sedgwick, the trust fund darling, immediately became "Baby" Jane Holzer's rival. With her shock of short white hair and anthracite eyes, she looked like the future personified, a walking, talking fashion magazine. She was so bad

with money (her family's money), that she often forgot to pay people, and at the time it was said that she went through limousine companies the way regular people went through cigarettes. Truman Capote said that Warhol would have actually liked to have been Edie: "He would like to have been a charming, well-born debutante from Boston. He would have liked to have been anyone except Andy Warhol."

She became such a willing accomplice that when Warhol appeared with Sedgwick on the Merv Griffin talk show in October, she told their host that Warhol would be whispering his answers into her ear, because he was "not used to making really public appearances."

Beautiful, young, rich, and already severely damaged, Sedgwick had no idea she was going to end the year as the avatar of Warhol's social desires. In 1965, as Pop Art's prince moved swiftly from painting into film, he made Sedgwick his very best Superstar, his very own Marilyn. In reality, they couldn't have been more different. An American heiress and bright social butterfly, aristocratic and glamorous, vivacious and sassy, she became the beauty to his beast, the princess to his Pop pauper, the exhibitionist to his voyeur. She was so storied, her great-great-great-grandfather, William Ellery, was a signatory of the United States Declaration of Independence. Edie was uptown, Andy was down. She took him to parties where everyone else was listed in the Social Register; he pushed her in front of a camera that she soon learned to love.

In Cambridge, Massachusetts, where she studied art, a whole set grew up around her. But by the time she reached New York she was already in need of repair.

Once warned about having children because of his struggles with mental illness, her father, Francis, and his wife, Alice, nevertheless had eight. If Edie was to be believed, her father tried to sleep with her at the age of seven. "Nobody told me that incest was a bad thing or anything, but I just didn't feel turned on by incest," she said. Edie was first institutionalized in the autumn of 1962 after suffering from acute anorexia and, like her brother Minty, attended the Silver Hill psychiatric hospital. Having been transferred to Bloomingdale, the Westchester Division of New York Hospital, she became pregnant while on a hospital pass and had to have an abortion. In 1964, the day before his twenty-sixth birthday, Minty hanged himself, having recently told his father he was gay. Edie's brother Bobby also experienced a nervous breakdown.

She carried it all so lightly though, and when she was introduced to Warhol, he had never seen such a shining star. She was so immediately fashionable

because she so obviously didn't care what was "in." She would turn up to fancy society parties barefoot, or for dinner dates in little more than a leotard accessorized with huge Greenwich Village bangles, multi-strand necklaces and dangling chandelier earrings. Maybe she'd be wearing just a white mink coat and nothing else. Above all else, she had her signatures: the delicate, alabaster skin, the "sootily rimmed teacup eyes," her Liz Taylor brows, and her—totally shocking for 1965—silver shock of gamine-like hair, dyed to match her mentor's. There were also the black opaque tights, which made almost as many appearances in the newspaper gossip columns as the socialite who wore them. As Life *magazine put it, "This cropped-mop girl with the eloquent legs is doing more for black tights than anybody since Hamlet."*

American aristocracy once decreed that a lady's name should appear in the papers only three times: when she was born, when she married, and when she died. Edie Sedgwick certainly changed all that.

Danny Fields: When Edie came into my life she became Andy's accessory, his girl of the year. She stayed with me. She was part of the Harvard circulation, like a Cambridge warm current. She was one of the young, beautiful, rich, smart boys and girls, America's aristocracy, rejecting their destiny and looking for a bit of low life on the wild side. She, like others, was pulled into Andy's Factory. It was kept alive by people from New York going up to Boston to host these salons, where people would sit all night and listen to music. Beautiful, stranded kids were absorbed into the scene. A lot of these parties were hosted by the magnificent Ed Hood, who would go on to star in Andy's film *My Hustler*. He was a gay aristocrat from Alabama. Trash mixed with nobility in New York and Boston. Debutantes and taxi drivers. This fed right into the Factory, and Andy loved all that.

At the Factory everyone wore black and ate junk food. In a way the place was an experiment about what happens when the veneer of conventional sociability dissolves and the power struggles stoked by gender, class, and even race erupts from beneath the surface of everyday life.

Mary Woronov: The Factory was an insane place, but I liked it because it was different. I wasn't intimidated, because it was Andy Warhol's world, and I already knew how important that was. He was starting to

become responsible for all this great stuff. Although people did ask how I could stand it when I would walk in and there'd be two fags humping each other right in front of you. Just four feet away. You kinda needed people around you for protection. I didn't know how to respond at first, but I soon learned that the best thing to do was just laugh. The fags were fabulous, they really were, and I think they liked me because I was pretty, and they liked pretty. But they could be so horrendous, so rude. There was an ice-cream parlor we used to go to, because in the early days there was no liquor, no drugs, and we'd go there and have ice cream, but then you'd hear Ondine's voice like a saw going through wood, eviscerating someone. I became friendly with Ondine, who was wonderful because he liked me. He could be a real fuck if he didn't like you. But I liked him as he was such a good person. He took a lot of speed, as did I. He sort of directed everything, in other words keeping everyone in check. Warhol did nothing, out on the stairs. That was his escape because even early on the atmosphere could be terrible. People were running around doing what they wanted to, and Andy tolerated people if they were gay, or had some money, or came from a good family. You could go higher in the Factory rankings but as you got higher people would try and bring you down, so it was very competitive. Andy just stood back and watched. Everyone else performed, including me. The person I supplanted at the Factory was [Factory Superstar] Orion. She was gorgeous. Before me she was the only woman there, and she was lethal.

Danny Fields: There was a lot of arrogance about that Warhol crowd: "We're the coolest people in New York." And we were!

Mary Woronov: Everybody thought Andy was shy but he was out everywhere all the time. He wasn't shy at all.

It is easy to forget that during the early part of the Sixties, when Warhol was really going for it, he was dogged by a prevailing sense that his work was something of a con, and that therefore he was fundamentally insincere. This was compounded by both his appearance and the deliberately "dumb" persona he adopted in interviews, disguising how smart, informed and well-read, he was. Thus, critics tended to damn him and all those around him. Including

the Velvet Underground. After all, said the papers, snootily, weren't they just a stunt? The suspicion that was swelling among the public had as much to do with their concern that they were somehow being taken advantage of, as a more existential worry that what was happening was a genuinely important cultural development, one they knew next to nothing about. Warhol was thought to be a countercultural fifth columnist, a completely new kind of threat.

And if Warhol had a reputation for being a sphinx and a phony, surely his group were guilty of the same thing.

In his later years, Warhol would be repeatedly criticized for embracing and endorsing people, often just because they were famous, whereas with the Velvets he liked them because they were genuinely different, transformative, transgressive, and compellingly annoying—all things Warhol liked.

Nicky Haslam: People thought Andy was a huge fake to begin with, and actually I thought Andy felt the same too. I don't think Andy ever took himself seriously, not until Fred Hughes came along and he started to make money.

James Young (musician, author): Andy's tongue was in his cheek, and there is a put-on, and there is deep irony, but it's not a joke, it's not meaningless, but that's what people assumed. There was a double bluff and people only saw the single bluff. People thought it was some kind of Situationist, Duchamp thing for cool Manhattanites. He was a work-aholic, not a *flâneur*.

John Cale: Warhol was a very shy person, and very sly, but I don't think he had a mean bone is his body. I think he played games on an international level, and anybody who wanted to play those games, they would have a good time. So, from my point of view, it was more of a professional relationship. Over the years, he was always available to me, and he was very generous. That's not a view shared by many.

Danny Fields: The people at the Factory were fascinating but then so were the Velvet Underground. They were these disparate, brilliant people who came together to make this shocking, beautiful, *urgent* music. I first saw them at the Café Wha? in the Village and fell in love with them—the melody, the beat, the songs.

Bob Gruen (photographer): I moved up to the city in '65, living in Greenwich Village with two other guys. We were just bumming around looking for girls. I was just this naive guy from Long Island but I knew who Andy Warhol was. At that time we all thought he was a bit of a joke. He made all these plastic silver balloons and Brillo cans and was really weird. And all his Factory lot were. Androgynous and homosexual and on drugs. It was kinda scary to me. I later got to know Holly Woodlawn and Jackie Curtis and I really liked both of them, but in the early days we all thought the Warhol scene was kinda creepy.

In July, Lou Reed, John Cale, and Sterling Morrison recorded a demo tape in their Ludlow Street loft without their drummer, Angus MacLise, because he refused to be tied down to a schedule and would turn up to band practice sessions only when he wanted to. When he briefly returned to Britain, Cale gave a copy of the tape to Marianne Faithfull, hoping she'd pass it on to Mick Jagger. Nothing ever came of the demo, although the trip was successful in another way as Cale brought back singles by the Who, the Kinks, and the Small Faces, which all had a sense of urgency that the Velvets would immediately inject into their own sound. On his return, in July the band recorded various new demos, including early versions of "Heroin," "Venus in Furs," "The Black Angel's Death Song," and "Wrap Your Troubles in Dreams." Their early recordings were hardly transgressive at all, and while the lyrical content was already dark, musically they were still experimenting with acoustic, folk sounds (which would eventually be released in 2022, to universal acclaim). This path would soon change, as the music got stranger and stranger. It seems they went from being an alternative folk group to something far more sinister in a space of just a few weeks.

Lou Reed: There are things I cannot even think of taking credit for. Pure luck. Dumb luck. Literally, I didn't get in the car. Or I moved two steps to the left. I could just as easily be in jail as sitting here. I know that. A bad break—over and out. Luck.

John Cale: If we seemed sinister and nasty and unfriendly, it was mainly a form of protection. I mean, we weren't unfriendly to what fans we had. There was a group of girls from New Jersey. They used to show up for concerts and they'd stand huddled together in the corner with

their eyes wide open, staring. When you saw the four of them together it was like looking out at the *Children of the Damned*.

Lou Reed: What I was writing about was just what was going on around me. I didn't realize it was a whole new world for everybody else.

In November, and still without a regular drummer, Lou Reed hired Maureen (Moe) Tucker, who was the younger sister of one of Sterling Morrison's high school friends. She was working as an IBM keypunch operator, but played drums in her spare time. She was inspired to start playing having fallen in love with the Rolling Stones, although she couldn't have been more different from Charlie Watts. Not only did she never use a hi-hat, but she also used the snare as a high tom-tom, hit her bass drum with mallets, and, of course, she did all this while standing up.

John Cale: I didn't want her to be in the band at first. We'd had our tails whacked by [another drummer called] Elektrah, and I didn't want another woman in the band. But she turned out to be incredible. No cymbals, brilliant. She was perfect because she understood the value of simplicity, the unadorned beat.

Moe Tucker's drumming style was the most sophisticated unsophisticated drumming style of them all, a blend of tribal rhythms, early beat group-like subservience, and manic alt-drug nonchalance. Her (occasionally military) playing style was a vital component of the Velvet Underground, along with Lou Reed's monotone vocals, John Cale's ominous, saturnine viola, and Sterling Morrison's precision guitar playing. An early fan of African music, as soon as the Rolling Stones' first album came out, "I didn't want to just listen, I wanted to play along. And since I didn't know how to play guitar or anything, I bought a snare drum, and I would sit in my room and just play along to their album until it was white. It made it more fun than just listening." She had little time for cymbals and treated her kit in a genuinely innovative way. She might use a mallet in her right hand and a stick in her left, while on some songs, like "Heroin," she used two mallets. "I think our technical background was what made our sound," she says. "For instance, if I was able to play rolls, I would have, and that would have made a big difference. If Lou had gone to music school, he would have learned, oh, you

can't play a D; this song is in F#—which, by the way, I've heard from five different session musicians over the years, who all went to music schools. I don't always know what note it is, but I do know when it's something I want to hear. Something I also realized much later is that we all really watched each other onstage. And it was fun, because we communicated—'Oh, he wants to go double time' or, 'He wants to emphasize this, so I won't emphasize it.' And we did a lot of improvisation. It was fun playing like that, not knowing what was going to happen."

And Lou liked her immediately.

"Lou came to my mom's house on Long Island," she says. "I guess I auditioned for him. I don't remember what I played, or played along to. He wanted to see if I could actually keep a beat, I guess. And it was three minutes or something and it was sealed."

Moe Tucker: I don't know who invented the foot pedal. I guess it allows you to play a crash at every moment; I don't know who started that either. I guess a cymbal company! If you listen to old music, the kind I like, you don't hear a cymbal from one end of the day to the next. You know, I never thought about it before, but maybe things got out of hand when it became about groups as opposed to studio musicians. Band members started thinking, We're stars—look at all these chicks! You know, trying to draw attention to themselves. But seriously, it became all about seven drums and all these cymbals, and two bass drums, which in my opinion is not only unnecessary, but horrifying.

Jimmy Page (musician): It was so radical, such a radical band. You know, Maureen Tucker just playing a snare drum, and the fact there was this electric viola with John Cale. You just didn't get this sort of line-up. It was really arts lab, as opposed to pop music, this wonderful glue, this synergy between them that was dark. It was very dark.

The band adopted the Velvet Underground as its new name in November 1965, and on December 11 the band performed for the first time with this new name, and with Moe Tucker on drums, at Summit High School in Summit, New Jersey, twenty-five miles from Manhattan, sandwiched between 40 Fingers and the Myddle Class, and earning seventy dollars in the process. When they decided to take the gig, drummer Angus MacLise abruptly left the

61

group, protesting what he considered a sell-out; he was also unwilling to be told when to start and stop playing. "Angus was in it for art," Morrison said. He was immediately replaced by Maureen Tucker, and so this was their first proper gig with the classic line-up. "Nothing could have prepared the kids and parents assembled in the auditorium for what they were about to experience that night," said Rob Norris, reviewing the gig for the local paper. "Everyone was hit by the screeching urge of sound, with a pounding beat louder than anything we'd ever heard." He said that after the second song, "Heroin," most of the audience retreated in horror, "thoroughly convinced of the dangers of rock'n'roll music."*

On December 15, just four days later, the band started a residency at an insalubrious Greenwich Village tourist trap called the Café Bizarre, where they were spotted by the young filmmaker Barbara Rubin. She was so flabbergasted that the next night she invited Andy Warhol, Paul Morrissey, Edie Sedgwick, and a bunch of glamorous Factorians to come and validate her experience. According to Morrissey, neither he nor Andy could tell if the drummer was a boy or a girl (they liked that), all the songs appeared to be about drugs (they liked that even more), and they all wore sunglasses. Which made them appear as though they were auditioning for the Factory. In truth, none of the Velvets had heard of the Factory. But they were about to become fully paid-up members. They were about to become Warhol's chosen court musicians.

Immediately after their set was over, Warhol turned to his gang and said, "Gee, do you think we should, uh, buy them?" In an interview a few days later, he announced: "We're sponsoring a new band. It's called the Velvet Underground." He said his intent with them was "to create the biggest disco-theque in the world." They set to work and quickly became assimilated into Warhol's grand vision of a touring art collective, known as The Exploding Plastic Inevitable (EPI). These shows would feature a 16mm, 67-minute silent black and white film of rehearsals filmed at the Factory, slide shows, screenings of Warhol's experimental movies, a constant parade of Factory boys and girls dancing, challenging poetry, and pioneering strobe shows, as well as the Velvet Underground's abrasive improvisations. They were, in short, targeted mayhem.

* Bizarrely, Norris would reenter the Velvet Underground narrative seven years later when he performed in the Doug Yule-led version of the band that toured Europe in 1972.

Sherill Tippins (author): Struggling to feed his tribe on the money brought in from a curtailed art career while enduring constant demands for cash by Factory denizens who couldn't believe that their filmed performances weren't making them rich, Warhol went so far as to place an ad in the *Village Voice* announcing: "I'll endorse with my name any of the following: clothing, AC-DC, cigarettes, small tapes, sound equipment, ROCK'N'ROLL RECORDS, film, and film equipment, Food, Helium, Whips, MONEY; love and kisses Andy Warhol EL5-9941." It was not surprising, then, that Warhol responded with alacrity to a commission from entrepreneur Michael Mayerberg to provide some sort of floor show for a disco he planned to open next spring. As the artist cast about for suitable entertainment, Barbara Rubin suggested he feature a rock band and make some extra money by becoming the band's manager.

The relationship between Warhol and Lou Reed may have initially appeared to have been one of mutual exploitation, but they genuinely liked each other. Reed was convinced that Warhol's patronage would help them land a record deal, while Warhol thought they would be perfect for the EPI. But personally, they clicked.

Tom Wolfe may have just lampooned Warhol by saying that "Nothing is more bourgeois than to be afraid to look bourgeois," but Lou Reed liked him immediately.

Reed was so enamored of Warhol that he even accepted Warhol's idea of shoehorning another singer into the band. Considering how much control Reed was already exerting, this in itself is somewhat extraordinary.

Lou Reed: I loved him on sight, he was obviously one of us. He was right. I didn't know who he was, I wasn't aware of any of that, amazingly enough. But he was obviously a kindred spirit if ever there was one, and so smart with charisma to spare. But really so smart. And for a quote "passive" guy, he took over everything. He was the leader, which would be very surprising for a lot of people to work out. He was in charge of us, everyone. You look toward Andy, the least likely person, but in fact the most likely. He was so smart, so talented, and twenty-four hours a day going at it. Plus he had a vision. He was driven and he had a vision to fulfill. And I fit in like a hand in a glove. Bingo. Interest? The same.

Vision? Equivalent. Different world, and he just incorporated us. It was amazing. I mean, if you think in retrospect, how does something like that happen? It's unbelievable. I went from being with Delmore Schwartz, who taught me so much about writing, and then I'm there with Andy where you get all the rest of it.

According to Reed, Warhol presented Nico as an ultimatum: he would manage them, give them a place to rehearse (the Factory), finance their equipment, support them, find them a record deal, produce them, and make them famous... as long as they gave him 25 percent of their earnings, did what they were told, and put Nico in the band. Warhol didn't think Reed was a good enough frontman (he didn't think he was especially attractive, either). And so Reed and the band went along with it. He didn't really feel the group needed a chanteuse, but as long as they were able to use her sporadically, he reckoned it would be fine. Edie Sedgwick had already expressed an interest in fronting the band, and Warhol sidestepped the issue by asking Reed to write a song about her. He duly did, penning "Femme Fatale." He gave it to Nico to sing "because she could sing the high chorus." The thing about Warhol that really appealed to Reed was that he knew they were real: "Andy told me that what we were doing with music was the same thing he was doing with painting and movies, i.e., not kidding around."

John Cale recalls his first meeting with Warhol: "The band went up to the Factory. We were invited by Gerard Malanga, who came down to see a performance and decided that dancing with a whip was good for our act. The first thing we noticed when we got there was that a lot of preconceptions about what went on in art went out the window. Everybody was very serious, which suited us fine. All we wanted to do was work on our music. They were crawling along the floor, but they were crawling along the floor making silkscreens, which, if you've ever tried to do, is quite a task. They were working very hard."

Moe Tucker: The place was totally nuts. I was very shy. I'll be blunt. I had never heard anyone say the word "fuck." I swear to God, that's the truth. That just was not the way anybody I knew talked.

John Cale: The Factory, the minute you got there, the great thing about it was you felt there were people who understood what you were trying to do. They got us. All of a sudden, we weren't just four people fighting

everybody else. You felt like you were part of what was a pretty good army. We went all over New York in a swarm. It was an endlessly entertaining scene to be around. Something was always happening. And what a parade of stars you saw coming through. There were several different layers to life at the Factory. There was the gay community, for a start. Lou understood that and enjoyed it. He threw himself into that, in fact. He had a lot of fun. Sterling and I, less so. Moe just tut-tutted a lot.

"When the Velvet Underground met the Warhol clan at the end of '65 and entered the Factory, John Cale described it as a kind of creative playground," says Todd Haynes. *"That's minimizing, I think, the euphoric sense of creative permission. It was a place where art was made, all the time. Ondine, who appeared in Warhol movies, describes them as 'Golden' years, where you almost couldn't make a wrong move. There was something going on in the Sixties—and this was a unique subset of all that, with its own terms that were very different from the wider counterculture."*

Mary Woronov: Barbara Rubin brought them to the Factory. Andy immediately liked them. These people couldn't get played on the radio. No one liked them. No one had heard of them before. This mattered. They were different, and they were sexy, but not normally sexy. All of Andy's movies are very much like the Velvets. And also, Andy's movies were sexy, but homosexually so. And Lou's stuff is very on the dark side. The same with Andy. I don't think he sat around reading [Jean] Genet, but Lou did. And so did I. To me, [gay people] were fucking exotic. Boys of the night were sexy, all those hustlers. Lou understood that kind of sex appeal. You know like some guys, they fall in love with hookers? They just love that. But Lou saw it differently. He saw boys. And he picked up on the vibe. And Andy shared that vibe. Not that Andy really fucked anybody. Lou liked being there. I don't know if John liked being there. First of all, John was more interested in women. And secondly, he was sort of condescending. Lou was never condescending. You could just never go down low enough for him. Because that's where he got the meat and potatoes of what he wanted to write about. Lou was a middle-class kid, and he was just phenomenally romanticizing the dark side. He loved transvestites. He loved the craziness of the amphetamine addicts.

Paul Morrissey (filmmaker): I put Nico in there. They really needed her. I made her the star of the group. I thought, "We need someone you can look at." Lou had no voice, no character, no personality. He just had a nasty attitude. And the way he treated Nico was disgusting. He was just so mean and selfish and jealous of her.

John Cale: I was just getting over the fact that we had Moe in the band. Did we really need another woman? Then it struck me that this was great PR on Andy's part. She had this blonde bombshell look, people couldn't take their eyes off her.

Danny Fields: Andy was like a vacuum cleaner. He sucked in the best and the brightest. The Factory was a very welcoming place if you were the right kind of person. We were invited everywhere, and no one knew why, no one knew who we were. Andy used to travel with an entourage of twelve to twenty people. We'd knock on the door of an ancient Jewish billionaire on Fifth Avenue. It was the real *Bonfire of the Vanities*. "Oh, Andy, come in. Who are your guests?" Everything was fertilizing everything else.

I think Andy saw the Factory as a court. It had jesters, priests, whores, princes, everything but a dwarf. It occurred to Andy that it would be nice if we had a band. These days you have a trainer and psychiatrist, back then you'd have a band, especially if you're inventing the idea of a mid-twentieth century. And by some godly coincidence, Gerard Malanga or Barbara Rubin saw, one night, this pathetic, about-to-be-fired unbelievably brilliant Velvet Underground at Café Bizarre in the Village, and Warhol started to go. And then it was, we have this big space, why don't you set up your stuff with us? And then there was the management, and suddenly rock and roll was the thing. And it was. The golden age of rock and roll. Comets everywhere. Supernovas everywhere. Every new album by every new band was a galaxy unto itself. Dazzling. One could get spoilt. One did get spoilt. The Byrds and the Airplane and the Dead, Hendrix, Janis.

Lou Reed: I was a product of Andy Warhol's Factory. All I did was sit there and observe these incredibly talented and creative people who were continually making art, and it was impossible not to be affected by that.

Bobby Gillespie: Lou Reed could make up lyrics on the spot.

Barney Hoskyns: Lou really channeled Warhol a lot. I think he based his whole cooler-than-thou attitude on Andy, the whole can't be bothered to care about anybody, oh dear, people are OD'ing, so what, that's what life is like on the Lower East Side, I'm not going to break a sweat over any of that... It's so blank and emotionless and misanthropic. Andy had a lot to do with Lou's whole persona, a lot more than he would ever admit.

Jon Savage: Warhol's world worked through magical inversion. What society regarded as a deficit became a benefit: no became yes. Drag acts, drug addicts, hustlers, the disturbed, destitute, desperate, and degenerate, the obverse, inverse, reverse, and perverse—all became superstars for a moment, their every tic, gesture, and amphetamined rant immortalized in movies, photos, magazines. The blank facade of the Velvet Underground as they played, wearing sunglasses to protect themselves against the barrage of lights projected upon them, was punk before the time. I might be dumb, I might be smart, but you'll never know. What you want me to be, I'll be. What is the worst you say about me—"sick," "trash," "garbage"—I most certainly am. So fuck you.

Tucker used to say that the band knew how good they were by how many people they drove out. They knew what they were doing was different, and people just didn't know what to expect. "Almost no one ever heard us," says Reed, "and if they did, they left." On December 30, the band played what would be their last concert at Café Bizarre. The owner had taken exception to "Black Angel's Death Song," as customers tended to leave whenever the band played it. The Velvets' response to her request to drop the song was to play it again, "a little louder, maybe," according to Cale. Consequently, they were fired. "We were very obstinate."

Jon Savage: Within the context of late 1965, the Velvet Underground would not have seemed too far out. The charts were full of strange sonorities: droning dirges ("Ticket to Ride," "See My Friends"), trance-like drug reveries ("Mr. Tambourine Man"), brutally riffing Stax rockers ("Satisfaction," "Day Tripper"), or monomaniacal on-the-one grooves ("Papa's Got a Brand New Bag," "In the Midnight Hour"). There were,

however, a few stones in the pathway of the VU's putative pop success. They sang about the wrong drugs: not the beatific allusions inspired by marijuana and LSD, but the desperate void created by heroin. And their attitude and sound instantly polarized audiences—as the Sex Pistols would do, ten years later.

CHAPTER 3

INSIDE THE FACTORY

1966

"The only reason we wore sunglasses onstage was because we couldn't stand the sight of the audience."
—John Cale

Danny Fields: Paul Morrissey and Andy thought the Velvet Underground were dreary visually, and they thought they needed a dazzling star. Paul was thinking like George Cukor. He hated rock and roll, and thought you should have something to look at. They were going to film their rehearsals and then project the film on the three other walls of a club whenever they played. I thought that was inconceivable. Because I thought the band carried you out to space and beyond. Andy and Paul were looking at them cinematically, which is why they wanted Nico. They thought, wouldn't it be wonderful to have a famous European model who was in *La Dolce Vita* up there because she's prettier than anyone in the band. Even though she was in love with Lou, he thought that. No one except the band resented her presence. She sure could sing those songs. Like everyone at the Factory, she was a law unto herself. You had to be self-contained. Your existence couldn't depend on a foil or a fool. You had to be complete, as a character. Sanity didn't matter. Uniqueness mattered. And she had a four-year-old son who was said to be the son of Alain Delon. Wow! Sure, bring her in. All the straight boys fell in love with her, and all the gay boys were in awe of her. And everyone was terrified. She reacted to the terror by freezing inward even more.

Andy Warhol: Nico was a new kind of female superstar. Baby Jane and Edie were both outgoing, American, social, bright, excited, chatty— whereas Nico was weird and untalkative. You'd ask her something and she'd maybe answer you five minutes later. When people described her, they used words like memento mori and macabre. She wasn't the type to get up on a table and dance, the way Edie or Jane might; in fact, she'd rather hide under the table than dance on top of it. She was mysterious and European, a real moon goddess type.

Lou Reed: You know, Andy had a vision, and he had this way of looking at it. "Have a chanteuse." Why not? That sounds like fun. What, are we hardcore or something? We were very hardcore about the music and the lyrics and the approach, but the rest of it, it was like he was a godsend, just amazing. He did everything. You know, protection; we were so nothing, what was there to criticize with us? No one ever heard of us; you can't criticize a zero, you know. So they criticized him. He could care less. I watched. I watched everything he did, and I studied everything he did, and I really listened to him because he's so smart. But I mean smart and does things, not just theoretical smart, like smart and he's right out there. Pretty admirable: one idea after another. People were like: "How can he produce the record? He's not a musician." Well, first of all he pulls me aside and he says: "Whatever you do, don't clean it up, don't slick it up. Don't clean it up, don't let them change anything, do it exactly the way you've been doing it." And he made sure that happened, because he was there. I mean, they wouldn't even talk to us. They talked to him. They said: "Mr. Warhol..." blah, blah, blah, and he would say: [adopts uncannily accurate Warhol voice] "Oh, that's great." And that would be that. They'd look at him, because however strange they thought us or we were, Andy with a silver wig? Right to the head of the class, you know. And he would be really, really aggressively fey on purpose. You know, really push it at them. And if you look at pictures where everybody posed for pictures, Andy would do something really odd or something, so when you look at that picture you have to look at him. And when you were with these people they had to go to him; none of us were wearing a silver wig.

He was a magnificent creature, and he really thought about it. Just look at the way he was before he switched over from commercial art.

It's one of the great ideas, and boom, he just goes and does it. And he would put his money where his mouth was: all the movies, the this-and-that, were funded by him out of his own money. And he wasn't getting anything back out of it. When I left, I just left. He didn't say, "Hey, I've done this and that for you, I want 20 percent forever," or anything. He was really noble.

Nico may have looked extraordinary, but not everyone who saw her perform was so enamored of her vocal prowess. One critic described her voice as "like a cello getting up in the morning." She was half goddess, half icicle, a female mirror to Warhol. She was blonde, possessed a shyness that manifested itself as arrogance, and—to those outside the set—weird. Which is why Warhol liked her so much. He also liked her because her talents were, unlike his, finite.

Brett Anderson (musician): I love Nico. I mean, how influential was Nico? I think she invented goth. Obviously when she did stuff on her own she really went out there, but with the Velvet Underground I love the juxtaposition between the songs' melodies and the fact that she couldn't really sing. She had her own style.

Nicky Haslam: Nico used to borrow my leather jacket to wear onstage when she played with the Velvets. I've still got it. It was given to me in New York back in the Fifties, it was a real James Dean-type thing. We all had the rocker look, with leather jackets and motorcycle boots. She used to live near me downtown and she was always coming round. She was sort of being difficult, you know, like girls of that age are. Quite silent and beautiful. I'm not sure she was particularly ambitious. Because we were doing things that nobody had ever heard of, ambition didn't really appear to be a part of it. We were just doing it. At that time in New York, people were still into Picasso. Proper artists. It was very uptown. Drugs were around a bit. Speed, black bombers. I stupidly wasn't on them; I wish I had been. Not much grass. No cocaine. LSD had come in, and people used to talk about their trips endlessly. Shepheard's at the Drake Hotel was the big disco, probably New York's first. It opened until 3 a.m., seven days a week. It had these silly little cards printed: "How to Do the Newest Discotheque Dances at Shepheard's in New York's Drake Hotel" with step-by-step instructions to dance the Jerk and the Monkey.

El Morocco and The Stork were still going, and Sybil Burton, Richard's wife, opened a club called Arthur's on the site of El Morocco. They called it Arthur's in honor of a George Harrison quip in the Beatles' film *A Hard Day's Night*. After someone asked the guitarist the name of his hairstyle, he replied, "Arthur." The clubs weren't rampantly homosexual, although they were about ten minutes after they opened. The gay scene was pretty clandestine, and it wasn't talked about. Everybody knew it was around, but it wasn't open. It was still fun to come back to London and go to the Ad-Lib. But being young in New York was very exciting because you almost felt they were doing it better, as you would at that age. It has a kind of magic for the young, and for the very old and very rich if you're a woman.

Bob Colacello (journalist, editor): She [Nico] often came to the Factory and was kind of silent, and when she said something, it was always in this really weird deep voice.

Lou Reed: Originally, I thought she could just play tambourine.

Tony King (creative director): Nico was perfect for the Velvet Underground, and I wasn't in the last bit surprised when she turned up with them. She was perfect for them, as Lou Reed had his deadpan delivery, and she had all this beauty.

Andrew Loog Oldham (entrepreneur): I wasn't surprised she became embroiled in the whole Factory scene, but I found the whole thing terrifying, namely because it was a premonition of my own addictive tendencies. I knew I couldn't survive in that world, and I wasn't sure she could. I was up for the dance I was doing, not for where it was going. It looked like a toxic environment. The world was already changing from a private club to a much more public one. So-called Swinging London was changing. Although in her defense she didn't appear to need a man. I didn't like her records much though... she was a survivor. In so many ways she was indescribable. She knew where to go and what to do, but they were places I definitely wasn't going. I was having enough trouble with the Small Faces in London.

When Mick Jagger first heard her, he started telling anyone who cared that he thought she was going to be the next Joan Baez, but with her ghostly Garbo-esque drone she was the least strident singer in New York, probably in the country. "There was nothing clarion about Nico," says the writer, Mark Rozzo.

Danny Fields: Nico was so impressive. The first time I saw her was at my so-called assassination party. It wasn't a party celebrating the assassination of JFK, it was a party to somehow get this blanket of gloom out of the way. Thanksgiving weekend in New York, a week or so after the assassination. We had a big DIY punchbowl full of grapefruit juice and vodka in equal proportions with a big cube of ice gloating in the middle, and a ladle. You were supposed to take a cup and ladle it in, but Nico just lifted the ladle up to her mouth and drank it all. Then she spotted one of my pretty boyfriends and said, "I want him." We hadn't even been introduced, and I told her he was probably gay, but she didn't care. Nico got what she wanted. She was being paraded around New York, and she soon ended up in the Factory. There was no real Factory yet, but she was already around.

Perhaps predictably, Nico was the result of an unhappy union. She was born Christa Päffgen, in Cologne, Germany, on October 16, 1938. Her mother, Grete, came from a beggarly Protestant background; her father, Willi, was the son of a wealthy Catholic brewing family, who were confounded by the prospect. Her parents divorced in 1941, and the following year her father died in the war, the victim of "friendly fire" from his own side (Nico would repeatedly create alternative credentials for him, and at various times he was a Turkish archeologist, a friend of Gandhi, a Sufi, and a spy). She and her mother ended up in post-war Berlin, a lawless, ruined city under martial law, with institutional looting and corpses in the street; she called it a "desert of bricks." It was here, when she was thirteen, where she was allegedly raped by an American Army sergeant, who was court-martialed and hanged for the crime. She also said the soldier was black, a claim that has been cited by many, Nico included, to explain conduct, on her part, that throughout her life would sometimes be called racist.

As an adolescent, Christa already spoke in the glacial, booming tones that would soon inform her singing voice. She wanted to be a ballerina, but her ambition was interrupted by a fashion photographer, Herbert Tobias, who gave her a new name, a career as a model, and took her to Paris. The next few years

73

have been subject to much mythologizing, not least by Nico herself, involving her working with Coco Chanel, sleeping with Jeanne Moreau, taking heroin with Chet Baker, and being seduced by Ernest Hemingway. What is certainly true is that she was given a minor role in Fellini's La Dolce Vita, *although an abortive role in* Plein Soleil *with Alain Delon resulted only in a son (Delon denied paternity). She then moved to Ibiza to look after her sick mother, where a friend suggested she might try singing. She started performing at clubs in Paris, where she met Bob Dylan, having a brief fling with him, and—so she says—inspiring him to write "I'll Keep It with Mine." A trip to London in 1965 (she was nothing if not a nomad) resulted in her first record, for Andrew Loog Oldham's Immediate label, a version of Gordon Lightfoot's "I'm Not Sayin'," although it was back in Paris where she first met Andy Warhol. He, in turn, invited her to visit him at the Factory, not knowing she was deaf in one ear.*

Jimmy Page: I met Nico in London in '65 for a session for Immediate Records. She was recording the Gordon Lightfoot song "I'm Not Sayin'," and there was a B-side that was needed, and Andrew and I came up with "The Last Mile." So I went with my twelve-string round to her place—she was staying in a mews flat off Baker Street—and rehearse the song with her before recording it. She was really quick learning the song. Really professional. I sang it to her, and left her the words, but she got it immediately. She had such a wonderful iconic voice, that's what made it. On the Gordon Lightfoot song you got all the bells and whistles, but "The Last Mile" was very modern.

Andrew Loog Oldham: I met her through Brian Jones, who wanted me to try her out. This would have been the end of 1964, and we probably made the record in April or May '65. I asked Jimmy Page and John Paul Jones to audition her for me. Oh Lordy, where is that tape! You have to remember that this was the era when you recorded your friends. If someone wanted you to meet this person, you did. And Brian wanted me to audition her. We were all learning on the job. At the time I would record anything and anyone. She looked incredible, and she is one of that group of women like Marianne Faithfull or Anita Pallenberg or Yoko Ono who gave British men legs. They brought a spirit, and Nico was definitely standing on the front of the *Titanic*. She had incredible presence. I never hung out with her, as that was not my job—I was

already really important! There's a photo of me with her at the launch reception for Immediate Records, with Mickie Most and Tony Calder, and she was dressed like a German model in department store tweeds. She could have passed for Marthe Keller. I wasn't dealing with any drug slag. She had style. She was elegant. She was amazing. We did lots of promotional tours and she made it fun because she was a fun lady. This was before her dark period, where she had to work with Lou Reed. I knew her before the war party began. I was taken over when I first heard her sing. This was my version of Burt Bacharach working with Marlene Dietrich, swimming in a different culture and reaping the benefits of that. When you're that young, you don't ask each other questions. You don't ask where someone comes from... but she had lived a life already. But no one bored you with that stuff then. Suffering had not come about. You handled your own luggage. But her voice and her presence and the way she acted... she was also a diplomat. She handled herself in difficult situations.

I didn't record her again after that single because the Stones really took over my life. I didn't mix with her because I didn't want to mix in Brian Jones's world. I didn't want to be with someone who was always accusing his girlfriends of wanting to sleep with Mick Jagger.

Tony King: When the Beatles came back from America after their Ed Sullivan appearance, they were completely different people. They got turned on to dope by Bob Dylan, and when they came back, we all started. We'd all go to the Ad-Lib Club, toking on hash and grass. The Ad-Lib was a very cool hangout place. The Beatles went for dinner with a dentist and he spiked their drinks with acid, and when they got in the elevator going up to the club, they thought it was on fire because they were so out of it. That was their first acid trip. This was when Swinging London started to move through the gears, and when suddenly teenagers were in positions of genuine power.

Andrew Loog Oldham was running Immediate Records as well as managing the Rolling Stones and he wanted me to be their promotion man. At first, I couldn't, as it didn't seem right that an eighteen-year-old was going to be my boss. But as the Stones got more famous, he approached me again and I jumped ship. At my interview he played me an acetate of "Satisfaction" and said, "Oh, we've just finished this." Keith

Richards didn't want it to be a single as he didn't think it was a hit. But Andrew knew. Andrew always knew.

Andrew was also into drugs, and I became the official joint roller in the office. Whenever anyone asked for a smoke, Andrew would say, you better talk to the promotion department about that. I used to keep it in a drawer. I saw the Stones all the time, saw Mick and Keith, and we hung out. We were stoned all the time. I went to a premiere with Andrew once and we were smoking in the car. We drew up outside the Leicester Square Odeon, and a policeman came to open the car door. As he did, a big cloud of marijuana smoke flew out. But in those days the police didn't know what it was.

After he signed Nico he wanted me to look after her. She always had a very Slavic look about her, very beautiful, but was actually great fun and not as severe as she looked. We were promoting her record "I'm Not Sayin'" as she was playing *Ready Steady Go!* We also went on this Immediate promotional trip up to Scotland with Andrew and Tony Calder, and Nico came too. We were due to have this very square meeting with some record company distributors, and beforehand we had all smoked a joint, and Andrew and I were completely fucking obliterated. It was so strong this stuff we had. I didn't think we'd get through the meeting. I looked over at Nico, who was very cool, very impervious, and wasn't giving anything away. She had this very Icelandic look about her.

I leaned over and whispered: "Are you as stoned as we are?"

And she looked at me without missing a beat and said, "I'm out of my fucking mind."

"Thank God," I said.

Andrew and I were like schoolchildren, giggling away, but Nico was cool as a cucumber. All of a sudden, this funny little Scottish lady leaned forward to Nico, tapped her on the shoulder, and said, "Dear, do you like Sarah Vaughan?"

And Nico boomed across the room, "YES I DO," and Andrew and I both collapsed with laughter. She was like this lovely cartoon. A beautiful, cool lady. She was very enigmatic but very easy to talk to. I always thought she should have ended up with Brian Jones as they would have made a perfect couple. Her record was interesting but not successful, and you always felt that singing was a bit of a sideline, and that she had other things going on.

Mary Woronov: It was cheap to have a child with a famous actor. Alain Delon? That's cheap.

Richard King: My mother is John Cale's cousin. As she was a teacher, she taught a lot of girls with difficulties. She said the difficult girls tended to write Nico on their pencil cases. Then she would say, John was in a band with her.

A band is always a drama in itself, and the Velvet Underground were no exception, as each member had issues with the others. Reed was becoming wary of Cale, Cale was becoming frustrated with Reed, and both now had their issues with Nico (sexual, as well as creative). Tucker and Sterling were mostly long-suffering, although their passive-aggressive nature contributed to the general spikiness of the group. Reed was desperate to be taken seriously as a writer, and even sent a batch of poems to the New Yorker. *But they rejected him, time and time again. "I would get a letter from a secretary or someone who really felt sorry for me and would say that there was some potential there and to keep up the good work, but they had all the poetry they needed until sometime in the Eighties." On the one hand he had overreaching artistic designs, and on the other he was very much into reductive pop.*

And things got even more complicated when Cale started dating Edie Sedgwick (who seduced him on his second day at the Factory), while Lou Reed started sleeping with Nico, writing three beautiful songs for his new girlfriend—"Femme Fatale," "I'll Be Your Mirror," and "All Tomorrow's Parties." (When they broke up six weeks later, out of the blue, she said, "I cannot make love to Jews any more.") Having seen how much attention Nico was getting now she was in the band, Sedgwick started lobbying Warhol to replace her. She was sick of dancing in front of her and wanted to replace her instead. But by then she was already starting to lose control of herself, and so he wisely ignored her.

Mary Woronov: Andy was in love with Edie. She would get wound up about things and then pull out a big wallet and go, here, here! She was nuts, but also well protected by Andy. However, he got very upset when she started dating that asshole Bob Dylan, and he turned against her. She made the wrong fucking move there. He hated her, tried to make her a star, told her to get bigger tits, it was all so hideous. He was disgusting.

He was a good entertainer, but he was mean, really mean. Especially with the women. He killed her.

Dylan and Warhol had started to dance around each other. The singer had agreed to come in for a screen test for one of Andy's movies (recording on a Bolex 16mm camera and 100-foot rolls of film), although according to many, it was done out of curiosity more than anything. Little did Dylan know that this was one of the reasons Warhol did it in the first place, to meet people, capture them on film, and create short films that were a kind of parody of Hollywood. "Andy always played the fan," said Gerard Malanga. "So, he was Bob Dylan's fan that day at the Factory—'Oh, Bob Dylan's coming to the Factory! Oh!'" Factory archivist and photographer Billy Name recalls Dylan putting out a "cold and unresponsive vibe" while another Factorion called Dylan "a mean, bloody-minded and miserable speed freak." After the screen test, Warhol showed Dylan a new series of portraits of Elvis, known as the Double Elvis pictures, silkscreens of him from his movie Flaming Star, *slinging a gun, cowboy-style. Warhol hated giving anything away but was so desperate to flatter Dylan that he gave him a painting; the singer then proceeded to strap it to the roof of his station wagon before driving north to Woodstock. He apparently hated the picture so much he first hung it upside down, and then relegated it to a cupboard (rumors he used it as a dartboard aren't true; another apocryphal story claimed Dylan had somehow arranged to have a hose come through Elvis's crotch so the painting could urinate on command). One day he showed it to Albert Grossman, his manager. "I don't want this," he said. "Why did he give it to me?" Grossman liked it, and so, knowing his charge was kitting out his house, swapped it for a sofa—probably the chaise longue, a wedding gift to the Grossmans from singer Mary Travers, that Sally Grossman and Dylan are seated upon in Daniel Kramer's iconic cover photo of* Bringing It All Back Home. *Warhol was horrified when he found out, although the joke would eventually be on Dylan. After her husband died in 1986, Sally Grossman sold the print at auction in 1988 for $720,000. Warhol later said, "I liked Dylan, the way he created a brilliant new style...I even gave him one of my silver Elvis paintings in the days when he was first around. Later on, though, I got paranoid when I heard rumors that he had used the Elvis as a dartboard up in the country. When I'd ask, 'Why did he do that?' I'd invariably get hearsay answers like 'I hear he feels you destroyed Edie,' or 'Listen to "Like a Rolling Stone"—I think you're the diplomat on the chrome horse, man.' I didn't know exactly what they*

meant by that—I never listened much to the words of songs—but I got the tenor of what people were saying—that Dylan didn't like me, that he blamed me for Edie's drugs." Attempting to have the last laugh, Dylan said, "I always wanted to tell Andy what a stupid thing [I'd] done, and if he had another painting he would give me, I'd never do it again." Warhol took to satirizing Dylan in films like More Milk, Yvette *(which included a harmonica-playing Dylan lookalike), a spoof called* The Bob Dylan Story, *and the repeated playing of a Dylan song at the wrong speed in* Imitation of Christ.*

Geraldine Smith: For a while Edie was living in a friend's loft down on the Lower East Side, and I did spend a night taking LSD with her, and had a fun old time, although I didn't see her so much after that. She kind of disappeared.

Lou Reed: The Factory was a really strange place. People came and went, got used up and then moved on. The regime changed all the time. One particular person become dominant there for a while and I just didn't like what was happening there and stopped going. Andy would moan at me, but I really couldn't face it.

Mary Woronov: The Factory became even more interesting when the Velvets arrived with Nico. It was such an intoxicating place to be. The place was set up, the whole thing, for guys to be queer, which hadn't happened before. It was amazing because there were so fucking many of them. You could be what you wanted to be—you're our asshole, so great, we need assholes. I got by because I flirted with the guys and I

* A lot of the speed that found its way to the Factory was supplied by Dr. Robert Freymann, a German-born New York doctor known for dispensing vitamin B-12 shots laced with amphetamines. Originally supplying his wealthy clientele on the Upper East Side (there were rumors he supplied Jackie Kennedy), he started supplying Edie Sedgwick and then other denizens of Forty-Seventh Street. He was also meant to be the basis of the Beatles song "Dr. Robert," which was largely written by John Lennon. "There's some fellow in New York, and in the States we'd hear people say, 'You can get everything off him; any pills you want,'" Paul McCartney said in 1967. "It was a big racket, but a joke too about this fellow who cured everyone of everything with all these pills and tranquilizers, injections for this and that. He just kept New York high. That's what 'Dr. Robert' is all about, just a pill doctor who'll see you all right."

looked like a guy. And that hadn't happened yet. I dressed like a guy. I refused to do anything sexual as I wanted to be different. Different good, different bad, I didn't care as long as I was different. I didn't want to be a girl, I didn't want to be a boy, I wanted to be left alone. So I fitted in in a weird way. Which was fine as long as I could rely on Andy. I did it consciously because I did not want to be bothered, if you dance onstage people always come up to you afterward and I didn't want that. I did it for security. People would be, maybe yes, maybe no, but we don't know. Andy started paying more attention to me. I wasn't gay but everyone else was. I didn't have any motivation at the time and it was quite new not to have any. I depended on everyone else at the Factory for motivation. Warhol wasn't interested in changing anything, he was only interested in explaining things. I didn't like being a girl so I became what I wanted to be. Fuck them. I'll be a boy. Be an artist. It felt like a very important place to be. It felt like the real truth. We'd be out in the street, with all these guys, someone of them would be named, high. It was great.

Mick Brown: Lou Reed was enamored with self-destruction, and he wanted to write lyrics that reflected the low-life world in Hubert Selby's books. He wanted to tell stories of the street. He was obsessed with the too fast to live, too young to die, all that facile stuff.

Bobby Gillespie: They elevated art-rock.

Lou Reed: Rock and roll is so great; people should start dying for it. You don't understand. The music gave you back your beat so you could dream... The music is all. The people just have to die for the music. People are dying for everything else, so why not for music? Die for it. Isn't it pretty? Wouldn't you die for something pretty?

Danny Fields: Lou was so sexy. Everyone at the Factory just had this raging crush... he was the sexiest thing going. He was a major sex object of everybody in New York in his years with the Velvet Underground.

Mary Woronov: Lou Reed on his own was different too, when he wasn't surrounded by other people in the Factory. He was a fucking asshole.

What is rarely mentioned when discussing the initial appeal of the band is John Cale's strikingly handsome face. With his cascading locks and chiseled cheekbones he looked more like a nightclub impresario or a Hollywood lounge lizard than a drugged-up viola player. Some even thought Cale was Native American ("Indian" is what they said). He also had an amazing Baptist baritone, not that Lou Reed ever let him sing. After all, Lou thought he was the star, as did everyone else. He had a head of short, tight curls, a thick neck, and enquiring, if defensive eyes, which combined with a degree of innate personal magnetism to make him an object of some fascination to the other habitués of the Factory.

Mick Brown: There was a lot of confusion in Lou's life regarding his sexuality.

Danny Fields: Everyone was in love with Lou. He was so sexy. And John was pretty sexy too. But Lou was the heartthrob. He was the Adonis of the month. He was the teen idol of the crowd. Everyone at the Factory spent at least a week or two in love with Lou. I was totally fearful of him because he was so sexy. I found myself sitting next to him on the couch at the Factory one night, and I think I asked him a question about what happens if you're wearing sunglasses and you get a tan so your eyes are all white. I mean, how stupid. What a girly-girl question. You know, how do you do your makeup? That day we became great friends. I loved him and I loved his work. We loved the band. We worshipped them. "Heroin" was our national anthem. We weren't opposed to other bands, but there was no competition because they were our band. As the Dead were the Haight-Ashbury band, so the Velvets were our band. We didn't care if nobody else understood them. And we didn't think it was so far-out and outrageous. Drugs, S&M, sure! They were no more obsessed with bondage, masochism, sadism, drugs than anybody else. They just wrote songs about them. They were the bards of our lives. Around '66 the world divided itself into Stones people and Beatles people, and you were a fan of one and aggressively not the other. And we were Stones people.

On January 13, 1966, Warhol was invited to be the evening's entertainment at the New York Society for Clinical Psychiatry's 43rd annual dinner, held

at Delmonico's Hotel. Bursting into the room with a camera, as the Velvet Underground acoustically assaulted the guests while Gerard Malanga and Edie Sedgwick performed the "whip dance" in the background, Factory filmmaker Barbara Rubin taunted the attending psychiatrists. Casting blinding lights in their faces, Rubin slung derogatory questions at these esteemed members of the medical profession, including: "What does her vagina feel like?" "Is his penis big enough?" "Do you eat her out?" As the guests began to leave, she continued her interrogation: "Why are you getting embarrassed? You're a psychiatrist; you're not supposed to get embarrassed." This was their first performance under the Warhol umbrella and was almost a rehearsal for what would become the Exploding Plastic Inevitable in the summer.

Mary Woronov: The Exploding Plastic Inevitable was amazing because I was amazing. It was home for me, and I didn't have to worry about anything, I could do what I wanted. It was great. I didn't necessarily feel empowered, I felt that I was finally looked at.

"The aim of the band on the whole was to hypnotize audiences, so that their subconscious would take over," said John Cale. "It was an attempt to control the unconscious with the hypnotic. We thought that the solution lay in providing hard drugs for everyone, but there was already a very strong psychedelic element in sustained sound, which is what we had... so we thought that putting viola drones behind guitars and echo was one way of creating this enormous space... which was itself a psychedelic experience."

In April, a former Polish wedding hall called The Dom in St. Mark's Place in the East Village hosted the debut of the first significant deployment of the Exploding Plastic Inevitable. Warhol showed his films and produced a light show while Factory acolytes danced along to the Velvets. Those who were there say the music was so loud it was actually harmful. The initial reviews were often just litanies, as this was the kind of content that most Manhattanites had never seen before (not even critics). "The rock and roll music gets louder, the dancers get more frantic, and the lights start going on and off like crazy," wrote George English in the Fire Island News. *"And there are spotlights blinking in our eyes, and car horns beeping, and Gerard Malanga and the dancers are shaking like mad, and you don't think the noise can get any louder, and then it does, until there is one big rhythmic tidal wave of sound, pressing down around you, just impure enough so you can still get the beat; the audience, the dancers,*

the music, and the movies, all of it fused together into one magnificent moment of hysteria." Soon, the reviews started to be genuinely subjective; a review in the Chicago Daily News didn't leave anything to chance: "Warhol has indeed put together a total environment but it is an assemblage that actually vibrates with menace, cynicism, and perversion. To experience it is to be brutalized, helpless—you're in any kind of horror you want to imagine, from police state to madhouse. Eventually the reverberations in your ears stop, but what do you do with what you still hear in your brain? The flowers of evil are in full bloom with the Exploding Plastic Inevitable."

The Velvet Underground proved that beauty and ugliness can be doppel-gangers, if only for the length of a song. In concert, they would routinely play a piece called "Melody Laughter," which was twenty-five minutes of minimal Moe Tucker percussion, guitar/viola drones, and Nico wails. The noise they made was completely original, completely particular; like Warhol's own work, it allowed little give or take, and you either accepted it for what it was, or you didn't. There was no middle ground. In the same way that Warhol avoided any reference to painting, either of the past or the present, so the Velvet Underground's music didn't really have any relevant antecedents. Where there could have been R&B there was onslaught, where there could have been blues there was a drone, and where there might have been some kind of romance, there was an urban hymn. There are very few bits of what the Velvets were attempting to do that had been attempted before, that mad fusion of almost mechanical avant-garde noise and linear melody. They were not in any way ironic, postmodern, or meta, they weren't any kind of comment on what had been before, nor were they a clever abstraction of it. They weren't reductive, they weren't reflective, or a clever marriage of styles. What they were was entirely original, a brand-new style. A completely new type of noise.

Live, they were testing the audience, both in terms of the amount of noise, and its repetition. The lighting could be sepulchral, the air thick with smoke, the room dominated by a compromised array of curious visitors, finding a way through the darkness, lost in the dazzle. The music, when it arrived, was monstrously loud.

The typical route to pop innovation is to introduce alien or aggressive sounds that provoke people who would otherwise have paid no attention. The Velvet Underground both scared their audience, and bludgeoned them with repetition. This was another Warhol trope, as boredom held a particu-lar fascination for the artist. Of course, there was a considerable amount

of improvisation, but a lot of what they did at The Dom was Sisyphean: redemption through repetition.

By appearing as part of the Plastic Exploding Inevitable, the Velvet Underground were also exaggerating the impermanence of art, combing both the temporal and the spatial. By destroying the time between creation and reception, by making art—or noise—happen as the spectator watched, made everyone complicit. They were a Happening within a Happening. Warhol liked the fact the Velvets were intentionally brutal. They were, using one of his favorite words, "different."

Deborah Harry and Chris Stein both saw the Velvets play The Dom. Harry says she remembers the stage being completely swamped in color. She says it was "Beautiful," and that Nico wore a "stunning" chartreuse outfit. "Warhol was running the lights, and it was just this beautiful burst of colors and vibrations," she says. "The projections behind them were just so lovely and impressionistic, but also dark and scary at the same time. I guess I was drawn to the darkness."

As for Lou Reed, he was proto-punk, having "hyper-cool, drawling-delivery and sneering sexuality."

A year later Stein and his teenage friends realized every garage band's dream when his band—called First Crow on the Moon—actually found themselves opening for the Velvets at another New York club, the Gymnasium. His friend Joey Freeman had a job as a gofer at the Factory, and one day he told Stein that the band that was supposed to open for the Velvets had cancelled. "I had never seen them but we had the Banana album [VU's debut self-titled LP with the Warhol banana image as cover art] and everybody know who they were, so we said, 'Oh fantastic!' The night of the gig we got on the subway with our instruments and we were totally hippied out. We had balloons and a couple of girlfriends, and everybody was dressed in beads and feathers. It was pretty late at night by the time we got out of the subway and headed toward the Gymnasium. Walking down the block with our guitars we actually saw some people coming down the street who had already left because the band hadn't turned up. We went inside and there was hardly anyone there. Somebody said Andy was supposed to be there, but he was off in the shadows with his entourage, we never saw him. It was a big echoey place, and we had absolutely no conception of playing a place like this whatsoever." Moe Tucker came to the rescue, telling them they could use the Velvets' equipment, including her drums. "So we plugged into their amps and the amps were all cranked up superloud." They played half a dozen

84

songs before the rest of the Velvets turned up, and then sloped off the stage. "After a while they started to play and they were awesomely powerful. It was just overpowering."

Bob Collacello: When Andy took over The Dom in St. Mark's Place, with the Plastic Exploding Inevitable, and the Velvets and the light show, that was very advanced, very avant-garde. That was a real happening. It was great both in terms of nightlife and performance art. And music. It was very exciting. It was like, these are the real rebels. The Velvets were at the heart of that. They were right up there with Jean Genet and William Burroughs and Allen Ginsberg and Jack Kerouac. You can trace the tradition back to Rimbaud and Verlaine but in America it was the beatniks, the beats and the hipsters. The hippies were never avant-garde, they were like Buddhists or something.

What the Velvet Underground represented was everything. There was pot, LSD, mushrooms, psychedelics, but heroin was considered to be really bad, so for a group to start singing about it was outrageous. To glorify it was pretty revolutionary. This was way beyond anything that Bob Dylan or the Rolling Stones or Jim Morrison suggested or represented. I loved the Velvet Underground. I went to see *Chelsea Girls* four times and loved anything to do with Andy Warhol. But it wasn't uncommon among my generation, and the more bohemian wing, shall we say. There was William Burroughs, Mick Jagger, Andy Warhol, the rebels.

Geraldine Smith: I remember seeing a poster for *Chelsea Girls* when I was very young, only sixteen, and I was so drawn to it, I thought I had to go and seek these people out. So I did. I was briefly at school at Washington Irving which was right on Irving Place and Seventeenth Street which was right near where Max's Kansas City was. So we went to school, but barely. We'd go around crazy at night. We'd go out at midnight, stay out all night, and that was our life. My parents went crazy because I was a runaway, and I never came home. They came looking for me, with pictures, and called the police, but lots of us were runaways. It was a fantastic time. We met everybody. I went to Max's one night with Andrea Feldman, who would go on and star in *Heat*, and she had a towel wrapped around her head that looked like a turban. She went up to Andy and said, "I'm Mrs.

Warhola!" and that's how we got in with the Warhol crowd. The Factory was wonderful as it was just what I was looking for, something really different, unique, completely something else. I was enthralled by the whole thing. I was intoxicated by the environment. If you knew Andy then you knew everybody, because he knew everybody. Everyone in the world passed through the Factory. Everybody who was somebody. You knew you were in with the in crowd. It was fascinating, especially to young people like me. There were a bunch of us who were friends—Nico, Viva, Ultra Violet, Andrea, Sylvia Miles. Andy called us his kids. If he liked something we did, he would always say, "You're really up there."

Bob Gruen: These friends said they were going to meet me at this restaurant called Max's. I said great, what time? When they said midnight, I said who meets at a restaurant at midnight?

On Monday April 18, the Velvet Underground finally entered a recording studio, and began to record their first album—at Scepter Records Studios, on New York's Fifty-Fourth Street, spending the rest of the week laying down the bulk of their material. The man who originally recorded the album was Norman Dolph, then a twenty-seven-year-old Columbia Records exec who was moonlighting as a DJ for various Warhol events in New York. Warhol told him he had found a band he wanted to record, and charged him with organizing the studio, the recording, and, initially, finding them a record deal. The initial recording took four days, and cost approximately $2,000. Having overseen much of the recording, he then swiftly pitched it to Columbia, who even more swiftly turned it down. "I never felt I had the authority to pick takes, or veto them," said Dolph. "That, to me, was clearly up to Cale, Reed, and Morrison. Lou Reed was more the one who'd say, 'This needs to be a little hotter'—he made decisions." And as for Warhol, Dolph said he sat quietly in the background: "He was a more of a... presence, really." The tapes then ended up in the hands of Tom Wilson, who had already had great success producing Bob Dylan and Simon & Garfunkel (and in particular "Like a Rolling Stone" and the accessorized version of "The Sound of Silence"). Having recently signed Frank Zappa's Mothers of Invention to Verve Records, he understood the complexities as well as the possibilities of the Velvets' sound, and encouraged them to record more songs, including "I'm Waiting for the Man," "Heroin," "Venus in Furs," and "Sunday Morning." Finally, the album was taking shape.

"We rehearsed regularly for a year," says John Cale. "This is what I was used to with La Monte—practice, practice, practice."

Lou Reed: For ages people thought Andy was the guitar player.

David Cavanagh (writer): He [Reed] is twenty-four. Rock and roll and doo-wop in his blood. English graduate (honors) from Syracuse University. Well-versed in Kierkegaard and Sartre, the heavyweights of existentialism. He's twenty-four going on thirty-nine. Ambitions to do for rock lyrics what Poe did for the short story and Selby Jr. has done for the novel. Ambitions, in other words, to raise the fucking bar. His flatmate, a viola-playing Welshman, has declared his songs ("very literate...tough") to be more important than anything by Dylan. Together they've formed a band to electrify New York.

The relationship between Reed, a Long Island accountant's son, and Cale, a coal miner's boy with both feet in the avant-garde, is the hissing engine of the Velvet Underground. Note the demarcation: Reed writes the words and the chords, but it's very often Cale, a surrealist working in close proximity to a realist, who pulls and drags the music into crisis and insanity. They don't know it but the 1966 recording sessions for the group's first album will determine what the Seventies and Eighties look and sound like. These are the people whom the creatives of the future will want to emulate. Entire careers—entire lives—will be inspired by these uptight pioneers in their black jeans and Ray-Bans, with their shocking S&M scenarios and their sophisticated little love songs for an icy-voiced chanteuse. History rides on the back of what the Velvets achieve in the studio today. No pressure. No quarter. No kidding.

Lou Reed: When I started out, I was inspired by people like Ornette Coleman. He was always a great influence. I had been listening to a lot of Cecil Taylor and Ornette Coleman and wanted to get something like that with a rock and roll feeling. And I think we were successful, but I also think we carried that about as far as we could, for our abilities as a basically rock and roll band. Later we continued to play that kind of music, and I was really experimenting a lot with guitar, but most of the audiences in the clubs just weren't receptive to it at all.

David Bowie (musician): The Velvet Underground actually created modern music.

Lou Reed: I saw the book [*Venus in Furs* by Leopold von Sacher-Masoch] and just thought it would be a great idea for a song. Then everyone thought I invented masochism.

David Cavanagh: What's interesting, when the birth is over and the child has been given a name (*The Velvet Underground & Nico*), isn't so much that Reed has fulfilled his objective of condensing a novel's worth of ideas into a three-minute framework (it will always be debatable whether his songs can ever do that), but that he has the most exquisitely perfect voice for his subject matter. Raised on whatever the exact opposite of the mean streets are, he sounds chillingly believable when he spins tales of hard drugs, sadomasochistic sex, and the dirt-poor underbelly of the city.

Lou Reed: To my mind, nothing beats two guitars, bass, and drums. If you can get an old, black-faced Fender with an old Tele, nothing, *nothing*, can ever beat that... getting the sound you want. I wanted to be able to get it just by *looking* at the guitar, you know what I mean?

Danny Fields: When they started recording, they really became a band.

Lou Reed: My writing is all about focus and energy and I say that to people, and they look at me like I just landed or something. I guess it sounds tacky to them, but I have a real love and respect for writing, and I love it a lot—a *lot*—and I really work at this articulate, literary stuff. I don't know why I bother, really, because people don't listen to lyrics in rock and roll records too much. I understand that but I just happened to get out of university, and I was in creative writing courses and playing in bar bands and I just combined the two. I thought it would be great if you could hear a rock and roll song written by a really fine novelist. Wouldn't it be amazing if you were listening to a rock and roll song written by Raymond Chandler or written by Joyce? Wouldn't that be astonishing? You could listen to that till you were ninety. Wouldn't that be a thrill? I was always inspired by Chandler because he'd come out

with these incredible images with so few words: "That blonde was as pleasant as a split lip." That is incredible because you get that image, and you get it fast—and that's the kind of thing I try to do in the lyrics of my stuff. Rock and roll doesn't have to be stupid.

In early May, the Exploding Plastic Inevitable took their sensory overload to the Trip on the Sunset Strip in Los Angeles. Dennis Hopper and his wife Brooke Hayward turned up to witness the spectacle, along with Tuesday Weld, Ryan O'Neal, John Phillips, and Sonny and Cher. Hayward found Andy Warhol mesmerizing. According to her biographer, she didn't see him as alien so much as otherworldly, almost saintly. Donna Ruscha, wife of Ed, recalled, "That show was mind-blowing. The light show, it was fantastical. If only one knew at the time that what one was seeing was historical. The performance left a huge impression on the UCLA film major Jim Morrison, who was extremely taken by Gerard Malanga's flowing hair, leather trousers, and billowing shirt, a look he stole au total. When the Doors started playing at the Whisky a Go Go later that month, Morrison looked exactly the same. In fact, he channeled the Velvets for his entire image, using their art school chic to offset his pretty boy looks. Morrison's cheeks were already gaunt, his torso lean, but what he needed to properly accentuate his image was a pair of wraparound sunglasses, something he stole from the Velvets. The journalist Paul Jay Robbins said the EPI extravaganza was "clean as a gnawed skull and honest as a crap in the can," while Cher was famously quoted as saying the Velvet Underground "will replace nothing, except maybe suicide." Warhol liked her line so much he started using it for promotional purposes.

Later in the summer, Malanga was walking down Eighth Avenue in New York and he heard two girls behind him say, "Isn't that Jim Morrison?" He felt like saying, "No, my jaw is a bit more angular," but he knew he'd been supplanted. "I felt a little eclipsed, but I didn't give a shit, really."

Jimmy Page: I first saw the Velvet Underground at Steve Paul's Scene club in the basement of 301 West Forty-Sixth Street, in late July 1966. Andy Warhol had decorated the club with Bacofoil all over the walls. It was called Mylar in the States, which Andy said was the color of speed. I didn't know anything about the band at that point, but as soon as I heard them it was mesmerizing. It was so dark, and it was so dense, and then Nico came on the stage and started singing, and up until then

I had no idea she was in the band. I know from seeing the acetate of the first album afterward that the music had already been recorded, and they were playing everything brilliantly. But the thing was, the club was completely empty. There was no one there in the audience. Not even the groupies went to this place. People probably found it really challenging, as far as the line-up and the music was concerned. You had John Cale's electric viola, Moe Tucker's standing-up drumming, it was a completely different sonic spectrum. People had never heard anything like this before. It was too challenging for people who had got used to seeing regular bands. It was an extraordinary thing to witness, it really was. It was fantastic, and it was really coming at you. At one point after the show, Lou Reed was sitting by himself over by the side of the stage and I went over to talk to him. I was thrilled with what they were doing and I wanted to tell him, and I asked him what his favorite guitar solo was. I was fascinated, and wanted to know what his points of reference were. He said, "Without doubt, it's 'Eight Miles High.'" When I heard that, the anarchic solos on things like "Run Run Run" started to make sense. You can see how that was so inspirational for him. I thought it was amazing that he had heard that and come up with a completely new pattern of playing. Maybe people think Lou's playing is haphazard, but I would disagree with that. It was really cool to meet him. I think I saw the Velvets twice, three times in a row at The Scene. I went back to see them because I thought that people would catch on, and the place would be full, but it never was. It's all very well for people to come up with all these statements after the event, but the simple fact is, they weren't there. It was too cool, and people didn't pick up on it. Maybe people thought it was too eclectic. I thought it was brilliant. I went and saw so many people play there—Dr. John, Traffic, Kaleidoscope, Howlin' Wolf...It was a real arts lab place.

In August, Luci Johnson (the daughter of President Lyndon Johnson) married Patrick Nugent at the Shrine of the Immaculate Conception in Washington, DC, and enjoyed their reception in the White House. It was the American wedding of 1966, with pictures gracing the cover of Time, *and with acres of coverage in* Life. *There was a rather less conventional tribute created by the* East Village Other: *they encouraged various artists to visit a rented studio to respond to the union in a recording called "The Electric Newspaper." One*

contribution was a two-minute musical celebration by the Velvet Underground. They called it "Noise."

Which was what they were all about, visually as well as musically. The Exploding Plastic Inevitable was a cabaret of sorts, with Warhol groping toward a kind of performance art that did not really exist yet. Audience members who witnessed the Velvet Underground in full flight compared it to an out-of-body experience, a sensory trip. They had been exposed to an onslaught of violent, three-dimensional sound and they had returned to earth—buffeted, deafened, and contorted. But alive, just.

John Cale said that what they really wanted to do was go out there and annoy people. And it worked. Almost immediately they were called a "Nonstop horror show," a "three-ring psychosis," and a "sadomasochistic frenzy." They didn't consider themselves entertainers. They never smiled, and purposely turned their backs on the audience. John Cale says their aim was to upset people, to make them feel uncomfortable, even to make them vomit. "We hated everybody and everything," he says.

And while they said the only reason they wore sunglasses onstage was because they needed to protect themselves from the intensity of the lights, no one believed them. They did it to unsettle the audience.

Of course, there was little doubt that people weren't necessarily coming to see the Velvets; they were coming to gawp at Warhol, who from his perch on the side of the stage, or, more usually, on the balcony of whatever theater they were in, was administering the lights, the slides, and the films which accompanied the nightly din. He always wanted as much reaction from the audience as possible, and if he saw them becoming somnolent, or enjoying the music too much, he'd immediately change the lighting, turn it off, or start messing about with the slides, trying to discomfort people. This was one of the first times a strobe had been used at a rock concert or on a dance floor, using a mirror ball he'd found in a midtown junk shop. This was a genuine innovation, and soon every club in the States had a mirror ball of some description or another. When Warhol took it to California for the EPI shows in San Francisco and Los Angeles in the summer, some thought the ball was a kind of political statement, reflecting what they all saw around them, but they should have known better. It was a gimmick, part of the show. New Yorkers wouldn't have been so provincial as to have an actual message. The shows were genuine multimedia events, designed to disconcert and enliven.

Toward the end of the summer the Velvets were given an opportunity to maximize their cult status when they were chosen by Michelangelo Antonioni

to appear in his period piece, Blow-Up. *If you are looking for a film to properly contextualize the euphoria of Britain in the Sixties, it would probably be best to watch* The Italian Job *or one of the first five James Bond movies, although if you want a snapshot of Swinging London you really need look no further than* Blow-Up, *which would go on general release in December. Yes, it starred Vanessa Redgrave, Sarah Miles, Jane Birkin, and David Hemmings as a barely disguised David Bailey (Hemmings swore a lot less), yes it had an open-top Rolls driving through the new Sixties city, yes it used the capital as a brilliant kaleidoscope of urban ambition, and yes it had a terrific Herbie Hancock score. But it was typically clichéd, quaint, and faintly ludicrous. It was both pretentious and self-conscious, which in many respects is exactly what it ought to have been. After all, it wasn't a documentary.*

Toward the middle of the film, Hemmings wanders into a club where a band behaving like the Who are giving it their all. Having seen Pete Townshend and co. almost incite a riot at a gig in Shepherd's Bush the previous December, Antonioni tried to hire them for the film, but ended up instead with the Yardbirds (complete with both Jimmy Page and Jeff Beck). When the Who fell through, he had actually tried to secure Manhattan's own subcultural house band, but when the Velvet Underground couldn't get their work visas in time, had to settle for what he thought was the third-best option. The Yardbirds actually work perfectly in Blow-Up, *although as a cultural mismatch it would have been fascinating to see Nico and Lou Reed trying to co-opt London's emerging* monde.

Mary Woronov: The Velvets had been extremely successful, but one night in the Factory Andy came over to me and said he wanted to speak to me. He wanted me to take Nico's place. I told him I couldn't sing, and he insisted I could. "Of course, you can sing!" I knew I couldn't as people would hide when I sang as a child, but then I guess Nico wasn't such a great singer anyway. I mean she couldn't sing. So Andy pushed a tape recorder at me on the table and then fled. But I pushed it back and left. I was onstage at school, and everybody would leave when I started, so I wasn't going to do it again. The Velvets were great—Maureen just banged up and down with her drumstick. Only she could do that. But they were great. But asking me to sing was crazy. If they had found out Andy had asked me to replace her, all hell would have broken loose. She was perfect. Her voice was dead, but she was perfect.

Lou Reed: When the Velvet Underground needed some money, someone offered Andy $50,000 to paint a pig. I guess they thought it was a really camp thing and they wanted to make a fool out of Andy. But Andy thought, *Great!* and we got the money, we bought more lights, more cameras, more this and more that—and they got a really exquisite pig. The pig was beautiful. You couldn't make a fool out of Andy.

Jimmy Page: I met Andy in a hotel suite, and he had someone who was his voice, who was speaking for him. He said, "Andy wants to feel the presence of the Yardbirds." He asked me to come to the Factory to do some sort of audition, but we were off on the road the next day. I met him again at the Mod Wedding in Detroit in November, at something called the Carnaby Street Fun Festival.*

The photographer Nat Finkelstein spent an inordinate amount of time at the Factory in 1966 and photographed the Velvet Underground repeatedly. One day he was writing a proposal for one of Warhol's publishing projects and he used the term "the psychopath's Rolling Stones" to describe the Velvets, and after Lou Reed read this, he never spoke to him again. "I thought he would like it," says Finkelstein. "He was very sensitive, had a deep sense of pride, wanted to be regarded as the best. Later the report came back to me that Lou had said that the three worst people in the world were Nat Finkelstein and two speed dealers."

In December, the multi-media magazine Aspen *published its third issue, branded "Fab." The New York-based magazine—which had been created by the former* Women's Wear Daily *editor Phyllis Johnson—was a genuine attempt to deconstruct and play with the traditional idea of what a periodical should be. Described by its publisher as "the first three-dimensional magazine," each issue came in a customized box or folder filled with materials in a variety of*

* As a centerpiece, a Motown publicist thought up the idea of a Mod Wedding. Since Andy Warhol was "the father of Pop Art," he became the perfect choice to play the father of the bride. A columnist for the *Detroit News* dug up a couple to get married—a twenty-five-year-old clothing salesman and his nineteen-year-old, go-go dancer girlfriend. While Gary Norris and Randi Rossi were married before a crowd of 4,500 people, the Velvet Underground played "Here Comes the Bride," and a roadie pounded on a car with a sledgehammer. After the ceremony Warhol signed some Campbell's soup cans and threw them into the crowd, and he and the bride cut the six-foot cake with a sword.

formats. There were flexi discs, posters, postcards, jigsaw puzzles, and even small reels of Super-8 film. Each issue was guest-curated by a contemporary artist; the third was designed by Andy Warhol and the writer David Dalton and was housed in a box with graphics based on the packaging of "Fab" laundry detergent. Inside was a flipbook based on Warhol's film Kiss, *a flexidisc by John Cale, and a "ticket book" with excerpts of papers delivered at the Berkeley LSD conference by Timothy Leary. There was also an Exploding Plastic Inevitable newspaper, and an essay by Lou Reed about the new immersive experience of pop. Aspen was actually the perfect consumer magazine, both a comment on the very cutting edge of contemporary culture, and an adroit example of it. It was, in Reed's words, "The only live, living thing."*

It was very 1966.

CHAPTER 4

WHEN MIDNIGHT CAME AROUND

1967

"We all knew something revolutionary was happening. We just felt it. Things couldn't look this strange and new without some barrier being broken."
—Andy Warhol

Lou Reed: When we were working with Andy, we were doing our shows and we weren't even making enough money to put the show on the next day, so Andy would go and do commercial art things constantly to get money to put on the show. That's how we stayed together. It was all down to Andy. Because for a lot of bands in the Sixties, it was a lot of fun because they could all get signed and those record company people had no idea what was happening, so they were just signing everybody. Unfortunately, it happened after the Velvet Underground, so we didn't get any of the big money. We got, like, nothing and then after us, all of a sudden, all these bands were getting millions of dollars. It would have been nice if we'd got something, but we didn't.

On March 12, 1967, in the US, Verve finally released the Velvet Underground's first album; parts of it were almost a year old. Lou Reed said that they were signed by MGM not because they were so enamored with their music, but because Warhol had already agreed to do the cover. The record wouldn't be

released in the UK until November. The US cover marked a spectacular break-through in the commercialization of music, while also looking like a work of art. Warhol elevated the humble banana to icon status, just like he'd done with Campbell's soup cans in 1962. The original album also came with a sticker over the banana (and was almost certainly a reference to Warhol's film Eat, *made in 1964). The instructions were "peel slowly and see," and when you did you found a pink fruit underneath. It was saucy, and it was autonomous, having nothing at all to do with the band. Warhol's alternative design was going to involve images of plastic surgery procedures—nose jobs, breast jobs, "ass jobs," etc. On hearing the final album at the end of 1966, the record company decided to postpone its release by several months, unsure exactly how to market it. They'd paid for it, but they hated it. When it eventually did come out, it met with a disastrous combination of disdain, indifference, hatred, and bewilderingly awful sales. Because of the nature of the lyrics, many record stores simply refused to stock it.*

In 1966–67, people didn't write songs about buying drugs, which is why "I'm Waiting for the Man" was so transgressive. The song was sonically advanced too, not least the way the instrumentation echoed the sound of a train heading to the intersection of 125th Street and Lexington Avenue, East Harlem. It was gritty, challenging, and almost cinéma vérité, *a paperback short story.*

"Heroin" was equally shocking, seven minutes in which Cale's shrieking viola shrouds the scene while Moe Tucker's heartbeat drumming replicates a dream-like state. Ditto "Venus in Furs," the title taken from Leopold von Sacher-Masoch's novella of the same name, a copy of which Reed apparently found on the street. At the time, sadomasochism wasn't just never discussed, even its existence was called into doubt. It certainly wasn't the subject of pop songs.

After listening to the first acetate, producer Tom Wilson thought the album lacked a discernible single and asked Reed and Cale to write a new song for Nico to sing.

Written by the pair in the early hours after a long Saturday night, "Sunday Morning" (a candy kiss with a kick in it) was almost a lullaby. But while it was certainly commercial, Reed decided to sing it himself, relegating Nico to background vocals. In the studio, Cale played a celeste rather than a piano, giving the song an eerie undertow.

Verve's press ads for the album were beyond embarrassing. They read as though they had been created by someone with no knowledge of a) pop

culture, b) youth culture, c) advertising: "What happens when the daddy of Pop Art goes Pop Music? The most underground album of all!...Sorry, no home movies. But the album does feature Andy's Velvet Underground (they play funny instruments). Plus this year's Pop Girl, Nico (she sings, groovy). Plus an actual banana on the front cover (don't smoke it, peel it)."

Lou Reed's favorite review of the album, which he used to repeat to anyone who would listen, was: "The flowers of evil are in bloom. Someone has to stamp them out before they spread." Reed had been vindicated.

Lou Reed: Andy made the Velvet Underground possible. By producing that LP, he gave us power and freedom. I was always interested in language, and I wanted to write more than "I love you—you love me—tra la la," you know? He wasn't the record's producer in the conventional way that when record company people would say, "Are you sure that's the way it should sound?" He'd say, "Sure, that sounds great." That was an amazing freedom, a power, and once you've tasted that, you want it always.

David Bowie: *The Velvet Underground* was a life-affirming moment for me. I think "I'm Waiting for the Man" is so important. My then manager brought back an album from New York, having been given it by Andy Warhol. This was months before it actually came out, it was just a plastic demo of the Velvets' very first album. He was particularly pleased because Warhol had signed the sticker in the middle. He said, "I don't know why he's doing music, this music is as bad as his painting," and I thought, "I'm gonna like this." I'd never heard anything quite like it, it was a revelation to me. It influenced what I was trying to do—I don't think I ever felt that I was in a position to become a Velvets clone but there were elements of what I thought Lou was doing that were unavoidably right for both the times and where music was going. One of them was the use of cacophony as background noise and to create an ambience that had been unknown in rock, I think. The other thing was the nature of his lyric writing which for me just smacked of things like Hubert Selby Jr., *The Last Exit to Brooklyn*, and also John Rechy's book *City of Night*. Both books made a huge impact on me, and Lou's writing was right in that ballpark. It was Dylan who brought a new kind of intelligence to pop songwriting but then it was Lou who took it into the avant-garde.

Jimmy Page: When I eventually heard the album it was exactly as they had sounded when I saw them. I'd never heard music go into those areas before, and it all made sense on record. The material on the first album is almost cinematic. Each song is so different, each song has such a strong identity. The crafting of it is absolutely incredible. The musicianship is just groundbreaking. There were just so many ideas on that album. Lou Reed doing "Sunday Morning." There were just so many layers and so many colors. Even if all the colors were dark.

David Bowie: The first track ["Sunday Morning"] glided by innocuously enough and didn't register. However, from that point on, with the opening, throbbing, sarcastic bass and guitar of "I'm Waiting for the Man," the linchpin, the keystone of my ambition was driven home. This music was so savagely indifferent to my feelings. It didn't care if I liked it or not. It couldn't give a fuck. It was completely preoccupied with a world unseen by my suburban eyes.

Jon Savage: The first Velvet Underground album is such a concentrated package that it is not surprising that pop culture took twenty or so years to catch up. *The Velvet Underground & Nico* straddles pop and the avant-garde with the decisive quality of a preemptive strike. Encoded within the record are references to authors like Leopold von Sacher-Masoch and Delmore Schwartz, Lou Reed's teacher, whose *In Dreams Begin Responsibilities* is the definitive account of the immigrant experience in the first quarter of this century. Best of all was the way the thing looked: a blurred picture of the group with five separate shots underneath, so lit that you could hardly tell which were the boys and which were the girls. This severe androgyny went further than English attempts at the same game, which had the innocence of childhood. Here the deadpan, blurred look is matched by lyrics about matters that were not hitherto the subject of pop songs. Underneath everything is John Cale's viola, penetrating enough to bring down the walls of Jericho. At one stroke, the Velvet Underground expanded pop's lyrical and musical vocabulary. This was deliberate and gleeful: contemporary interviews had Reed blithely discussing a Cale composition "which involved taking everybody out into the woods and having them follow the wind." Reed was in love with the doo-wop that we'd

never heard in Britain, the Spaniels and the Eldorados, intense, slow ballads with a lot of heart from the early/mid Fifties. Sometimes, these songs would slow down to the point of entropy—an oasis of calm and a refusal of the harshness of ghetto life. The simple fact is, to hear the record in 1967 was to be let into a secret world, once you'd got past the first frisson of pure evil. Like every other great pop record, it changed your life.

Nick Kent: I came to France as a fifteen-year-old on holiday with my parents and there was an issue of *Paris Match* the week that we were there, and there was a color spread on Andy Warhol and his gang, that crowd, photographed under a light show. And of course, the Velvet Underground were part of that crowd. Ten years later Malcolm McLaren used exactly the same idea to launch the Sex Pistols, and whereas Warhol used Gerard Malanga and Mary Woronov, McLaren used Siouxsie Sioux and Sue Catwoman. By using all these weird, exotic, misfit people around him, he wasn't just saying this is a new rock combo, he was saying it's a potential cultural movement. I was aware of the first album as soon as it came out in England, although you have to remember that when it came out here, it didn't have the banana sleeve. The music wasn't played a lot in England, and I don't remember John Peel ever playing the Velvet Underground, because it was very different from the hippie stuff. It was not the Jefferson Airplane or the Incredible String Band. The Doors were the only group who you could say were any way like them. They were out on their own, as was Warhol. It was like, who are these weirdos? The music disturbed me slightly, and it wasn't love at first hearing. It spooked me. In '67 it wasn't the right context to listen to the Velvet Underground. It was an acquired taste, and yet it improves with the passing of time. This is the real Velvet Underground record because it's here that Cale's European sensibility and Reed's all-American sensibility blend together perfectly. If you listen to Lou Reed's demo of "Venus in Furs" it's like a folk song, but when Cale gets hold of it, he adds a European chill. It's unique. Lots of people have tried to copy the Velvet Underground but no one has been able to capture that sound. And just using Nico for three songs is great. She didn't need to be on the whole album. That would have ruined it. You had a group with three really fascinating personalities, people of real

substance. The musical chemistry was stunning, but because of that it was never going to last long.

Brian Eno remembers first hearing the Velvets on John Peel's radio show The Perfumed Garden *when he was at Winchester School of Art in 1967.* "Within the first few moments, I thought, "OK, this is important." I could hear the La Monte Young influence, the sort of drone thing that John Cale was doing on the viola. I think I heard "Heroin" first. So I bought that album [The Velvet Underground & Nico], which not many other people did at the time. It might be hard for some people to understand, but they were a big influence on Roxy Music. Bryan [Ferry] liked them as well and we both knew about their connection with Andy Warhol, which gave them a sort of cultural position.*

"When we started Roxy, rock and roll was really fifteen years old. And in that time, you had the whole of doo-wop, Elvis, the Liverpool scene, psychedelia, Frank Zappa, Captain Beefheart, this incredible compression of all that stuff. The history of the music form was already substantial enough to draw from. We were pop artists in the little 'p' and big 'P' sense. Bryan had studied with Richard Hamilton at Newcastle [University], who people often say is the father of Pop Art, and I'd been tutored by one of his most brilliant students, Roy Ascott. So we both had that connection to the idea that culture was its own subject, as it were, and kept redigesting itself all the time. And that wasn't an idea you were supposed to like back then. That's what The Velvet Underground represented to me. They sort of endorsed all those things that people had said were wrong about pop music."*

Richard Williams (journalist, author): In early 1967 I was living in Nottingham, working for the local morning and evening papers. I was nineteen, twenty. I read the *Village Voice* and the *East Village Other* thanks to a very good alternative bookshop in Nottingham, which had all the Black Power literature, and all the alternative magazines like *International Times*. And I was very up for all that. Richard Goldstein in the *Voice* wrote about the Velvets at about the time the first album came out, and I think he reviewed a gig at the Dom, and I thought, "Wow, this sounds amazing." The album didn't come until November in the UK, even though it came out in America in March. It came out without the banana cover. I bought it immediately, and it was everything I imagined it would be. So, I wrote an 800-word piece

about it in the *Nottingham Guardian Journal*, the morning paper. I said basically what Richard Goldstein had said. I'd been listening to a lot of different kinds of music. I'd grown up with rock and soul music, I went to clubs a lot, and there were a lot of bands to go and see, so I was pretty well-versed in all that. I don't think I was ever going to be hippie, so I responded to the kind of non-hippieness of the Velvet Underground, and the art element of it. I was already a fan of Warhol. I'd been listening to free jazz, Ornette Coleman, John Coltrane, Albert Ayler, Cecil Taylor, as Lou Reed had. And I knew about modern classical music and beat poetry, so none of that stuff scared me. When I heard "Black Angel's Death Song" it was very interesting to hear those musical philosophies applied to rock music, by what was basically a guitar band. And the wilder it got, the more I liked it. I wasn't scared by lyrics about heroin or S&M. It all seemed perfectly natural to me. Exciting, but not shocking.

Michael Zilkha (entrepreneur): I first heard them when I was at Westminster [School], when my friend Tony Rothschild borrowed the first album from the local library. We played it in the music room, which had great speakers. I thought it was totally otherworldly. They were everything to me.

Mick Brown: I was aware of them as soon as the first album came out in '67, when I was sixteen, living in London. I was transitioning from soul music, trying to broaden my horizons. I'm sure that one of the things that first attracted me to them was the sort of dark, saturnine, demimonde quality they exuded. I'm sure that was an attraction for lots of people, as they were just so different. At the time the center of gravity was the West Coast, flowers and peace and psychedelics, long hair, tie-dyed T-shirts, and so forth, and the Velvet Underground were the dramatic counterpoint to that. They were sullen, wore dark T-shirts, and had this association with Andy Warhol. So, the difference was quite marked. Which is why when they first played the Whisky in LA they got a terrible reception. Pockets of culture were quite distinct across America at the time. Everything was regional. We got everything secondhand in England at the time. I was working as a messenger boy at the time, and while we had our own summer of love in London,

the Velvet Underground exemplified the summer of despair, despondency, and decadence.

Courtney Love (musician): "Black Angel's Death Song" is really scary. Even on dope.

David Bowie: Actually, though only nineteen, I had seen rather a lot but had accepted it quite enthusiastically as all a bit of a laugh. Apparently, the laughing was now over. I was hearing a degree of cool that I had no idea was humanly sustainable. Ravishing. One after another, tracks squirmed and slid their tentacles around my mind. Evil and sexual, the violin of "Venus in Furs," like some pre-Christian pagan-revival music. The distant, icy, "Fuck me if you want, I really don't give a damn" voice of Nico's "Femme Fatale." What an extraordinary one-two knockout punch this affair was. By the time "European Son" was done, I was so excited I couldn't move. It was late in the evening, and I couldn't think of anyone to call, so I played it again and again and again.

That December, my band Buzz broke up, but not without my demanding we play "I'm Waiting for the Man" as one of the encore songs at our last gig. It was the first time a Velvet song had been covered by anyone, anywhere in the world. Lucky me.

Ed Vulliamy: I grew up in Notting Hill, just off Portobello Road, the Haight-Ashbury of Europe, if you like, where the Pink Floyd would rehearse in the local church hall. I was born in the street in which Jimi Hendrix died, Lansdowne Crescent. So I was in the thick of it. Oddly, this distanced me from flower power, as I was the only one in my circle of friends who didn't take drugs—marijuana made me sick, and acid scared the shit out of me. John Kay from Steppenwolf said, "We felt there were too many serious things going on in the world to be dancing around in a park with a bunch of flowers." I felt the same way. I felt the same about Portobello Road. As an earnest fourteen-year-old, there was too much going on—the Soviets were in Prague, the British were in Ireland, and it was all happening in Paris. I was already politically active, if uncommitted. I was very aware that I was on the side of people contesting power, not on the side of those wielding it. Even though the Velvet Underground were not overtly political, they were almost

anti-political. As John Cale has since said to me, "It was all subliminal." There was a diagonal distance between them and the air-headed stuff you could only understand if you were on acid. It isn't there in the lyrics and it isn't there in anything they said, but when I heard the banana album I thought, "Something's happening here. And this is for me." I used to go to the Proms as a precocious fourteen-year-old, and I didn't know that the most important ingredient in the band was classically trained. But you kind of sense it, in the dissonance and the drone, in that musical sonority that was unlike anything else. It was a small "p" political attraction.

I went to buy the Velvet Underground album from a tiny little record store in Notting Hill Gate called Virgin Records, where you used to sit on a cushion with headphones and listen to your LP before deciding to buy it for 32s 6d, which was a lot of money in those days. And I listened to it over and over again. It was electrifying. I later got arrested for spray painting a circled A on the outside. In those days the world was quite understandably divided into hip and square, and in between the two was pseud, and I thought Richard Branson was a pseud. I didn't trust him. I was fined £20 at Marylebone Court.

Richard Williams: The first time I played the record I remember being surprised by "Sunday Morning" as it was so orthodox and soft. But then "I'm Waiting for the Man" and the viola in "Heroin" were much more as advertised. I remember thinking how diverse it was, and every track seemed to have a different angle to it. A little bit like mid-period Beatles albums, when each track came from a different angle. I wanted to tell the world about them, but I knew the world wasn't going to be very receptive. I said in my first piece about them that the chances of you—the reader—liking this music would be very slim indeed.

Jimmy Page: We were one of the first bands to cover "I'm Waiting for the Man," as the Yardbirds used snippets of it in our version of "Smokestack Lightning," and sometimes in "I'm a Man" when we played live. That song had lots of things that were thrown into it. I tried to do things that were really dense and really unnerving, especially with my bow playing. It was meant to be disturbing. So something on that level, that the Velvets were doing, was unlike anything I'd heard before. Nobody had done anything like that before. It was a combination of the material

and the way it was being played, and the character of it all. Clearly they had set pieces, obviously with improvisation within them.

David Cavanagh: "I'm Waiting for the Man," about a drug deal in Harlem, will become the essential text about drug deals in Harlem. The buyer in a state of itchy anxiety. The dealer sauntering along in a straw hat. Twenty-six dollars, not twenty-five. The details will be written into the Constitution. And where the language ducks and dives with street precision, the music is as relentless as a machine. No backbeat, just punch-punch-punch. Cale, playing two instruments, announces himself as a monster bassist and also pounds away at a piano as if trying to manhandle it across the studio floor. In the song's dying seconds Reed is moved to laughter as Cale clangs out an atonal piano chord while his bass cavorts maniacally. How could these two men not want to work with each other forever?

You've seen the drug being bought. Now watch it being injected into an arm. Society's ultimate taboo opiate is the subject of a seven-minute epic ("Heroin") in which Reed reports not only the deed but also the motive, the effect, and the strict terms of his addiction. Moe Tucker accelerates dangerously as the narrator slumps forward in ecstasy, before Cale's viola goes haywire in an astonishing climax. Dropped on unsuspecting turntables in 1967, the same year that Great Britain prosecutes Hubert Selby Jr.'s *Last Exit to Brooklyn* for obscenity, "Heroin" is a hit with the cognoscenti around the Rolling Stones (who will borrow its guitar intro for "Stray Cat Blues"), but Reed's clipper-ship rhapsodies ensure that squeamish disgust, rather than peer group approval, is the dominant reaction among critics and DJs in the States.

On an album where Reed's impulsive, world-weary protagonist constantly seeks to impress on his audience that the extremes of experience neither faze him nor pique his curiosity anymore, he's already shown us a dominatrix whipping the skin off a submissive wretch ("Venus in Furs") and ferried us around Manhattan ("Run Run Run") where a cast of characters with colorful nicknames while the hours away until they can get their hands on some dope. On the closing "European Son," whose ominous bassline follows the disorientating onrush of word association and seesawing viola that is "The Black Angel's Death Song," Reed leaves an unforgettable imprint of himself

as a guitar soloist. Twanging the strings like a demented banjo player, he appears to understand that everything he's doing is iconoclastic. His solo becomes a flailing fist-fight, a battle of wills, breaking through into a new world of possibility where the instrument makes noise after noise that it's never been asked to make before.

After he heard it in 1967, Brian Epstein, the manager of the Beatles, liked the Velvet Underground's first album enormously, and was considering getting involved with them in some capacity. At publicist Danny Fields' behest, Lou Reed jumped in Epstein's cab in New York in the spring of '67, having been at the same party. Reed lobbied Epstein to get involved in the band, and even asked if the Liverpool-born entrepreneur could help promote some gigs in Europe. Epstein was intrigued by, and attracted to Reed, but when he died aged thirty-two on August 27, any plans he may have had for the band disappeared with him.

Lou Reed: Even from day one with the Velvet Underground we were not aiming at fourteen-year-olds because to get my stuff, you have to pay attention to it. People didn't go on about William Burroughs because he was a novelist, and novelists are allowed to fuck up. [But] it was such a big deal, a song called "Heroin" being on an album and I thought that was really stupid. It was only because it was on a rock and roll record that it was such a big deal. I mean, they had it in the movies for Chrissakes in the Forties—*The Man with the Golden Arm.* So what was the big deal? It was like talking to pygmies. People were offended because we did a song called "Heroin" but there's plenty of stuff about that in literature and no one gives a shit but this is rock and roll so we must be pushing drugs or something.

Obviously, they'd never read any books. Then we did "Venus in Furs," because I'd read Leopold von Sacher-Masoch's memoir, and these stupid people who found that so shocking didn't even know the book existed. I used to think, "Jesus, I could write a song called 'The Bible.' These people don't read the Bible so I can get the credit for all of it. Those pygmy people don't know any better."

It was difficult being a member of the Velvet Underground in 1967, principally because they looked so intimidating. Especially in the Midwest. The band may

have been considered to be the very apex of downtown cool in New York, but in the flyover states they were just a bunch of black-clad ne'er-do-wells in wraparound sunglasses and European shoes.

"They were primitive times," says John Cale, "driving around in a van, taking enormous amounts of speed, being stopped by the police."

Once, in the middle of Ohio, driving back to New York from Cleveland, overnight, they were waved down by traffic cops and accused of kidnapping children as the girls they had with them were young and didn't have notes from their parents. The police apparently didn't consider what kind of parents would have sanctioned going out on a night with the Velvet Underground.

"Madness," says Cale. "Complete madness."

One of the reasons the press was initially so wary of Warhol was because of the way he looked. At the time artists were allowed to be odd, demonstrative, even feral, but they weren't allowed to look like they were courting any kind of obvious media attention. They could look like tramps, in the way that the beats did, with their scrappy "urban rustic" look, an appropriation of blue-collar style that set them squarely against the so-called establishment. If you were an abstract expressionist or a writer or a poet, you needed to have effortless cigarette-smoke-tinged cool. You needed to look like Jack Kerouac, with his self-consciously bohemian take on rugged Americana. It was the style of the lumberjack, the farmer, the factory worker, the painter and even the military man, that moved him. Being an artist meant being innately critical of the American way of life, so in order to play against that, you needed to ape the style of the everyman wanderer, the Woody Guthrie look, the one that was already being adopted by Bob Dylan (to disguise his own middle-class upbringing): check shirts, work boots, T-shirts, pea coats. The style of the street. Your clothes were probably dirty, as you would have needed to give signals that you were either actively involved in the making of whatever it was you were doing (were your trousers covered in paint, for instance?), or moving from one experience to another (no time to wash!).

What you didn't do was try and look like a rock star.

As Warhol moved from the gentrified world of department store and magazine illustrator to fully fledged artist, so his wardrobe changed with it. No longer was he sporting preppy jackets, chinos, and Oxfords, but adopting more of a downtown look of biker boots, denim jackets, sunglasses, T-shirts, and skinny jeans. And, of course, the Breton top. It had first been worn in the Factory by the radical dancer Jill Johnson while she was being filmed by

Warhol in April '64, who was then copied by Barbara Rubin, who had first introduced Warhol to the Velvets. She was then copied by Gerard Malanga, and then by Edie Sedgwick, and then by Warhol himself. A Breton top soon become mandatory at the Factory.

Warhol was by now no stranger to the vagaries of fashion, and in 1965 had anticipated a future punk look by sticking a series of safety pins through the neckline of his shirt, beating the Sex Pistols' John Lydon by over a decade. John Cale was equally prescient and had taken to sporting a dog-collar necklace and bracelet. But it was the Breton top that caught on. Jean Seberg had worn one in Jean-Luc Godard's À bout de souffle, *and Lee Marvin wore a stripey top in* The Wild One.

Alex Bilmes (journalist, editor): Andy Warhol and fashion were made for each other. Celebrity, shopping, money, novelty, surfaces, color, black and white, mass production, inauthenticity, youth, nightclubs, boredom, movies, Eurotrash, dropouts, pop, the future: all the things he celebrated and satirized and fetishized and derided are the same things fashion obsesses over, fantasizes about, rips off. He didn't so much predict the future as create it. Warhol was fashion, but Warhol was bigger and better than fashion: in his surface was his depth.

Warhol wasn't the first artist to adopt it. The pioneering photojournalist Robert Doisneau is probably best known for his famous 1950 staged image of a couple kissing on the streets of Paris, *"Le Baiser de l'hôtel de ville (Kiss by the Town Hall)."* Almost as memorable is the picture he took two years later at Pablo Picasso's house at Rue Grands Augustins (in the 6th Arrondissement). The artist was having lunch with his mistress, the painter Françoise Gilot, and the table was covered with small loaves. Sensing a photo opportunity—Picasso could always sense a photo opportunity—he hastily arranged the bread to make them look like huge fingers, while he peered off into the middle-distance with a nonchalant look on his face.

In Doisneau's photograph Picasso is wearing one of his trademark Breton tops (introduced in 1858 as the uniform for the French Navy, it featured twenty-one stripes, one for each of Napoléon's victories, and made it easy to spot a sailor if they happened to fall overboard), an item that helped characterize him as a public figure. Throughout his life he also intermittently sported a beret, creating a silhouette that was

almost as recognizable as Jacques Tati's hat and pipe. Although Picasso was known to wear various types of hats—everything from Peruvian knitted hats to straw boaters, from Homburgs to handkerchiefs—it was his beret, frequently featured in his paintings, that seemed to strike a chord. When he showed at the ICA in London in the 1950s, employees found lost berets more than any other personal item, including umbrellas and bowlers.

Like Warhol, Picasso's entire life was an exercise in self-mythology. It wasn't enough to have completely reinvented Western painting, jettisoned idealized notions of beauty, and banished conventions of perspective (for starters), he needed a platform for the fripperies which surrounded his genius, needed to be appreciated for the calculatedly bohemian way in which he conducted himself.

But it wasn't all about the Breton top. Picasso completely understood the power of marketing, and throughout his career used everything in his power to publicly ameliorate his own personality. Tyrannical, entitled, and possessed of a massive ego, he used an almost cynical playfulness to project another face to the world. One of the ways he did this was through what he wore.

Warhol was similar. Bob Colacello, who worked at *Interview* for years and was among Warhol's closest confidants, says his Sixties look of "silvery white wig, dark wraparound sunglasses, black turtleneck under black leather jacket, black boots, and, yes, blue jeans—was calculated to create a cool, hip, rebellious, even a bit sinister image. And it succeeded."

Warhol's gnawing insecurities about his own appearance were rooted in his sickly childhood and exacerbated by premature baldness, the taboo of homosexuality, and a general feeling of physical inadequacy. Self-consciousness about physical imperfections is universal, but the Pop Art icon took it to another level. Disguising the way he looked was just another way of reinventing himself, while body abstraction would become a seminal trope in his portraits. It wasn't long before the Velvet Underground started sporting Breton tops, along with black leather jackets, Cuban heels, sunglasses, biker boots, and tight jeans, honing an aesthetic that would soon become iconic.

Kurt Vile (musician): So cool. So unapologetic.

By late May, Lou Reed had finally had enough of Nico. They had been involved in a passive-aggressive war of attrition since they first met, with Reed initially being unhappy she had been drafted in as a focal point by Warhol, and then irritated he had to write songs for her. This irritation was briefly assuaged when they started their affair, but once that was over, Reed was never overly happy with her association with what he still considered to be his band, and so he set about getting rid of her. The power struggle that existed between the pair was largely in Nico's imagination, as the other three members were not overly happy with her presence either. She was late to rehearsal, late to gigs, and constantly wanted more songs to sing onstage. Finally, when she arrived over two hours late for a concert in Boston, Reed snapped. He refused to let her onstage, and she was fired soon afterward. The chief Velvet had simply had enough of her. He didn't need her now, so she was gone. "Everybody wanted to be the star," she said. "Of course, Lou always was. But the newspapers came to me all the time." Cale meanwhile considered this "a symbolic cutting of the umbilical cord with Warhol."

And so it proved. In early June, after a disagreement about where the band ought to be performing, Reed let Warhol go, relieving him of all his managerial duties. Cale would later say he didn't know how brutal Reed had been with their mentor: "If I'd known at the time, I wouldn't have let him get away with it." Reed said this about his decision to bench Warhol: "He sat down and had a talk with me. 'You gotta decide what you want to do. Do you want to keep just playing museums from now on and the art festivals? Or do you want to start moving into other areas? Lou, don't you think you should think about it?' So I thought about it, and I fired him. Because I thought that was one of the things to do if we were going to move away from that world."

By "that world" he meant the small, insular, "mini-market" world of art openings, trendy parties, and small, dark clubs. For Reed, this wasn't just a jettisoning of his mentor, this was patricide, ditching Warhol before Warhol had the chance to ditch him. Andy was so pivotal to everything happening in the New York underworld that people were scared to move out of his orbit. Much better to be inside the tent. Much better to be an acolyte, even if it was occasionally demeaning, even if a privileged position wasn't always guaranteed. Lou Reed wasn't as enamored of Warhol as the rest of his Superstars, because he actually thought he had a chance of being a real *superstar.*

Reed's decision can be seen as extraordinarily arrogant. It was Warhol who had given him a platform, Warhol who had wrapped his organization

around him, Warhol who had made the band notorious. No, he hadn't made them famous, but he had delivered far more than the Velvet Underground would have been able to muster themselves. In their own world, they were infamous, flyers of their own East Coast freak flag, a musical heart attack, a mad creation, a ridiculous assault. And because they were part of the Factory, they were bathed in Warhol's fabulous, wonderful, incongruous glow. Without Warhol they might still be performing in Greenwich Village dive bars, might still be poor and desperate. Of course, by the midpoint of 1967 they were still poor and desperate, but they were cool.

But Lou Reed's ambition was only just starting to blossom. The great purge had only just begun.

Catherine Guinness: Lou always seemed like a perfectly normal nice person, but Andy thought he was a bit weird. Lou could be very genial, and he adored Andy, principally because he respected him, I think.

The Velvet Underground were to the East Coast what the Grateful Dead were to the West, New York's brutalist realist streetwise riposte to San Francisco's hippy-dippy love-ins. If you study the narrative of the Velvet Underground, what passes for plot is a series of geographical movements. When the Exploding Plastic Inevitable landed in California in the spring of 1966, some compared it to an alien invasion. Ever the ringmaster, Warhol brought a substantial crew with him—there were leather-clad dancers with whips and masks—along with the Velvets. Their appearance on the West Coast highlighted the vast differences between East Coast culture (New York, basically), and the soporific delights of Los Angeles and San Francisco. Bill Graham, the infamous promotor who hosted the Velvets at the Fillmore West, said, "It was sickening, and it drew a real Perversion USA element to the auditorium."

There was no love lost on either side.

"Not since the Titanic *ran into that iceberg," said one reporter from the* Los Angeles Times, *"has there been such a collision."*

"We spoke two completely different languages," said Mary Woronov, one of the Exploding Plastic Inevitable's dancers. "We were on amphetamine, and they were on acid. They were so slow to speak with their wide-open eyes—'Oh, wow!'—so into their 'vibrations'; we spoke in rapid machine-gun fire about books and paintings and movies. They were into 'free' and the American Indian and 'going back to the land' and trying to be some kind

of 'true authentic' person; we could not have cared less about that. They were homophobic, we were homosexual. Their women, they were these big round-titted girls, you would say hello to them and they would just flop down on the bed and fuck you; we liked sexual tension, S&M, not fucking. They were barefoot; we had platform boots. They were eating bread they had baked themselves—and we never ate at all!"

It was almost as if the Addams Family had paid a visit to the Archies.

The music of California was all about sunsets and the warm glow of summer; the Velvet Underground were all about late nights and cold breaking dawns.

Martin Scorsese says that Lou Reed's lyrics could only have come from "someone who grew up in the New York area and came of age in Manhattan, who moved and wrote and sang from the pulse of life in this city. They describe the city as it was, but they also incarnate it." In the Velvet Underground, Reed was an avant-garde nihilist who wrote material about drug abuse, prostitution, paranoia, and sadomasochistic sex at a time when the rest of the world was singing about peace and love.

As Warhol said, "They were really the first punk band."

To the denizens of Venice Beach, Hollywood Boulevard, and Laurel Canyon, the Velvets epitomized exactly the wrong kind of countercultural sophistication. Here, among the gently swaying palms, the ice-blue kidney-shaped swimming pools, and the burgeoning alt coffee shops, the patchouli-oiled, tie-dyed stoners espoused a collective ideology, a binary and often simplistic understanding of middle-class rebellion. There were common goals and blind acceptance rather than the kind of brash individualism you found on the streets of downtown Manhattan. In San Francisco, the antipathy toward the Velvets was almost aggressive. "A prime example of me bringing in something I don't like was the Andy Warhol show," Bill Graham later remembered.

In terms of gay rights, San Francisco would start to pull away from New York, but in 1966, when the Velvets first visited, the genuine freakishness of the Factory crew was generally bewildering to an emerging community happy to wallow in the sun-kissed promises of the Mamas and the Papas or the benign presence of the Grateful Dead. Both the Underground and the Dead started out as very similar bands. In fact, for a while in 1965 they were both called the Warlocks. On the West Coast, Ken Kesey hired the Dead to provide music for his community acid tests, while in New York, Warhol obviously used the Velvets as a vehicle for his Factory events and a featured role in the Exploding Plastic Inevitable. They were both responsible for creating soundtracks in multimedia

experiences, where the music could have been said to be secondary. Hence long improvisations, and random and wayward, droning noises.

Lou Reed: We had vast objections to the whole San Francisco scene. It was just tedious, a lie, and untalented. The Airplane, the Dead, all of them...

Caleb Kennedy (blogger): The Velvets had first come to San Francisco in May '66—they played the Fillmore with the Mothers of Invention, and developed an instant mutual dislike for Bill Graham. They also hated Frank Zappa—Lou Reed later called Zappa "the single most untalented person I've heard in my life—he's two-bit, pretentious, academic, and he can't play his way out of anything. He can't play rock and roll." Reportedly Reed also hated the Jefferson Airplane's music so much that he refused to share a bill with them. Cale admitted that on this first San Francisco trip, "No one liked us much." Audiences met them with bewilderment—one witness remembers, "they had this weird stuff onstage with some chick getting whipped, and I went, 'Oh wow, this is music?'" Ralph Gleason wrote a very hostile review of their "sick, campy, dull, joyless, non-artistic" show—"a bad condensation of all the bum trips of the Trips Festival... Opening night was really crowded, even though hippies were continually walking out shaking their heads and saying 'Wow!' in wonder that such a bore could be."

The Velvets ended a Fillmore show by putting their guitars against the amps and letting the feedback howl as they left the stage. Bill Graham couldn't stand this, or the rest of their stage act—he called them perverted, sickening, and negative, "the worst piece of entertainment I've ever seen in my life"—and they all agreed that the Velvets would never play any Fillmore show again. The police in Los Angeles that month also found the Velvets' show so offensive they shut down the club they were playing in.

The Velvets later believed that Bill Graham had even stolen the idea of their light show. They found the Fillmore's current light shows laughable, and they felt that when they showed up with the Exploding Plastic Inevitable, that Graham was doing kindergarten-level light shows, and they opened his eyes and then he ripped them off, took all their ideas and put that out as his own.

Lou Reed: They're amateur...they can't play. Jerry's not a good guitar player. It's a joke, and the Airplane is even worse, if that's possible.

Caleb Kennedy: The Velvets, of course, were sworn enemies of the Grateful Dead. Maureen Tucker called the Dead the most boring band she'd ever heard. Sterling Morrison also loathed them, and despised San Francisco music in general. (But he did make an exception for Quicksilver Messenger Service, saying they sounded great and John Cipollina was a really good guitar player.) Lou Reed also had harsh things to say, although he did like the first Moby Grape album; and they were fans of LA bands Buffalo Springfield and the Byrds.

Both the Velvets and the Dead, however, liked to take simple modal patterns of one or two chords and spin them out into long jams, though they took these in different directions. Both bands were innovators in using feedback as a meaningful musical statement (of course they weren't alone—the Who and Hendrix among others were doing the same—feedback was an exciting new thing in those days). If you've heard the Velvets' early soundtracks for Warhol films, they're freaky ambient noise not far removed from the Dead's later "spaces."

The Velvets were one of few rock bands I know of to do half-hour freeform improvisations in 1966. Rock music was stretching out and solos were getting wilder, but not many instrumentals had gone to such monstrous lengths yet. (The list of twenty-minute live rock jams is a short one that year—there's Moby Grape's "Dark Magic," the Butterfield Blues Band's "East/West," and Pink Floyd's "Interstellar Overdrive.")

Improvisation is very much a live art, though, and was frowned upon in studio recordings of the time—as was any tune longer than three minutes. As a result, there are many bands who were known for their long jams onstage, who confined themselves to short pop material on their records. By 1968, with "Sister Ray," the Velvets had a piece that could be transformed into something different each time they played it, and they were happy to stretch it out to thirty, forty minutes or more. There's one show where just the intro to "Sister Ray" is a forty-minute quiet trance drone. Other songs could sprout ten-minute guitar solos as well, depending on the band's mood; long jams would develop in the sets and then disappear.

While the Dead had Phil Lesh to give them that avant-garde dissonant edge, John Cale brought a quite different avant-garde slant from his

previous noise/drone experiments. In much the same way as Lesh came to the Dead fresh from absorbing Luciano Berio and Stockhausen, as Cale had studied with La Monte Young, he brought that influence into their music. There's a 1965 recording from the Dream Syndicate (with La Monte Young and Tony Conrad) which is just one note (on two or three violas) sustained for about a half hour. Now that's a serious drone.

Sterling Morrison: We left California alone for years, because they were so determined to do their own thing, their own San Francisco music. We were just rocking the boat—they don't want to know about that. "There's only one music, and we all know what that is…it's what the Grateful Dead play. That's the very best rock and roll can ever get…" We said, "You're full of shit, your city, your state, and everything else."

Lou Reed: It's what people are settling for…they're getting third-hand blues. It's a fad…People like Jefferson Airplane, Grateful Dead, all those people are the most untalented bores that have ever lived. Just look at them—can you take Grace Slick seriously? It's a joke. And the whole thing is, the kids are being hyped this on FM radio. Well, now finally it's dead, the whole San Francisco thing is dead.

Caleb Kennedy: But they did come back. In fact, in '68/'69, they played San Francisco more often than anywhere else except for Boston, playing numerous shows at the Avalon, Family Dog, and Matrix. One reason was that by then, the audience had caught up with them, and loud hard rock was the order of the day, so the Velvets were now well-received by enthusiastic fans. Peter Abrams liked them enough to record hours of their Matrix performances ("I wanted to get as many recordings of them as I could"), and Robert Quine was one fan who'd recently discovered the Velvets and also taped as many shows as he could. (Both of them, though, had to erase most of their recordings and keep only highlight reels, since they couldn't afford all that tape.) But ironically, most of the Velvets' live releases come from San Francisco.

One audience member saw a show with the Velvets and Quicksilver Messenger Service in '68, and noted the Velvets' "depressing drug-type songs, very heavy, very dark, very heroin, with a dangerous underground feel…"

Some California newspaper reviewers tried to describe the Velvets' sound in their shows: "The band makes a sound that can only be compared to a railroad shunting yard, metal wheels screeching to a halt on the tracks. It's music to go out of your mind to..."

And, "In the middle of 'Sister Ray,' they created this harmonic that sounded like the roof of the building was cracking open! It was just wild; it went on for a long time. It was really the ultimate in trance music, even beyond what La Monte Young was doing, because it was so loud and there were so many instruments..."

Or, "The Underground played an extremely involving two-hour set which completely destroyed the audience, left limp at its conclusion. The music was earthy with a heavy beat and moderate use of electronics and feedback. The sound it created was all-enveloping. Catharsis was particularly strong in 'Heroin' and the forty-five-minute concluding number, which included electronic viola and organ as well as the guitars...they're a heavy group."

"We all really disliked the hippie crap," says Moe Tucker. "Flowers, peace, and love will not change the world. Nothing will change the world since people are people. Plus, I think the vast majority of hippies were just jumping on the bandwagon and really just liked the idea of laying around doing nothing and thinking they were stunningly cool. Hippies on the East Coast, hippies on the West Coast: they were all the same."

Ironically, one of the coolest stores in San Francisco had already been named after the band, a store that specialized in the hippie Victorian chic that Californians liked so much. "The clothes I wear, that doesn't change," says Stevie Nicks. "I love long dresses. I love velvet. I love high boots. I never change. I love the same eye makeup. I'm not a fad person. I still have everything I had then. That's where my songs come from. There's a song on the Fleetwood Mac album Mirage *that mentions the Velvet Underground, which was a clothing store in downtown San Francisco, where Janis Joplin got her clothes, and Grace Slick from the Jefferson Airplane. It was this hole in the wall. Amazing, beautiful stuff." That song was "Gypsy," and she told herself, "I'm not buying clothes, but I'm sure as hell standing in the place where the great women have stood."*

Warhol was rather more forgiving of the West Coast, as Los Angeles had been the first place he'd sold one of his twenty-by-sixteen-inch soup can

paintings. It had been bought by Dennis Hopper, with money he'd earned on Rebel Without a Cause *and* Giant.

Bob Colacello: The Factory was very anti-hippie, I quickly learned when I got there. It wasn't pot, it was Stolichnaya on the rocks.

Geraldine Smith: A lot of people say very negative things about Andy, but I never found him anything but charming. He was always very nice to me. He took me to California, to the Beverly Hills Hotel, to a nightclub called the Factory, and everyone was there—Ryan O'Neal, Leslie Caron, Jane Fonda, Roger Vadim, everyone in Hollywood.

Caleb Kennedy: The Velvets and the Dead would play together a couple of times in 1969, including two gigs at Chicago's Electric Theatre on April 25 and 26. It's commonly believed among Dead fans that on the twenty-fifth, the Velvets opened and played a very long set, leaving the Dead only a short time to play. In revenge, when they switched and the Dead opened on the twenty-sixth, the Dead played for almost three hours, making the Velvets wait through their forty-minute wall-of-feedback encore. This story is wrong, though. If you listen to the end of the Dead's short set on the twenty-fifth, it's clear that they were the opening act that night—when the audience cries for more, Bob Weir says, "We're gonna come back and do a second set in a little while, and we're gonna bring on two other real good bands, and they'll blow your minds anyway; so we'll be back in just a short while." Doug Yule reports that the first night "the Dead opened for us—we opened for them the next night so that no one could say they were the openers. As you know, the Grateful Dead play very long sets, and they were supposed to only play for an hour. We were up in the dressing room and they were playing for an hour and a half, an hour and forty-five minutes. So the next day when we were opening for them, Lou says, 'Watch this.' We did 'Sister Ray' for like an hour, and then a whole other show."

Danny Fields: If a hippie drifted into the orbit of the Factory, or the band, and he or she were talented or beautiful and rich, or two of the above, they would certainly be in. Hippies were just how upper-middle-class culture manifested itself more on the West Coast rather than the East Coast. I'm not sure they hated hippies. Who would be a hippie to hate?

How could you hate Ed Sanders or Abbie Hoffman? They were just flowery, watery people. Non-New Yorkish. That's what they meant by that. Of course, when they came to California, the Velvets all said, "They hate us, so we're going to hate them," straight off the bat. And that set up an interesting dynamic. It was imagined.

Leee Black Childers (writer, photographer, manager): I was staying at the Tropicana Hotel in Hollywood. One day we heard all this noise. We looked across the parking lot to the other side where the noise was coming from and suddenly the whole door of this room came flying out onto the balcony, and there stood John Cale. He couldn't work the doorknob, so he just knocked the door down, right off the hinges.

Lou Reed: Once when we were playing on a bill with the Grateful Dead, some reporter from the *Daily News* asked me what was the difference between us and the Dead. With a perfectly straight face, I told him, "The difference is that they take the kids backstage and turn them on—but we shoot 'em up!" Don't you know, he actually believed me and printed that.

In July 1967 a much-abridged version of the Doors' "Light My Fire" was released as a single. It quickly climbed the American charts, staying at number one for three weeks, selling over a million copies, and becoming the biggest-selling single of the year. To celebrate its success, Jim Morrison went out and bought his most iconic piece of clothing, a custom-made black leather suit. The band's publicist, Danny Fields, attempted to get him an appropriate girlfriend, too. Distressed by the kind of girls Morrison was surrounding himself with (mainly down-at-heel circuit groupies), Fields tried to elevate his taste in women—firstly by introducing him to Nico. She was staying with Edie Sedgwick at the Castle Hotel in the Hollywood Hills, a huge fake 1920s Spanish mansion which had recently become a popular rock and rollers' haunt, frequented by the likes of Jefferson Airplane, Bob Dylan, and Warhol himself.

Gene Krell (journalist, pop archeologist): She was very much in love with Jim Morrison.

Danny Fields: Nico and I became great friends when I introduced her to Jim Morrison. She always said that Jim really encouraged her to write

songs. I have to scrape deep and hard to find good things to say about him, but she appreciated him. Even though he was an asshole. You never went to criticize Jim face-to-face, you just didn't do it. I would never say, "Why don't you shave, or lose ten pounds, or use a deodorant?" It never occurred to me, or anyone else. The rest of the band worked around him. I never saw anyone treat him like anyone but Elvis Presley. But I really thought he should be hanging out with better women, so I introduced him to Nico. I thought they would make a cute couple. They were both so weird and icy and mysterious and charismatic and poetic and deep and she was sensitive and wonderful.

That night I rounded Jim up and persuaded him to follow me to the Castle in his car. You could tell how nasty he was then, because he really wasn't trying to keep up—falling back and being a real pain in the ass, so I'd have to keep stopping and waiting for him. He played those kinds of games, tried to get you in his power. So, we got there, and after I introduced him to Nico they just stood and stared at each other for hours. They stood in doorways and stared at the same spot on the floor. Then we got incredibly stoned. I traveled with a lot of drugs in those days—everyone did—and we took just about everything I had—everything, that is, that hadn't been taken by Edie Sedgwick. I had hidden most of my drugs underneath the mattress of a bed in a room that wasn't being used, but she still managed to find them. There was acid, hash, uppers, downers, and a bottle of vodka. I split most of this with Jim, although he had far more than I did—he had a much greater capacity for narcotics than anyone I knew. It was amazing, I didn't know how anybody drank, smoked, and swallowed so much stuff and still stayed up. But he did. He was up on the roof, naked, climbing all over it, completely stoned.

Paul Rothchild (the Doors' record producer): Morrison took Nico up in a tower, both naked, and Jim, stoned out of his mind, walked along the edge of the parapet. Hundreds of feet down. Here's this rock star at the peak of his career risking his life to prove to this girl that life is nothing.

Danny Fields: Him and Nico got into this fight, with him pulling her hair all over the place—it was just this weird love-making, between the two most adorable monsters, each one trying to be more poetic than

How could you hate Ed Sanders or Abbie Hoffman? They were just flowery, watery people. Non-New Yorkish. That's what they meant by that. Of course, when they came to California, the Velvets all said, "They hate us, so we're going to hate them," straight off the bat. And that set up an interesting dynamic. It was imagined.

Leee Black Childers (writer, photographer, manager): I was staying at the Tropicana Hotel in Hollywood. One day we heard all this noise. We looked across the parking lot to the other side where the noise was coming from and suddenly the whole door of this room came flying out onto the balcony, and there stood John Cale. He couldn't work the doorknob, so he just knocked the door down, right off the hinges.

Lou Reed: Once when we were playing on a bill with the Grateful Dead, some reporter from the *Daily News* asked me what was the difference between us and the Dead. With a perfectly straight face, I told him, "The difference is that they take the kids backstage and turn them on—but we shoot 'em up!" Don't you know, he actually believed me and printed that.

In July 1967 a much-abridged version of the Doors' "Light My Fire" was released as a single. It quickly climbed the American charts, staying at number one for three weeks, selling over a million copies, and becoming the biggest-selling single of the year. To celebrate its success, Jim Morrison went out and bought his most iconic piece of clothing, a custom-made black leather suit. The band's publicist, Danny Fields, attempted to get him an appropriate girlfriend, too. Distressed by the kind of girls Morrison was surrounding himself with (mainly down-at-heel circuit groupies), Fields tried to elevate his taste in women—firstly by introducing him to Nico. She was staying with Edie Sedgwick at the Castle Hotel in the Hollywood Hills, a huge fake 1920s Spanish mansion which had recently become a popular rock and rollers' haunt, frequented by the likes of Jefferson Airplane, Bob Dylan, and Warhol himself.

Gene Krell (journalist, pop archeologist): She was very much in love with Jim Morrison.

Danny Fields: Nico and I became great friends when I introduced her to Jim Morrison. She always said that Jim really encouraged her to write

songs. I have to scrape deep and hard to find good things to say about him, but she appreciated him. Even though he was an asshole. You never went to criticize Jim face-to-face, you just didn't do it. I would never say, "Why don't you shave, or lose ten pounds, or use a deodorant?" It never occurred to me, or anyone else. The rest of the band worked around him. I never saw anyone treat him like anyone but Elvis Presley. But I really thought he should be hanging out with better women, so I introduced him to Nico. I thought they would make a cute couple. They were both so weird and icy and mysterious and charismatic and poetic and deep and she was sensitive and wonderful.

That night I rounded Jim up and persuaded him to follow me to the Castle in his car. You could tell how nasty he was then, because he really wasn't trying to keep up—falling back and being a real pain in the ass, so I'd have to keep stopping and waiting for him. He played those kinds of games, tried to get you in his power. So, we got there, and after I introduced him to Nico they just stood and stared at each other for hours. They stood in doorways and stared at the same spot on the floor. Then we got incredibly stoned. I traveled with a lot of drugs in those days—everyone did—and we took just about everything I had—everything, that is, that hadn't been taken by Edie Sedgwick. I had hidden most of my drugs underneath the mattress of a bed in a room that wasn't being used, but she still managed to find them. There was acid, hash, uppers, downers, and a bottle of vodka. I split most of this with Jim, although he had far more than I did—he had a much greater capacity for narcotics than anyone I knew. It was amazing, I didn't know how anybody drank, smoked, and swallowed so much stuff and still stayed up. But he did. He was up on the roof, naked, climbing all over it, completely stoned.

Paul Rothchild (the Doors' record producer): Morrison took Nico up in a tower, both naked, and Jim, stoned out of his mind, walked along the edge of the parapet. Hundreds of feet down. Here's this rock star at the peak of his career risking his life to prove to this girl that life is nothing.

Danny Fields: Him and Nico got into this fight, with him pulling her hair all over the place—it was just this weird love-making, between the two most adorable monsters, each one trying to be more poetic than

the other. Then he started asking for his car keys, and of course I was afraid that he was so drunk he'd kill himself, so I told him no and hid the keys. The worst situation in the world for him was to be out of control, to be in the thrall of other people. He hated that.

Morrison snarled and shouted and an argument broke out. Unable to win, Morrison crawled to bed. The next day, still drunk, still drinking, Morrison again begged for his car, which again Fields denied him, eventually agreeing to drive Jim downtown to his own car.

Danny Fields: Whilst we were gone, the group had been to the Castle looking for him, because he was due at a rehearsal. When we came back, we found all the chairs on the table—this was their way of expressing anger. They were all scared of him, all very, very afraid of him. They loved him, but they hated him as much as they loved him. They knew that he was everything. Before they'd gone, they'd written on the back of a still from the *Chelsea Girls* movie which was hanging up in the lobby: "Jim, you'd better get back, your ass is mud."

A little while later, after he'd sobered up, I put his keys back in the ignition, telling him they were there all the time. He hated me from that moment on. He thought I was being sneaky and treacherous, and I was, but I was also being protective. I didn't care if he got killed, but the record company would have lost their biggest star and I would have lost my job. And that one very intense night we spent together, taking all those drugs and talking all night long, it was so incredible. It was a very intense experience, probably the most intense I've ever had. I can't remember what was said, because we were on acid, but you know, it was deep. You'd think that some kind of bond would remain after that, so at least you acknowledge that there had been some kind of intimacy, even if it's embarrassing for you to recall, but he never did. It's like if you slept with someone once, as much as you don't want to say anything about it, or nudge or wink or whatever, something is always there. Not that we slept together...but it was so close.

Nico (singer, musician): I was so in love with him that I made my hair red after a while [he liked redheads]. I wanted to please his taste. It was silly, wasn't it? Like a teenager.

In his memoir, Light My Fire: My Life with the Doors, *Ray Manzarek provides an overly detailed narrative of Nico and Morrison's sex life, particularly Nico's oral expertise: "Evidently, she gave great head, understanding the proper use of the tongue on the underside of the penis, especially that supersensitive area at the base of the head where that small crease attaches to the shaft, that crease that when lightly licked and flicked with a moist, soft tongue produces shudders of ecstasy in the male of the species. And she wasn't ashamed to do it. To bring her man to climax and not remove his penis from her mouth. To hold it close and take it in even deeper at his moment of consummation. To not deny him the warmth and moisture of her mouth as he ejaculated."*

Danny Fields: It wasn't a gratifying experience working for Jim Morrison, and it was always kind of frustrating. He never really did what I wanted, but I was naive too—it was my first job as a legitimate publicist and people don't do what you want them to do. He had his own idea of how he wanted his image projected, and he was right. He was the custodian of his own creation. I flattered myself that I could manipulate it, but he was a much better manipulator than anyone. I wanted him to do a photo session with Nico, but he refused to do it. He'd never say no, but he'd never turn up. Nico would be waiting at the location and Morrison was always nowhere to be seen. He didn't want to pose with a woman, and I don't blame him—his instincts were right. Posing with a woman would have diffused his image, and he wanted to remain aloof. It would have been better for Nico than for him, because by that time Nico needed the publicity.

In October, Verve released Nico's debut album, Chelsea Girl, *a chamber folk/ baroque rock concoction that was the result of sessions conducted a month after the eventual release of the Underground's first record. Both Reed and Cale worked on the record, and were surprisingly encouraging, Cale especially so. It contained five songs written by the pair (the title track was composed by Reed with Sterling Morrison, while "It Was a Pleasure Then," written by Cale, Reed, and Nico, was described as sounding like the feral cousin of "European Son"), Bob Dylan's "I'll Keep It with Mine," Tim Hardin's "Eulogy to Lenny Bruce," and three songs from an emerging singer-songwriter called Jackson Browne (including the soon-to-be classic "These Days"), who started dating Nico after*

they met in the back room of Max's Kansas City, Mickey Ruskin's cool new nightclub and restaurant on Park Avenue South, earlier in the year. When Nico first saw the sunlit Californian beauty, she simply said, "Mine. Mine."

Attempting to make it as a singer-songwriter, Browne had traveled cross-country by car to try his luck in the fading Greenwich Village folk scene. Tim Buckley was playing in New York at the time, and Browne went to see him play at The Dom. "Dom was mod spelled backward, and there was always this carnival of people around," said Browne. "Andy Warhol with his entourage, a film loop of Lou Reed eating a Hershey Bar, Nico sitting at one end of the bar in this Dietrich pose singing these incredible songs, and Tim as the opening act."

When Browne got hired to play, Nico was being accompanied by Reed and Cale on alternate nights. "She was getting crap about not having the same guy backing her up every night, so she asked Tim to do it and he said no. Then she asked me. First thing they asked me was whether I could play an electric guitar. I said yes, but I didn't have one. They said if I could get one, I could have the job. So I borrowed a friend's."

Browne soon returned to LA, where he briefly tried to form a West Coast version of the Velvet Underground. He ended up joining an East Coast band called, ironically, Soft White Underbelly. This wasn't an attempt to copy the Velvets' name, but, according to their founder, Sandy Pearlman, "They were named after Winston Churchill's description of Italy as the soft underbelly of the Axis during the Second World War." Browne was unable to get the musicians to play the kind of music he envisaged, so he walked away. They would later become Blue Öyster Cult.

Nico: I remember when we were outside in the middle of the night in Laurel Canyon, [Jackson] had a big circus whip that Gerard Malanga used to use for his act with the Velvet Underground, and Jackson used to whip the air! He wasn't whipping anybody—just the air. Maybe he was exercising to be a lion tamer. That's what I knew of Jackson Browne.

On release, the record sold even fewer copies than the Velvets' debut. Nico blamed producer Tom Wilson and arranger Larry Fallon (soon to defray any criticism by working on Van Morrison's Astral Weeks*) of sabotage. "I asked for drums, they said no," said Nico. "I asked for simplicity, and they covered it in flutes." Nico's music was described as being so white, it was almost translucent.*

Gene Krell: I was running a store called Stone the Crows in New York, which is where I first met Nico and the Velvets. One of my clients was Marcello Mastroianni, who was in New York at the time, and they all came into the store at the same time. Can you imagine Andy Warhol, Nico, Paul Morrissey, and Marcello Mastroianni all together in the same store? I got to know Andy through Gerard Malanga, and we became very close. Andy was always considered to be monosyllabic and very quiet, but in fact he was remarkably talkative, and he delighted in so many things. I found him to be a very kind man. For example, at Christmas and Thanksgiving he would get us all to go down to the Salvation Army. It was such a wonderful time to be in New York, with such amazing people. I was very fortunate. One time this guy came into the store with his mother's drapes and asked if I could make a suit out of them. I said sure, but first you gotta dry clean them. He wanted flying dildos on them. It was inside the Salvation Club on Sheridan Square in the Village.

We used to go to Max's Kansas City and drink the Max's Snowball, which was ice cream surrounded by coconut. The most amazing people would come in. Truman Capote would come in, Nico, Andy, then some ex-prizefighter, or Edie, who came from a very prominent family. Everything was so diverse. There was a human dialogue. There was an understanding that you could benefit from listening to people's opinions which were different from yours. Art really mattered, and it was the first time the art world mixed with the music world. Everything was an extension. It was the start of a period where people started to redefine what we mean by beauty. There was real virtue in going to a flea market and finding an old waistcoat from the 1930s and pairing it with Landlubber jeans. Cheekbones didn't necessarily matter. Warhol was a product of that. No one had witnessed someone like Gerard Malanga in his black leather pants dancing in the Exploding Plastic Inevitable. Nobody had seen someone like Nico. People like Viva I don't think were particularly gifted, but it was the personality they possessed. It was a time not a place. It was time when we all realized the importance of self-expression, like Paris between the wars. People were literally doing their own thing, because they felt they could make a difference. It was truly a wonderful mosaic where the imperative was one's individuality.

Danny Fields: Lou really helped her with her solo shows in New York. They rehearsed at Richard and Lisa Robinson's apartment every day, and Lou was there, encouraging her, practicing with her. She was going solo and he was helping her with her act. They had a very affectionate relationship.

Geraldine Smith: Lou was always hanging out in Max's. At the time he was best friends with my boyfriend, Andrew Wylie, who became one of the biggest literary agents in the world. We were all friends, we were like a family. Lou was smart, although everyone was also taking drugs of some sort. Everyone. Speed, or coke, pills. Everybody did a little bit of everything.

"Max's Kansas City was the place to be seen," says Deborah Harry. "That was another fabulous time in New York, no end of creativity and decadence, and most of downtown seemed to end up at Max's." Harry was a waitress there, and worked the four-till-midnight shift, or seven-thirty until the place closed. She says James Rado and Gerome Ragni were there in the back room every night writing Hair, *sitting alone while the cream of downtown swirled around them: Gerard Malanga, Ultra Violet, Candy Darling, Jackie Curtis, Eric Emerson, Holly Woodlawn, Edie Sedgwick, and Warhol himself. What a place.*

CHAPTER 5

SEX AND DRUGS AND PROPULSIVE DRUMS

1968

"I couldn't play a perfect roll for a million dollars."
—Moe Tucker

Mary Woronov: I felt like Sir Lancelot around the Round Table, and Andy was King Arthur. That's how I looked at him. Loyalty was everything at the Factory.

Bryan Ferry (singer, writer, lounge lizard): I had this whole American dream thing, living up in Newcastle yet constantly dreaming about Warhol's Factory and Baby Jane Holzer.

Barney Hoskyns: Born in 1945 in the village of Washington, Tyne and Wear, Bryan Ferry was the son of a miner, propelling himself out of his humble origins via a four-year art course at Newcastle University and stints in such Tyneside R&B/soul bands as the Banshees (no relation to Dame Siouxsie) and the Gas Board. From the ashes of the latter was born Roxy Music, a group formed in London two years after Ferry gained a 2.2 BA in fine art in the summer of 1968. Among Bryan's many inspirations at this point was Andy Warhol, whose Pop Art love affair with trash was crucial to the Roxy aesthetic.

Bryan Ferry: After school I decided to study Fine Art, and was encouraged to go to Newcastle University rather than go to London and it was the best thing I ever did. For the first time I met other people of my own age who shared the same interests in art and music, and I was very lucky to study under the great English Pop artist Richard Hamilton. Instead of painting a bowl of fruit or flowers he did beautiful paintings based on details of American cars. It brought art right up to the here and now, so the things you saw around you became the subject matter for paintings. One of my best friends actually worked with Andy Warhol in New York. There was this connection between the Newcastle Fine Art department and the American artists, which made it feel special. I also had this classic American car, a Studebaker. It was a beautiful machine. I think I spent more time pushing it than driving it because it was always conking out. But just to look at it was enough for me. I used to live in Eslington Terrace in Jesmond and had it parked outside.

Richard King: My mother recoiled when I played it to her. *White Light/White Heat* was too much for most people.

Did the Velvet Underground ever come out during the day? Were they purely a nocturnal idea? The new year started with a dark almighty clang as they released their second album, White Light/White Heat *in January 1968. With its heft and presence, weight and resilience, it was relentless, dangerous, screeching, formidable, all about pushing the boundaries of sound and taste. Any louche charm or sweetness and light had either disappeared or evaporated. Nico had been eased out, and it was left to John Cale and Lou Reed to battle it out sonically and psychologically between them. The poet Lavinia Greenlaw says, "One minute it sounds like the most fabulous and finely judged convergence and the next as if the musicians belong to different bands and the tracks to different albums." There were just six songs, with lyrics designed to alienate anyone who had managed to accept their debut, and a guitar solo on "I Heard Her Call my Name" that was a tribute to jazz saxophonist Ornette Coleman, ending with "Sister Ray," which one critic called a "mondo-Godzilla perverso epic," a one-take, two-chord, seventeen-minute speed freakout.*

On "The Gift," John Cale reads a short story, written by Reed, about a lovesick young man named Waldo Jeffers, who tries to surprise his girlfriend by

mailing himself to her in a large cardboard box, but meets an unpleasant end when an unsuspecting friend uses a sheet-metal cutter to open the package. "I wrote 'The Gift' while I was at college," Reed told Lester Bangs in an interview in Creem *in May 1971. "I used to write lots of short stories, especially humorous pieces like that. So, one night Cale and I were sitting around, and he said, 'Let's put one of those stories to music.'" In order to achieve the sound of a blade plunging through bone, Reed stabbed a melon with a knife, directed by Frank Zappa, who was recording with the Mothers of Invention in the same studio. This didn't make the record popular. "No one listened to it," said Lou Reed. "But there it is forever—the quintessence of articulated punk. And no one goes near it." Cale called it "rabid": "The first one had some gentility, some beauty. The second one was consciously anti-beauty." Talking to Victor Bockris, Sterling Morrison was equally defiant: "Inspired by media hype and encouraged by deceitful songs on the radio (Jefferson Airplane, the Mamas and Papas), teenage ninnies flocked from Middle America out to the coast. And so, at the height of the 'Summer of Love,' we stayed in NYC and recorded* White Light/White Heat, *an orgasm of our own." On the* Billboard *chart, it peaked at number 199.*

Uncut's *John Robinson says the album stretched the form, even the fidelity, of rock and roll, as the band had previously stretched its content. John Cale would go on to call it "anti-beauty," while Lou Reed said it was "the quintessence of articulate punk." "The notion of applying a freeform 'assemble the personnel and roll tape' process to parts of the recording (as on 'Sister Ray') derived not only from free jazz, but also from the Factory's constant process of self-celebration and documentary," says Robinson. "If the band's debut had excelled in the precise, literary articulation of extreme behavior, their second album assumed a terrifying naturalism on the same beat. You were no longer a witness, but an accessory, present at the scene, as the chaos of the sound engulfed you."*

When the album was released in the UK, the Melody Maker *was damming: "Utterly pretentious, unbelievably monotonous."*

A monotony driven by the childlike wallop of Moe Tucker.

A review in the Pittsburgh Point *of a show at the Stanley Theatre exemplifies the nature of Tucker's appeal: "The power of the Velvet Underground has its source in the train-like rhythms of Maureen Tucker, their curly-haired drummer. Hunched over her drums, flailing the skins like some madwoman, she was quite an impressive sight. Tucker is not a very good drummer by any*

means, but her primitive, nerve-throb style and her seemingly endless fount of energy make her ideal for the Underground."

Lou Reed: She's one of the greatest drummers. Her style of drumming, that she invented, is amazing, and you still see occasional groups where the guy will be playing standing up. But I'm surprised that the other girl drummers were very obsessed with being like a guy drummer, not with following Maureen's lead, which is standing up, because it adds some strength.

Bobby Gillespie: When I listened to the records, I could tell that the drummer wasn't playing traditional rock drums. It wasn't like anyone else. Minimal. Most of the time just keeping a backbeat. It was something that I loved. I also loved Kenny Morris in the Banshees and the Glitter Band drums. Lots of tom toms. Propulsive. Driving. Not a lot of cymbals and hi-hats. Drums that didn't get in the way of the song. Egoless. Moe seemed to stand up when she was playing, so I found that intriguing too. She only played two drums, so when the Jesus and Mary Chain asked me to play drums, I said I could only play two. I said this is what I can do. So, we had a rehearsal and they loved it. I said I'll show you what I can do and if you don't like it then fine, as I don't want to fuck it up for you guys. So I got rid of the rest of the kit onstage, and as I didn't want to sit behind them, I stood up. Like Moe. It was out of necessity, plus I wanted to look good. I thought I'd look better if I stood up. Sitting down in the seat felt like being a spectator. I wanted to get involved. But Moe was a huge influence.

Richard Williams: I particularly liked *White Light/White Heat* because it was their most extreme album, but I was disappointed that the "Sister Ray" direction wasn't taken further. That's what I loved about them.

Michael Zilkha: I was on a plane coming home from New York to London, and "The Gift" was on the plane's playlist. So I immediately bought it when I got home.

Jimmy Page: I love the black humor of "The Gift" on *White Light/White Heat*, because in stereo you had John Cale doing the narration in one

channel, and the band's instrumentation in the other, so you could just turn the band up really loud. It was this mad instrumental. Fantastic. And of course it's got "Sister Ray" on it, which is just brilliant. I was someone who came across the Velvet Underground, and I was absolutely transfixed by them. I couldn't believe just how cool it was.

Nick Kent: I listened to *White Light/White Heat* a lot when I was taking speed. It's a real amphetamine record. It's exhausting.

Jon Savage: Recorded in the red, *White Light/White Heat* is nihilism, with a certain black humor.

Lou Reed: We were mauled by critics. Now everyone says they loved the Velvet Underground, but that means a lot of people must have changed their minds. Mostly, though, critics didn't waste their time on us because we weren't even small potatoes at the time. We were like little strands of rice. It meant nothing to savage us. So everyone just went after Warhol, which was a real training ground for me because I watched all that... how people came at Andy and how he handled it.

Sterling Morrison: There was fantastic leakage because everyone was playing so loud and we had so much electronic junk with us in the studio—all these fuzzers and compressors. [Engineer] Gary Kellgren told us repeatedly, "You can't do it—all the needles are on red," and we reacted as we always reacted: "Look, we don't know what goes on in there and we don't want to hear about it. Just do the best you can." And so the album is fuzzy, there's all that white noise...we wanted to do something electronic and energetic. We had the energy and the electronics, but we didn't know it couldn't be recorded...what we were trying to do was really fry the tracks.

Chris Difford (musician): I was fourteen when their second album came out, and it was a record that opened up the possibility to be a musician, because it didn't seem that difficult to play Velvet Underground songs. At the time I started to play guitar I had started to listen to King Crimson, sub-Genesis, complicated music, things that I knew I would never be able to play. My friend Bob Blatchford lived on the

same council estate and he was listening to a lot of MC5, Iggy Pop, and the Velvet Underground, and I was at the other end listening to Tamla Motown. But when we started playing, we were also listening to a lot of Sparks records, but we knew we couldn't emulate them as they were too difficult. It was complicated. The first thing we wrote was a musical called *Tricksy* that was based on a Damon Runyon short story that was heavily influenced by Sparks. The Velvets' music fed my depression, if I'm honest. When I felt low, and in a dark place, I felt like I had a kindred spirit in the Velvet Underground and their songs. It was a safe place. But more interestingly, for me, Lou Reed's voice, and his lyricism gave me the opportunity to be brave. It made me come out of my bedroom to write lyrics, and not worry that I couldn't sing properly. It was a difficult record as it had "The Gift" on it, which was a lot of information to take on board. But it gave me the confidence to say, yeah, I can do this. I was a young guy, not educated musically, but I thought I could do this. The Velvet Underground were definitely one of the reasons I became a musician and songwriter. To the degree that the first band I had at school was called Porky's Falling Spikes, which was the early name of the Velvets. We had two drummers, I played bass, and we emulated the Velvet Underground by making a really big racket. We shrouded ourselves in darkness, just playing a couple of chords and making up songs. The lyrics were really exciting to me because it was a world that I didn't know. I was living in a council estate in south London, and this was a completely different world.

John Cale: [The album] shows a different moral struggle between the creative ideas of a "no Nico" and the soon to be "no more experimentation." Raw unfettered nihilistic exploration on full display. There was so much more to be done.

Henry Rollins (musician): As a teen, I heard the second Velvet Underground album, and it was too much for my limited scope of appreciation. It was intense, but I didn't get it.

"The Velvet Underground, for a time, made Reed feel less alone," says the journalist Chris Roberts. *"And while his words and voice (predominantly) characterized the foreground of their sound (though Nico's tones provided*

a contrasting flavor at first), it was the chemistry sparked by the coming together and scratching against each other of its distinct individuals that gave them their unique edge and pioneering power."

Robert Quine (musician): By '65 I was in law school—St. Louis—just out of inertia. I knew that I didn't want to go to Vietnam. I had a band in St. Louis. By then, things that influenced me were the first Stones albums, the first Byrds albums, and later the Velvet Underground. When I first heard them, though, I thought it was the worst thing I ever heard—they couldn't play, the guy was trying to sing like *Highway 61 Revisited*, and the drummer had a physical disability. A year later, a friend played me "I'm Waiting for the Man" over and over and I became a total fanatic. They must have had twenty fans on the face of the earth. The Andy Warhol thing worked for them, otherwise they would have been on ESP-Disk. They were known as a death-rock band. Well, I brought a friend to see them. I was too terrified to talk to Lou Reed—he was friendly enough though. I was at the Matrix shows in San Francisco where *1969* [the live album released in 1974] was recorded. They had shows on some weeks with two or three people in the club. I was one of the people, so they knew me and got to be friendly with me, and I taped them. I have hours of cassettes of them. A lot of their best stuff from those gigs never came out. One night Lou Reed did "I'm Waiting for the Man" where he totally improvised new lyrics. You take that song, for instance—the lyrics... I hate to use the word "poetry" but there's very few poets in rock and roll and Lou Reed has put too much emphasis on the poetry factor. There's Chuck Berry, Lou Reed, Bob Dylan. The lyrics are perfect. The symmetry of the arrangement. The lead over it. The deliberate cretinism of the drums and bass. The way that the bass walks at the end. In the middle of the song, he says, "Work it now," and there's no guitar solo. That's beyond cool.

White Light/White Heat completely changed my life though. "Sister Ray," "I Heard Her Call My Name"...I spent thousands of hours on headphones wearing that out. That was a big influence on me. They were starting to make a big deal about people like Larry Cornell, and rock musicians playing jazz, but there was no real fusion going on. What Lou Reed did, he actually listened to Ornette Coleman, and

deliberately did off-harmonic feedback and the deliberate monotony of it. This stuff is like Jimmy Reed—it's monotonous or it's hypnotic. For me, it was hypnotic.*

When Roxy Music were about to embark on their second album, For Your Pleasure, *which would be released in 1973, Brian Eno told Nick Kent that "we are actually using the Velvet's* White Light/White Heat *album as a fair example of what we eventually want. I'm not saying that we are going to sound like the Velvets in any way, it's just that we will probably use the same conditions they used to record the album. We hope to make it in a single afternoon."*

David Bowie loved the title track immediately, and recorded it as soon as he had a band that he thought was good enough to do it justice. He recorded it in a BBC session in 1972 while the song became a staple on the Ziggy Stardust tour. Bowie recorded another version during the Pin Ups *sessions in the summer of 1973, at a time when he was considering a follow-up of purely American songs. The project came to nothing, however, and Bowie disbanded his group to focus on* Diamond Dogs. *"At the time I was intending to do an album of songs by New York people that I liked, but I never finished it," he told* Melody Maker. *The backing track, however—which had Keith Moon-style drums and some vintage Mike Garson piano—was salvaged for* Play Don't Worry, *Mick Ronson's second solo album, with Ronson adding new vocals. "Dave was thinking of doing it for* Pin Ups, *and in a spare moment the band did a one-off," said Ronson. "He didn't want to use it so I kept the 16-track and just overdubbed some guitars. After the first verse I made up the lyrics myself because I could never hear what Lou sung, couldn't make head nor tail of it, and there would be this little line here and this line here and I just filled the rest around."*

Both Bowie and Ronson had their eyes carefully focused on the market, something the Velvets had never been particularly good at. In one sense, their brand was a meeting of art and commerce, not that there was much commerce

* In 1969, Quine did indeed make a series of cassette recordings of the Velvets, performing in St. Louis and San Francisco, where he lived between late 1969 and 1971. These were eventually released in 2001 by Polydor Records, as Bootleg Series Volume 1. Though lo-fi in sound quality, the album is an important document of the group. In the liner notes Quine writes: "I got a lot of pleasure and inspiration from these performances. As a guitar player, they were an important element in shaping what musical direction I wanted to take."

involved, as they rarely had any money. Their records didn't sell in any vast numbers (if truth be told they didn't really sell in small numbers, either), they only toured sporadically and didn't command huge fees. Plus, they didn't get a lot of radio play and their songs were almost never covered by other people. Throughout her career in the group, Moe Tucker worked as a temporary computer typist. The agency she worked for knew she slept late but had no idea she was in a band. Living with her parents, she didn't draw on the group's income as much as the others, although "I do remember chasing Andy around the Factory for three dollars for gasoline." She also stayed away from drugs, meaning she didn't have any addictions acting as a strain on her finances. She was "grounded," and usually had a wry smile on her face whenever she was photographed at the Factory.

Duggie Fields (artist): In '68, I came to America for the first time and America was a real eye opener for me. I landed in New York in the summer, and I got a traveling scholarship. I hadn't applied for it, I'd been put in for it and I had to go to this interview and there were all these other students saying they wanted to go and study such and such, and I just said, oh well I'd like to go to Paris but there's riots, 1968. So, I don't want to go there because of the riots, and I said I don't want to go to Rome because of the riots there. I'd really like to go to New York, but there are riots there too. So, I really don't want to go. She said, "You just want the money, don't you?" and I said yes, and I got the money as a result, and I went to New York and the first morning there was a riot in the street of the building I was staying in. And literally it was like, oh New York was so dirty and sweaty and sticky and hot and noisy and oh I couldn't stand it. I met some people and we drove across the country to LA. Then I flew up to San Francisco on my own, which was the summer after the summer of love—1967 was the summer of love and this was '68. I stayed right on the Haight-Ashbury, which had been the center of it all. I thought it was a real knife-in-the-back territory and it was terrifying. But I saw the Jefferson Airplane, went to New York, arrived in New York, and I thought, "This is home." I just loved New York when I got there. I was taken to Max's Kansas City, and I'd never heard of it, and there was the whole Warhol crew who also I had never heard of, hanging out there and it was like hey, this is great I don't want to leave but I had to as my money ran out. I thought I was going

to go back but it took me five years before I got enough money to go back. So, in any case, I had a love affair with America as a result. Great eye-opener, New York in particular.

Geraldine Smith: I was living with my friend Andrea Feldman. Her parents had this big, two-bedroom apartment on Park Avenue and Ninety-Fourth Street, and they were never there, as they traveled all over the world. They wanted somebody to stay with her, so I said I'd move in with her. Her mother left credit cards for Andrea, so we went out all the time. She'd call up the limousine, and call Andy and say we were coming down to Max's and pick him up on the way. She picked everyone up in the limo, and paid for everyone. And when her mother eventually came back to New York and saw what had been happening she said, "You girls are both going to have to find rich men."*

Mary Woronov: Sixty-eight was the year of *Flesh* and *Lonesome Cowboys*, both made with Paul Morrissey. But Morrissey was always trying to drag Andy down. Fuck him. I hated him. He was an idiot. Always, always trying to take the credit for things that had really nothing to do with him. It's like when a child sits down in front of the TV, they immediately know who the bad guy is. That was Paul Morrissey. He was the bad guy.

In April, John Cale married fashion designer Betsey Johnson at New York's City Hall. Cale became convinced that this is when Lou Reed seriously started to distance himself from him, thinking the partnership was some kind of betrayal

* Over the years Feldman suffered from appalling mental health issues, experiencing nervous breakdown after nervous breakdown, and repeatedly being incarcerated in state institutions. In August 1972, several days after returning from a trip to Europe, Feldman summoned several ex-boyfriends, including poet Jim Carroll, to the New York City apartment of her parents to witness what she called her "final starring role," by which she meant jumping out of the apartment. Her suicide note said she was heading for the big time, on her way up there with James Dean and Marilyn Monroe. Geraldine Smith wrote her obituary in the *Village Voice*: "Andrea Feldman, one of Andy Warhol's Superstars, jumped to her death on August 8 at 4:30 p.m. from a 14th floor window at 51 Fifth Avenue, taking with her a crucifix and Bible she found in a church a few days before... Andrea left a note addressed to everyone she knew, saying she loved us all, but 'I'm going for the big time, I hit the jackpot!'"

which diverted Cale's creative energy away from the band. There was also now another assertive woman championing her new husband's talents and ambitions.

In his book Andy Warhol: The Factory Years, *Nat Finkelstein wrote, "John Cale married Betsey Johnson [in 1968] shortly after I left the scene. I wasn't invited, even though I didn't vomit on his floor and he did on mine..." In his own memoir,* What's Welsh for Zen?, *Cale wrote, "Betsey took amphetamine every day—diet pills, black bombers. She was a little overweight and very sensitive about it, and she would sit up all night making clothes. Betsey was a strong individual character. When she started showing up at all the VU gigs because she could afford to, I really admired her...It seemed to me that Betsey knew everybody I knew, and she was living at the Chelsea Hotel. It was a match made in heaven." They met in May 1967, when she was designing costumes for the Edie Sedgwick movie* Ciao! Manhattan. *She had been using Edie as her fitting model for years and had even designed her "Edie dress," a jersey knit with a criss-cross back. Johnson was dating Sterling Morrison at the time.*

It was a busy year in Warhol's gilded workplace. In 1967, the radical feminist Valerie Solanas had asked Warhol to produce her play Up Your Ass, *but he claimed to have lost her script, hiring her to perform in his movie* I, a Man, *as some kind of compensation. At this time, a Parisian publisher of censored works, Maurice Girodias, offered Solanas a contract which she interpreted as a conspiracy between him and Warhol to steal any future work of hers. Incensed, on June 3, 1968, she went to the Factory, shot Warhol and art critic Mario Amaya, and attempted to shoot Warhol's manager, Fred Hughes. Solanas then turned herself in to the police, where she was charged with attempted murder, assault, and illegal possession of a gun. She was diagnosed with paranoid schizophrenia and pleaded guilty to "reckless assault with intent to harm," serving a three-year prison sentence, including treatment in a psychiatric hospital. After her release, she continued to promote the SCUM (Society for Cutting Up Men) Manifesto. (She would die of pneumonia in San Francisco in 1988.)**

The shooting would radically effect Warhol's modus operandi.

* When Warhol interviewed Alfred Hitchcock in the September 1974 issue of *Interview*, and they discussed murder, assassination, and the proliferation of handguns in America: "Well, I was shot by a gun, and it just seems like a movie," said Warhol. "I can't see it as being anything real. The whole thing is still like a movie to me. It happened to me, but it's like watching TV. If you're watching TV, it's the same thing as having it done to yourself."

After his film Darling *was nominated for five Academy Awards, the British director John Schlesinger suddenly had the power to determine his own future (or at least his next movie). Deciding to adapt Thomas Hardy's* Far from the Madding Crowd *turned out to be a mistake, because even though it starred Julie Christie and Terence Stamp, it bombed at the box office, and was panned by critics. Considering this, his next film was even more of a gamble, another adaptation, this time of James Leo Herlihy's novel* Midnight Cowboy, *about a Texas hustler (not rustler) who moves to New York to make his fortune. The book was dark and transgressive, and not the most obvious material for box-office success. Set against an urban background that was a Hollywood tiptoe into* cinéma vérité *(much of it was actually filmed in New York), its content—prostitution, homosexuality, violence, sexual assault, and plenty of sleaze—would eventually earn it an X rating when it was released (at the time a commercial red flag), and yet it would soon become acknowledged as a modern classic, a movie that genuinely pushed the medium forward.*

In Herlihy's novel, there is a big party scene straight out of the late Fifties, a hipster-style affair set in an East Village loft involving marijuana and bongos, indicative of a period when both these things were lightning rods for imminent social collapse. By May 1968, this already looked like ancient history, so the producers hired Paul Morrissey to create an Exploding Plastic Inevitable-type extravaganza. The first thing Morrissey did was take Schlesinger to dinner at Max's Kansas City, to introduce him to the latest set of Warhol Superstars. And he loved them.

"John thought they were rather extraordinary freaks," says Michael Childers, an assistant on the film (and Schlesinger's partner). "All these drag queens shooting up in the bathroom and Andy being vacuous." Warhol was asked to play an underground filmmaker in the movie, but knowing he'd be out of his comfort zone, with no ability to control his appearance, he passed, encouraging Schlesinger to hire Viva, instead, one of his favorite Superstars at the time. In the end, about forty party extras were hired, some of whom were genuine Factorians ($25 a day plus lunch if you were "background," $125 if you had a speaking part).

On the afternoon of June 3, Viva called Warhol to tell him she was uptown at Mr. Kenneth's renowned hair salon on East Fifty-Fourth Street, trying out styles for the filming. As she was talking she heard several loud pops down the line; at first she thought it was someone cracking a Malanga whip, but quickly realized she was hearing gunshots within the Factory.

The filming of the party scene carried on without Warhol, eventually being shot in a cavernous studio up on East 127th Street. On June 28, a coach pulled up outside Max's at seven in the morning, and picked up forty to fifty Factory recruits, ferrying them uptown. "The party scene got a little bit crazy," says Brenda Vaccaro, who was starring in the film. "There was no discipline, no security. I walked into my dressing room, and two people were on my bed fucking. Most of them were high on dope."

Warhol was eventually so jealous of Schlesinger co-opting his Superstars that he encouraged Paul Morrissey to produce his own hustler film, Flesh, *starring Joe Dallesandro, about a male prostitute who sets out to earn enough money to pay for his wife's girlfriend's abortion.*

Geraldine Smith: When we started shooting *Flesh* with Joe Dallesandro in 1968 with Paul Morrissey, I asked him where the script was, he said there wasn't any script, and that I was to make it up as I went along. So that's what I did. I did an improvisation and made up the story about Joe having to go out and hustle because my lesbian girlfriend was pregnant. Everything came out pretty good in the end.

Danny Fields: Then he got shot, which meant that the possibility of assassination was enhanced by fame. So nothing was ever the same after that. He lived with a lot of pain, and afterward was never without pain. He was destroyed in many senses. If they hadn't found out he was famous on the operating table, he wouldn't be alive. After the shooting he went back to being an artist, a painter. The multiples became a great gimmick as he could literally phone it in.

Bob Colacello: After Andy was shot in 1968 it all changed. Jed Johnson had just been hired and he was sent to live with Andy to help Andy's mother cope with Andy's long rehabilitation after the shooting. They fell in love. Jed was the last person to smoke pot, and he was totally clean-cut and hardworking, and not at all what you would call a rebel. It was the same with Pat Hackett. She used to take down his diary dictation every morning. Vincent Fremont was like a Swiss banker, and he was like the most secretive person I ever knew who wasn't a Swiss banker. So Andy gave him the checkbook and made him the keeper of the castle. Fred Hughes was sort

of a society dandy. It was a whole different regime. Paul Morrissey was very much in charge and gradually he was supplanted by Fred—even Paul was totally anti-sex, drugs, and rock and roll. Brigid Berlin was a Hearst Corporation heiress, which is about as right wing as you can get. There was a decision to go from crazy to normal. From a combination of street kids and disgruntled heiresses to basically clean-cut, middle-class suburban kids and college graduates. After that Lou Reed and the Velvet Underground didn't really feel welcome. The Factory became very Eurocentric. Bottega Vanetta became one of our first big advertisers and they wanted one of the family to have a job at the Factory. The problem was she only spoke French and Italian. Andy said we should make her the new receptionist, so the drag queens won't be able to get through. Every so often Andy would say, looking at Pat and Jed and me, "Oh gee, you kids are so boring. The Sixties group were so much more creative, the speed freaks and everybody." And we'd say, "Well, take them back, Andy, and get shot again."

Tracey Emin: I really respect what Warhol did after he was shot. He said all the tax has got to be paid, we're cleaning up...He just grew up. He got rid of the Factory and got an office, and everybody wore suits and ties. He realized all he could really give was to be an artist.

Geraldine Smith: After he got shot Andy became a little more paranoid. He became very suspicious and afraid of being out a lot. He didn't like being around certain people, and started hanging out with more people in society.

Nicky Haslam: It all began to go bad. Not bad as in off, or BAD, man, as in good, but bad like forbidden fruit. Everyone wanted to touch it, eat it, drink its heady nectar, be part of it. Andy's natural reserve, and yes, modesty, held the gawkers at bay up to a point. The Factory went into overdrive, the prices sky high.

Mary Woronov: My drug of choice was amphetamine, until I couldn't handle it anymore. My father was a doctor so he told me all about it, told me what it did and told me I was crazy and should just stay home. The Factory turned me off people for a while. I went to Europe as I

couldn't cope with it anymore and by the time I came back Andy had been shot, and nothing was the same again.

The assassination attempt changed Warhol's narrative in another major way too. It was almost as if, in the media's eyes, he had banished all the wayward-ness of his formative years, and literally gone straight. The art community had always been strangely coy about Warhol's sexuality, somehow denying that it may have had an influence on his work. This was insulting as well as reductive, as by ignoring his gayness, so the gay community was denied any meaningful association with the artist. Over the years there have been concerted attempts to reclaim Warhol as a gay artist, not least in the 1996 book, Pop Out: Queer Warhol, *edited by Jennifer Doyle, Jonathan Flatley, and José Esteban Muñoz. "Warhol's critics have usually aggressively elided issues around sexuality or relegated his queerness to the realm of the 'biographical' or 'private' to usher in his oeuvre to the world of high art," they write in their introduction. "Or when they have alluded to Warhol's sexuality, usually without mentioning that he was gay (more often 'asexual' or 'voyeuristic'), it has only been in order to moralize about the 'degraded'" quality of Warhol's art, his career, and his friends. Despite the fact that many people 'knew' that Warhol was gay, hardly anyone, at least in the world of criticism and theory, will speak of it. As the media studies expert Mandy Merck notes, 'Out as Warhol may have been, gay as* My Hustler, Lonesome Cowboys, Blow Job *may seem, his assumption to the postmodern pantheon has been a surprisingly straight accent, if only in its stern detachment from any form of commentary that could be construed as remotely sexy.'"*

At the time, Warhol's countercultural volte-face only tended to compound this mass-media denial.

The narrative was moving quickly. Before meeting Lou Reed, Cale says he had snorted, smoked, and swallowed the best drugs in New York courtesy of La Monte Young, but he had never injected anything. When he joined the Velvet Underground, he had started to take nickel and dime bags of heroin. Initially squeamish about needles, Reed helped him inject the drug. He said he enjoyed the experience of being on heroin because this "was magic for two guys as uptight and distanced from their surroundings as Lou and I." What they had in common was drugs and risk-taking. When they started inhabiting the Factory, they found there was quite a mature and profound drug culture there—Warhol, for instance, was constantly taking Obetrol, a pink diet pill.

Amphetamines, it seemed, were the order of every day and night, creating an atmosphere of almost permanent paranoia among anyone spending time in the Factory, and building up tensions specifically between Reed and Cale. Artistically they were already pulling in different directions, but in September Reed suddenly snapped.

Allowing Shakespeare to enter the fray, Reed fired Cale and banished him from the kingdom. You can live, he said, still wearing his shades, but you have to leave the city. By early 1968, barely three years since they started working together, the group were tired of receiving such little recognition for their work, and Reed and Cale were pulling the Velvet Underground toward different poles.

And by September, Reed had had enough. He knew he had leverage, so he went for it. After two VU gigs at the Boston Tea Party on Friday the 27th and Saturday the 28th, Reed called Morrison and Tucker to a meeting at the Riviera Café in the West Village without Cale's knowledge, and told them that Cale was out of the band; when Morrison objected, Reed gave him an ultimatum: "Him, or me." Neither Morrison nor Tucker was happy with the idea, but, faced with a choice of either no Cale or no band at all, the pair reluctantly sided with the singer and principal songwriter. "I really didn't know how to please him," said Cale. "There was nothing I could do. You try to be nice and he'd hate you more."

It's impossible to imagine just what might have happened if the band had stayed together, although in reality the directions were already being mapped: Reed was leaning increasingly toward three-minute pop songs (structurally not completely unlike the ones he had been mucking about with when he was at Pickwick), and Cale was determined to keep stretching. So while it's tantalizing to imagine what might have been, a third Reed/Cale album would probably have been a curate's egg, their own "White Album."

Of course, all this was completely unmediated. In 1968, no one cared about the Velvet Underground, not even their record company, and scarcely their management, as any fluctuations in the band were treated in the same soap opera manner that everything else in the Factory was treated. When John Cale was let go from the group he semi-invented, the creation he helped sculpt from little but raw emotion, the only people who knew and cared were the people in the band. He was a true disrupter, and he had been disrupted through little but spite.

When I had my marathon interview with Malcolm McLaren in the sushi restaurant in the Kensington Hilton in 1987, he talked about the power of the voice at the front of a band. Predictably disparaging about John Lydon, his former charge, he was surprisingly enthusiastic about Lou Reed, someone the

Sex Pistols manager had previously belittled. My C-90 tape captured McLaren's estuarial whine above the clatter of Japanese beer bottles: "The thing is, man, Lou Reed was a star. He may have been a little ridiculous, maybe a little intense, but he captured the audience. Of course, he kicked Johnny Cale out of the Velvet Underground. You can only have one person at the front, and if you're at the front then you know it."

Mary Woronov: Andy knew the band was crippled. He knew that Lou was crippled because he was the one who took all the power away from John Cale. John was really smart about things but he wouldn't stand up to Lou. He was an idiot! But I didn't like Lou. Nobody else asked me to go to bed with them, but Lou did. I was offended because we all knew that after you'd gone to bed with Lou, he hated you. I saw it, we all saw it. He thought I didn't, but I did. I didn't like him. He was damaged and he wanted everyone to know it. John Cale wasn't damaged. He was smart, brilliant, and Lou knew that too. But John wouldn't fight. He just wouldn't. So he left. He was really a classy guy. He was normal, nice and smart.

Moe Tucker: That was a lousy way to end that foursome. An unhappy ending is...unhappy.

John Cale: I had often assumed Sterling and Lou saw eye-to-eye about things, and that couldn't have been further from the truth. Sterling was very angry about the Velvets. Very bitter, angry with Lou about overseeing the demise of the band. I don't know whether Sterling was aware of what Lou was doing, but the first part of the plan was when [new VU manager] Stephen Sesnick showed up and got rid of Andy Warhol. Things got worse with Sesnick aboard because he got in the middle of everybody and started turning the screws. He told the band, "This is Lou's band, you do what he says." The games being played were just disgusting. Lou let it happen. Sterling didn't know what to do in all this. The next step in the plan was to say, "Cale's out." Whatever power Moe and Sterling had in the band was completely erased. All they could do was follow, and it went nowhere. It was grinding Sterling's nose in it. I didn't know what Sterling's feelings were after I got the boot. We lost touch for a while.

Doug Yule joined the Velvets later in September, although he had already seen them perform—ironically, without Cale, who was sick—at Harvard University. They were dark, theatrical, and, remembers Yule, Reed was clad entirely in black leather. There was a completely black stage with a white ceramic vase in the middle of it. Then the vase would fall over and break into pieces. "At the time I had just finished doing a year as a theater major," says Yule, "so theater was kind of my thing." When he first went into a studio to record with them, he remembers thinking that it was all about "keeping up." He didn't want to fall behind. When they started recording their third album, and the first with Yule, they were all staying in the same bungalow at the Chateau Marmont in LA, and "it was kind of like we were a little band of gypsies. We were like family."

Importantly, Yule knew his place. Well aware that both Reed and Cale were "very strong type A personalities," he understood he wasn't chosen for his demonstrative chops. "My own value at that point to Lou was that I was a much more deferential person. I'm much more of a facilitator than I am a leader."

When Moe Tucker was asked what Yule contributed to the band she said, "He brought sweetness, he could sew."

Doug Yule (musician): The band was Pisces, Pisces, Virgo, Virgo, and astrology was all the rage, and when John was fired, [the new manager Steve] Sesnick wanted a Pisces and wanted someone who was more manageable than John Cale, because John had a strong personality, which I guess is part of the conflict between him and Lou.

Interviewed in San Francisco in 1995, Doug Yule was refreshingly frank when asked about Lou Reed's collaborative process. The interlocutor suggested that Reed had a habit of milking his collaborators dry, then throwing them away before moving on to the next one. "His relationship with me was very similar. We would spend time together, where he would take out these songs he was fooling around with, and ask for help: 'I'm thinking about this melody. What's a chord that goes with that?' He'd ask for help building things, then he would return six months later with the song put together, and announce it—'Here's my new tune.'"

Lou Reed: Not too many songwriters, when they write songs, go for broke. When someone does who's really good, it's astonishing. There's a reason a three-minute song can devastate you, or make you get up and

dance, stop what you're doing and go, "What is that?" It just hits you. And it's a very potent thing you're playing around with.

"OK, what was the difference between the Velvet Underground with John Cale and with Doug Yule?" asked long-term fan Jonathan Richman in a VU Uncut Ultimate Music Guide. "Well, they were two different bands, and some of this had nothing to do with them. By the summer of 1968, Lou Reed was thinking of a different direction for the band—appealing to a wider public, for one thing—and was making new songs that were more melodic, and less antisocial."

Jonathan Richman (musician): Cale did not just quit. He was ousted. And not everyone in the band was happy about it. But they decided to press on and so would need a replacement on bass and keyboards for Cale. I'd say that for their emerging sound, Doug Yule was a very good choice and helped them create a new and unexpected sound as well as a more inclusive serene relationship to the audience. In other words, he helped them go where they were headed already. When Cale and Reed formed the Velvet Underground it was to be a rock band that experimented in sound and noise with dissonance and microtones. Microtones are what happen when the center of the note is no longer necessarily the place you're aiming for—this is important: if one player (Cale) in a band thinks in these ways, the sound of the whole band changes. The tone-color palette is then different. I quote La Monte Young: "It is the application of pitches that creates the moods in music." This early band was wild! (Their very first drummer Angus MacLise was quite a mystical and independent-minded character who quit in disgust after the Velvet Underground's very first show because the band accepted money—seventy-five dollars to perform at a high school in New Jersey.)

Cale was a pulsing, riveting, hypnotizing bass player. Sterling Morrison once explained that all bass players use passing tones, notes played that, while temporarily dissonant, help you climb up back to your root note or your "fifth" or whatever. Say you're playing a twelve-bar blues in the key of E, if you use a B-flat to lead you up to your B note (the fifth) most times you'll be off the B-flat before the B against it would make it a dissonant. Cale, on the other hand, would just ride the B-flat against all the other chord changes the rest of the band was playing.

And that's just on the electric bass, which he wasn't even trained in. How about his piano and organ playing, which he was trained in? Cale was staying at a friend of mine's house and she had a piano there with the sheet music to one of Wagner's operas set up on the music stand. He just sat down, opened the music, and played it. Well, *yah*! Why not? This is *John Cale*! So when he played keyboards for the Velvet Underground he would hypnotize you in an already hypnotizing band. He would move you, and astound you. Dark and sinister, multi-dimensional and able to call on reserves of musical theory and discipline on the level of the world-class concert violist that he was; it was sort of like having Stravinsky in your band.

And he played the electrified viola, on which he was the inventor and still the high-water mark of dissonant drone in modern pop music.

And these are just the things we know he was doing. You'd watch the four of them play and hear five people. Seriously. You'd watch everybody's hands. Not him. Not her...Who? Five! I'm telling ya.

And right up to his last show with the band, on September 28, 1968 (no, I didn't have to look it up—I was there and I've never forgotten because I knew this was his last show and I was *sa-ad*), he was still experimenting with sound. He'd just started bringing a red solid-body Hagstrom eight-string bass along with his other gear. I never heard him, to my knowledge, play anything but life-or-death, dedicated, searching, never-showing-off music. But by that point Lou Reed seemed not so much coconspirator in noise as lead singer in need of accompaniment that didn't get in the way of the song.

John Cale had been perhaps the most forbidding presence in a forbidding band. Newcomer Doug Yule walked with bounce in his step and a smile on his face. He laughed easily and looked like he maybe played in a local band. Cale looked like he played in a local band too, except that band would be local to Transylvania and they'd be playing in a dungeon somewhere with bats and stuff and it'd be 1340 or something. Their new bass player looked approachable, and he was. Go ahead! Walk up and say, "Nice set." No need to be self-conscious. For Doug, you see, was the most comfortable member of the band in the role of professional musician and entertainer.

Lou Reed did not look like he played in a local band. He looked like a grad student from Greece or France. He looked like the curious,

sensitive, delicate genius that he was. You wouldn't be as likely to walk up and say, "Great set!" But if you had, it could have gone either way.

Well, how about that tall stalwart-looking fellow? Better. If you walked up to Sterling Morrison he'd at least say thank you and maybe ask you how it sounded at the back.

Ah...I guess I shouldn't approach that quiet, shy-looking woman with the short hair. Their drummer, right? Right. But do walk up to her, because she'd be the most friendly, humble, and down-to-earth of any of these people.

And Cale? Nah. Just nah.

Like Nico, Cale was soon busy elsewhere. In November, Elektra released Nico's second solo album, The Marble Index *(again produced by John Cale, this time with Frazier Mohawk), which Lester Bangs said in his opinion was the greatest piece of avant-garde classical "serious" music of the last half of the twentieth century. "Great art has always confirmed human values," he wrote, "but what are we to do when the most that our greatest works of art can affirm is that the creator fears he or she may be slowly, but surely, losing humanity entirely, along with the rest of mankind? I don't know if I would classify it as oppressive or depressing, but I do know that* The Marble Index *scares the shit out of me." Reviewing it for the* Guardian *a few years ago, Dorian Lynskey said, "The Marble Index is a remarkable record, one with the annihilating beauty of a late Rothko painting, but I can't see a time when I'll feel compelled to play it again. I suspect that if you're ever in the perfect mood to play* The Marble Index, *then it's probably the last thing you should be playing."*

The record contained the kind of music that wouldn't have sounded out of place in a Greek Orthodox church.

Predictably, the record was a commercial failure, which wasn't a surprise to Mohawk, who described it as not "a record you listen to. It's a hole you fall into." Cale, meanwhile, said, "You can't sell suicide."

Danny Fields: I always got on splendidly with Cale. I loved everything he did. I always told him this, but I don't think it mattered much to him because to him the Velvets were Lou's band. He had other hopes...What he did with Nico's songs was magical. I don't think I've done much in my life apart from connect the right people, but *The Marble Index* happened because I connected everybody. I brought Nico to [Doors producer] Jac

Holzman's office. He was in awe of my taste and he trusted me. Two hundred years from now people will still be saying how remarkable that record is. What a song cycle. His genius astonishes me. I've become very friendly with his ex-wife Lisa and of course from a divorced wife you hear the worst. But he was good to Nico. Always. By creating a setting for her to dazzle. She would come over and look through my college poetry books. She picked up Wordsworth…"Ooh, I like this." There was a passage where he says, "I'm contemplating a bust of Isaac Newton in the hallway of such and such building in Cambridge University…" It's an ode to a statue of Isaac Newton, in which he invokes the marble index of a mind traveling along in the universe. She liked that, and said she wanted it to be the title of her record. It's perfect because no one knows what it means.

Tom Pinnock (writer, *Uncut*): The invitation arrives. You RSVP to Warhol's Superstar secretary Tinkerbelle to secure your place at the Factory for the premiere of Nico's new album. On September 18, you turn up at Union Square, excited about the follow-up to *Chelsea Girl* and the "wine, supper, and dancing" to follow. You're feeling good. And then you hear *The Marble Index*. Quite how much merriment was made that night after thirty-one minutes of Nico's second record played out is unknown; but this is not an album that can be brushed off as you get down to dancing. It's a record that leaves deep marks, either of revulsion or revelation. Even for the weirdos, this was weird.

Chelsea Girl had been an album whose songs came with polite arrangements but nestled at the end of its second side, "It Was a Pleasure Then," looked back to the spidery freeform of *The Velvet Underground & Nico*—and forward to *The Marble Index*. It showcased the singer's own lyrics for the first time, her voice tinged with North African ululations; yet it was still based around the electric guitar. Nico had long relied on guitar players—in this case Reed, in others Jackson Browne, Sterling Morrison, and Tim Buckley—but now she finally bought her own instrument, a harmonium, during a trip to San Francisco in 1967. After Ornette Coleman taught her how the left and the right hands work on a keyboard, and Nico reversed the roles, her left playing the melody and the right adding the drones and endless circling patterns, she was away. She would make this strange contraption, a European parlor organ reinvented as Indian accompaniment, very much her own.

Danny Fields: John Cale was the person you called when you could hear something but it needs a little help. Who can handle this and not cost me a lot of money and play a lot of instruments? Get me John Cale. He was the go-to for things that sounded unique, provocative, things that aren't in the basket where we pick things that go top ten. The Stooges, Jonathan Richman, Patti Smith, Nico.

Lou Reed: Nico is the kind of person that you meet, and you're not quite the same afterward. She has an amazing mind, and *The Marble Index* is just one of those milestone albums. It's like nothing else you've heard.

Tom Pinnock: Nico's relationship with Jim Morrison was perhaps the most important of her life, for he encouraged her to truly explore her own poetry and music, to follow her visions. So with a set of new songs combining her interest in heavy literature, myth, and psychedelic drugs, recording for her second album began in May 1968 at the Hollywood studio of her new label, Elektra—home to the Doors.

The flutes and chamber strings were gone; in fact, all that remained from *Chelsea Girl* was John Cale, then and always the most prominent cheerleader for Nico's work. With his background in avant-garde classical music, and European roots, perhaps he alone in the scene understood what she was trying to do. Frazier Mohawk was enlisted to produce the record, but he left the sound of the album up to Cale. In just two feverish days, the Welshman added a small army of instruments to Nico's voice and harmonium, his improvisation skillfully giving each track its own sonic identity. Mohawk only sequenced the album, but crucially kept it powerfully compact.

One of the album's standouts was "Lawns of Dawns," a hallucinatory waltz that described a peyote-fueled night with Jim Morrison at LA mansion The Castle (built in the 1920s, it had been rented by Arthur Lee and Love and had become a hangout for the Los Angeles/Sunset Strip rock scene).

Lou Reed: I don't mind a repetitive chorus; I mind repetitive verse. I mean, it's the same amount of space. Why would you have only three diamonds if you can have six?

Just before Christmas, the Rolling Stones released Beggars Banquet, *the first of their truly imperial albums, a harbinger of the coming decade. One song—contentious at the time, truly transgressive nowadays—was "Stray Cat Blues," a song told from the perspective of a man lusting for illegal sex with a fifteen-year-old groupie. Musically it was a direct lift from the Velvet Underground. When Nick Kent interviewed Mick Jagger in 1977, "he said the song was actually the Stones trying to copy the sound of 'Heroin' and 'I'm Waiting for the Man.'" "The whole sound and the way it's paced, we pinched from the first Velvet Underground album," said Jagger. "Honest to God, we did!"*

Mary Woronov: Then Warhol started dating and that was the end for me. I wanted him to go on scaring people.

CHAPTER 6

THE FOLK NAZIS
1969

"The Velvet Underground was very much just a Long Island garage band."
—Sterling Morrison

Bebe Buell (singer, model): When I saw pictures of the Velvet Underground, I knew they were my people, I knew I would be part of this family. I just didn't know how. I saw pictures of them in a magazine and spent the next three years working out a way to get to New York to see them. Getting to New York became my ultimate goal. New York was where I was going to find myself.

Nick Kent: It was reading people like Lester Bangs in the American press who made me understand how important they were. Richard Williams in the *Melody Maker* was a tireless supporter, but he was the only one in England. His taste often coincided with mine, so I went back to listen to them. The third album is probably my favorite, as the songs are really good. It's a blend almost of folk rock, plaintiveness, and the darker side is captured really well. There's no bad songs on there. Each of their records is a career in itself, as they're all so different.

Michael Zilkha: With the third album they became a great folk band.

Richard Williams: The third album is a story from beginning to end, which only occurred to me after listening to it for a couple of weeks. But I remember saying at the time that it was much better at telling a story than say *Tommy*, which had also just come out. I had quite a lot of space to write about teenage matters, as by then the editors of local papers knew there was something going on, even if they didn't know what it was. Because I had so much space I could write about people like Albert Ayler and the Velvets, which gave me some good cuttings to show the *Melody Maker*. I'd done a live review for them of Maynard Ferguson, the Canadian jazz trumpeter, and soon after that they offered me a job. So I moved to London. After six months a lot of the staff went off to launch *Sounds*. I was invited to join them, but I liked *MM*, so I stayed. Very quickly I became Features Editor and then Assistant Editor. I was never discouraged from following my enthusiasms, which included the Velvet Underground.

Chris Difford: When this came out, the band's sound became more floral, with songs like "Jesus" and "Pale Blue Eyes." It was much more of a relaxed record.

Gary Raymond (novelist, critic, broadcaster): When I was young, I was in a band whose ultimate ambition was to do an hour-long gig that comprised of one song, a cover of the Velvet Underground's "What Goes On." We would play that song true to its five-minute duration, but then we would hammer the three chords of its closure over and over for the remaining fifty-five minutes. We wanted to bring the walls down of any pub or community hall or club who were unsuspecting enough to book us, rattle the foundations like those chords were the terrible reverberations of an industrial drill, a drill the size of the Empire State Building. We wanted to make the music sound like the base noise of the universe, the undersound, that leftover harrumph of the Big Bang.

Two things aren't quite true about that. Firstly, the band's ultimate ambition was not to do this for an hour, but to do it for several hours, or indeed, for days, months, weeks, without stopping. *Chug chug*

chuddugug, chug chug chuddugug, chug chug chuddugug, chug chug chuddugug.
We wanted it to go on for centuries, "like Chinese music," as John Cale
says in the Todd Haynes *Velvet Underground* documentary. The second
thing that is untrue of that opening memory is the suggestion that this
was a communal ambition. The other band members wanted nothing
to do with it. It was just me. They thought I was a bit mad. But I stuck
to my guns all through the brief existence of that combo and carried
it forward into the maelstrom of several other bands I would join and
found in the following years. Something about that primal chiming of
those propulsive chords kept bringing me back to the idea. The Velvet
Underground had gotten under my skin.

When I first heard the Velvet Underground—"Venus in Furs" on a
compilation tape—it seemed to come from a different place to everything
else I'd been listening to. It wasn't the Beatles, and it wasn't the Blues. It
wasn't classical and it wasn't psychedelic. It was the music of the earth,
of the soil, but of concrete too. It was the music of the dank drizzled
Welsh streets, hit blind by the fizz of the neon lights. The music of
collars pulled up tight and shoulders hunched and hands pushed down
hard into pockets.

*There is no call these days to walk into common-rooms or coffee bars with
albums under your arm that alert your peers to your marvelous good taste
(which would be a bit like carrying around a framed poster, or one of
those cardboard cut-outs they used to have in record shops), but for years
the first two Velvets albums were the records that had the best currency.
They were considered to be the ones that best exemplified what the Velvets
were all about; maybe so, but probably their best record, and latterly their
most influential, was their third, simply called* The Velvet Underground, *released in March 1969. This was a quiet affair—due in part to John Cale's
departure. From "Candy Says," about transvestite Candy Darling (sung by
Cale's replacement Doug Yule), to "After Hours" (sung by Moe Tucker), via
"Pale Blue Eyes," and "Beginning to See the Light," VU3 is forty-three minutes
of the most understated music of the Sixties. This is the sound of the loft, the
squat, or the bedsit at 3 a.m.*
With good reason.

Having made one of the loudest albums ever recorded, with their third LP, the Velvets made one of the quietest, and it's as if Lou Reed and Sterling Morrison's amps were dialed down from eleven to one. In many ways it sounds almost like a singer-songwriter album, prefiguring the confessional work of Joni Mitchell, Jackson Browne, and Neil Young. Its tempered, hushed tones sounded almost confrontational, especially considering their previous two records. It should be of no surprise that the album was recorded at TTG Studios in Los Angeles, near Grauman's Chinese Theatre and the Hollywood Roosevelt Hotel. Three songs from the first album had been recorded here, but by the time of their third album, the Velvet Underground had gone native—veering from one extreme to another, moving swiftly from almost industrial urban excess, to the most mellifluous of sounds. This was largely because of Cale having left the band, allowing Reed to try and make some commercial headway by writing far less attritional songs. The new band embraced intimacy and redemption rather than sex and drugs, but they still sounded otherworldly. One of the album's highlights was "Pale Blue Eyes," in which Morrison's ever-so-subtle guitar and Tucker's schoolgirl tambourine acted as filigree counterpoints.

It was the sort of record that made real life dim as you became absorbed in its heartbreaks, love affairs, and revelations. Seemingly designed without a constituency in mind, it was all the stronger because of it. If the first two Velvets albums had been transgressive, this initially appeared to be far straighter, until of course it got its hooks in you.

By the time they recorded the album, Reed's confessional songwriting was more in sync with the laid-back feel of LA. The cover photograph was taken in The Factory by Billy Name (the album was nicknamed The Grey Album *at the time), but there is little else on the record that screams* New York. *In some respects, it's almost pastoral, the subdued morning after following a speed-fueled party.*

"We did the album deliberately as anti-production," says Sterling Morrison. "It sounds like it was done in the closet—it's flat and that's the way we wanted it. The songs are all very quiet and it's kind of insane."

The only real "old-school" Velvets song was "What Goes On," a clash of multi-tracked guitars, a raggedy solo, and, as one reviewer put it, "an organ

*sound so beatific that Talking Heads lifted it for the end of 'Once in a Lifetime'
and Stereolab made an entire discography out of it."**

Fundamentally, the songs were simple.

Bobby Gillespie: They went from writing about heroin to Jesus in such
a short time period. Redemption. As a young songwriter I was fascinated
by this. On the third album they look like mature students. Sterling says
that Lou had "Pale Blue Eyes" for years, but it's only on the third album
as Cale would have said, "No fucking way."

Jonathan Richman: The Velvet Underground, when Doug Yule joined,
were already performing things like "Pale Blue Eyes," "Jesus," and "What
Goes On." "What Goes On" has both guitarists (Lou and Sterling) playing
fuzz-guitar solos, but the difference now is that they went with the
melody—not like on "European Son" or "Run Run Run," or the fabulous
one, "I Heard Her Call My Name" of the year before. No, this new stuff
had both more melody and more intimacy.

* As 1977 drew to a close, Jerry Hall had left the Roxy Music singer Bryan Ferry for
Mick Jagger. So Ferry retired to Switzerland to contemplate a breakup album, a mix
of original songs and cover versions, *The Bride Stripped Bare*. The title was a direct
reference to Marcel Duchamp's *The Bride Stripped Bare by Her Bachelors, Even*, and was
obviously directed at Hall. He told Michael Bracewell that Duchamp hugely influenced
his approach to cover songs: "I like the idea of Duchamp taking something like a
bicycle wheel and just placing it in a different context and putting his signature on
it, really. And I guess I was thinking that when I took a song that was by someone
else, and did my version of it, that I was adding my stamp to it, my signature." An
odd choice was Lou Reed's "What Goes On," not least because Velvet Underground
covers were far from commonplace in 1978 (Ferry also weaves in a couple of lines
from another song from the third Velvets album, "Beginning to See the Light"). The
video for "What Goes On" was stranger still, as it featured Ferry with a beard, a sign
that he was either letting himself go, or that he was very much moving on to pastures
new. Ferry was a big fan of the Velvets, and as well as mentally using Brian Eno and
Andy Mackay to echo John Cale, had encouraged the Roxy drummer Paul Thompson
to play in an especially "powerful, earthy" way, "which was one of the features of [the
band]." The Velvets were also the principal reason Roxy were written about by *Melody
Maker's* Richard Williams before they were signed by Island Records. Williams had
written enthusiastically about the recently reissued first three Velvet Underground
albums, which intrigued Ferry: "I always seemed to agree with his taste. So I thought,
'If anyone is going to like my music, it's going to be this guy,' so I sent him the tape.
And he phoned me the same day to say how much he liked it."

The new songs, which often took as much from Broadway musicals as they did from rock and roll ("Here Come the Waves," "Who Loves the Sun," "After Hours," "I'm Set Free," "New Age"), had real unusual structures, a lot of them. What I'm getting at is, it's not fair to just say: "Oh, they were more melodic and subdued now, because they wanted to be big stars and go commercial." They were still subtle, challenging, and courageously intimate, just in a different way. And Doug added to this a joy, a lightness. For example, when this band played "What Goes On" for a packed house on a Friday night at the Boston Tea Party, there was such melody and magnificent sound in the air soaring around for fifteen minutes throughout the hall over Maureen Tucker's spartan, all-heart drumming with gorgeous playing by Doug that made these evenings of two forty-minute sets with a twenty-minute break exultant, with a sense in the air of a new era, even. The Place To Be in Boston on Friday night (for a certain crowd, at least).

And I do mean that "for a certain crowd" part. Because this band with Lou Reed as its non–Freddie Mercury, non–Neil Diamond frontman, with his obtuse, erudite lyrics with at least some weird abstract stuff in almost every song, could only go so far into the Top Twenty. Foghat, Deep Purple, and Rod Stewart weren't worried a bit.

Was Doug Yule a more conventional player than Cale? Yes. But Jimi Hendrix was a more conventional player than Cale! Anyone in rock… I mean, who wasn't a more conventional player than Cale? But Doug added a different "playing against type" tone-color palette and a lightness to a band that wanted to go someplace they hadn't been before, and deserves respect.

Moe Tucker sang the childlike "After Hours" on the album, and was a nervous wreck throughout the sessions. It took eight takes for her to get it right, as she kept laughing, or flunking the lyrics. "Finally, I had the sense to make everybody except Lou leave the studio. I was really nervous. I'd never sung anything before."

Lou Reed knew what he was doing. He wasn't always good at what he was doing, but he knew exactly what he was trying to do, and he was also better at what he was trying to do than anyone else. He may not have always succeeded in his task, but no one was going to get there before him. And when we talk about "there," we're talking about New York, the city he knew how to eulogize

better than anyone. He may not have been from the streets, but he knew the streets better than anyone.

*Reed had an obsession with doo-wop, which from a personal POV was all about his past, about memoir and sentimentality; but from a professional perspective it was about simplicity, which is something he talked about relentlessly in interviews. Musically he was all about stripping things back, and trying to achieve without embellishment. This obviously played into his (successful) attempts to distill his adopted city. New York in the hands of Lou Reed was a dispassionate, violent, ridiculous place full of people who didn't deserve to be there.**

Alastair McKay (writer, *Uncut*): According to Sterling Morrison, there was a simple reason for the change in direction. The ammunition cases that contained the group's special-effects boxes were stolen at JFK airport, just as they were preparing to fly to Los Angeles to record. For Morrison, replacing Cale with Doug Yule took the group "more toward unanimity of opinion." This was not, he thought, a good thing. For Yule, the deal was straightforward. He wasn't particularly familiar with the Velvet Underground's previous work, and didn't question what had gone on before. Almost as soon as Yule joined, the group went on tour. The bassist made his live debut in Cleveland on October 2, 1968. A month later, the Velvets embarked on a West Coast tour, with recording sessions booked in between shows. Interestingly, Yule has no memory of the theft of those lost fuzzboxes, and has suggested that, besides, it would have been easy enough to replace them in Los Angeles.

"The oft-maligned Doug Yule has arguably taken more stick than any substitute player in the history of rock," says Chris Roberts. "Very little of what he's blamed for was his fault. His chief crime was, essentially, not being John Cale." "How

* In one very important respect, Reed had come full circle, as the more refined, mellower music he was now making echoed the original folk roots of the Velvet Underground. In 2022, Light in the Attic Records would release their version of the "Legendary Copyright Tape," a demo recorded on May 2, 1965, containing, among other songs, earthy folk renditions of classic Velvets songs such as "I'm Waiting for the Man" and "Heroin." Some had long been available on bootlegs, but their official release added even more luster to the group's legacy. "Hearing the tape is like coming across some folkways recording from the Thirties," said Reed's widow Laurie Anderson at the time. "I mean, 'Heroin' as a folk song?"

do you define a group like this, who moved from 'Heroin' to 'Jesus' in two short years?" asked Lester Bangs.

Jonathan Richman: They were, even before Doug joined, becoming less that gang of feedback-and-rat-piss, vomit-and-drone misfits, and more the culturally intriguing, melody-promulgating, Fender 12-string and Gibson 335-playing understated quartet of flower-pattern-shirt balladeers. As long as you're communicating something honest, that's fine with me. But did I miss Cale? Oh God, I missed Cale! I was seventeen! What could I not miss about sinister, droning anarchy; dissident dissonant delinquency; as played by perhaps its most gifted living exponent? The way they sounded at a live show circa 1967, two years before Yule joined, had the band going wild and Lou Reed chanting and shouting stuff that you couldn't hear so good over the top of this metallic experiment in sound. Even the slower stuff had an element of this. By the winter of 1969 you could hear every word of a slow song and 60 or 70 percent of them in a faster one.

Ellen Willis was the first pop music critic of the New Yorker, where she started working in 1968. As such, she was one of the first American popular music critics to write for a national audience. She got the job after having published only one article on popular music, "Dylan," in the underground magazine Cheetah, in 1967. She carried a torch for the Velvet Underground, believing them to be true originals, something that was exemplified in their third album.

"The Velvets were the first important rock and roll artists who had no real chance of attracting a mass audience," she said. "This was paradoxical. Rock and roll was a mass art, whose direct, immediate appeal to basic emotions subverted class and educational distinctions and whose formal canons all embodied the perception that mass art was not only possible but satisfying in new and liberating ways. Insofar as it incorporates the elite, formalist values of the avant-garde, the very idea of rock and roll rests on a contradiction. Its greatest exponents undercut the contradiction by making the surface of their music deceptively casual, then demolished it by reaching millions of kids. But the Velvets' music was too overtly intellectual, stylized, and distanced to be commercial."

Their songs, she said, were all about sin and salvation.

In April, Elektra released the first Stooges album, produced with some gusto by John Cale. At the time, Iggy Pop's band were considered to be genuine

bottom-feeders, a group deliberately celebrating the raw primitive aesthetic of American garage bands. They would become regarded as the seminal proto-punk group, but at the time their schtick was determined by their musical ability, their indolence, and Iggy's rapacious exhibitionism. "I had never heard an album like that before," said Alice Cooper, another Detroit artist who would follow in the Stooges' wake. "I had always listened to bands that were trying to be the Beatles, trying to find the best guitar player or the greatest drummer, whereas this was absolutely anti that. The guitar player doesn't play anything he doesn't have to play."

By any indices of assessment, James Newell Osterberg was the first punk. Lou Reed may have reframed the contest, and throughout the first five years of the Seventies may have personified what would soon become known as punk, but Iggy Pop was the first punk. When the Stooges started out in Ann Arbor, Michigan, in 1967, they were a spectacle, an oddity, and yet girls and boys both came to see the band as they were not only weirdly mesmeric, but they were also unlike anything anyone from that generation had ever seen before. They came to stare and they came to dance. But mainly they came to stare (snickering to fend off the fear). Initially playing a raw, primitive style of rock and roll that was determined as much by talent as ambition, the band gained a reputation for their confrontational performances, which often involved acts of self-mutilation. Pop reveled in his punk persona (in 1969, when they made their first album, no one else had it, or wanted it, frankly), and yet he immediately became a sex symbol, a nerdy boy-man who invented a new kind of rock and roll role model. And liked girls as much as they liked him. My favorite Iggy quote: "She looked at me penetratingly. So I suppose you can figure out what happened next." Their first album was deliberately neanderthal (it was all they could do), and yet even then it came heavily laden with influences: guitarist Ron Asheton's main guitar riff in "1969" was "inspired" by the Byrds' "Tribal Gathering," the drum pattern in the same song was directly lifted from the famous Bo Diddley percussive beat, the riff in "I Wanna Be Your Dog" was inspired by the opening guitar riff to "Voodoo Chile" by the Jimi Hendrix Experience, and the arrangement of "No Fun" was inspired by Johnny Cash's "I Walk the Line." Nevertheless, it was all very tribal, and seemed designed to repel potential customers. It was ignored by critics and consumers alike, although in hindsight it's now purposefully salivated over. Pitchfork, bowed by recontextualization, said that John Cale's production "harnesses just enough studio magic to make [the Stooges] sound positively otherworldly, from

the swollen low end, dark as a bruise, to the blown-out sonics of Ron Asheton's guitar solos. Throughout, in unexpected pockets of silence, handclaps pop like fireworks. What could be more American than that?"

In New York, Nico started coming with Cale to the studio, and so soon got to know Iggy, and then started a relationship with him. Iggy says that not only did Nico teach him the secrets of oral sex, but that she also gave him his first STD. "Nico had a relationship with me that was not unlike a kind of an art mother or art instruction at a certain time in my life," he says. "I could have done better by her. I did learn how to drink Beaujolais instead of Boone's Farm [a cheap American wine] and certain other things that women liked, so that was something."

Ron Asheton (musician): John Cale took us over to the Factory to meet Andy Warhol when we were in New York. We'd met him before, sorta. We'd played in this old, burned-out apartment building next to John Sinclair's building that we called the Castle. It was the MC5, Sam the Sham and the Pharaohs, and Bob Seeger, and afterward there was a party at the Castle. It was me, Dave Alexander, and my brother, Scotty. We were just sitting around talking and then we saw this weird-looking guy with silver hair and sunglasses and a leather jacket. He was just sitting there looking at us and he had a tape recorder, and he was taping us. We didn't know he was taping us, so we got up and moved, but he was following us around, and my brother said, "Hope I don't have to hurt this guy." We didn't know it was Andy Warhol, and that's the first time we ever saw him. We never talked to him, we just kept trying to avoid him and he was following us around everywhere with a tape recorder. Someone said later, "It's a good thing one of you guys didn't hit him or something, man, because that was Andy Warhol!" The Factory was all tinfoil, that's all I remember, it was all tinfoil and kinda grungy. We hardly stayed at all, because we were freaked out. We were just Midwestern kids, and it was way too weird for us.

Once we were at The Scene, one of the better clubs in New York City, and Jimi Hendrix came in. Iggy and I had a beer with Jimi, he was wearing the same outfit he wore on the *Are You Experienced?* album. Iggy was speeded out, you know, so after we had a beer with Jimi, Iggy starts walking around with Nico. I'm sitting at the table, snickering because she's leading him around like her kid. Nico's so tall and Iggy's

short and they're holding hands, it was real lovey-dovey. She wouldn't let him out of her sight. Nico wound up actually coming to the Stooge Hall and living there for a few months. Iggy had a room in the attic and they stayed up there a bunch and the only time we saw her was when we practiced. We had a rule that nobody was allowed in the practice room, so we resented her at first, but then she'd make these great curry dishes and leave them on the table with really great, expensive bottles of wine—and we finally broke down and let her come to our practices. That's when we actually started to drink as a real part of our lifestyle, because of the great wine Nico turned us on to. So we all got to like her. I think she was kinda shy, and we all felt kinda weird about infringing on their thing.

Liz Derringer: I used to bounce between The Scene and Max's. Jimi Hendrix would play every night at The Scene, and I loved Jimi. Used to wear curlers in his hair. Loved him. We both reached for the same drink and our hands touched, and sparks flew. It was like magic. I remember the day Jimi died. He did a charity gig, and all of a sudden just walked offstage and just sat there. I guess he was in a very bad place. The whole race thing had done him in. If he was playing with a white band, blacks were mad at him, and he played with a black band, whites were mad at him. It was ridiculous. But they were crazy, free times. Nico played at The Scene, all the British bands. We were either there or in the back room at Max's. Candy Darling, Jane Fonda, Bebe Buell, Jimmy Page, everybody was always there. A lot of my girlfriends were dating rock stars, but what I really loved was the music.

When Andy started *Interview* in 1969, he told me to go out and interview the rock stars I knew, so I did. He used to call me Mrs. Rock Star because I was married to Rick [Derringer of the McCoys]. I thought he was crazy, but he said come up to the Factory and we'll help you. He was my mentor because without him I wouldn't have had a career. He believed in me and I didn't want to disappoint him. I loved Andy. He liked my husband's brother, who was gay, so we spent a lot of time talking about him. He was quiet but he had a sense of humor. A lot of people thought he wasn't kind to people, but what he did was give them a chance, an opportunity. What you did with that chance was up to you. Some people thought they were going to be famous for the

rest of their lives, because Andy had made them famous. But he gave them an opportunity and the rest was up to them. If it didn't work then it was their problem, not his. But he was the city. He was New York. The first interview I did was with Bernie Taupin, [then] Johnny and Edgar Winter, Linda Blair, I did Mick Jagger, Rod Stewart, everybody. The atmosphere at *Interview* was great. I loved Peter Lester, who was the editor before he died of AIDS, and then his successor Robert Hayes also died of the same thing. Then Christopher Makos took me to *Circus* magazine, and I just kept going.

The director François de Menil wanted to make a video to accompany the song "Evening of Light" on The Marble Index, *and Nico agreed as long as her new beau was in it. So in the film a face-painted Iggy Pop cavorts around a frozen potato field near the Stooges' group house in Michigan. "To me it evokes the old Europe, the feeling around twilight when the church clock is ringing six and the kids are playing in the square and there's a kind of a peace at hand and a kind of a crack between the worlds and a kind of a feeling that you're part of this ongoing generation of Euro culture," says Iggy. "That's how I heard it. John [Cale] was astute enough to make sure this all musically collapses into some pretty scary violence." Later he would say, "What a great song. It's a real mind-fucker."*

Iggy Pop (musician): In my way, I loved her. I had a great admiration for her. She was a great, great artist. It was just a real kick to be around her.

In June, the Velvets were a surprise addition to the Saturday night bill at the Toronto Pop Festival, a two-day event sponsored by Coca-Cola that featured, among many others, Rotary Connection, the Band, Johnny Winter, Sly and the Family Stone, Steppenwolf, Dr. John, Chuck Berry, Tiny Tim, Edwin Starr, Procol Harum, Al Kooper, the Welsh band Man, and, even more incongruously, the Bonzo Dog Doo-Dah Band.

Danny Fields: The Factory continued to be a crazy place, even though it was changing. At the Factory everybody was recording everything, all the time. Someone would say, "Oh, I have to change my batteries, so I can keep recording this confidential phone call." "Me, too. I have to turn the tape over."

David Bailey: The Factory was always fascinating. As was Andy and all the others. The group changed all the time, with people going in and out, like a weird club. Joe Dallesandro was kind of scary and had a kind of violence about him. There was a side to him that I didn't want to know. I wasn't physically intimidated by him—how could I be after spending time with Ronnie Kray?—but he was definitely odd. I got the feeling that he didn't particularly want to be there, that he would have preferred to be a Hollywood star, a real star. He didn't fit in, and was just this beautiful boy who had somehow tagged onto the scene. I enjoyed it because it was all verbal sparring. I'm not interested in fighting and if there was any danger I'd run in the other direction. But what I learned early on was that if someone's talking then they're not dangerous. It's the ones who don't talk you have to look out for.

"We all perform," the photographer Richard Avedon once wrote. "It's what we do for each other all the time, deliberately or unintentionally. It's a way of telling about ourselves in the hope of being recognized as what we'd like to be." On October 30, Avedon cherry-picked Andy Warhol's inner circle from the familiar surroundings of the Factory and placed them in his own Upper East Side studio (celebrating "the dubious glory of the whole disreputable crew," according to one critic). Avedon was obsessive about this neutral setting, believing it neutralized people. "I always prefer to work in the studio," he said. "It isolates people from their environment. They become in a sense…symbolic of themselves." In front of Avedon's camera, the thirteen Factory Superstars lined up against the white background in various states of dress and undress, almost as though in a Greek sculptural parade—Candy Darling, stripped naked; Brigid Berlin baring a breast; Joe Dallesandro naked at one end, clothed at the other. And then Andy, lurking impassively at the edge of the frame. Avedon had started to shoot group shots he called "families," shooting people individually or in small groups and then pasting them together in order to create larger collections. With this flexible, multipaneled approach to portraiture, Avedon could make a series of portraits over many months and then assemble them to reveal what he thought he had sensed about group dynamics. The careful arrangement of bodies and casually abandoned clothes suggests a spontaneous image that reflects the louche world of Warhol's Factory, whereas this is how the Superstars actually arrived. Sure, Joe may have taken his clothes off, but it wasn't like he'd never done it before. The flat lighting was deliberately democratic: "A photographic

portrait is a picture of someone who knows he's being photographed," said Avedon. "What he does with this knowledge is as much a part of the photograph as what he's wearing or how he looks. He's implicated in what's happening, and he has a certain real power over the result."

Warhol actually had little affection for Richard Avedon. In an entry from his diaries, the artist recalled running into a woman they both knew at a dinner party in New York. "We talked about how horrible Avedon is," Warhol wrote. "She said he gets what he wants out of a person and then drops them. I agreed and then everybody screamed at me that I do the same thing." Avedon's images were in no way random, while his family portraits were composed, manipulated, and artful. And as no incidental was accidental, so Warhol's positioning in Avedon's portrait was as premeditated as everything else the photographer did. Andy was in charge, forever.

In the media, Warhol was still being treated as an art freak, someone for whom traditional forms of communication were unavailable. He was considered to be an "other" because his art wasn't like anyone else's, in the same way his communication skills and his sexuality weren't. According to the critics, Warhol didn't have any sexuality. Because he was portrayed as some kind of human oddity, so the artist was denied his sexuality, denied his queerness. Of course, the media was far more timid than it is today, when sexuality is brandished like a sword, but even so, Warhol was treated like such a cartoon that sex really didn't come into the picture at all.

Sure, his movies may have been "faggotty," but was Warhol a faggot himself? They were "butch," "masculine," "camp," etc., but the narrative tended to focus on the banality of his films rather than their innate sexuality.

"The first time I got busted was together with some two hundred people watching Lonesome Cowboys in its first week of screening in London in 1969," writes Simon Watney in his essay, "Queer Andy." "Serious structuralist film critics undoubtedly attended too, but by and large it was a very queer audience indeed, as were the audiences for all Warhol's film screenings in London in the Seventies. To this teenager, two years before the first meetings of the UK Gay Liberation front at the London School of Economics, Warhol positively reeked of a seductive American queer culture at its most exaltedly blatant. Yet as soon as one turned to Warhol criticism, one was confronted by a virtual cliff-face of denial and displacement, one consistently directing attention away from any question of subject matter in his films toward primarily if not exclusively technical questions—the speed of film stock he used, details about projection speeds, and so on."

*However, as Watney says, the local Tottenham Court Road police took a line much closer to the audience. They didn't stop the film on aesthetic grounds. "On the contrary, they understood only too well that Warhol had made a 'dirty' film, a film that encouraged the Western to speak to its subconscious, which is, of course, always sexual and usually perverse."**

* When Watney's essay was published, in a collection called *Pop Out: Queer Warhol*, in 1996, Douglas Crimp from the University of Rochester said, "There is an emphatic way of declaring 'thank you' that means, 'finally someone has said the one thing that is on everybody's mind, but which until now no one has risked saying.' And that's what I want to say to the editors and writers of these essays. Thank you for calling Warhol queer, for calling his art queer, his public persona, his interviews, his philosophy, queer. After this book, a lot of the old Warhol criticism is going to seem, well, peculiar."

CHAPTER 7

WHAT THE HELL IS A STUTZ BEARCAT, JIM?

1970

"Once you 'got' Pop, you could never see a sign the same way again. And once you thought Pop, you could never see America the same way again."
—Andy Warhol

Nineteen-seventy was an extraordinarily diverse year for music, as the Sixties counterculture bled into a more mainstream initiative, so on the one hand the year saw the release of everything from Syd Barrett's The Madcap Laughs, *Spirit's* The 12 Dreams Of Dr. Sardonicus, *Vashti Bunyan's* Just Another Diamond Day, *and the Soft Machine's* Third, *to less esoteric fare such as Simon & Garfunkel's* Bridge Over Troubled Water, *Black Sabbath's* Paranoid, *Santana's* Abraxas, *and Derek and the Dominos'* Layla and Other Assorted Love Songs. *It was also the year the Sixties actually ended, as on New Year's Eve 1970, Paul McCartney initiated proceedings to wind up the Beatles. And nothing would really be the same again.*

Lou Reed didn't appear to have much time for the Beatles, and throughout his career went out of his way to diminish them. At first these sideswipes seemed to be designed to draw attention to himself rather than his opinions, but as he was so consistent in his disdain it makes sense to take what he says seriously. "From my point of view," he said, "the other stuff [the Beatles did] couldn't come up to our ankles, not up to my kneecap, the level we were

163

on, compared to everyone else. I mean they were just painfully stupid and pretentious, and when they did try to get, in quotes, 'arty,' it was worse than stupid rock and roll. What I mean by 'stupid,' I mean, like the Doors."

In a later interview with the journalist Joe Smith, he was even more pointed. "The Beatles? I never liked the Beatles, I thought they were garbage," he said. "I don't think Lennon did anything until he went solo. But then too, he was like trying to play catch-up. He was getting involved in choruses and everything." He was harsh. "I don't want to come off as being snide, because I'm not being snide, what I'm doing is giving you a really frank answer, I have no respect for those people at all, I don't listen to it at all. It's absolute shit."

However, there was one Lennon song that Reed thought worthy of praise, which came from his 1970 album, John Lennon/Plastic Ono Band. "But [Lennon] wrote one song that I admire tremendously, I think it was one of the greatest songs I ever heard, called 'Mother.' Now, with that, and he was capable of great pop stuff, which is nothing to sneeze at, but the question you asked me was 'on another level.'" In a later interview with the writer Bruce Pollock, Reed said, "That was a song that had realism. When I first heard it, I didn't even know it was him. I just said, 'Who the fuck is that? I don't believe that.' Because the lyrics to that are real. You see, he wasn't kidding around. He got right down to it, as down as you can get. I like that in a song."

In 1970, a small, alternative musical narrative was starting to build in the US, with outliers such as the MC5, whose Back in the USA was a rabble-rousing, proto-punk collection of radical rock, and the Stooges, whose sophomore album Fun House was the very personification of creative tension. One might perhaps have expected John Cale's first solo album to be something in this vein, but it was anything but. Vintage Violence, released in March, was a selection of melancholic, largely orthodox songs that was completely at odds with what anyone was expecting. Considering that Cale was responsible for the more avant-garde elements of the original Velvet Underground, most critics were expecting something outré and challenging. How wrong they all were. What was John Cale doing masquerading as a singer-songwriter?

The cover of Vintage Violence featured a photograph of Cale with his face obscured by a glass mask over a nylon stocking, which he would cite as symbolic of the record's content: "You're not really seeing the personality." Cale said the album didn't contain much originality, and was symptomatic of him growing up in public, learning how to make a record. Perverse as ever, he formed a band to play on the album, Penguin, although they didn't last

beyond the recording sessions. It was an odd record, one that didn't really fit with the burgeoning Californian ethos of the emerging rock fraternity. Rolling Stone*'s review, while not being remotely accurate, was apposite because of its incongruity: they claimed it sounded "like a Byrds album produced by Phil Spector who has marinated for six years in burgundy, anise, and chili peppers." Greil Marcus was positively euphoric: "An exquisite, unheard solo album... in some ways comparable to Van Morrison's* Astral Weeks: *the personal vision is that intense, the execution almost as graceful."*

Syd Fablo (blogger): John Cale's solo debut is shocking. One might have expected some all-out avant-rock, maybe some droning classical compositions like he recorded with Tony Conrad, or maybe even something like the albums he produced for the Stooges or Nico. Instead, he delivered a Bee Gees' *Odessa*, a Beach Boys' *Sunflower*, or something along those lines at least. Cale wrote songs with a vast awareness of what he was capable of. *Vintage Violence* casts the arty ambitions aside and works from scratch. What surfaces is a delicate naivety. The songs are nostalgic. Every word seems to reference a fond, or at least strong, memory. Recording his debut, Cale was still married to Betsey Johnson; lots of things could be said about that influencing the lush, sophisticated pop of *Vintage Violence*. You could stack a hundred Neil Diamond albums on top of each other and not have the elegance of Cale's compositional grace ("Big White Cloud" is worthy of a Scott Walker song).

Elsewhere, Lou Reed left the Velvet Underground on August 23, after a final show at Max's Kansas City, leaving Manhattan for his parents' home in Freeport, Long Island. He was exhausted, both physically and psychologically, just completely drained. Having been responsible for the birth of the Velvet Underground, having bonded with—and then dumped—Warhol, and having stayed with the band through years of undistinguished failure, he was finally calling it quits.

The world was moving on, moving around him. By 1970, the Velvet Underground had been in play for nearly five years, and yet they remained an almost determinedly modest proposition. A genuine cult attraction, when they played the Second Fret in Philadelphia on January 1, there were just eighty people in the audience. Their appeal appeared to be finite.

Reed had already told Moe Tucker he would be leaving—she was temporarily nonoperational as she was pregnant—while the news seeped out to the other band members a few days later. Reed thought that night he might have a panic attack, but as it was, he just finished the set and asked his parents to come pick him up. The panic wasn't pushing against his chest, his arms and legs didn't liquefy, and he didn't start panting. He was simply exhausted, both physically and mentally, simply tired of being in the Velvet Underground. He was even tired of the possibility of success, and having spent six years without so much as a sniff of having a hit, even the thought of it now bored him. "I was giving out interviews at the time saying yes, I wanted the group to be a dance band, I wanted to do that, but there was a large part of me that wanted to do something else," he said. "I was talking as if I were programmed, that part of me that wanted to do something else wasn't allowed to express itself, in fact was being cancelled out."

Several months after Reed left, Lester Bangs quizzed Reed about it, by phone, while he was in his father's law office on Long Island. "I'm not going to make any accusations or blame anybody for what happened to the Velvets because it's nobody's fault," he said. "It's just the way the business is. So, some of the stories that've been circulating, I can see how people would've gotten those ideas because of the circumstances under which I left. I just walked out, because we didn't have any money, I didn't want to tour again—I can't get any writing done on tour, and the grind is terrible—and like some other members of the band, I've wondered for a long time if we were ever going to be accepted on a scale large enough to make us a 'Success.'"

Bobby Gillespie: They were often only playing to thirty people, so they didn't feel the pressure to play the hits—they could just branch out and experiment.

Danny Fields: Brigit Polk was sitting in a booth at Max's recording the whole set. She recorded most nights. That night Lou came out from backstage, and I said "Hi," but he kept walking. He didn't turn around, which I thought was odd. He looked serious, and when Lou was serious, he was really serious. Then one of the road crew said, "Do you know what just happened? Lou just quit. He quit the band, and just told them he'll never play live with them again." I asked Brigit to rewind the tape to make sure it recorded, and the next day we took the tape to Atlantic Records.

I think we got a check for $15,000. After that they became the Velveteen Underground, and Lou went on to become a singer-songwriter, which is what he wanted. He was a song guy who wanted to get away from the shiny boots of leather. Lou was a songwriter with a twist, the twist being he was a lunatic. As soon as he left, I became his manager for two weeks and said I'd get him a solo career, so I got him into Atlantic and he did a nine-song demo. They said they weren't interested. They didn't want him.

Lou Reed: It was just a terrible thing with the manager. Where the manager feels that he is more important than the artist or is in competition with the artist. It's always a bad situation. You know, the manager has an apartment, and the artist is sleeping on the floor by the fireplace like a sheepdog. Willie Nelson's autobiography is very, very funny, because at the end of the book he's staying in some really nice hotel suite wherever the hell he is. But he's traveling with his Samoan back doctor. The Samoan doctor gets the bed, Willie—because he's got a bad back—is sleeping on the floor. And Willie says something like: "This is kind of a parable for the music industry."

"Upstairs was separate from the rest of Max's," Lenny Kaye told Michael Bonner. "There was a bar there and chairs in front of the stage. When they cleared out the chairs, if there were a hundred people in there it would feel way packed. As I remember it, the Velvet Underground were the first people to play upstairs that summer. I think it was Thursday through Sunday. I went to the opening night—and when they extended the engagement, I kept going back. Onstage, Lou was in the middle, Sterling stage left, Doug Yule on the other side, and Billy Yule filling in on drums, because Moe was pregnant at the time. Max's was not a large-scale venue. The stage was maybe eight-to-ten-feet deep—enough to set up a rock and roll band. It was very casual—like a hangout. For the first set, you'd watch the Velvets play but then for the second set, which cleared out the room a little bit, you'd dance to 'What Goes On' or 'Beginning to See The Light' or whatever they were playing. They were about stretching out the songs. If you listen to the Velvet Underground live records that came out from around then, they had fun. I first met Lou upstairs at Max's. We sat at a corner table, chatting. We both had an interest in old doo-wop records and EC horror comics. In fact, I loaned him my collection of EC comics. He still

had them, after he left the band and retreated to Long Island. Then, one day, I got an envelope in the mail—he'd returned them to me. I still have them upstairs. They have Lou's eye tracks on them! That time in Max's, he also told me he was looking for a doo-wop record by Alicia & the Rockaways—a Long Island group he must have heard locally when he was growing up. I actually found it for him about ten years later—so I was able to fulfill his dreams of hearing that record again."

Bob Colacello: Eventually the Velvets were almost too cool for their own good. It was kind of a dead end. They were so cool they couldn't get cooler. It was time to end it.

Marco Pirroni (musician): It's entirely understandable for him to leave the Velvets because they were getting nowhere. "I can't do this for the rest of my life!" That was a pretty sensible decision, because they weren't getting anywhere.

By the time Reed had left the band they had already recorded their fourth album, Loaded, *but even before that, Steve Sesnick had started to believe that Doug Yule, rather than Reed, might be the savior of the group. In Reed's words, Sesnick had begun to drive "a wedge between" him and Yule, minimizing Reed to such an extent that he would eventually leave. As a result, Reed was never overly fond of the album, saying at one point, "*Loaded *didn't have Maureen on it, and that's a lot of people's favorite Velvet Underground record, so we can't get too lost in the mystique of the band...It's still called a Velvet Underground record, but what it really is, is something else."*

"Sweet Jane" was an oddity, not least because its true meaning is the opposite of what you first think. A cautionary tale of forgiveness, it's one of Reed's most empathetic lyrics. Musically the version included here is rather light, although as soon as it was released it immediately became something of a rock classic, a song like Free's "All Right Now" or Deep Purple's "Smoke on the Water" that would start to be ruined by hundreds, probably thousands of college rock bands, trying to establish a personality through covering "rock" standards. It would also start to become Reed's signature song, a true paean, and one that Reed would play ad nauseum. Not just him, either: if you walked down Denmark Street, London's Tin Pan Alley, in 1970, and loitered outside any of the guitar shops, you would hear any number of amateur axmen inexpertly working their way through

*"Sweet Jane," treating it with the same reverence as Jimi Hendrix's "All Along the Watchtower" or Led Zeppelin's "Immigrant Song," while systematically ruining it.**

When David Bowie was producing Mott the Hoople in 1972, he didn't just encourage them to record "Sweet Jane," he almost forced them. "David said he would give us more songs if we needed them [he had already given them 'All the Young Dudes'], but he didn't really want to," said Ian Hunter in 1980. "He needed all the material he had. He wanted us to do 'Sweet Jane.' I didn't know what the fuck that was about, so he stood next to me, and I sang line after line exactly how he was telling me! Lou [Reed] came in to do the demo and I had less idea of what to do than before. Plus, I told him a joke that went wrong so Lou stared at me. Bowie was going apeshit over him at the time, but I didn't know. This slob comes in and goes 'eeaugh' all over the microphone!? We didn't know if he was kidding or what. When I heard the Velvet Underground, I thought they stunk as well. There's another New York legend. They don't tell the truth in New York. It was the same with the Dolls. They wanted them to be the greatest band; that doesn't necessarily mean they are, although they had very endearing qualities. They supported us and they used to go offstage in total silence." Hunter says Bowie also encouraged the band to sign with his manager, Tony DeFries, who Bowie later famously fell out with.

 Loaded *was also responsible for Jonathan Richman's Modern Lovers. While their signature song, "Roadrunner," was a homage to the rhythm that anchors "Sister Ray" (celebrating AM radio rather than blow jobs and junk), the band's locus was* Loaded*: this was the album that Richman was holding when he walked into the apartment shared by bassist Ernie Brooks and keyboard player Jerry Harrison. "We were like the original punk band," says Harrison. "Most music had gone away from heartfelt things toward professionalism. We put inspiration first."*

Michael Bonner (writer, *Uncut*): Looking back on the circumstances around his departure from the Velvets, Lou Reed had this to say: "I gave them an album loaded with hits to the point where the rest of the

* When I started messing about with local bands when I was about fourteen, every rehearsal would involve at least one attempt at "Sweet Jane," along with equally rudimentary goes at "Do Ya" by the Move. When I bought my first (very much entry-level) drum kit, one of the first songs I played along to was "I'm Waiting for the Man," simply because it seemed easy. It was, but then it actually wasn't.

people showed their colors. So I left them to their album of hits that I made." Reed took a long time to get over *Loaded*. Although the band's most commercially successful album, for Reed it was synonymous with a period of immense drama, both personal and professional. It continued even after he'd left, as their manager attempted to write Reed out of his own history.

Two months after the release of The Velvet Underground *in March 1976, the band began work on their fourth LP. By August the band had parted company with MGM—new MD Mike Curb envisaged a more wholesome direction for the label. Suspecting how that might pan out for the Velvets, manager Steve Sesnick extricated the group from their contract. Come November, the album had disappeared. Reed, meanwhile, was having personal problems of his own. His long-running affair with Shelley Corwin, his muse, was in slow decline. Increasingly disturbed by the effects of long-term drug abuse on close friends including Factory compatriot Billy Name, Reed responded by getting even more out of it. "Lou went out of his skull and ended up with a warped sense of time and space that lasted several weeks," journalist Richard Meltzer says.*

At the start of 1970, the band signed to Atlantic Records, while still $30,000 in debt to MGM. Tucker, meanwhile, took maternity leave in March; her stand-ins were Doug Yule's younger brother Billy and the engineer Adrian Barber. Existing frictions between Reed and Sterling Morrison continued. The April to July sessions at Atlantic Studios overlapped with a ten-week homecoming residency at Max's Kansas City. Reed, worried about straining his voice, ceded four lead vocals to Doug Yule. The songs represent a refinement of the band's aesthetic, a vibrant middle ground between the avant-garde stylings of the first two albums and Reed's Top Forty sensibilities. And such variety too! From jaunty, Monkees-style pop ("Who Loves the Sun") to freewheeling rave-ups ("Oh! Sweet Nuthin'"). Then there's "Sweet Jane" and "Rock'n'Roll."

Duncan Hannah (painter, diarist): I went to summer art college in Minneapolis in the summer of 1970, and there was a blonde student who seemed far more decadent than the rest of us, and she invited me over to her apartment after school one day. She was dark. We smoked weed and she held up the banana album and said, "Do you like this?" She put it on and I couldn't believe it. I was so used to British psychedelica, San Francisco psychedelica, but this music really struck me as disturbed. It's

WHAT THE HELL IS A STUTZ BEARCAT, JIM?

funny in retrospect as now it just seems like one hit song after another. We had a great DJ in Minneapolis called Tony Glover who was really cool, and he played on the only underground station in the area. He had taught Dylan how to play harmonica, and he had his own band, a folk trio called Koerner, Ray and Glover. When all the bands came to play, he'd interview them for this local magazine called *Connie's Insider*, and he was so famous they would often ask him to bring his band on for the encore. So whenever I saw the Doors or Jimi Hendrix, he'd come out as a special guest. It was very exciting because he was our DJ. One night he played "Rock'n'Roll" from *Loaded* on his show, and as I was about to move to New York, it knocked me out. It was my story too, an innocent who was going to jump in. Tears came to my eyes. It was driving and euphoric. So I quickly bought all the Velvets' records and moved to Manhattan.

Richard Williams: I loved *Loaded*, I was interested in what John Cale was doing after he left the band, and then there were Nico's albums, which I was really intrigued by. Of course, they didn't have any following among the general public or indeed in our readership at *Melody Maker*, which was closing in on a circulation of two hundred thousand copies a week at the time. In 1969 Geoffrey Cannon had become the editor of the *Radio Times*, which at the time was selling nearly four million copies a week. He transformed the magazine, bringing in a lot of good feature writers, illustrators like Ralph Steadman, lots of good things. He was also the rock critic of the *Guardian* for several years, and he was a huge Velvets fan, so we bonded over them.

Soon after the album's release, Elton John was the guest contributor to Melody Maker's *"Blind Date" column, where a musician was asked each week to identify and comment on a selection of newly released records. As a keen follower of the US music scene, when he was played "Rock'n'Roll" Elton immediately guessed the identity of the Velvet Underground, even though the album hadn't actually been released in the UK. "Great album," he said. "The best I heard in the States. I've never been a Velvet Underground freak, so it was something of a surprise to me. It's just a simple, relaxed album. They're a strange band, too... they made this album and apparently disappeared."*

Barney Hoskyns: I think I bought *Loaded* in Cheapo Cheapo, the second-hand record store in Rupert Street in Soho. I liked it. Didn't love it but liked it. "Sweet Jane," "Rock'n'Roll," and "New Age" are all great songs, along with the silly stuff.

"It's always struck me as strange that no one has ever attempted to record any of the Velvets' material," wrote Lenny Kaye in Rolling Stone, *"though it must be admitted that its previously bizarre nature probably tended to frighten many people off, but there should be no excuse with the present album. Building from chord progressions that are simple innovations on old familiars, Reed constructs a series of little stories, filling them with a cast of characters that came from somewhere down everybody's block, each put together with a kind of inexorable logic that takes you from beginning to end with an ease that almost speaks of no movement at all." Melody Maker's Michael Watts rhapsodized about "New Age": "The images he [Reed] evokes are loaded with that sort of camp make-believe that enables a movie like Russ Meyer's* Beyond the Valley of the Dolls *to transcend its material. There is a sweet decadence about the way he manipulates the melodic styles and themes of bygone pop that is far removed from the attitude of Frank Zappa, who works with early Sixties rock structures as a vehicle for his sharp satiricism [sic]. For Reed it is more a slightly unhealthy love-affair, conducted in an exotic hot-house."*

Jan Younghusband (filmmaker): I worked with Lou Reed just once at the BBC and then he was gone. My brother introduced me to the Velvet Underground in the early Seventies—he was totally sick of me bashing out Mozart all day long on the piano. "Listen, Sis, this is real music." I remember feeling frightened because it was so powerful—so free and open. Transporting. We think the Velvets is about the music but it's also the poetry behind the notes and expressing things ordinary people worry about. It makes you realize you are normal to feel this way. This was completely original at the start. The music is the serum to carry the words we cannot speak. It shapes our anxieties. The songs become about the strength of self-expression, not about the weakness. This music was obviously born in the Sixties, when life was very different. The Velvets gave birth to everything we have now. I was brought up in a family of brothers in a generation taught from birth to suppress their feelings, and never show their emotions or express them. So, the birth of rock was

liberating and self-medicating and gave everyone a way to channel their feelings and learn how to feel—and have a lot of fun as well. Every time a new song came out, it was life changing. Later I read about the Velvets, that they were called "avant-garde" and "experimental"—desperate labels trying to control and make sense of the free spirit of this music. Great art is somehow already in the future, showing us a place we haven't arrived at yet. Not just to entertain us but to make us grow. That time I met Lou, singing these great songs, was so profoundly touching, taking me back to that moment with my brother all those years ago. In the end, music has always been a way to work out and express our feelings when words are not enough. The Velvets and Lou told us that the wall we can all feel up against is actually a door.

Bob Colacello: This was the year when I started moving in Andy's orbit, although by that time most of the original Factory people had moved on. Or, more accurately, were moved on. Lou Reed wasn't around much by this time at all. Pat Hackett was still around. She started at the Factory in '67 and typed up Andy's book *a*, the novel. And although she was very square, she did get a kick out of the Sixties people, and if she was disapproving, she didn't show it. I was born in Brooklyn, I grew up on Long Island, we moved from a nice middle-class suburb to a nice upper-middle-class suburb. I went to Georgetown, which was the Catholic Harvard, especially the foreign service school. It was very international, so that did open my eyes to a broader world, but to suddenly one day get a phone call from the Factory and to hear that Andy was reading reviews I wrote for the *Village Voice*, for my film criticism classes at Columbia, then joining everyone at the Factory, and being whisked off to Paris to have lunch with Marie-Hélène de Rothschild or to Rome to see the Agnellis, or going to Mick Jagger's birthday party, yeah, it was pretty great. I wasn't really intimidated, I was impressed. Of course, it went to my head thinking all these people really wanted to see me, and not Andy. But along the way I did make some really good friends. We had fun. I did take one piece of my mother's advice. She said when opportunity knocks, open the door. So I did. I really did. And I have walked through a lot of doors.

It seems almost quaint by today's standards, but this was a time when Warhol's films were still considered to be "blue" by a prurient media whose job it was to

complain while looking as intently and as closely as possible. In the Sixties, to the mainstream media, Warhol's films equated not just to pornography, but in their eyes something worse—arthouse pornography which was contextualized as porn with ideas above its station. Highfalutin muck. Even the alternative press remained a little suspicious of Warhol's motives, and if you lived in New York, you'd have seen a listing in the Village Voice for "A Title That Can't Be Revealed." In mainstream papers, 1964's black and white short movie Blow Job was referred to as "A title that can't be mentioned in a family newspaper." The film itself consisted of thirty-six minutes of a camera framing the face of a man receiving oral sex. You never see his penis, or any of the act itself, although if you read any of Warhol's interviews concerning the film, you'd learn that "five beautiful boys" performed the act in the film.

For an artist who would often claim that he found sex beyond him (or beneath him), he went out of his way to feature it in his movies. Warhol himself was quite prurient, although you wouldn't have gleaned this from 1964's Couch which depicts various couples kissing, hugging, and fucking on a sofa, 1969's Fuck/Blue Movie (a feature-length depiction of uncensored, unscripted sex which became the first erotic film to be released widely in cinemas across America), or 1968's Flesh (starring Joe Dallesandro as a hustler) or Lonesome Cowboys from the same year (and which featured five renegade gay cowboys and their (mis)adventures in a small western town; Warhol initially planned to call the film Fuck, then The Glory of the Fuck). Censors fretted about giving the films the correct classification, while West End cinemas worried about being shut down for showing them. Consequently, anything associated with Warhol was treated with the same suspicion. Was whatever it was he was peddling now overtly sexual? Obviously, it was! Was it all a ruse to foist transgressive sex on those who didn't want to see it? Wasn't this just proof that all his art, not just his films, was a con? And surely all the members of the Velvet Underground were deviants as well as poseurs? Just look at the ghastly members of the Factory etc. If, by the end of the twentieth century, Warhol would be considered to be one of the most important artists ever to have lived, by 1970 he was still thought to be dangerously kinky.

Nevertheless, Warhol's productivity was increasing at a crazy pace. The Valerie Solanas episode had left more than physical scars, and Andy seemed to be in a race with himself to widen his purview and work like stink. Of course, he was increasingly aware of the commercial ramifications of his work, but he hadn't stopped experimenting either (even though it is still fashionable in

some circles to say he was doing precisely the opposite). "His work ethic was incredible," says Deborah Harry. "He would wake up early every day and go to his studio and paint, break for lunch, and work all afternoon—often spending hours on the phone—then at night he would always go out and socialize. He went everywhere. In fact, I first met him—and his dazzling entourage—when I was waiting tables at Max's. I admired Andy so much. Like Andy, I felt the influence of Marcel Duchamp and a kinship to Dada and Popism, which became foundational to what I was creating."

Nico: My music is not accidental. If you want it to be an accident, it is an accident, but it also can be something else. It can be very well thought out. That's what I've been doing. Just thinking what was the best way.

In December, Nico released Desertshore, *again coproduced and arranged by John Cale, who said the record had more of a relationship with twentieth-century classical music than anything else. While many found it challenging, others thought it a masterpiece, with Nico's dour Teutonic monotone and the steady drone of her harmonium making even the grimmest medita-tions on fate somehow sing with pathos. Like most product by ex-Velvet Underground members, it tended to polarize its listeners.* Melody Maker *called* Desertshore *"a medieval ruin of a record," and yet among Nico's obsessive fan base it immediately became an otherworldly masterpiece. "It is an illusion—a mirage—a desert has no shore," said one reviewer. "A beautiful nightmare welcoming death's release." Some reviewers dismissed her as a "chanteuse" or a "siren," while Robert Christgau—the doyen of New York critics—said, "Nothing new here—bohemian hangers-on always get to publish their work while the less socially adept ('charismatic') are shafted." Richard Williams in the* Melody Maker *composed a prose poem about his feelings for her: "Nico frightens me, yet somehow draws me closer to drink from her fountain of desolation and alien fantasy; I don't think she's at all aware of the effect she has."*

It was around this time that Nico started to describe herself as "a frustrated movie director...I always have to see a sound, I can't listen to it only." Joe Boyd, who had already discovered Nick Drake, and was producing the Incredible String Band, helped produce the record with Cale. He had his own take on his charge: "Being around Nico was kind of depressing," he said. "She was a very tortured character. I mean, you can see the romance of Warhol, the Factory,

and the Velvets, but when you get up close to it, you think 'Jesus, this is pretty gloomy, boring stuff.'"

Gene Krell: She is beyond measure. *Desertshore* is a masterpiece, and her work is sublime. Her contribution was quite remarkable. She defined the idea of looking over the mountain and seeing what's on the other side. She was into herself. She had mystery and she created curiosity. You wanted to know more about her. Her contribution in that way is immeasurable. It was more than the music, as it was more about the philosophy behind it. You know it's not what we do in life, it's why we do it. So, there are two guys sitting in a police station and one says to the other, why are you here? And the guy says, "Ah, I knocked a woman down." And the first guy says, "Wow, I knocked a woman down too. What were the circumstances?" The second guy says, "I knocked her down and stole her purse. You?" And the first guy says, "I knocked her down because she was about to be hit by a bus." With Nico it was always about to get hit by a bus. She was not driven by commerce. She never surrendered to her lesser angels. Apart from changing the color of her hair, she never ran with the times. She was motivated by all the right things. Generally, her music was an extension of her experiences, and who she was. It was the proverbial what you see is what you get. There was no mandate. She was never that bothered by the accoutrements, she was just too busy trying to discover the world and distill it on her own terms. She was unique, beyond measure. Creation in itself is very singular, very solitary, particularly as a writer, but the ramifications are universal. The one thing you can say about Nico is that she came and went the person she was, without deviation. Very few of us can lay claim to that. She was completely unique.

CHAPTER 8

DRESSING FRIENDS UP JUST FOR SHOW

1971

"The darkness is my birthright."
—Nico

Richard Williams: I interviewed Nico in London in March, when she was playing the Roundhouse. We arranged to meet in a pub on Kensington Church Street, opposite where Biba used to be. It was a shock to see her with dark hair. She wore a dark cloak and big boots. She said that after the Roundhouse gig, she was going back to Ibiza. "It's my favorite place," she said, "and I think I'll die there." She was being dramatic, obviously. We talked for an hour or something, and then she disappeared off with a bloke in a sports jacket, cavalry twill trousers, and a cravat, who she didn't seem to know. She appeared to have met him in the course of our interview, this completely incongruous bloke.

The same year, in the El Quixote restaurant attached to the Chelsea Hotel in New York, Nico attacked the young black singer Emmaretta Marks, after Marks complained to an adjacent table of racial inequalities. "Suffering!" Nico reportedly yelled at her. "You don't know what suffering is!" Marks needed twenty stitches but pressed no charges. In 1985, Nico said, "Didn't they [the Black Panthers] kill Jean Seberg? She was a good friend of mine. I'm a little afraid of them, because I once hurt a girl's face. I was high on angel dust

and had been drinking, not much, and I hit this girl's eye with a glass and she had seventeen stitches, and they were looking for me. I was hiding in New Jersey, and then I had to leave the country. The girl had plastic surgery and Germaine Greer paid for it. She was in the bar too. It was an accident, it wasn't intentional."

Gene Krell: I actually had a fistfight with a guy from Tangerine Dream who was giving her flak. Nico would also say things that she knew would create a polemic, but I don't know about the thing she was meant to have said.

Danny Fields: I wasn't there but I heard about it a few minutes afterward from people who were there. Emma was a very good friend of everyone's. Nico's attack was a moment of bestial fury. She exploded, and I couldn't believe it when I heard. I knew she was walking a tightrope, but this was…Something blew. I had never heard of anything so vicious. Savage. Thank God the cut wasn't more serious than it was, in terms of injury to the skin tissue and the eye. The glass cut her around the eye socket, not the actual eye itself. She could have so easily gouged out the eyeball. I imagine there was a lot of blood. Paul Morrissey got her out of there, to Paris probably. I thought, "Nico, even for you this is uncool." People say it was racist, but I hate that word as I think all human beings are racist to an extent. This attack wasn't racist, it was a psychotic explosion. Nico was a naughty girl from time to time.

Gene Krell: Bernie Rhodes [manager of The Clash] later got into Nico for some racial slur she was meant to have made.

David Bowie's box of tricks was bigger than most people's, and his propensity for rummaging around in the work of others was usually redeemed by the fact that whatever he produced that had been "inspired" by his long list of influences was often better than the original. "Queen Bitch" on 1971's Hunky Dory *certainly wasn't an improvement on the Velvet Underground, but it managed to distill what they did into a bite-size package that positively reeked of the dirty streets of New York (along with a hint of blood, semen, and glitter—Jon Savage says it was "saturated in homosexuality and Manhattan sleaze"). If the other homage on the album, "Andy Warhol," was actually rather gauche,*

"Queen Bitch" is the best Lou Reed song that Reed never wrote himself, with a riff that purposely echoes "Sweet Jane." As Bowie himself says on the album, "Some V. U. White Light returned with thanks."

He had been introduced to their music in November 1966, after his then-manager Kenneth Pitt, on a trip to New York, visited Warhol at the Factory. "He was everything I had expected, looking exactly as he did in the gossip column pictures: the shades, the polo-neck, the mask," wrote Pitt in Bowie: The Pitt Report. *"I cannot recall what we said or even that we said anything at all. Having been introduced and it having been proved to each other that we existed seemed to be all that was required to set the seal of approval on our plans. In retrospect, I realize that the most significant aspect of my visit to the Factory was my meeting with Lou Reed and being given an acetate advance copy of the Velvet Underground's forthcoming album. That record was to play an important part in David's future." On his return from New York, Pitt gave his charge the album, along with another he'd heard in a Greenwich Village record store, by the Fugs. He apparently loved both of them, especially "I'm Waiting for the Man," which he started playing in his act.*

What isn't discussed as much as it should be in regard to the origination of Ziggy Stardust is Bowie's slightly embarrassing meeting after a Velvet Underground gig at the Electric Circus in New York in January 1971. After the show, Bowie showered Lou Reed with praise, only to be informed that the man being showered wasn't Reed at all, but rather John Cale's replacement in the band, Doug Yule. As Reed had since left the band too, Yule was the focal point, the cause of Bowie's embarrassment.

David Bowie: The trip to America in January 1971 changed how I felt about what I was doing, as it opened up so many new doors for me. The country was still alien, and the music that was coming out of the cities was far more urban than it was in Britain. The whole scene with Andy Warhol, the Velvet Underground, Ultra Violet, Moondog, the Stooges, it was all fascinating, and I have to admit that I was swept up in it. Obviously, it was during this trip that the whole Ziggy Stardust thing began to gel. I couldn't believe the country could be so free, so intoxicating, and so dangerous. It suddenly made Beckenham seem very small, very timid, and very English. I needed to get out of that whole British sensibility, and that's what I did with Ziggy Stardust.

Bob Colacello: David Bowie came to the Factory a couple of times, and he was something new, but he wasn't really decadent, he was just playing at decadence.

Catherine Guinness: Andy's standing in the art world was not good at all at the time. Robert Hughes was so rude about Andy, and I remember Andy really minding about that. He always thought he was a bit of a fake himself, I think. I don't think he thought at all that he was the genius people think he is now. He was also wounded by the David Bowie song about him. He hated Bowie after that. Andy was worried about his looks having lost all the pigment in his face. He didn't like Bowie saying he looked a scream.

David Bowie: I'd come back from New York, having caught one of the last performances of the Velvet Underground, a band I had admired tremendously since around '66/'67. One of that tiny bastion of Velvet Underground fans in London at the time, before they were generally known. And I'd gotten into the Electric Circus to see the gig. I watched the entire show, and there were not that many people in the audience because their star had begun to dim in New York. The whole band were there with Lou Reed singing the songs and I thought it was just tremendous.

I was singing along with the band, stuck right there at the apron of the stage. "I'm Waiting for the Man," "White Light/White Heat," "Heroin." All that kind of stuff. And then after the show, I went backstage and I knocked on the door, and I said, "Is Lou Reed in? I'd love to talk to him, I'm from England, because I'm in music too, and he's a bit of a hero to me."

This guy said, "Wait here." And Lou comes out and we sat talking on the bench for about a quarter of an hour about writing songs, and what it's like to be Lou Reed, and all that... and afterward I was floating on a cloud and went back to my hotel room. I said to this guy that I knew in New York, "I've just seen the Velvet Underground and I got to talk with Lou Reed for fifteen minutes," and he said, "Yeah? Lou Reed left the band last year; I think you've been done." I said, "It looked like Lou Reed," and he said, "That's Doug Yule, he's the guy that took over from Lou Reed." I thought, "What an impostor, wow, that's incredible." It doesn't matter really, because I still talked to Lou Reed as far as I was concerned.

Coming back to England, one of the memories I brought back with me, was all that. So, I wrote "Queen Bitch" as a sort of homage to Lou Reed.

To his credit, Bowie thought the whole thing rather funny, although as he left the venue that night, he started ruminating on the idea that perhaps he could do the same thing, impersonate someone onstage. Such was his confidence that it didn't appear to concern him that, unlike Lou Reed, Bowie wasn't famous, so how would anyone know he wasn't real?

It should also be noted that Ziggy appeared during a period when many other glam stars pretended to be other people when they were onstage, notably Alice Cooper, Gary Glitter, and to a certain extent, Bryan Ferry. Bowie's extra gear was pretending to be Ziggy offstage too.

David Bowie: The first time I went to America there was a wonderful writer who lived in Greenwich Village. The first thing he did within a couple of days of me getting there was play me *Loaded* by the Velvet Underground and this was like the new release. I thought, "Wow, I'm in America, I'm in Greenwich Village, and there's this guy playing me *Loaded*—this is heaven and I've brought a dress with me." In New York I was very impressed by transvestites, they were kind of pre-Raphaelite, there was something about the Edward Burne-Jones, Rossetti thing that I thought was a purist new energizing of the British spirit. I had long hair at the time, and it looked like something interesting—so I wore that around for a bit.

Rodney Bingenheimer (DJ): I had been Davy Jones's stand-in on *The Monkees* TV show, and then got a job as DJ at KROQ. I was also doing FM promotions for Mercury Records, and my job was to take the artists around to different radio stations. I had a friend at the time called Al Hernandez who had seen David play back in London in 1969 and he told me about him, so when he came into LA in February 1971, I took him around all the studios. I picked him up from the airport in a friend's Cadillac. He was all by himself, dressed in these loose black clothes, looking like a ghost. He was great as he was into the Stooges, Velvet Underground, all that stuff that most people had never heard of at the time.

Ken Scott (producer): The five of us—me, David, Mick [Ronson], Trevor [Bolder], and Woody [Mick Woodmansey]—started on *Hunky Dory*, and got so close that we could almost finish each other's sentences. It had almost reached that point. We were making records for ourselves, and if other people happened to like them then that was great. For me the transformation happened over a period of time, so it wasn't any great surprise. I didn't really notice as it was going on because it was so gradual. I was seeing David fairly regularly, and the character just got further and further evolved. It's like your kids: when you see them every day you really think they're changing, you don't realize how much they've grown until their grandparents come over and say, "Oh God, they got so big." It was that kind of situation.

The thing that surprised me most about *Ziggy* originally was the fact that David thought I wouldn't like it. We'd finished *Hunky Dory*, and it was only a very short time later that I saw David and he said we've got to start making another record. *Hunky Dory* hadn't even come out yet, but his management wanted him to do another album, so that's what we did. And he said, "Although I don't think you're going to like this one. It's going to be a lot more rock and roll." I can't remember if he said it was going to sound like the Velvet Underground or Iggy Pop, but as I didn't know of either band at the time, it didn't really make much difference. And he was completely wrong, as I loved every second of the album. I think my greatest achievement with the record was making an album that the five of us were happy with. It was the perfect team, and there was a great sense of camaraderie when we were making the record.

Tony Zanetta (actor): In September 1971, David and Angie [Bowie] came to New York to sign with RCA. I took them to the Factory to meet Andy, and that was interesting. One of the main impetuses of going to the Factory was so that Tony Defries could meet Paul Morrissey and talk about representing Factory Films in Europe. He thought he could solve all their problems. There was Andy Warhol, and there's me, who played Andy in Andy Warhol's play, there's Allen Midgette, the guy who played Andy on the college circuit when Andy sent an impersonator out instead of doing it himself. Then there's also David Bowie, who played Warhol in the film *Basquiat*. It wasn't an excruciating meeting, but it wasn't great. The meeting was kind of tense because Warhol was not a great talker,

and neither was David. It was awkward. Nobody was really taking this conversation and running with it. So they were circling each other and then David gave him a copy of *Hunky Dory* and played "Andy Warhol," which Andy hated. Which didn't help the meeting. He also met Lou Reed and Iggy Pop that week. Lisa and Richard Robinson introduced David to Lou Reed. Richard worked at RCA in the A&R department, and that week he had a party and invited Lou and David along. RCA also threw a dinner on the day David signed, at the Ginger Man restaurant. After that dinner I took David to Max's Kansas City, bumped into Danny Fields who called up Iggy to come down and meet David. When Iggy met David he basically never went away again. David was magnetic. There was something about David's personality that was very, very sexy. He had charisma, and was seductive more than sexy. At the time the English were very different sexually from Americans, because even though we were fucking everything in sight, we were still very repressed. The English weren't. They were easier with it, and bisexuality wasn't a big deal. A lot of couples would occasionally have a threesome with a man or a woman, and so what? It wasn't earth shattering. You didn't have to brand yourself. You were just sexual. That certainly applied to David and Angie. David wasn't a sex hunter, he wasn't going out looking for sex all the time. But sex was always a little part of the equation. A lot of people might have ended up in bed with him because he was so seductive. Whether he needed to be adored, or whether he was just adored, it would always surface. He was the adored one.

Danny Fields: One night in September 1971, Richard and Lisa Robinson called me and asked if Iggy Pop was still staying at my apartment, which he was. We had both fallen asleep watching television. Lisa said she was with David Bowie, they'd just had dinner with Lou Reed at the Ginger Man, and now they were on their way to Max's Kansas City and wanted to know if we were coming down. David really wanted to meet Iggy. So I woke him up, and told him that the person who had been so nice about him in *Melody Maker*—he'd voted him as vocalist of the year or something—was down at Max's and wanted to meet him. We thought it was astonishing that someone in the UK knew who Iggy was. I was de facto managing Iggy then, and I thought it would be a good idea if they met, as Iggy was at a loose stage of his career. Professionally,

prospects were not too promising. So we walked down from Twentieth Street and Fifth Avenue, where I lived, to Eighteenth Street and Park Avenue. Five short city blocks. We walked into the back room at Max's, which was kind of empty, but then it was 2:30 in the morning. They were introduced and immediately began talking about music. I made my excuses and went to sit elsewhere, as I didn't know anything about music, and have always found it difficult to talk about it intelligently. And that was the beginning of their relationship. They were off and running. David was very good at spotting talent more cosmic than his own, and very good at flattering people. And Iggy knew that David had more money, more resources, and more credibility. They worked it out between them, and we have the records to prove it. But both Lou and Iggy were a little bit closer to heaven. David was a vampire, but a good vampire, he did something good with the blood. He shared the nutrients.

David Bowie: I was at an RCA party at Max's Kansas City and was introduced to Lou Reed. He immediately started telling me some story about a guy who injected smack through his forehead—that was typical Lou. Anyway, up comes this funny ragged, ragged little guy with a broken tooth and Lou says, "Don't talk to him, he's a junkie." That was Iggy. You couldn't help loving him, he was so vulnerable.

Bob Gruen: I got to know Lou Reed around this time although I always kind of kept my distance. I found him surly and insulting, and I found his music really depressing, like the Doors. I didn't get it. It was gloomy. I was not impressed. Rachel [Humphreys, Reed's girlfriend] was gorgeous, but not Lou. The New York Dolls were always very friendly, and so was Alice Cooper and Kiss. Gene Simmons would have you in hysterics all day long and all night long. Lou could be a pain in the ass.

Iggy Pop: [David Bowie was] looking to co-opt the American avant-garde. I was an interesting candidate to join the circus. Bowie knew about me and it was just a happy coincidence that I happened to be in town, or a freak coincidence.

Angie Bowie says that she supposes Lou Reed was a little more sophisticated than Iggy, but whereas Lou didn't do the reading, Iggy did the reading. "Iggy

had schoolteachers for parents, and he actually read, you know, Dostoevsky and all that kind of crap. Lou had that New York thing—he could make out like he'd read it even though he hadn't. But he covered enough ground, and it was superficial enough that you didn't get a headache by the end of the conversation. With Iggy, if you ever did have a serious conversation with him, the whole idea he would point out was that you were ignorant and stupid, and that he was as smart as a whip. And that having been said and established, now he was gonna use you any possible way he could—either to eat, get drugs, or cop a piece of ass."

Kris Needs (journalist): When Bowie made his first appearance at Friars Aylesbury on September 25, 1971, as he told me at the time, its success created the path he should now take. At that time, Friars was already one of the coolest clubs on the circuit. It was only an hour from London, and regularly hosted the likes of Mott the Hoople and Genesis. It was a warm club, as were the audience. It was a benign place, and you knew you would get a good reception there. In 1971, the promoter David Stopps phoned me to discuss some prospective bookings, and he mentioned that he'd been offered David Bowie. At that time, Bowie was only really known for "Space Oddity," but he had also been dabbling with some Velvet Underground songs, and as I really liked them, I was intrigued. I recommended he hire Bowie, so Stopps paid Tony Defries £150 for Bowie to test his new band at Friars on September 25. This was the first proper performance by the Spiders, and I designed the flyer for it. There was already a bit of an Aylesbury connection as Bowie had given a song he had written, "Star," to a local musician called Les Payne, who had often appeared at Friars with his band Chameleon. He liked Aylesbury. The "market square" in the opening line of "Five Years" is actually the clock tower in front of Friars. On the day of the gig, Bowie turned up, and was both amazingly shy and amazingly charming. He was such a sweet man. He still had long blond hair, and had a big black hat, sort of baggy black culottes, red platforms, and a beige jacket. Oh, and no shirt. He looked cold and asked if we had a heater. The hall was only half full, even though it was only 50p a ticket, and he was supported by the band America, who had just had a hit with "A Horse with No Name." I stood on the side of the stage, just behind Mick Ronson's amp. David said, "We're gonna start slowly 'til we get the hang of it," and then

they played "Fill Your Heart" from *Hunky Dory* and "Buzz The Fuzz" by American singer-songwriter Biff Rose to warm up, so the gig sort of started slowly, quietly. It got rowdier as the band played "Queen Bitch" and Chuck Berry's "Around and Around," which I think he said was going to be the title of his next album. As yet another, less oblique nod to the Velvets they did "I'm Waiting for the Man" as an encore, and then I went backstage. He was really pleased that it had gone so well. He said that he really wanted to come back and play later in the year, but that when he did, he was going to be completely different. He actually said that he was going to be a huge rock star. You could tell that he was on the verge of something. And he'd used the Velvet Underground as one of his touchstones.

Nick Rhodes (musician): I would have been somewhere between ten and fifteen for sure when I discovered Warhol. There was a progressive art gallery in Birmingham called the Ikon Gallery which John Taylor and I used to visit fairly often. It's where I also first saw Duggie Fields' beheaded Marilyn Monroe, and where I first saw posters and screen-prints by Andy. Then I found the Rainer Crone book in a local library and spent hours poring over it, trying to work out what it was. Then of course through Davie Bowie I got alerted to Lou Reed, Iggy Pop, and the Velvet Underground. At the time it seemed impossible to me that Warhol could have made all that art, made all those films, and found and produced the Velvet Underground, and pretty much invented the twentieth century at the same time. His fingerprints were on everything. And they remain so; his films for instance are the first examples of Reality TV, he was the first video artist, he was the first artist with that kind of gaze. Just look at the way he got fame. Mundane things and beautiful people.

In 1971 Cale swapped New York for LA, heroin for cocaine, swapped his fashion designer Betsey Johnson (whom he had married in 1967) for his second wife, Cynthia "Cindy" Wells, better known as Miss Cindy of the GTOs.

Nick Kent: I got to know Nico and John Cale quite well, and whenever I broached the subject of the Velvet Underground, it was a subject they didn't particularly like talking about. They both had very blurred

memories of it, as you can imagine, because they were on speed most of the time, or downers. Their memories of the sixties and the seventies were pretty blurry. Both of them would say, if you're talking about the Velvet Underground you're talking about Lou Reed, because it was Lou Reed's group. And at the end of the day, it was.

Lou Reed: Sterling had talked about leaving for so long that it was no surprise when he finally did it.

Moe Tucker: The story of him [going with his bandmates to the Houston airport in August 1971] with an empty suitcase is true. I guess he had difficulty facing the moment when he had to say, "I'm not going." He went so far as to get in the cab and go to the airport with a bogus suitcase. We were one step away from the gate...then he said, "I'm not going back to New York."

John Cale: He went to the airport with an empty suitcase? I didn't know that. He must have been stewing for a long time.

Michael Bonner: On October 5, 1971, the Velvet Underground made their live debut in England. But who were these four musicians who plugged in at Leicester's Palais de Danse? We recognize the thin, wiry singer-guitarist with a shock of curly brown hair as Doug Yule and the drummer is unmistakably Moe Tucker—but who are these other two guys, all flared denim and long hair? The Velvet Underground had always been a band in transition: in the four years since their debut, they had remade and remodeled themselves with each successive album. But what exactly was the plan now? The two other men on the Velvets' 1971 UK tour were guitarist Willie Alexander and bassist Walter Powers—veterans of the same Boston music scene that had incubated Doug Yule. The trio first played together in 1967 in a band called the Grass Menagerie and had come together incrementally during 1971, with Powers first replacing Lou Reed at the start of the year and Alexander joining after Sterling Morrison's departure in August. As the tour finished, Tucker, Alexander, and Powers returned to the States while Yule stayed behind at the behest of the band's manager, Steve Sesnick. It transpired that Sesnick had struck a deal with Polydor's UK arm for a new Velvets album. Ensconced

in a studio in late 1971, Yule began work on *Squeeze* (which wouldn't be released until 1973). Geographically, ideologically, and spiritually, the Velvet Underground were a long way away from home.

Ed Vulliamy: They came to play at Kingston Polytechnic in 1971, but by then both John Cale and Lou Reed had gone, so while it wasn't the original Velvet Underground, it didn't matter. Sterling Morrison is not an unimportant part of the sonority, and you could argue that Morrison, along with the Edge, created a kind of wall of sound. The drone is John Cale's mainly, but not exclusively. It was thrilling to see him play live. There was another university gig in Manchester, and then I got a boat from Harwich to the Hook of Holland to see them play in the Netherlands and Belgium. It wasn't Lou Reed singing the songs, but so what? They didn't really have an Anglo-American audience. Europe at the time was interestingly different, and what was happening in Berlin, Paris, and Amsterdam was intellectual as well as fun. The response to rock and roll in Nordic Europe was more cerebral, and it was great to be in that audience. Dutch and Belgian hippies wore black! Even without the two central figures, that band was amazing. Hearing Sterling Morrison and Moe Tucker make that sound, it got to my gut as much as I hoped it would. It upset me, as I hoped it would. It was complicated to listen to. The pounding guitar on "I'm Waiting for the Man" was like an Irish jig, and it should have gone on forever, round and round and round. The guitar was so hypnotic, it was techno before techno. I listened to every note. I was a proper fan.

After a gig in Groningen in the Netherlands on November 21, Moe Tucker left the Velvet Underground. This was the last date of the band's 1971 European tour, and the last documented performance by the Doug Yule/Maureen Tucker/ Willie Alexander/Walter Powers line-up. Back in Long Island, Tucker picked up her job as a keypunch operator.

By contrast, by the end of 1971, Edie Sedgwick had lived more lives than all of the Factory's original Superstars. Frustrated by Warhol's unwillingness to give her more screen time, and irritated by not having a more meaningful role in the Velvet Underground (she had enjoyed dancing in front of them, but what she really wanted to do was sing), by 1966 she had largely moved on from Warhol to Bob Dylan (who wrote most of "Just Like a Woman" about her, the

parts that weren't about Joan Baez, that is). Shortly thereafter, Sedgwick started a relationship with Dylan's friend, folk musician Bobby Neuwirth. "I was like a sex slave to this man," Edie said. "I could make love for forty-eight hours... without getting tired. But the moment he left me alone, I felt so empty and lost that I would start popping pills." She was already spiraling down, so much so that in her final movie with Warhol, the artist gave one chilling direction: "I want something where Edie commits suicide at the end." Later, pondering aloud, he said, "Do you think Edie will let us film her when she commits suicide?"

As was pointed out in Jean Stein's famous oral biography of Sedgwick, she was glamorous, original, yet tragically exploitable. Like Edie says in the semi-biographical movie Ciao! Manhattan, *"I was a good target for the scene."*

When the affair with Neuwirth ended, her most consistent relationship was with drugs—her favorite cocktail was a speedball, or a shot of heroin in one arm and amphetamines in the other. She set fire to her apartment in the Chelsea Hotel, underwent electroshock therapy, and was incarcerated and hospitalized time and time again. By 1971, she had married Michael Post, a fellow patient at Cottage Hospital, where she had been admitted when she returned to California in 1968. The couple tied the knot on the Sedgwick family ranch, Laguna. Four months later, on November 16, 1971, Sedgwick was dead. She had suffocated in her sleep, face down in her pillow, at the age of twenty-eight. The coroner classified the death as "Undetermined/Accident/Suicide" and the cause of death as "probable acute barbiturate intoxication." As one obituarist said, she was born with a silver spoon in her mouth and died with a ladle of barbiturates in her system. Edie was buried in Oak Hill Cemetery in Ballard, California, and Andy Warhol did not go to the funeral.

To paraphrase James Wolcott, who reviewed Stein's tome in the New York Review of Books, *while in life, Edie Sedgwick was the crowning ornament of the Warhol entourage, in death, she was elevated into the company of Jim Morrison, Brian Jones, and Jimi Hendrix—that pop cavalcade of the beautiful slain.*

CHAPTER 9

THE GAY BLADES

1972

"I'm an artist and that means I can be as egotistical as I want to be."
—*Lou Reed*

Leee Black Childers: I got a job for *Sixteen* magazine, working for the gloriously brilliant Gloria Stavers, who taught Jim Morrison to shove his cock down the side of his leather pants, so it looked big and bulging. She taught him that trick, so she was a star maker. And then the call came from David Bowie. He wanted us to work for him. He'd become a huge sensation and he was going to do an American tour, but he didn't want business-type people working for him, more arty-type people.

Typical of us we just said yes OK, even though we didn't know anything about the music business. So Tony Zanetta became the president of the company [MainMan], I was vice president, and Cherry Vanilla was secretary. So over Bowie came to do the tour. Now, of course we had read that interview in which Bowie says he's bisexual. That had preceded him of course. Now to most of America, bisexual just means gay. It's queer. So, there was a lot of backlash against that and everything. David was right at the forefront with Bolan and Elton John, admitting they were bisexual. And with Lou Reed, like a lot of performers I've known, it wasn't even a case of bisexuality. It's just that they're so bizarre anyway, that they're attracted to bizarre sexual partners. It's not like David was particularly looking for boys, but he

wasn't particularly looking for girls. He was just looking for bizarre and wonderful people. I guess because it was so close to the Sixties, he got away with it on that basis.

Nick Rhodes: The thing about David Bowie is that he totally changed the whole game at that point. There were lots of other people who were equally as innovative at the time, some people maybe even further ahead—you look at Lou Reed, Iggy Pop, Bryan Ferry and Roxy Music, Eno, there were lots of people with progressive ideas—but it was David who managed to focus that Seventies energy into something that was irresistible. You bought into the whole thing. You didn't just buy into how great the songs were, or how strange the lyrics were, you bought into him being different, and it rubber-stamped you as being someone who thought about life in a different way.

Chris Thomas (producer): Both Bowie and Roxy did that "dang, dang, dang, dang, dang" thing you hear on "I'm Waiting for the Man." Just look at "Virginia Plain."

Mick Rock (photographer): David was very charming, and very friendly. It was never difficult being around David. He was amazingly self-disciplined, and he was always very careful in how he approached things. He didn't micromanage, but he liked to surround himself with people he could trust, who knew what they were doing, even if they weren't sure they could do it themselves. That's sort of what happened to me, as he gave me the confidence to just go for it. Somehow, I was at the right place at the right time with the right instincts. Through him I met Lou Reed, Iggy Pop, Mott the Hoople, and I shot all of them. All these people had been dropped, they were failures, and yet David was trying to resurrect them all. He waved his magic wand, and I got a little touch of that too. It was like a rising tide, as all the boats went up.

David Bowie: Just the verbal and musical zeitgeist that Lou created, the nature of the lyric writing that had been hitherto unknown in rock... gave us the environment in which to put our more theatrical vision. He supplied us with the street and the landscape, and we peopled it.

Richard Williams: I got friendly with Lisa Robinson, Richard Robinson, and Lenny Kaye in New York, and of course they were completely au fait with the Velvets. It was through them that I met Lou, when he was in London to record the first RCA album. I had lunch with him, and then went to Morgan Studios in Willesden to listen to what he was doing. Lou Reed in Willesden. That was where Rod Stewart's *Every Picture Tells a Story* had been recorded, so it was a decent studio. Odd set of musicians, though—Rick Wakeman, Steve Howe, Clem Cattini. I think it's a better album than its reputation suggests. Lou was genial. I enjoyed talking to him.

In April, Lou Reed finally released his first solo album, which was generally considered to be something of a disappointment. He hadn't appeared to have used his best songs—and by then he had stockpiled quite a large number—hadn't chosen the most appropriate musicians, and the production was flat. The only truly clever thing about the record was its cover, an illustration of the Spring Flower Fabergé egg on the sidewalk in the middle of Park Avenue.

Bobby Gillespie: The first Lou Reed album cover scared me. What the fuck was that?

When Rick Wakeman was hired to play on the sessions for the album at Morgan Studios, the British comedians Rolf Harris and Ronnie Barker were also recording in an adjacent studio. Wakeman says it was like a doctor's office, waiting to be called by Reed to add whatever he deemed acceptable. "Eventually someone came over and told me: 'Rick—Lou is ready for you now.' So I went up, and the studio was pitch-black apart from a lamp on the piano. I put the cans on, and I hear Lou's voice in my ear: 'I'm gonna play you this track, and I want you to play piano real quick over it. Just make sure you play real quick.' I played over a few song snippets, then he went: 'Thank you. That was great.' I got up, the lights came on, and he came down, thanked me, and I walked out the door. It was an incredibly bizarre session."

While Reed's attitude toward the recording process may have been rigidly transactional, the resulting record was tentative in the extreme. Boring, even. In a climate in which his former group were starting to infect the mainstream— David Bowie had a bad case of it—Reed almost seemed as though he was in denial about his past. Critics didn't like the record, it didn't sell, while Reed

had deliberately tried to market himself as a straight-ahead rock star rather than the transgressive street figure he had successfully become in the minds of the small coterie of hardcore Velvets fans. Danny Baker was one of the few critics to like it: "I missed the Velvet Underground and have never really caught them since," he says, "but those first four Lou Reed solos became VERY personal to me at the time and ever since. The first one gets short shrift but ever since I bought it in Petticoat Lane, I have held it close."

Glenn O'Brien had just started working at Interview *and he commissioned Reed to write a piece about his record. O'Brien had seen the Velvets play back in '67 at La Cave, a folk club on the east side of Cleveland. "The club, which was located in a basement, was either half full or half empty, but it wasn't exactly the usual folkie crowd," he said. "There was a biker contingent present. And strange pale people, not deadhead hippies." He was smitten, and was excited about the possibility of bumping into Reed when he started work at the Factory. When he eventually met him, he thought he was "really pathetic. I don't know what he was on, but he was really out of it. He was my hero, but it was like his life was over." O'Brien said he seemed "strangely damaged," but thought it would be interesting to ask him to write a piece about making his first solo album. "He sent me a piece and I thought it was embarrassingly earnest, but also kind of lobotomized. I told Lou that it wasn't really what I had in mind, and he apologized to me. I felt awful."*

Bowie and Reed shared a record label, RCA, and when Bowie suggested to them he produce Lou's next album, Reed was as enthusiastic as they were. For once, his commercial instinct allowed him to box up his ego. The alliance with the encroaching world of Ziggy Stardust would instill Reed with some glamour, while Bowie would be imbued with instant cool. Both would be anointed in ways that made sense for their respective careers. A natural collaborator, Bowie used his considerable fame to help popularize artists who would have had less of a chance without him. In 1972 he did this with Iggy Pop, Mott the Hoople, and Lou Reed. And he didn't break a sweat. With Bowie it was charm, charm, charm, and it worked. He told Reed he had written "Rock'n'Roll Suicide" for him, but then Reed surmised that he might tell everyone a particular song had been written for them. He actually didn't care, as he was going to use David Bowie just as much as David Bowie was about to use him.

Marc Bolan, who was quickly starting to realize that everything he did with T. Rex was being overshadowed by Bowie's ascent, and knowing that he was now working with Lou Reed, dismissed the American: "I never liked

the Velvet Underground," he said. "The singer always sounded like a bad copy of Dylan to me."

But Reed was learning to exploit the new glam world. When Roy Hollingsworth interviewed him for Melody Maker *in June, the singer told him to describe him as a "bisexual chauvinist pig."*

David Bowie: Lou was going through an incredibly bad patch around the time that I first met him, and he was being left on the side in terms of what his influence had been. And none of us knew what his influence was going to be—the direction of the Velvet Underground's reputation.

Michael Zilkha: My first week at Oxford, Lou Reed played the Oxford Poly, in September '72. I yelled out "Venus in Furs" and there was a silence and then he said, "Not a chance kid. Read the books. That's where I got it."

Barney Hoskyns: Lou allowed himself to be a vessel. Bowie in a sense was using him, as an adjunct to the whole Ziggy project. Bowie was just so charming, so seductive, so flattering, and so noncompetitive. He wasn't attempting to oust or displace Lou from his place on the cult rock and roll pedestal. He really wanted to pay tribute. I suspect Lou was quite flattered by all this, plus he could obviously see how brilliant Ronson was as a player and as an arranger.

Lou Reed: Mick Ronson's arrangements were killer. The thing about Ronno was that I could never understand a word that he said; it's, like, he's from Hull. You had to ask him eight times to say something, and he was like, "Ouzibuzziwoozy..." Absolutely incomprehensible... I mean, sweet guy, but incomprehensible. Completely. But listen to that arrangement of "Perfect Day." That's Ronson.

Nick Kent: I first interviewed Lou Reed in the autumn of 1972, when he was finishing *Transformer*, and I met him in Mr. Chow's in London. He was there with the guy in the cap on the back cover of the album, the one with a plastic banana down his pants, a bitchy New York guy called Ernie Thormahlen. Reed was in a pretty dour, weird mood. He was never comfortable in his own skin. There was something not quite right

going on between his ears, and I think his overuse of speed had rendered him paranoid. He was always complaining about being underrated, and that nobody recognized his innovations. For instance, he told me the Beatles had stolen the idea for the cover of the "White Album" from the cover of *White Light/White Heat*. This clearly was paranoia, as the Beatles probably didn't even know that *White Light/White Heat* existed. Richard Hamilton designed it and he probably hadn't heard of it either. Then Lou claimed Bob Dylan had ripped him off, but none of it felt plausible. He was in a world of his own, and hadn't become the rock star he wanted to be. That night he only said good things about David Bowie but I could tell from the conversation he was having with Ernie that he didn't think Bowie was in his league.

Tony Visconti (record producer): I first met Lou during the making of *Transformer*. I was in London and David was dressed as Ziggy Stardust at the time, in his daytime life as well as the shows. He was producing *Transformer* and he asked me to pop in the studio to meet Lou. I think at the time, when Velvet Underground came out, I was in fear of Lou. I didn't want to meet him. He was too awesome and intimidating, if his lyrics were anything to go by. I went to Trident Studios in London where a lot of famous recordings were made. I worked with T. Rex. David made *Ziggy* there. Queen made a bunch of their recordings there. I met Lou there and I think he was on heroin. He was just sitting in the corner on the floor kind of nodding off. I remember kneeling down and shaking his hand and saying "hello" and he just looked up and was all glazed over.

Mick Rock: I mean, Bowie wanted it. He was extremely ambitious and in the early days of Ziggy he could taste it. He knew it was about to happen and that made him an invigorating person to be around. He was hip, too, because much as everyone knows about the Velvet Underground and Iggy Pop these days, no one knew about them back then. But I did, and he did. We thought we were very hip. I'd taken a lot of LSD at Cambridge and thought I was pretty experienced.

Nick Kent: Lou Reed, Iggy Pop, and Mott the Hoople were all signed to MainMan, and they realized quite quickly that Tony Defries was mainly interested in Bowie, and while he may have been ostensibly

looking after them, through MainMan, he was mainly interested in protecting Bowie. He saw Bowie as his Elvis and just saw the others as afterthoughts, as Carl Perkins...Bowie was the only star. Bowie had cracked the mainstream, and Iggy and Lou Reed never did. There were times when Iggy was in a bad way and he would reach out to Bowie, and there was always a connection between them, a respect and genuine affection. Bowie didn't have that for other people. Bowie genuinely loved Iggy, but then Iggy is very lovable. He had an unlovable side, but he was lovable too. When Iggy was in the Stooges he was the general of his own army, but when he went to work for David Bowie he was the lone soldier on the hill, standing with mercenaries.

Hanif Kureishi (author): Bowie was very disappointed in his relationship with Lou Reed because Lou Reed was such a cunt. However, I remember him talking to me about being at Lou Reed's apartment and finding all these Andy Warhol things. He had such huge admiration for Warhol because of Warhol's ability to change, to steal. And to not worry about being original. Bowie *loved* that.

Nick Kent: Lou Reed viewed Bowie as Bette Davis viewed Eve in *All About Eve*. Lou Reed even referred to Bowie as Eve on several occasions. But once they'd worked together, he realized that Bowie had skills that he didn't have. The thing is, Bowie got Lou Reed hits, he got Iggy hits. Up until Bowie they hadn't had any hits. The only two hits that Lou Reed ever had were "Walk on the Wild Side" and "Perfect Day," proper mainstream hits, produced with great elegance by David Bowie.

Ray Davies (musician, songwriter): Before he passed away, Lou Reed told me that "Lola" was "a big influence on him." He said it was "reassuring" to him when he did "Walk on the Wild Side."

Mary Harron: If David Bowie hadn't produced *Transformer*, would Lou Reed have had such a successful solo career? All the hardcore Velvets people thought Lou had sold out by doing this. But Lou was genuinely into transformation, he was genuinely bi. Can you believe Tony Blackburn chose "Walk on the Wild Side" as his single of the week?

Duncan Hannah: I liked *Transformer*, but I thought he'd hopped on the glam bandwagon, and it didn't seem appropriate to me.

Marco Pirroni: I first became aware of the Velvet Underground in that magical year, 1972. I was thirteen at the time, and going into record shops like Harlequin, just seeing what they had. I didn't know who anyone was, and you flicked through until you saw something you liked. I kept seeing this album with a banana on it, then another one, a double, with a big Coke bottle on it, that turned out to be a Velvets compilation. I'd read some article in a defunct music magazine about Bowie producing *Transformer*, so I checked it out. I thought it was fucking brilliant, so I thought I should check them out. I didn't know anything about them, didn't know what order the albums came in. You didn't in those days. So I bought another compilation called *The Best of Lou Reed and the Velvet Underground*, which had a strange foil cover, and as soon as I heard "I'm Waiting for the Man" I was hooked. Then I bought the banana one because I liked the cover, then all the others. I was out on my own because nobody seemed to know anything about them. I was at school in Harrow at the time, at a comprehensive, and nobody had heard of them. I was completely alone. It was quite fun playing "Sister Ray" in the common room because everybody hated it, and it made me love them more.

Lou Reed: The whole glam thing was great for me. This was something I had already seen with Warhol, but I hadn't *done* that thing. The Seventies was a chance for me to get in on it, and since no one knew me from Adam particularly, I could say I was anything. I had learned that from Andy: Nobody knows. You could be anything.

Bobby Gillespie: I only caught up with *Transformer* later on as I hadn't followed Lou Reed's career, and it was difficult to think this was the same man who had been in the Velvet Underground. It sounded like AOR with risqué lyrics. I remember when I first saw someone holding the record under their arm—this would have been about '74, '75—and thinking the image was really heavy. It looked druggie. This guy looked like he was into forbidden stuff. Strange. I could see there was some darkness there.

Marco Pirroni: At the time I couldn't discern any influences the band had. It didn't sound like anything else. Now I know that all my heroes—Bryan Ferry, David Bowie, and Lou Reed—were all obsessed with Bob Dylan. I remember talking to Pete Sinfield, who produced "Virginia Plain," and he said that when Bryan first played him the song it sounded like a Bob Dylan song. And it does.

Nick Kent: Lou really loved the first piece I wrote about him, which to me was a piece of shit. It was one of my very early pieces for the *NME*, and because he had been doing all this bragging about what he had innovated, I put it all in. I once met him in Michigan with Lester Bangs, who had been writing about him for ages. Reed obviously had a problem with Bangs, and so he gravitated toward me. So it was strange. Perhaps Bangs was too enamored of him. Lou Reed was very much, "Whatever you think of me, that is who I am not." He was one of those guys. If someone came along and said, "I think you're like this, which is why I can relate to you," Lou Reed's response would have been, "No I'm not. You're wrong, and you're an idiot." Iggy Pop was the same way. That famous picture of Lou with Bowie and Iggy? People call them the Three Amigos, but it should have been called the Three Big Egos. Big, big motherfucking egos. Bowie genuinely admired those two, but those two didn't admire him so much. They admired his professionalism, and they could see that he had a range of musical talents that was wider than theirs, but as they were rock purists, what anyone else did wasn't quite the right stuff. Lou Reed often talked in glowing terms about Brian Wilson, James Brown, and Elvis Presley, but he ran down everyone else. His peers? Forget it.

Lou Reed: Bowie was very clever. We found we had a lot of things in common. Associating with me brought his name out to a lot more people, too. He was very good in the studio. In a manner of speaking, he produced an album for me.

Harvey Goldsmith (concert promoter): Publicly Lou and David got on extremely well, fed off each other, although privately I think there was a lot of rivalry. I suppose he could think that he'd been conned by Bowie, and there are a lot of casualties that Bowie has left along the way.

Bowie was a terrible magpie, but then he worked with a lot of people. In his heyday Lou Reed was very coquettish, as was Bowie really, and I think essentially they were friendly rivals. I don't think Lou had any resentment that I was aware of, but I can't be sure.

Nick Kent: Lou Reed and Iggy Pop were two of the most maniacal, ego-driven people you could ever hope to meet. They were control freaks. So the very fact that they would acquiesce to Bowie tinkering with their music was a major thing. They saw Bowie in conflicted ways. They could see that he was using them to a certain degree, but you have to remember that they were marginal characters. Nowadays people claim that the Velvet Underground and Lou Reed had amazing cachet back in the early Seventies, but they were the cult of cults. It's true that if you went round to someone's house and they had a Velvet Underground record then you thought that this person was worth talking to. But maybe one thousand people in Great Britain owned Velvet Underground records. Maybe five hundred people owned Stooges records. Maybe. So he may have been using them, but it wasn't as though he was glomming onto the Rolling Stones or Rod Stewart. These were marginal people. He chose Iggy Pop and Lou Reed because he knew that the Sixties were dead. He understood that since the Beatles had broken up, the decade was over. No one else understood that. He realized that his future lay in articulating a new sensibility that could be aligned to the Seventies. The pendulum was swinging. It wasn't about big guys with beards playing mandolins anymore. The Band were over. Nineteen-seventy was all about clean-shaven men singing about science fiction, like Marc Bolan. It was a 180-degree swing. Bowie understood the pendulum swings because he'd been through all of this in the Sixties. One month he was in a rhythm and blues group, the next month a mod group, then a freak-out group. He knew how things changed, and how you could become obsolete in the blink of an eye. He made it his business to stamp his personality on that decade. And he knew that Lou Reed and Iggy Pop were both ahead of their time. And those were the guys to be with. He wasn't going to sell more records, but his work was going to be informed by these guys, and he could align himself with them. It was cachet.

He also genuinely believed that these guys were the cat's pajamas. He wanted to learn from them. Two months after the Imperial College gig

the Spiders from Mars played the Polytechnic of Central London, and the Stooges, Lou Reed, and Mott the Hoople were all in the audience. This is the first time that I met Ron Asheton from the Stooges. And all these guys are standing around thinking we're here because we have to be, because Bowie is now our patron. The Stooges were like a motorcycle gang, and they're thinking, What is this shit? They're not usually impressed. Bowie knows that they're all there and at the end of his set he turns to Iggy in the audience and he performs "Sex Machine" by James Brown, which is the only time he ever played it. And he did it for Iggy, as if to say, OK, you think you're the James Brown of garage rock, and you might think I'm camp, and you might think I'm fake, but I can do James Brown as well as you can, and he did. That was how Bowie got people's respect. And Iggy respected him. Honestly, you should get Iggy Pop on Bob Dylan or Bruce Springsteen. Bowie tried to copy Iggy, and he did some of it successfully, but not the stage diving, as you can't stand up on an audience if you're wearing platform boots. That was Bowie being a magpie. I remember Mick Jagger telling me that the only person he had respect for as a performer was Bowie. He knew he had to be on top of his game…

Charles Shaar Murray (journalist): Did Bowie rip off Iggy Pop and Lou Reed? Maybe. He ripped people off, put them on the shelf, and then would maybe come back for them. Maybe not. Lou Reed did feel used. Lou's biggest ever hit was the *Transformer* album, and that was Bowie and Ronno. The only two songs that civilians are aware of are "Walk on the Wild Side" and "Perfect Day." Art rock geeks will be able to argue for hours over which of the two live versions of "I'm Waiting for the Man" is definitive. But civilians just know those two songs. Lou wrote the songs, but it was David and Mick who crafted the arrangements and made them popular. Just as I think David had something to prove on *Diamond Dogs*, that he didn't need Ronno, so Lou was very miffed that people might think he needed David Bowie. David wanted to work with Lou again, but Lou was notoriously stingy about sharing credits, let alone royalties, and he didn't want to write with him again. He had an auteur complex, and Bowie didn't fit into that. Lou was also a prime member of the awkward squad. He could lose a charm competition with Van Morrison.

Bob Harris (broadcaster): Mick Ronson was fantastic in the studio, and while I know that David gets the production credit for Lou Reed's *Transformer*, the hub of it was Mick. But because Mick was a modest sort of guy, really, despite the showmanship, he never really wanted to push anybody else out of the spotlight and claim it for himself. You can't overestimate Mick's contribution to the sound, the look, and the image of Ziggy Stardust. Much later I spent some time with him in Woodstock while he was hanging out at Bearsville Studios, and I got the sense that he felt very sad and disillusioned by the fact that David had moved on from him so comprehensively. I just felt he had this sadness about him, I think he found it very difficult.

Ron Asheton: When Bowie was rehearsing for his show at the Rainbow, we went to the rehearsal. We were watching these guys get ready for their first big Spiders from Mars show. So we were at the show and we'd gotten prime seats and he was playing, and the place was packed, and my brother and me were going, "Ah, we already seen this shit, let's go get a beer!" We went to the bar, and there was Lou Reed. He was drunk and on pills, so he gave us each a Mandrax. The next day I got a phone call to come down to the MainMan office. Bowie's manager Tony chewed me out for getting up in the middle of David's show and walking out. He was furious. I was like, "Fuck you, man. I mean every seat was full, and I just didn't wanna be there!" But when we went over to London to work with Bowie, it was a good situation. It was all top-notch stuff. We had a mews house with four stories and a driver. MainMan, at that time, was just top notch. I must say, Bowie helped Iggy every step of the way. I don't know how many fucking times Bowie got him deals. If it wasn't for Bowie, Iggy would be dead. The only reason Iggy is playing music today is because of Bowie. I mean, Bowie admired Iggy—and in a way, he wanted to be like him.

Nick Kent: In March or April of '72, Lou had briefly appeared onstage with David Bowie at one of the early Ziggy Stardust gigs, which was his first appearance on a British stage. But the first full performance was at the Scala Cinema in July 1972. It was an all-nighter, and he played at two o'clock in the morning. MainMan, who were managing Lou Reed at the time, had flown a lot of journalists over from the US. Lou Reed played on the Friday, then Bowie played on the Saturday evening at Friars in

Aylesbury, and then the coach deposited the journalists at the Scala to see the Stooges playing early on the Sunday morning. I went with the Stooges' guitarist James Williamson to see Lou, and we went backstage before the show, behind the screen. All performers get a little nervous before a show, but I've never seen anyone shaking like Lou Reed that night. He was all made up. The cover of *Transformer* was taken that night, by Mick Rock, and that's what he looked like. He looked like Frankenstein's monster. He was wearing so much theatrical makeup his face was completely white. He was physically shaking, so much so that his voice tightened up onstage. It was terrible to watch. He had stage fright on a level I have never seen. Mick Jagger told me that of all the people he'd met, Lou Reed had the worst stage nerves. I don't think he was ever comfortable onstage.

Stephen Troussé (writer, *Uncut*): Following his exit from Doug Yule's VU, during his "period of exile and great pondering," Lou Reed was supposedly approached by the production team behind the revival of *The Threepenny Opera*, who told him that, "after Ray Davies," Reed was the writer best suited to producing songs for an off-Broadway adaptation of Nelson Algren's "book about cripples," *A Walk on the Wild Side*. The show was never produced, but Lou already had the theme song, which he vowed "to save for the day I decided to assault the world." That day turned out to be November 8, 1972, when, against all odds, *Transformer* was released and Lou Reed was finally transmuted from monochrome cult hero into solid-gold glam pop star. The supposed Broadway origins of the album's best-known number still feel suggestive. Listen to the album in this context and you could easily imagine a Lionel Bartian exclamation mark: TRANSFORMER! (or even an alternative title: LOWER EAST SIDE STORY!). If *Transformer* is an exploitation album, it's one of genius. Partly because it's not always clear who's screwing who, and who stands to profit. Was Lou, as his betrayed fans maintained, simply cashing in on his legend, desperately hitching a ride on the fashionable coattails of his more successful disciples? Or was his new mentor and producer David Bowie (by now not so much in an imperial as a messianic moment, bringing all manner of Lazaruses back from the grave) sucking on the last drops of Factory ichor to lend dark and shade to his own nascent legend?

Barney Hoskyns: I think I heard *Transformer* before I knew there was a group called the Velvet Underground. Coming into glam rock, with Bowie, T. Rex, etc., that was the first music I consumed as a pop fanatic. Then I became aware of this slightly older gentleman who Bowie was rehabilitating, in the same way he was rehabilitating Iggy Pop. I was reading *Sounds* at the time, because of the color posters inside, to cover the walls of my dormitory wall at Westminster. Then I started reading *NME* and *Let It Rock*, which had Lou Reed on its cover—"The Phantom of Rock!" The success of *Transformer* gave him a new form of identity, a new kind of status and a new direction. If you were into Bowie, the fact that Bowie was almost operating as Lou's patron counted for a lot because Bowie counted for a lot. You wanted to know what Bowie and Mick Ronson were doing with this slightly older geezer. And it's a really good record. There are a couple of meat and potatoes songs that sound like they were made by a bar band—"Wagon Wheel" and "Hangin' Round" for instance—but everything else on it is very distinctive and very interesting. It's a marriage of New York and London at a very pivotal moment. The album is shot through with Warhol, blatantly channeling his decadent, sinister, transgressive version of Manhattan. But then it's being recorded at Trident Studios in London, with Bowie and Ronson shaping it. Culturally it's important because it's one of those glam records that challenges normality, especially in the way it's presented, with the greaser with a banana in his pants, combing his hair. It's Lou celebrating everything that's transgressive about the residue of post-Factory New York. It's a very trans record. He is transformed. Bowie was the transformer. Before this Lou had been dour, monochrome, and forbidding. With this record he was transformed into an honorary glam peacock. It stems from Angie Bowie saying, "Why don't *you* dress up!" Previous to this he'd spent all his life wearing black. It's also an example of Bowie's incredible creative flowering. Mick Ronson's arrangements are wonderful, as are the surprising instrumentations. There is also some blazingly beautiful guitar playing. All in all, it's a seminal document of that moment in rock and roll where you get a convergence of glamour and debauchery, with Lou as this arch commentator on that milieu.

Jimmy Page: I loved *Transformer*. Lou was a strong character. He was always Lou Reed. No matter how many incarnations there were, it

was still really strong, the Lou Reed character. The writing. The playing. The construction. It was all cool.

Richard Williams: I didn't like *Transformer* because I didn't like David Bowie. At that stage I thought he was a charlatan, and I didn't like his influence on Lou. As a foil for Lou, I didn't think David Bowie was an interesting replacement for John Cale. Lou was working with Bowie because he wanted to make it. It wasn't desperation but he wanted to be successful. He saw a vehicle for that. He saw a bus approaching and if he jumped on it he'd get to where he wanted to go.

Bebe Buell: I moved to New York from Virginia in 1972. I'm a Southern girl, like a lot of people who ended up in New York. It was a dream to be in New York City. I knew I was meant to be there. Supposedly there was a ton of crime, there was lots of garbage, unemployment, but for me it was heaven because I was in Max's Kansas City. When you're eighteen you really focus on that kind of thing. Once I discovered Max's my fate was sealed. I'd been there once with Todd Rundgren, on our first date, but only in the front room. When I went to the bathroom I saw the back room, all lit in red light. I figured to get into the back room you had to deserve to be in the back room. And I wanted to go back there. I was living in a woman's residence run by nuns up on Seventy-Second Street that Eileen Ford, my agent, had put me into, thinking that I wouldn't get into trouble. But then she didn't know me. One night I saw all these drag queens going on the Second Avenue bus so I just followed them. I loved the way they were dressed, loved all the feathers, and they ended up in Max's and as they walked straight into the back room, I slowly trailed behind them. The first people I met were Lou Reed and this beautiful creature called Rachel. Lou could tell that I was only eighteen, as he came up and asked if I was new in town. I'd only been in New York for a couple of months. They invited me to sit with them and took me under their wing. I hit it on a good night, as Warhol was there too. It was written in the stars. He looked at me and said, "You look like your parents breed horses." He was trying to see if I had enough money to buy one of his paintings. He was so famous for selling himself. He did it in a way that people responded to. He was majestic about it, so people weren't offended. Every night I went there were

these wonderful luminaries. Judgment wasn't as rampant then, as we all hung out together. Painters, sculptors, designers, models, artists, and rock stars. A colorful artistic smorgasbord of beautiful energy. I've never been anywhere like it. I saw Patti Smith's first gig there. At Max's you couldn't be a dumb ass. You had to have some intellectual flair. It was a very tough room.

Bob Colacello: The Factory was based on confusing sexuality. It's why a lot of people visited. Everyone from the society ladies to David Bowie. Andy was always creating mysteries, and in a way it was sexier not to be so defined. Andy would never say if he thought someone was gay. He would say someone has a problem. He would say, "Oh come on, Bob, Peter Beard has a problem." And I'd go, "No, Andy, Peter has fifteen girlfriends, I don't think he has a problem. I wish he did! But he doesn't." And then Andy would say, "That's what I mean. He has a problem because he's trying to cover it up."

They say that you know you're from New York when you can get into a four-hour argument about the best way to get from Columbus Circle to Battery Park at 3:30 on the Friday before a long weekend, but couldn't find Wisconsin on a map if someone held a gun to your head (which, being from New York, you're probably used to by now). They say you know you're from New York when you believe that being able to swear at people in their own language makes you multilingual. They say you also know you're from New York when you consider Frank Sinatra's "New York, New York" to be the American national anthem.

Some cities have their buildings, others have their bridges. New York has its songs. Lots of them. From Rodgers and Hart's "Manhattan" and "New York, New York" from the musical On the Town, *to Billy Joel's "New York State of Mind," New York has more anthems than any other city in the world.*

From the hem of Harlem to the bowels of the Bowery, via the tiny town-houses of the Upper East Side, the bohemian brownstones north of Columbus Circle, and the rejuvenated skyscraper hotels of midtown, Manhattan is a city of song. Or, more specifically, a city of songs.

Just think of the way the town has been personified by words and music: "Native New Yorker" by Odyssey, "An Englishman in New York" by Sting, "New York's a Lonely Town" by the Tradewinds, "Hey Manhattan" by Prefab Sprout,

"New York" by U2, "Bad Sneakers" by Steely Dan, "Lullaby of Birdland" by Ella Fitzgerald, "53rd and 3rd" by the Ramones, "On Broadway" by the Drifters, "59th Street Bridge Song" by Simon and Garfunkel, "New York on Sunday" by Mel Tormé, "Everybody's Out of Town" by Nilsson, and everyone's favorite yuletide yomp, "Fairytale of New York" by the Pogues and Kirsty MacColl. A while ago readers of Rolling Stone *surprisingly voted "Back in N.Y.C.," from* The Lamb Lies Down on Broadway *as one of their top ten New York songs; and who could forget the song that many think is Manhattan's real signature tune, "New York Minute" by Don Henley?*

Sinatra's epic is probably the best-known New York song (even though it was originally written for Liza Minnelli, for Martin Scorsese's much-neglected film of the same name, from 1977), but it was usurped by another anthem, Jay-Z and Alicia Keys' "Empire State of Mind," which is probably the best New York song of the new century so far. The song became so iconic so quickly, it even attracted its own feature in the New York Times, *written by Ben Sisario. "The song breaks down as roughly 50 percent rote Jay-Z chest-beating ('I'm the new Sinatra'), 30 percent tourist-friendly travelogue ('Statue of Liberty, long live the World Trade'), and the rest a glorious Alicia Keys hook." As Sisario eloquently points out, "New York is all about scale, from the skyline to the ambitions it frames, and like other great NY songs, Jay-Z's anthem offers a panoramic, postcard view of the city, leaping from landmark to distant landmark."*

These songs take ownership of the town, using the city as a personal playground, an aural smorgasbord comprising their own predilections, power, and personality. Or, to put it another way, ego. New Yorkers often have a sense of destiny. By dint of their location, they can think they are invincible, indestructible. Impervious to pretty much anything and everything you care to throw at them. Consequently, it is the only city in the world that not only entertains anthems, it demands them. On a regular basis.

"Walk on the Wild Side" didn't start out as an anthem. In essence it was a perfectly dispassionate encapsulation of the old Warhol gang, a celebration of the Factory Superstars Holly Woodlawn, Jackie Curtis, Candy Darling, Joe Dallesandro, and Sugar Plum Fairy. "They were the raging queens of Max's Kansas City, and they got very little in return for all of the groundbreaking things that they did," said Patti Smith about some of the more prominent characters in Reed's song, "and to be heralded by someone like Lou was lovingly compassionate without being syrupy." Its famous bass line, played by Bowie

stalwart Herbie Flowers on both stand-up and electric bass, is one of the most identifiable in pop. Bowie and Reed were photographed together a lot around this time, prompting gossip about an affair, although this was always an unnecessary aspect of their Faustian bargain. "Lou didn't feel he needed to do that," says one London-based PR who knew them both. "He'd put up with a lot from Bowie without sleeping with him."

Lester Bangs thought he'd put up with too much. Bangs, whose confrontational style made him the most important music critic of the early Seventies, told Reed he thought Bowie "fucks everybody in the rock and roll circuit. He's a bigger groupie than Jann Wenner."

"He's the one who's getting fucked," parried Reed.

Bangs thought Reed had lost his edge, accusing him of using Transformer to play to pseudo-decadence, to an audience that wanted to buy a reprocessed form of decadence. "Why is this guy, who has made a career out of terminal twitches ever since the Velvet Underground surfaced dead on arrival in 1966, still here?"

Nick Tosches wasn't much of a fan of the record, either. "A real cockteaser, this album," he wrote in his Rolling Stone review of Transformer. "That great cover: Lou and those burned-out eyes staring out in grim black and white beneath a haze of gold spray paint, and on the back, ace berdache Ernie Thormahlen posing in archetypal butch, complete with cartoon erectile bulge, short hair, motorcycle cap, and pack of Luckies up his T-shirt sleeve, and then again resplendent in high heels, panty hose, rouge, mascara, and long ebony locks; the title with all its connotations of finality and electromagnetic perversity. Your preternatural instincts tell you it's all there, but all you're given is glint, flash, and frottage."

Even as a precocious twelve-year-old I'm fairly certain I didn't know what frottage was at the time, but it would have been suitably intriguing for me to look it up. The review I would have read before anyone else's would have been Charles Shaar Murray's in the NME, on December 16, perused with interest because of Bowie's involvement. "Transformer is an incredibly irritating album," he wrote. "On the front is a heavily retouched photo of Lou in his sweetest gay-Frankenstein drag. On the back is this absurd guy in jeans and a skimpy T-shirt with a cigarette packet twisted into the sleeve, a sailor-boy cap, and a grotesquely reinforced codpiece. He's staring at a lovely young chick (at least, I think it's a chick) in a filmy black lace thingy. 'Transformer,' huh? Fahhh out."

Oh dear, not much cop then, I assumed. I had been one of the many millions who had seen Bowie on Top of the Pops *that summer performing "Starman," and like many of them, I very much felt that I was now orbiting him. I had other interests—Alice Cooper was (incongruously) replacing Manchester United, Joseph Heller and Tom Wolfe were starting to nudge out* The Goon Show, *but Bowie was front and center. For my generation, Bowie acted much like Google, introducing us to a motley collection of fascinating cultural oddballs. And if he liked Lou Reed, then I was going to love him too.*

Bizarrely, one day my father admitted he liked him too. Being an incredibly violent man—he'd nearly killed a boy when he was at school—my dad was the kind of person it was best to be wary of. He spent the best part of a decade knocking seven bells out of me and my mother, and so we had learned to be careful how we acted at home. He had spent most of his career in the air force, although every now and then his creative frustrations poked through, indicating he spent most of his time denying them. And in 1972, these frustrations started to manifest themselves in strange ways. My father, who had previously shown no interest in sartorial matters, began wearing brightly colored peaked caps and cravats, and started sporting an equally garish shoulder bag. It was almost as though he was trying to tell the world he was gay (something I didn't think was possible), but probably pointed to a midlife crisis (he would have been in his forties). His transformation only lasted a few months, but it was disconcerting to say the least.

But nothing had prepared me for what happened next. As I came in from my secondary modern one day, he handed me a copy of "Walk on the Wild Side," the first single from Transformer, *brandishing it as though it were a fresh ten-pound note. I can't remember how he described it, but it was less a peace offering and more an overeager display of his apparent hipness. I didn't have the heart to tell him I had already bought it—this may have resulted in a punch to the head—but it made me never want to bring the subject up again. Luckily, he never mentioned Lou Reed again.*

Now, I'm not sure I'd heard of the Velvet Underground before Bowie's endorsement of Lou Reed, but after buying and loving Transformer *I started to scour local record shops to see what treasures I could find. In a junk shop in High Wycombe, I eventually found a copy of the* Andy Warhol's Velvet Underground featuring Nico *double album (the one with illustrations of lips and Coke bottles on the cover that were meant to*

look as though they were painted by the artist), and shortly after bought a second-hand copy of the first album—albeit with the British cover—in Kensington Market.*

At that age—I was twelve—I spent most of my spare time in record shops, hunting through the racks for rarities and bargains; these two purchases were both. One of the most appealing things about the process of discovering esoteric and idiosyncratic music at the time was imagining what kind of lives the musicians had outside of recording and touring. What did they do during the day? Where did they live? Did they make this mad, crazy, intoxicating music because they were on drugs? Or did they take drugs because they made this mad, crazy, intoxicating music? When I started listening to the Velvet Underground and the Stooges (another Bowie recommendation, obviously), I was not equipped to imagine what they got up to when they weren't playing music. Which obviously made them even more alluring. They just felt so... urban. Two years later, before fully embracing butterfly-collared shirts, velvet jackets, and Oxford bags, I even went through a period of rolling up my drainpipe jeans—skinhead style—worn with pink socks and black Dr. Martens shoes, in the vain hope of trying to advertise the fact that I owned records by people who lived in New York. In my eyes the city started to take on an almost mythical glow, reinvented in my imagination as an island peopled exclusively by the weird and the interesting. This was why I would initially lean more toward the New York punk groups, preferring the Ramones to the Sex Pistols, and Richard Hell and the Voidoids rather than the dubious and parochial delights of the Damned. If you were from New York, you were exotic.

Particularly if you were Andy Warhol. By 1972 I had already become quietly obsessed with Warhol. Earlier in the year David Bailey had self-published a transcript of his controversial TV documentary on the artist, which I had bought in a local newsagent. In 1971, the media impresario Lew Grade had hired the

* This is the first Velvet Underground album Jarvis Cocker bought, when his band Pulp had been compared to them in a Sheffield fanzine. "I bet Andy Warhol was mad as hell when he saw this picture," says Cocker. "Someone at the record company has commissioned a kind of 'cover version' of one of his paintings. Big red lips sucking on a bottle of Coca-Cola. Fizzy Pop Art. But he'd brought it on himself: Warhol's genius move was to get people to reappraise the contents of their rubbish bins. Until he came along a Campbell's soup can was just a container for soup. And a Coke bottle was just a Coke bottle. He changed the way people saw the everyday world around them. And once he'd done that, the whole world jumped on the pop bandwagon. Including the guy in the record company art department."

photographer to direct a series of arts documentaries for the ATV franchise, despite Bailey's complete lack of experience in the field. He ended up making three films, on Luchino Visconti, Cecil Beaton, and, infamously, Andy Warhol, which would go on to cause press outrage and legal action from moralizing fanatics. The Warhol documentary turned out to be a portrait of the dying days of the Factory, with Bailey getting extraordinary access to both Warhol and the likes of Holly Woodlawn, Jane Holzer, and Candy Darling. At one point the artist says he'll only be interviewed by Bailey if they share a bed together, which obviously made for great TV. Elsewhere there was footage of Brigid Berlin, who was filmed making her "tit prints"—painting her breast and then pressing it to paper. It was this section that caused such a fuss among a small group of self-appointed moral guardians, who tried to get the documentary banned. When ATV screened the film to the press, it caused a predictable tabloid storm, and these moral campaigners saw a chance to stand up against what they considered to be the tide of filth they thought was engulfing the nation. The film was initially banned, but after an appeal it was eventually broadcast on March 27, 1973, and unsurprisingly was a ratings hit—although while fourteen million viewers tuned in to be titillated and outraged, many were inevitably disappointed.

However, it was the transcript of the show, complete with Bailey's intriguing photographic glimpses of this secret New York world, that piqued my interest. I didn't for one minute imagine I could somehow make it to New York, but a growing obsession with Warhol encouraged me to think about little else but going to art school. Precociously, American Pop Art became my thing, and I devoured anything I could find on Warhol, Roy Lichtenstein, Robert Rauschenberg, Interview *magazine, and all those travel books I found in the library full of photographs of Main Street America, billboards, Coca-Cola signs, Las Vegas swimming pools, palm trees, traffic lights, backlit Perspex shop signs, and the cluttered skylines of Los Angeles and Detroit. Americana, that was what I was in love with, an Americana seen through the quizzical eyes of Pop Art and trashy pop, Tom Wolfe and Vance Packard.**

* Forty years later Bailey and I were sharing an industrial-size tent in Camp Bastion, the British Army airbase, northwest of the city of Lashkargah in Helmand Province, Afghanistan. We were spending a week here to produce a book in aid of Help for Heroes, the wounded ex-servicemen's charity, photographing and interviewing frontline troops. One night in the tent, Bailey, a terrible insomniac, was reading a book wearing a makeshift miner's helmet. Droll as ever, he said, "I wish I was in bed with Andy Warhol."

THE GAY BLADES

David Bailey: I made a film about Andy, and he said he wouldn't do it unless I went to bed with him, so we ended up doing the interviews in bed together. The Sunday papers went for it, calling it "shocking, revolting, and offensive," while the *Daily Mail*—inaccurately, true to form—said the finale included "a fat female artist who dyes her breasts and then rolls about painting on a canvas." This was Brigid Polk, or Brigid Berlin, who painted with her breasts, and she was ultimately the reason there was such an uproar about the film in Britain.

These reviews were then seen by Ross McWhirter, who was a sports broadcaster and a compiler of *The Guinness Book of Records*, and he started a campaign to get the program banned, taking out an injunction against the Independent Broadcasting Association, which was the ITV watchdog. His writ was laughable: "At one point there is a conversation between a man dressed as a Hell's Angel and a girl," he wrote. "In that piece, the girl discusses sex with the man and says she would like to have sex with him on the back of a motorcycle doing sixty miles an hour. Apart from anything else, that does not sound as though it is conducive to road safety."

Bob Colacello: At the Factory everyone loved the song ["Walk on the Wild Side"] because it was clearly about Joe Dalessandro and Candy Darling and Holly Woodlawn, and they were still very much around when I got to the Factory. These legends, these Superstars, part of their allure became being mentioned in this song. Lou immortalized them.

Mick Rock: Lou is not really street, but he brought this street sophistication and merged it with high art. But it was "Walk on the Wild Side" and *Transformer* which put him over the top and made him famous, that's for sure.

In May, Atlantic Records released the seriously underwhelming Live at Max's Kansas City, *a badly recorded (by Brigid Polk on August 23, 1970) mono fourteen-track collection that adds almost nothing to the Velvets' IP. The cassette recorder was actually placed on a table, so often the audience is louder than the band. Not that this is any great loss. There is some novelty in hearing Lou Reed murdering "After Hours," but mostly they sound like a bar band who got together five minutes before reaching the stage, without anything resembling a rehearsal. This would be Reed's final performance with the band, and it shows.*

The year had been a busy one for Reed. When he was midway through recording his self-titled solo debut earlier in the year, he accepted an invitation to perform with John Cale and Nico at the Bataclan Club in Paris. By this point in their careers, a fragile truce had been formed between them all, and the gig was something of a success. They spent two days rehearsing for the reunion show at the tiny club, and the sixteen-song set was taped for French television. Reed was so pleased with the show that he suggested re-forming the band. Nico and Cale declined. Cale was gainfully employed, although Nico seemed unsure about what she was going to do next. In a letter to Danny Fields in March she made it clear she was exploring options, telling him Joe Boyd wanted to produce her next album.

Warhol was still a fan. "When a person is the beauty of their day, and their looks are really in style, and then the times change and tastes change, and ten years go by, and if they keep exactly their same look and don't change anything and if they take care of themselves, they'll still be a beauty," he said.

Cale, meanwhile, spent the first half of the year preparing for the release of his second solo album, The Academy in Peril, *and the next six months promoting it. A predominantly instrumental, generally challenging classical record (although "Days of Steam" is a thing of wonder),* Mark Williams in Melody Maker *echoed what many felt (including, presumably, his record company), when he wrote that while Cale was obviously an artist of some significance, "too often this album appears as eccentric doodling. Broadly speaking,* The Academy in Peril *is Cale setting out to write a symphonic piece, implementing the talents of the Royal Philharmonic, and then seemingly becoming stricken with whimsy. The result, it has to be said, is a musical hotch potch."*

CHAPTER 10

BERLIN, TWINNED WITH NEW YORK CITY

1973

"There were elements of what Lou was doing that I thought were unavoidably right."
—David Bowie

Squeeze *was the fifth and final studio album by the Velvet Underground. Released in February 1973 by Polydor, it featured no members of the original band. Doug Yule wrote and recorded the album almost entirely by himself, with a little help from Ian Paice from Deep Purple on drums. Moe Tucker was originally meant to appear on the record, but decided to leave before it was recorded.*

Michael Zilkha: *Squeeze* is a great album, especially the song "Louise."

Doug Yule: I look at *Squeeze* as being, it's like the equivalent of a tenth-grade term paper—it's a piece of work that I did; it's not my best work, but it shows a lot of where I was going.

Bobby Gillespie: Jim Beattie, who cofounded Primal Scream with me, had an older brother who was into prog rock, and he actually had a copy of *Squeeze*, but we didn't realize it was the Velvet Underground in name only. It wasn't very good.

Chris Difford: Even though *Squeeze* isn't the Velvet Underground, it's really good. It's really polished, the songs are really tight, the recording is very minimalist, very honest. I really like it. Glenn [Tilbrook] called me recently to say he'd been listening to it, and it's good. And it's responsible for our name, obviously. When we were looking for a name for the band, in 1974, we put five or six names in a hat, and Glenn's girlfriend's mum Anthea pulled "Squeeze" out. So, we could have easily been called the Hubcaps. But we put "Squeeze" into the hat because of that record and because of the Velvet Underground.

This was also the year the young Difford stole 50p from his mother's purse to put a card in a local sweetshop window to advertise for a guitarist to join his band, although he was not actually in a band at the time. Glenn Tilbrook was the only person who responded to the advertisement. Difford and Tilbrook started writing songs together, and soon added Jools Holland (keyboards) and Paul Gunn (drums) to form an actual band. They performed under several names, most frequently "Captain Trundlow's Sky Company" or "Skyco," before choosing the name "Squeeze" as an ironic tribute to the Velvet Underground album.

John Cale's Paris 1919 *was released in the same month as* Squeeze, *an album infused with a deep European sensibility, its title a reference to the 1919 Paris Peace Conference. Ironically the record was actually recorded in Los Angeles, at Sunwest Studios, and featured Little Feat members Lowell George and Richie Hayward as well as Wilton Felder from the Crusaders.*

Mick Brown: *Paris 1919* is a major classic, largely ignored. A gentle, reflective album with clever lyrics cushioned in some lavish arrangements. Cale now dismisses it as "Procol Harum music."

Chris Thomas: I was working on a Procol Harum album that had been recorded with the Edmonton Symphony Orchestra, and I think John thought I would be appropriate for *Paris 1919*. I met him in LA in the summer of '72 and he was a real expat. He used to have the *Guardian Weekly* sent over, and he played tennis on a Saturday, and I had an image of him as a kind of Hollywood star of the Forties. I went back in October and they put me up at the Chateau Marmont, which then was a place where people would stay if they were in Los Angeles for two or three months. There was no room service to speak of, but one of the

magical things was that if you got in at three o'clock in the morning and cooked something, it would be gone by the next morning. You'd wake up at eleven, and they'd been into your room, cleaned everything up, and not even woken you. It was a very exciting time—Bowie played there, it was full-on glam. We made the record at Sunwest Studios and he employed Little Feat as his backing band, until John fell out with Lowell George. Cale was chaotic to work with. The night I arrived he turned up at the Chateau and was shouting out loud about cocaine addicts. I didn't really know what was going on. He was a nervous sort of person. Slightly awkward. But we bonded. At the time he was married to Cindy from the GTOs, and Miss Christina was around, and the four of us went out to dinner after I arrived. She said, "Chris, if you need anything, and I mean anything, let me know." But my girlfriend was arriving. Four weeks later she was dead. When we were finishing the record, I brought in two bottles of champagne to celebrate. John managed to consume them both when we were doing the final mix. A few hours later, after he'd disappeared, I got a call from him asking if I could get a bail bondsman. He'd gone to pick up some beer, been arrested for drunk driving, and was in North Hollywood jail. He wanted a hundred dollars to get out. I only had twenty dollars so I asked Little Feat, who were actually recording next door, if they could help. They all said, "Fuck him, leave him there."

Ed Vulliamy: "Half Past France" is my favorite John Cale song, and that includes his work with the Velvets. From a distance it's looking across a gap, looking through the window of a train into an existential mirror. It's separated from what's going on outside the window, thinking back to Norway, making odd points about temperature. It's an ethereal meditation. I saw him perform it at the Brooklyn Academy of Music, and he tore the song into shards. It's deeply disturbing. He does what Coltrane does, although it's probably more rehearsed than anything Coltrane ever did. You also have to have a good grasp of what they used to call general knowledge.

Bobby Gillespie: Cale's solo work has been a huge influence on me in recent years, especially the starkness of the arrangements. It sings to the heart. I love the production on *Paris 1919*. He was a genius.

Richard Williams: In 1973, I joined Island Records as an A&R man. Which, to me, meant that I could sign former members of the Velvet Underground. One of the reasons I think they wanted me was because I was one of the first people to write about Roxy Music, who were one of their acts, and the Wailers. In the three years I worked there I didn't find another Roxy Music or Wailers. It was just before punk, where there was still a lot of prog, which I detested with a passion, and pub rock, some of which I liked. I should have signed Dr. Feelgood, but they had a relationship with Andrew Lauder from United Artists. I tried to sign Kraftwerk. We had Sparks, but that was nothing to do with me. I signed Cale first, as Warners were letting him go. *Paris 1919* had got some good reviews, but he followed it up with *The Academy in Peril*, which I think was not what they were looking for.

Nick Kent: Cale could wear you out. He was a naturally hyperactive guy, and at the time I knew him, in the early Seventies, had taken a lot of speed. I could understand why Lou Reed got rid of him because John Cale would never stop. He loved conspiracy theories. If there was a conspiracy theory out there, he would latch onto it, and he would find a new way to make it more labyrinthine. So he could be exhausting in that respect. When I met him, he had an obsession with the Labour Prime Minister, Harold Wilson, who he thought was an evil-minded figure who was out to control God knows what. He was on cocaine at the time, taking every ten minutes. He was someone who would grab a guitar and write a song in front of you. It probably wasn't that good a song, but he had all this energy. He was like a rugby player on cocaine. Talking ten to the dozen. He was another misfit. He was a functioning weirdo. As am I. All these people were. They had to be to make the music they played. But he could be very good company when he was in a calmer mood. He had a great intellect.

Lou Reed was moving on. After the enormous commercial success of Transformer, *it might have been prudent to try and build on his newfound fame, but Reed almost seemed to have become embarrassed by his hit. Embittered by the narrative that he had been saved from obscurity by David Bowie and his trusty steed Mick Ronson, Reed went off in another direction altogether, recording an album that can only be described as brutal.*

Berlin *was a bleak examination of a doomed relationship between two Americans—Jim and Caroline—in the bisected German city, with songs about infidelity, drug abuse, violence, and suicide. It wasn't exactly a walk in the Tiergarten. While it's conceivable to claim that its gloomy atmospherics inspired both David Bowie's Berlin Trilogy as well as the post-punk dynamics of Joy Division and their ilk, it's fair to say that the bulk of the record-buying public were not ready for what one critic called such an "ambitiously bleak record," certainly not when they had just been seduced by an album of cute, sexually ambiguous glam rock songs. What* Berlin *was, was belligerent, but then so was the person who made it, demonstrably so.*

"That was the bad move," Lou Reed said, decades later, about following Transformer *with* Berlin. *"That's one of those career-ending moments. They said, 'You want to do what?'" Looking back, Bob Ezrin (once described by Alice Cooper as "our George Martin") recalls a chaotic time. It had similar effects on others, too:* Rolling Stone's *reviewer said it was "taking the listener into a distorted and degenerate demi-monde of paranoia, schizophrenia, degradation, pill-induced violence, and suicide. There are certain records that are so patently offensive that one wishes to take some kind of physical vengeance on the artists that perpetrate them. Reed's only excuse for this kind of performance (which isn't really performed as much as spoken and shouted over Bob Ezrin's limp production) can only be that this was his last shot at a once-promising career. Goodbye, Lou."*

Nick Kent: I met Lou Reed a year after *Transformer*, and he was still unhappy. I think he was a misfit inside his own skin. The Sixties is full of misfits. Warhol was another, which is why I think they got on. He connected with Warhol, and then deconnected, because of the ego. But the Seventies was another thing altogether.

Lou Reed: My problem was just to survive me. Forget about legends and all the rest of it. Just to survive as a person: if you can do that, the other stuff will come around. You can't do it the other way.

Richard Williams: *Berlin* is a masterpiece. It was ambitious, not superficially attractive or ingratiating in any way. To make that when he could have just carried on repeating the formula of *Transformer*, that was brave.

Nick Kent: The next time I met him was when he was recording *Berlin*, by which time he was a mainstream success.

Duncan Hannah: I thought *Berlin* was pretentious.

Bobby Gillespie: *Berlin* was too slick for me.

Marco Pirroni: I think Lou Reed was a cantankerous, angry person. There was talk about him working with Bowie again, and of course he resisted it. I saw this with another lead singer, whose name begins with A. "I don't want to work with this producer even though it will make me successful because if I'm successful everyone will say its him and not me." And I used to say, "Adam, no one gives a fuck. It's your name on the record." Lou didn't want the credit taken away from him.

Bob Ezrin is a great producer, and *Berlin* is a great album. It's one of the world's most depressing albums, obviously, especially that bit when the kid starts screaming. You think, I can't take any more. But it's a fucking amazing record. I was looking forward to more "Vicious" or "Satellite of Love" but it's brilliant in a different way. It's a heavy trudge. It's not the fluffy, camp stuff of *Transformer*, but *Berlin* is also a work of genius. I think he liked to sabotage himself.

Lou Reed: It was just getting together with [Bob] Ezrin, we wanted to do what we were calling a movie for the mind, and it grew out of that idea. It's not, "Let's sit up and dance and be happy." I prefer to think of it as a Bergman movie or a Kurosawa movie. You know, it's not, "Hey, hey, hey, yippy-doo," it's more film noir. Which I guess lets Kurosawa out. But when I say Kurosawa I mean intensity, or in *Rashomon,* depending on how you look at it. That's the reference points for me. It was simply that Berlin was a divided city, and it was cosmopolitan and a very sophisticated city. It was the home of German film noir and expressionism. And I wanted this to be the city in which this little plot takes place, and it was emblematic that it was a divided city.

Nick Cave (musician): He taught me that you can put the most sonically aggressive music and put it side by side with some of the most beautiful ballads that anyone has ever written. There was something that Lou

started when he did his stuff. Which was that kind of punk ethic that he still held true to himself until the end. He moved beautifully about and surprised people. He could do something tender, something very thoughtful and then something that you had to rethink over again whether you liked Lou Reed again. His records were so polarizing.

Nick Kent: Because he was selling records, Lou Reed got sidetracked into thinking he could be some mainstream rock act. But he was too weird. He couldn't disguise it.

Moby (musician): Lou was no more the son of a millionaire than he was a child of the streets.

Gene Krell: I always found something disingenuous about Lou. You know, I question the legitimacy of it. I was born and raised in Brownsville, Brooklyn, which was distinguished by the highest crime rate per capita in America. We produced the most world champions per capita—Mike Tyson, Riddick Bowe, Mark Breland, I boxed at the same gym. These were Raymond Chandler's mean streets, and I was just never drawn to Lou Reed's personality as I thought he was the least charismatic character I'd ever met, and not believable. With Richard Hell it was inherent, and he was genuinely like he was. Including his means of expression. But I think Lou took a dislike to me when I was involved with Nico. He was antagonistic and seemed propelled by a perpetuation of self-interest. "Take a walk in the wild side?" Really? If you want to see the real wild side, go down to the docks and see the rent boys who put their lives in jeopardy each night. I thought John Cale was a creative genius. It's like Picasso and Braque. I thought Braque was always the better painter, but he was shy. Picasso was Picasso and he would dress in this particular manner, and he was gregarious. Even Lou's girlfriend Rachel looked like she was only there so he could complement how he wanted to portray himself. Perhaps I'm being unfair, perhaps they were in love, [but] I failed to see the virtue in what he did. It seemed one-dimensional. He actually told a friend he thought I was good for Nico, so maybe I'm wrong about him. But I think he wanted to be considered an OG, but if you threw him into the lion's den, he couldn't survive. He wouldn't survive a day in Brooklyn. When I was filming there a while ago this guy came up to

me who was so big, he blocked out the sun, and he asked me why I was there. I said I was coming back to the old neighborhood. And he said, "Anybody mess with you, you tell 'em to deal with me." I asked one of the guys what he tells his kids about the street, and he said he tells them not to go out at night. I got chills, because it was what my dad had told me sixty years ago. If you have this particular reality, you don't have time to indulge yourself in your fantasies.

The Velvet Underground were alive and well and living in the Seventies, resigned to being constantly reinterpreted by Lou Reed onstage, on record, kept alive by a steady stream of reissues and live albums, and growing in influence with a new generation of consumers who were only children in the Sixties. Not only this, but Reed's persona appeared to continually morph around the idea of who he had been in the band. The same was true of John Cale and Nico, both of whom pivoted to versions of their previous selves. Essentially all three were becoming far more exaggerated versions of themselves.

Duncan Hannah: In the fall of 1973 I was at Parsons School of Design, living at Number One Fifth Avenue. I'd been going to college upstate for two years and kept coming down to New York to see the Dolls, and Bowie and T. Rex and things like that, and I suddenly thought, what am I doing upstate? So I dived into Manhattan. I transferred art schools and started hitting the fabled Max's Kansas City, and everything opened up. I met Danny Fields on Halloween at the Waldorf Astoria as the Dolls were having a party in the ballroom. He had the keys to the kingdom, and he opened the gates. The city wasn't really geared to youth the way cities are now. New York was a grown-up city. So there was only Max's and these dumps where you'd see the Dolls or Suicide and people like that. The city wasn't set up for kids. You could see that things were going on because you saw it in *Rock Scene* magazine, which of course was Danny and Lisa Robinson, and they did all the after parties for these shows. We wanted backstage passes for the Mott the Hoople show and we wanted to go to the Hawkwind after party. That's where Danny came in. He said, "Darling, don't ever worry about that. You're always welcome." So I felt like I was plugging in to something that was already going. Then Television came along and thought, this is for us by us. This was the first time I felt like this is new and it's ours.

Andrew Loog Oldham: Nico and heroin. Oh dear. Heroin is the one drug that even if you stop it, it affects your behavior the way it did when you were on it. Fortunately, I only dabbled. She wasn't protected and she was alone because she saw people for what they were, and that can sometimes be difficult. She wasn't easily impressed, which was one of the wonderful things about her. She didn't just go ga-ga over people. She could read men, which is a wonderful quality to have unless you bring so much luggage to the game that it brings you down. She didn't moan, she just got on with things. Back in the day we were children compared to her. And yet she had this chameleon quality where she could slot in and be whatever it was that you saw. And whatever you saw was still all her. She was too smart to be driven by ego as she had the armor, and the armor was very attractive.

Chris Salewicz (journalist, author): In December, just a few days before Christmas, suddenly I'm in a light airplane with Richard Branson flying to Reims cathedral where Tangerine Dream and Nico are playing. It was full of hippies all smoking these incredibly heavy hash joints. And it was fucking freezing. I remember she played "Janitor of Lunacy" with her harmonium, echoing around the cathedral, and it was absolutely sensational. It was fantastic. There was a party afterward in the champagne caves, and Nico rather spoiled it all by turning up in this beaten-up old VW, and literally falling out of the door. That's what happens with junk.

Duncan Hannah: Danny Fields called me on a Sunday and asked if I could come and babysit Nico as she had just arrived from Ibiza. He had to finish some articles and she really needed a minder, was how Danny put it. So I raced up there and we spent the day together. It was so much fun. She'd been out of touch for two years at least, and [her son] Ari was still a kid. Kevin Ayers was still involved, I think. So she had no idea what had been happening. I showed her the first Roxy Music album and said, "You haven't heard *this*?" I pointed at Eno and told her that he had said she was the greatest rock singer who had ever lived. She said, "Ooh, who is this boy?" in her ridiculously slow drawl. Eno was playing that night in CBGB, which had just opened, and I said we should go. He was recording with Television, who, I told her, are a bit like your old band. All afternoon I kept making vodka and grapefruit for us both, and at one

point she fell over. She was a big woman, and it made a lot of noise. It was hard to tell if she was on drugs or not. She was so strange anyhow. She was an opium addict, and I don't know if she was that Sunday, but if you are, you are. You're going to have to fix yourself somehow. It was her first time back in New York for years, so maybe she cleaned up for the trip. She was so out of it in terms of contemporary culture that it seemed as though she'd been gone for ten years, not whatever it was. So, we went to CBGB and there was Eno at his console, as he was doing a demo for Television. He looked up but ignored me as he was always kinda snooty with me, even though it was a tiny little scene. He was a kind of a dick. So he looked up from his board, but when he saw who I was with, he said, "Duncan, hi!" And then I said, "Brian, I'd like you to meet my friend Nico...Nico, he's the boy I was telling you about who says you're the greatest rock singer ever." He swept her off and that was the end of my friendship with Nico.

Gene Krell: There was an old Ma and Pa store next to our apartment, and then one day the man wasn't there anymore. And Nico would walk there every day to ask about his health and to find out how he was. She cared. She was genuine. She believed in people as people believed in her. She was masterful. She was very powerful and demonstrative in how she expressed herself, and that could easily be misinterpreted. But underneath it all she was a truly wonderful person.

Nick Kent: I got on with John Cale and Nico because we were taking the same drugs, and we knew a lot of the same people. I really liked Nico. The amazing thing about her was that here was a truly pristinely beautiful woman, flawlessly beautiful. She had this real presence, but she had none of the diva bullshit. She was so focused on being an artist. *The Marble Index* and *Desert Shore* are unique. *The Marble Index* in particular is an extraordinary piece of work, as extraordinary as the Velvets. She wasn't physically narcissistic, and only cared about being an artist. She almost purposefully went out of her way to degrade her looks. When I knew her, she was not the beauty she had been, and you could tell that she thought being less attractive would help her be taken more seriously as an artist, or as a musician. I didn't get any sexual vibe off Nico, and she was almost like a man to me, or someone who was

basically asexual. Maybe the fact that she was addicted to heroin had a lot to do with that. Nico was someone that you don't forget. She wasn't a groupie, or a gadfly.

Gene Krell: This writer, who was a peripheral guy, had a crush on Nico, who thought he was just obnoxious, and so did I. This guy was the definition of a scavenger. He would impose himself in every kind of situation. If there were pop stars in the room, he would get between them and have his picture taken. He was a decent enough guy, and we tolerated him. In his book he said that "my friend Gene had a brief affair with Nico until she said to him, 'You no longer amuse me.'" As if she would say that at all! It was complete fabrication. How could anybody say that? My relationship with Nico went on for years, on and off.

Nick Kent: In 1973, New York was a playground, man, it was there for the taking especially if you were a young man in his twenties. It was so much more exciting than London. London was very much in a Sixties hangover, whereas New York felt as though it was going through some kind of transformation. If you were from London, you couldn't wait to get on a plane.

CHAPTER 11

TAKE A WALK ON THE WILD SIDE

1974–1975

"CBGB was a shit hole."
—Patti Smith

Duncan Hannah: Parsons is on Thirteenth and Fifth, and the bookstore Cinemabilia was downstairs, run by Terry Ork. He was flirtatious and would give me free stuff. Once he said, "Oh, you've got to come and see my band on Friday night." He called them his dogs. He said, "Richie, give him a flyer." And that's how I met Richard Hell. He had the dark glasses, floppy hair that was a bit spiky, and an old fraying thrift-store suit. It was a flyer for Television's first gig at the Townhouse Theatre, in March '74. They opened for the Modern Lovers, who were playing their last gig. Because of Danny I could get into the back room of Max's, which of course was very small. But you could always see who was in town. So, there would be Johnny Thunders, Lou Reed, and then Richard Lloyd turned up, with peroxide hair. I asked Leee Childers who he was and he said he was a male hustler who had blown in from LA. "We love him." So he and I became chums and he joined Television. He was completely unembarrassed about being a hustler. No one had any money, even though I had an allowance, and when I asked him how he got his money he said, "I'm a whore." At the first CBGB gig Roberta Bayley was at the door. There were probably only twelve of us. It was

a Sunday night. I brought my friend Rob Duprey, who would go on to play with Iggy. And we loved it. The gig was so ramshackle. It was a bit like Quicksilver Messenger Service with those dueling guitars. But fucked up. The scene started growing, and Patti Smith turned up and fell in love with Tom Verlaine. I brought Nico there one night.

Bebe Buell: One of the craziest line-ups I ever saw was at the Felt Forum, in Madison Square Garden, in '74. Lou Reed, Hall & Oates, and Al Green. Andy Warhol was there, Mick Rock was there. Lou used to pretend to inject himself with heroin onstage, using the microphone cord. It was crazy.

Lou Reed: The Phantom of Rock thing was kinda like my own fault, up to a point. I allowed it, and it was kind of a convenient thing to duck behind and use as a shield against just about everything. I kind of liked it—the dark prince and all this shit. And it was offered to me. I didn't have to do anything to get it. In the end it was a straitjacket, and it was very confining, but... I didn't know any better, I hadn't done this before. And once I'd left the Velvets, there wasn't any control on it—there wasn't a Maureen to say, "Forget that one," or a John or Sterl to say, "That's getting a little tired" or even just "Are you having fun?" Very few people can leave a group and survive. The trouble was, I ducked behind the image for so long that after a while there was a real danger of it becoming just a parody thing, where even if I was trying to be serious you didn't know whether to take it seriously or not. There'd been so much posturing that there was a real confusion between that life and real life. I was doing a tightrope act that was pretty scary no matter where you were viewing it from. It's not like I didn't know, I just didn't know how to get out of it. And I wrote about that too. People would say, "Oh, this is a parody"...ooh, don't be too sure about that! You might have said it's not well done or that it's mannered, but a parody? Not necessarily.

Chris Difford: I went to see Lou Reed play at Charlton football ground in 1974, and he came on with two guitar players and it was rock music at its worst, but what was really thrilling was this really skinny guy muttering away in front of this heavy band. I went to see him in London, and he came onstage with loads of makeup and had his back to the audience

for most of the show, and everyone just loved it as there was a mystique about it. If anyone could play with their back to the audience, it was Lou Reed. It was theater. Just like the Velvets, as Andy Warhol had drawn it out of them.

Marco Pirroni: I saw Lou Reed at Charlton supporting the Who in '74, which was a bit odd because it was during the day and I didn't think Lou Reed should have been out during the day. But then I started to see those Mick Rock pictures of him wearing Sex clothes, like the mohair top with the studs on it. The winklepicker boots. He was the only person from outside wearing those clothes.

Ed Vulliamy: The Who played Charlton Athletic Football Club in '74, which at the time was meant to have been the loudest gig ever. It was a coming-out party. "Baba O'Reilly," "Won't Get Fooled Again"— it was wonderful. Lou Reed was supporting them that day, playing *Transformer*. And he shrunk the stadium. People who can do that are rare. It was daylight, too. So, it wasn't easy, but he did it.

Bob Colacello: Lou was always disagreeable. He was always mysterious sexually. I mean, did he like girls, did he like boys? I remember when we met in 1974 when he was trying to get Andy to do a production of *Berlin*, we went to this club called the Ninth Circle, and I didn't know if the kid he fell in love with was a boy or a girl as they were so androgynous. They were very skinny and obviously strung-out on something or other. Lou's opener that night was, "I want your ideas, Andy, not anyone else's." He certainly didn't want my ideas about how to stage *Berlin* as a Broadway show.

Andy Warhol: I wanted to produce *Berlin* as a musical comedy costarring Lorna Luft, but it didn't work out because in the meantime Lou had done another album called *Rock'n'Roll Animal* and he was living up to that title. He weighed ninety pounds, had jet-black hair shaved in the shape of a star, silver fingernails, black leather clothes—and would only see me alone. Since I don't work alone, the project never got off the ground.

Michael Zilkha: *Rock'n'Roll Animal* is just an anodyne heavy metal band with Lou on speed. Not very interesting.

Duncan Hannah: *Rock'n'Roll Animal* was heavy metal Lou Reed and I didn't like that.

Marco Pirroni: I fucking loved *Rock'n'Roll Animal,* but it was a bit of a guilty pleasure. I played it over and over again. It was basically Lou Reed and the Velvets but not as you'd ever heard them before. It's worth it if you sit through the organ solo in "Heroin." I loved Alice Cooper and I loved Hunter and Wagner, the two guitarists. It had a great cover as well. It's not really heavy metal—only in the way that Alice Cooper was.

Lou Reed: I had a lot of time to think after the Velvet Underground broke up and here were these songs of mine. And then I heard Mitch Ryder's Detroit Wheels, produced by Bob "Wonderboy" Ezrin, doing "Rock'n'Roll," and I said, "Aha, that's fun." So Ezrin got Alice Cooper's band for me. I said, "OK, here's the material." They didn't know it from the Velvet Underground, they'd never heard it, so I just taught them the whole thing. It was probably one of the greatest live records ever made. So there you have it. There's all kinds of other music to fall asleep to and relax to, but this is supposed to be visceral. This is really physical music.

Bebe Buell: When I did *Playboy* in '74, a lot of people thought I'd done a taboo thing, but at Max's, they loved it. A rogue move. I was burning my bra but in a different way. With Roe versus Wade in '73, women had power over their bodies, then Nixon got impeached, and it felt like things were changing. Progressive. People were still scared of the hippies, but it was changing. And back then New York City was the place that represented freedom.

Deborah Harry (singer, musician): I always liked the way the New York characters from the early Seventies played with their sexuality. Just look at Lou Reed around the time of *Rock'n'Roll Animal.* He was out there, like a cartoon. The Blondie character I created was *always* meant to be androgynous. Obviously, I don't think that I am physically androgynous, but I think that mentally my feelings about sexuality have always been very—how would I say it?—conflicted, so I wanted "Blondie" to have more supposedly male traits. I've always been frustrated by the idea that I grew up in an era when women were not expected to

have a career or to have strong opinions. I felt akin to a more kind of liberal mentality and I always felt angry about being told, "Oh you can't do that because you're a girl." I mean also mentally I had capabilities and the drive that most men had and had been given this authority to have that. The idea of not having that authority was something that probably pushed me into being a punk. It might not have looked like it at the time, but I was all about androgyny. I think the cartoon element certainly had a lot to do with Chris [Stein]'s photography and being at ease in front of the camera. It was a tricky position for me because I did appreciate creating this kind of image, and I feel it's a sort of art form in its way, and as an actor bringing a character to life, to bring this kind of cartoon, if you want to call it a fetish cartoon kind of character to life was maybe an art form. I have always enjoyed doing that. I've enjoyed characterizations and dressing up, and creating these characters is something I really enjoy doing. It's sort of been an underpinning of my aesthetic in my performances.

Robert Risko (illustrator): Lou Reed was one of my earliest drawings. He was always the coolest of the cool. He had the blonde, buzz-cut hair, and always looked like a Frankenstein monster—half man, half machine, half zombie. He was a transformer, on a slab coming to life. And that's how I drew him, as a monster.

Duncan Hannah: One night Danny and I are sitting in a booth in the back room at Max's, having a cognac. Fran Lebowitz sat down for a little while and started kvetching about some girlfriend of hers. Then she got up and left. She was probably only nineteen and was writing a column for *Mademoiselle*. Everyone liked her because she was so funny. Then Danny looks up and shouts, "Louis!" And I thought, "Who's Louis?" And I turned around and it was Lou, very drunk. So he came over and sat down, eyed me, and said, "Who's she?" And Danny said, "Oh, she's Duncan Rathbone Hannah. She's an art student." I was excited but my excitement was dwindling as I was being referred to in the third person. It was bad manners. They objectified me in the extreme, talking about me as though I was a blonde bimbo. My feeling was, this is their room, this is their town, and I'm a newbie, so I had to play by their rules. Lou started asking me questions, like where did I live. I said I lived at

One Fifth Avenue, and he said, "Yeah, I've been there. A friend of mine jumped out the window there." Then he asked me where I was from, and when I said Minneapolis, he said, "I've been there." He kept ordering tequilas. Then he started talking about Raymond Chandler, as he'd just read one of his books. That summer I'd just read all of Chandler's books, so I knew them well. I was prepped! I started contradicting him as he kept getting his facts wrong, and when I did this, he said, "Danny, what's she talking about?" Danny said, "She reads!" He slipped up again, and then he said, "Danny, she's doing it again. Do you let her do that?" Danny said, "She does what she likes!"

Then "Walk on the Wild Side" came on the jukebox, and I said to Lou that we should sing, and I started going "do do-do do-do do-do-do-do-do ..." He looked at me like I was out of my mind and then he started singing along. Then when Danny went to the bathroom Lou asked me if I liked David Cassidy. When I said no, and asked him if he did, he said, "I love David Cassidy. Do you want to be my little David Cassidy?" I said, I don't think so. He said that was too bad, as he had a hotel room, and we could go there. "And you can be my David Cassidy and shit in my mouth. Would you like that?" And I said, "No." He said, "You wouldn't? That's too bad. How about you come back and be my little David Cassidy, and I shit on a plate and then I'll eat it. How would that be?" And I said that wouldn't be very good either. He said, "You'll be missing out!" Then he went to the men's room, and when Danny came back, he said that Lou was in love with me. When I told him he wanted me to shit in his mouth, he said, "Oh, didn't you want to?" I think he wanted to totally gross-out a kid from Minneapolis. I told a version of this story to Legs McNeil for his book, and when I went to the launch, all these old Factoryites like Leee Childers and Wayne County came up and said, "Good for you for blowing the whistle on that Shit Queen Lou." I didn't really know anything about him that way. I knew he was bisexual, and a junkie, but that was it. I asked them if this was consistent with what they knew, and he said Lou was always trying to get cute boys to shit in his mouth. And sometimes they did. He was into extremes. I remember seeing Lou years later in a chocolate shop with Laurie Anderson. I was with my girlfriend, who knew the story, and we were all looking down at these latrines of tiny chocolates, and it really did look like he was peering at these little turds. I wondered if something might click in his

head, and that he might remember what happened that night in Max's. But there was no recognition. None.

Legs McNeil (writer): I think it only added to Lou Reed's legend. Anyway, I thought he was just fucking with Duncan. He was fucking with him. In a way only Lou Reed could.

Danny Fields: Lou used to go to a lot of gay clubs, and they were wild. The Mineshaft and the Anvil were crazy places. You were asked to take off any of your clothes that might look preppy, then as you walked through, the first thing I saw was a pool table with a guy on his back, being fist-fucked by a guy using his whole arm. I had never seen that before. Right up to the armpit. But when the guy pulled his arm out, he was missing half of it. So it was only a stump fuck. He was just fucking him up to the elbow. I mean, does that count? There were slings for you to sit in, glory holes, stage shows. I remember once seeing this guy in a suit and tie sitting in a bathtub inviting people to pee on him. He didn't say thank you, he just sat there, as the tub filled up. When I was leaving that night, he shook himself off like a dog as he got out of the tub and went and hailed a cab. I mean what would the taxi driver have thought? Once I took Tam Paton, the manager of the Bay City Rollers. He loved it. I was his gay guide to New York. He just sat there and laughed. It was the New York version of a woman getting fucked by a horse.

Jayne County always used to say that the back room of Max's was vicious. Everyone was on a different drug so consequently no one knew what condition anyone was in. If you got up to go to the bathroom you knew people were going to talk about you because the best part of defense is offense, by being offensive. "People would say horrible things about you the minute you got up," said County.

Marco Pirroni: Lou was into it, but he wanted the right people to hear about it.

Harvey Goldsmith: Everyone said he was a nightmare, but Lou Reed and I actually became quite good friends. I found him funny, and he was a really nice guy. Whenever I was in New York he would take me down

to the Mineshaft, this members-only gay club on Washington Street in the Meatpacking District. He had a sailor for a boyfriend called Rachel. Whenever I went, he would take me to one weird and wonderful place or another. I think he was trying to turn me at one point!

Rachel Humphreys met Lou Reed in 1973, immediately becoming his lover and muse, inspiring lyrics, songs and artwork (she is featured on the back cover of Reed's 1974 album Sally Can't Dance, in an illustration by David Edward Byrd, wearing Reed's trademark sunglasses), and accompanying him on tour up to 1977, when they separated. She was a trans woman of reportedly part Native Mexican descent. Humphreys used both male and female pronouns at different times and both Reed and Humphreys enjoyed wearing each other's clothes.

Marco Pirroni: I did wonder about his sexuality. When I was in the Models we were managed by Miles Copeland who had offices in Dryden Chambers, and he brought over Lou Reed to play at Hammersmith Odeon. He was terrible. And I met Rachel in the offices. I thought, "What is all that about?" He was quite clearly a man or was a man. He wasn't feminine at all. I think she was there to pick up some money from Miles. That's why everyone was in the office. Waiting for Miles to give them money. It's very telling that he met his first wife at an S&M meeting.

Part of the residual narrative of the Velvet Underground is the way in which they jettison the experimental, avant-garde side of their business when John Cale left in 1968, allowing Lou Reed to streamline the band, producing more orthodox records in the process. But if you listen to "What Goes On," the third track on the live double album 1969, a driving nine-minute tour-de-force that at times feels like some kind of art endurance test, you realize that Reed hadn't completely abandoned the idea of using the Velvets as a transformative force. The song is almost a drone, a repetitive masterpiece that may have been made possible by the vast number of gigs the band performed in 1969—by the time it was recorded, on October 19 and November 25, they had toured constantly all year.

In the September 1974 issue of Creem, Patti Smith reviewed 1969. "It goes beyond risk and hovers like an electric moth," she wrote. "Dig it, submit, put your hands down your pants and play side C. 'Ocean' is on and the head cracks like intellectual egg spewing liquid gold (jewel juice) and Lou is so elegantly

restrained. *It nearly drives me crazy. The cymbal is so light and the way they stroll into 'Pale Blue Eyes' not unlike Tim Hardin's 'Misty Roses,' the way it comes on like a Genet love song... This set stands in time like a Cartier gem. The only criticize I got is the eyes, the cover eats shit. Music like this so black and white so 8 millimeter should have been wrapped in the perfect photograph—a Mapplethorpe still life: syringe and shades and black muscle tee. L.R. + V.U. 69 are a kool creem oozing soothing mesmerizing...It will relax you, help it all to make sense. When the music's over and you turn out the light it's like...coming down from a dream."*

Richard Williams: I went to LA to see John Cale, and he came to pick me up from the Hyatt House in a dark green Shelby Mustang 350GT. He'd just come off the tennis court and he was still in his gear. It was a very stupid deal I did, offering him £30,000 per album, with him paying the recording costs. Of course, the flaw in that idea is that the artist will then spend as little as possible recording it, in order to have something left over to spend on other things—e.g., recreational substances. But that certainly didn't affect the quality of the first two albums he did for us, *Fear* and *Slow Dazzle*. I suggested we get Eno and Phil Manzanera involved, who I knew both liked the Velvets, and they were keen to do it. The first single from *Fear* was "The Man Who Couldn't Afford to Orgy," although we deleted the word "Orgy" from the label of the 45 in case it scared the radio programmers. Anyway, it wasn't a hit. Cale was great to work with on a musical level. I won't say that he was biddable, and on a personal level he could be quite difficult. I think I'd persuaded Island that he could be a success as a singer-songwriter, maybe like Cat Stevens or Elton John. He was a very good-looking man, very striking, although he frightened people in the office a bit. He had a strong presence, and he could be unpredictable. He was playing a festival in Provence once, and he was absolutely flying, and very nearly killed an Island press officer by swinging a microphone stand at him. On purpose, I think. God knows what would have happened if my colleague—who was very drunk—hadn't swayed out of the way at the last minute. A lot of the onstage antics I didn't see, like beheading chickens onstage, and I wasn't keen on the Cambridge Rapist mask. He was certainly a harbinger of punk.

Ed Vulliamy: Fear is a man's best friend? As a war correspondent I couldn't have agreed more.

Chris Salewicz: I thought *Paris 1919* was sensational, I was a big fan of the Velvets, and thought John Cale was rather a good thing. Al Clarke, who was the head of publicity at Virgin, said that when Cale had been working at Warner Bros. as an A&R man, he had Proust on his desk instead of *Billboard* and *Cashbox*. Also, I always respected Richard Williams, who had signed him as a solo artist to Island. He thought he was something of an intellectual. But then I went to see him play in Amsterdam, at the Paradiso, in late 1975. I don't think they felt they were going down so well, so after playing "Heartbreak Hotel" they came back and played a forty-minute encore in order to try and get the audience going, as they were all completely out of it. He looked like a chemical Neil Sedaka, very overweight and probably on Mandrax or something of that ilk. Back at the hotel bar afterward, I was talking to Chris Spedding and Chris Thomas, who had been playing with Cale that night. Then Cale appeared clutching a bottle of Rémy Martin. I started asking him about his intellectual background, and he just launches into this attack on me, in this really unpleasant way. Then I discovered that the last time he'd been in Holland he'd done something similar live on a radio show. He'd also done it again with Phil Manzanera from Roxy Music when they were on a radio show in Newcastle. I thought he was a bit of a cunt, to be honest. There was a guy who worked at Island Studios, who once drank half a bottle of brandy that someone had given Cale when he was recording there. But it had been spiked so badly that this chap ended up having a complete breakdown. It just shows you how strongly whoever spiked the bottle wanted to get their own back on Cale. He was the antithesis of what you expected, you know, this gentleman in a white suit. His aggression was far more genuine than Lou Reed's.

Richard Williams: I signed Nico soon after I'd signed Cale. I didn't know that Chris Blackwell, who owned Island, knew about the incident where she was alleged to have bottled the black activist Emmaretta Marks, who was one of Jimi Hendrix's girlfriends. There were a lot of conflicting accounts of that event. Anyway, we made *The End...*, which is the third part of the trilogy. It was my idea to put them all together for the June 1,

1974 gig at the Rainbow, with Brian Eno, Cale, Nico, and Kevin Ayers, which was then released as a live album, in the shops within three or four weeks, which was very fast at the time. We got Kevin involved because he had written a song that sounded like one of Lou's—"Stranger in Blue Suede Shoes" on *Bananamour*—and another supposedly about Nico—"Decadence" on *Whatevershebringswesing*. If you had to identify an English band who you could say were operating on the same level as the Velvets, it would have been the Soft Machine, with Kevin and Robert Wyatt. With the same degree of popular success, of course! Muff Winwood had signed Kevin to Island, and the company was very enthusiastic about him. The evening was complicated by Kevin having had a fling with Cindy, Cale's wife, the night before. It added a certain edge to the backstage atmosphere. We also did another gig, this time without Kevin, in Berlin. Cale, Eno, and I took a walk into East Berlin, through Checkpoint Charlie, which was an adventure as Brian had long green hair at the time. At the concert Nico sang "Deutschland Über Alles," with the verse that isn't on the record, the one that you're not supposed to sing. We didn't make a second album with her. Within the company, I don't think there was an appetite for any more.

The Sex Pistols' Steve Jones mentioned Cale's wife a few years ago, recalling an episode when Glen Matlock allegedly slept with her in the early days of punk. "The whole Cale's wife thing was very hush-hush at the time," he said. "I suppose the Velvet Underground's was one legacy even Malcolm [McLaren] felt quite respectful toward. Given that she'd been one of Frank Zappa's groupie group the GTOs, and I think she shagged Kevin Ayers at that big concert that he and Cale did at the Rainbow, it wasn't like Mrs. Cale was the conquest of the century." Jones went on to acknowledge that Cale had written the song "Guts" about the dalliance, but then claimed that Cale "was such a miserable old fucking gringe" when he came on Jones's radio show that he wasn't surprised that his partners sought solace elsewhere.

 Equally sensitive, Island advertised The End... *with the tagline: "Why waste time committing suicide when you could buy this album?" Even Cale, her most constant musical ally, said of her work, "You can't sell suicide." Frazier Mohawk (the album's coproducer) described it as "not a record you listen to. It's a hole you fall into."*

Chris Thomas: Lou was a presence in John's life I suppose. In '75 I was in his flat in London and in walked Lou Reed with Mick Rock. It was a bit of a weird night. The less said the better. It became a photo shoot and Mick got rid of the film in the end.

Bebe Buell: Mick Rock and Lou were like brothers.

Barney Hoskyns: The heavy rock version of "Sweet Jane" on *Rock'n'Roll Animal* with Dick Wagner and Steve Hunter on guitars turned it into a rock monster.

Jon Savage: Lou Reed made his own drone move with 1975's *Metal Machine Music*, so forbidding that it was rumored to be a contract-breaker with his record company. Legend apart, there is no reason to believe it was not sincere.

Marco Pirroni: I went and bought *Metal Machine Music*, from the record shop opposite Browns in South Molton Street. It was the only place that had it. It was really expensive, it was six quid, and it had a brilliant *Rock'n'Roll Animal* cover, which was deliberately designed to piss people off. But I thought, "I don't care what it is, I've got to have it." I was heavily into noise, so I loved it. I've never played it all the way through, but it doesn't matter. The thing exists.

Lou Reed: I was somebody who really liked heavy metal, as it was called back then, electric guitars blowing up amplifiers, and the sound of broken speakers, and I thought it would be a lot of fun not to have to worry about a drum, and not have anything for anybody to sing so you didn't have to worry about a key.

Michael Zilkha: In 1975 you could see John Cale every night in New York, usually at CBGB.

Never had there been a record that screamed "I am a bohemian" so loudly, so plaintively. While the Velvet Underground, the MC5, and the Stooges had invented their own particular genres seemingly just by falling out of bed, Patti Smith was a keen student of everything alternative. And what she had learned

was all fed into Horses. *The poetry. The guitars. The androgyny. The death wish. This was the tortured brow as fait accompli. The rock and roll devotee as wannabe martyr. And it worked: critics in both London and New York were mesmerized by the cultural anomaly before them, anointing her immediately. For someone who aspired to be "outside society," Smith was an astute social operator, at pains to act and look like the quintessential downtown beatnik. "Patti wanted to look like Keith Richards, smoke like Jeanne Moreau, walk like Bob Dylan, and write like Arthur Rimbaud," said one of her pre-fame flatmates.*

When Charles Shaar Murray reviewed Patti Smith's Horses *for the* NME *on November 22, 1975, he said it was "better than the first Roxy album, better than the first Beatles and Stones albums, better than Dylan's first album, as good as the first Doors and Who and Hendrix and Velvet Underground albums. It's hard to think of any other rock artist of recent years who arrived in the studios to make their first major recordings with their work developed to such a depth and level of maturity." Of course, in the studio that depth and maturity was steered expertly by John Cale. When he was originally asked to produce the record, he initially didn't know if he was being asked out on a date, or whether he was being hired for a job of work. Smith turned out to be incredibly direct, telling Cale precisely what she wanted. He in turn says that the experience was intoxicating, and although he never knew where the record was going to fly off to, it was "miraculous in its flight." The record is a masterpiece, much of which is down to Cale.*

Shaar Murray said the album was a definitive essay on the American night as a state of mind, an emergence from the dark undercurrent of American rock that spewed up Jim Morrison, Lou Reed, and Dylan's best work. "In general, there's a Doors feel to the keyboards (particularly the organ) and a Velvets noodge on the guitars," he wrote, "though this is purely coincidental, as no resemblance is intended to anybody living, dead, or intermediate."

"No one expected me," said Patti Smith at the time, by way of explanation. "Everything awaited me." And, beyond cocky, and convinced of her own importance, she meant it.

"My picking John was about as arbitrary as picking Rimbaud," Smith told the journalist Dave Marsh a year later. "I saw the cover of Illuminations *with Rimbaud's face, y'know, he looked so cool, just like Bob Dylan. So Rimbaud became my favorite poet. I looked at the cover of* Fear *and I said, 'Now there's a set of cheekbones.' In my mind I picked him because his records sounded good. But I hired the wrong guy. All I was really looking for was a technical person.*

Instead, I got a total maniac artist. I went to pick out an expensive watercolor painting and instead I got a mirror. It was really like A Season in Hell, *for both of us. But inspiration doesn't always have to be someone sending me half a dozen American Beauty roses. There's a lotta inspiration going on between the murderer and the victim. And he had me so nuts I wound up doing this nine-minute cut ['Birdland'] that transcended anything I ever did before."*

However, while Cale was praised for his production work, and generally creating these extraordinary orbits of excellence, it was his solo career that obsessed him at this period, particularly live performance. Cale's stage presentations in the mid-Seventies owed a lot to Antonin Artaud's Theatre of Cruelty, a dark energy that prefigured punk. He truly developed an onstage persona, at which he went "hammer and tongs," assuming an aggressive, dysfunctional stance, screaming into the dark, wearing ski masks, ice hockey masks, or gas masks and boiler suits, playing salaciously with mannequins, pretending to shoot himself, seriously abusing his band, and treating his newfound audience to an overly melodramatic sub-Velvets spectacle, fueled by brandy, cocaine, and jealousy.

He also famously chopped the head off a chicken during a performance of "Heartbreak Hotel" in Croydon, in 1986. "Thwock! I decapitated it and threw the body into the slam-dancers at the front of the stage, and I threw the head past them," Cale said in his autobiography. "It landed in somebody's Pimm's. Everyone looked totally disgusted. The bass player was about to vomit, and all the musicians moved away from me. Even the slam-dancers stopped in mid slam. It was the most effective showstopper I ever came up with."

Later, he would say he looked back upon the incident with fondness. "The whole thing was fucked up to begin with. We stopped at a farm between Oxford and London to pick up the chicken. I said: 'Keep the damn thing in the box, don't pull it out.' And the guy, this idiot, comes walking out of the farmhouse holding it up high, proud. You could feel the tension in the car on the way down to the gig, everyone was murmuring. Then sure enough someone said: 'What are you going to do with the chicken? Are you going to hurt it?' I said: 'No. I won't hurt it.' After the show they said: 'You lied, you said you wouldn't hurt it.' And I said: 'I didn't hurt it, I killed it.' That was kinda silly."

"Of course, one notes the points where hip approval is considered appropriate," wrote one reviewer in the Melody Maker *of a gig at the New Victoria Theatre in November '75, who called Cale's performance a "Hip Man's Black Sabbath." Eek.*

"The entrance in all-white fencing kit," the Melody Maker *review continued, "like a refugee from* Dr. Who, *the 'urban menace' implicit in donning shades when he removes the face mask, and world-weary lines such as, 'Life and death are just something you do when you're bored…'"*

At this point in his career, Cale's performances tended to be extreme in the extreme, although not everything was Sturm und Drang, *and on his 1975 album* Slow Dazzle *he paid homage to his teenage hero Brian Wilson on the song "Mr. Wilson," celebrating the troubled Beach Boy while acknowledging his personal struggles. "What Brian came to mean was an ideal of innocence and naivety that went beyond teenage life and sprang fully developed songs," says Cale. "Adult and childlike at the same time. I thought how it was difficult for me not to believe everything he said. There was something genuine in every lyric. That can be a very heavy burden for a songwriter." When Wilson heard the song, he was apparently unamused, as he thought it was sarcastic. It wasn't, although the lyrical ambiguity of the song was complicated by the fact that the song was also written about the incumbent Prime Minister, Harold Wilson.*

Michael Zilkha: I saw him play the Theatre Royal Drury Lane during the *Slow Dazzle* tour, and the intensity was insane. He seemed to be in another world, which he was, because he was very, very druggy. The band was so tight, so beautifully orchestrated and arranged. He was totally on his game. He was a great stage act, but the records weren't always commercial. John's records were abstract, dense, and delicate. He's also incredibly versatile, and that doesn't necessarily stand you in good stead commercially.

Chris Thomas: I did four tours with John, and I loved them. There's a reason that you say you play an instrument, because you're playing. It isn't hard work at all. It's just the best fun. Although he was chaotic onstage. When we played the Paradiso, he kept disappearing backstage after every song. It was nerves, and I think a lot of his strange behavior was him covering up. On that French tour we played with Nico, and she kidnapped me on the first night. John called me up and said, "She wants you in her room." So, for that tour I traveled with her, separately from the rest of the band. When the tour ended, I went back to her apartment in Paris, until John called me up and summoned me back to London for a rehearsal. When I arrived, there was no rehearsal at all.

I was so pissed off but he claimed he was doing so for my own good. On another occasion he was banned for life from the Theatre Royal Drury Lane. He came up with this idea of getting a mannequin, dressing it up as a nurse, and then he'd fill a balloon with theatrical blood and put it in her panties. He also had some blood capsules in his mouth. At the end of the gig, he ran across the stage in front of me and went to punch the nurse in the crotch, but fell over, and blood went everywhere. He was mad, but the bands always had an incredibly high level of musicianship. It was a performance in every way.

James Wolcott (critic, author): Where Reed did his death walk by looking like an emaciated survivor out of *The Night Porter*, Cale went the rock-Dada route—performing cunnilingus on a mannequin during a concert, playing guitar in a goalie's mask, lurching around with Frankenstein menace.

In the Village Voice, *James Wolcott said that some of John Cale's outbursts on his 1975 album* Helen of Troy *are worthy of Ray Milland in* Lost Weekend. *(This from a man who described* Metal Machine Music *as an example of Lou Reed's "psychopathic insolence.")*

Mary Harron: John Cale never got the fame he deserved as a solo artist. But things like "Fear is a Man's Best Friend" had a huge impact on me. I would go and see him every time he played CBGB. I think a promoter told him this, and Cale said, "You're crazy. Why would you come and see me every night?" He had a great voice and wrote great melodies. Michael Zilkha always said Frank Sinatra should be covering his songs.

Catherine Guinness: I went to America in 1975 as I couldn't find a job in London. There were cutbacks everywhere, but then it seemed as though New York was having the same problems. They weren't hiring. They were in recession. I had already made friends with Robert Mapplethorpe because he'd been over in London for a couple of summers. When I first arrived, I hid my handbag under my coat because I'd heard it was dangerous, which Robert thought was very funny. I was having lunch with him one day and he was delivering a photograph to the Factory for *Interview*, and I went with him. I met Andy and Fred Hughes and they invited me out to dinner, and I got on really well with them. When

it came time for me to go back to England, they offered me a job on *Interview*. "Come and work here," said Fred. "You want to be a journalist so come work at the magazine." So I went to live with him in Andy's mother's old house on Lexington, and started work at *Interview*, as European editor. It was a very slick operation by then, with Andy and Fred and Bob Colacello, who was the editor at the time. I loved Andy, as he was a fundamentally nice person, smart, kind, and driven. He was also a mass of contradictions. He was a devout Christian and would go to church every Sunday. He was sweetness and light if you spoke to him after going to church, but he obviously had a making-money side, and he was quite down on Bob and Fred if they weren't performing financially. Luckily, I wasn't involved in that side, I just had to find young, cute boys to be interviewed by Andy. It was a great way to meet a star. They were good for the magazine, and it's always nice to meet a star. Andy and I would go out to lunch with people like Jodie Foster, which was great fun. We interviewed the Ramones, although Joey didn't come as he was having singing lessons. I always thought it was odd that he would have singing lessons after becoming successful.

Andy never did research, he would chat about banalities with them, as well as trying to plumb their depths. It's always interesting to find out what famous people eat for breakfast. He opened up to me quite quickly, although he had different walls for different aspects of his life. He could be naughty. My very good-looking brother Valentine came out to stay with me once and I had to rescue him from being taken back to the Factory by Andy. He said I saved him from being in one of the piss paintings!

Catherine Guinness: By the time I got there, the people from the first iteration of the Factory had been banished. He couldn't be bothered with them anymore. He wanted the grand life and was more interested in shopping for diamonds than going downtown. He liked going to nice restaurants and getting people to fund his lifestyle and so on. Also, since the shooting he had become rather frightened of those odd-style people. It made him wary, not so open. There were still people from the Sixties in his orbit, some of the drag queens, Glenn O'Brien. Lou Reed was still around, although he'd slightly fallen out with Lou. We went to see him play at the Bottom Line a few times. Because I was English, I adored

the Velvet Underground, so it was all very exciting to me. But I think Andy had become dismissive of them and had seen through what we all thought was so glamorous.

Mick Brown: I met Warhol at the after party following a Robin Trower concert at Madison Square Garden. I shook his hand, and it was like shaking hands with a talcum-powdered skeleton. It was nothing. It wasn't damp, it wasn't strong. It felt like shaking hands with pampas grass.

Bob Colacello: There were certain people in the art world, like Lou, who really didn't like me because I was seen as the person who got Andy to do the portrait of the Shah of Iran and his wife, Farah. I would eventually put Nancy Reagan on the cover of *Interview*. It wasn't quite cancel culture back then but within the art world you weren't meant to be anything but a liberal Democrat. Andy found it useful to have me around when he was trying to get rich husbands to pay for their wife's portrait. Andy would say, "Well, Bob likes Nixon," and the husbands would relax, thinking there's someone in this room that they can relate to. So I always got the feeling that Lou didn't like me.

Catherine Guinness: The Factory was such fun. We went out every night, private views, openings, to restaurants, Le Cirque, nightclubs, always ending up at Elaine's—although she didn't like you just sitting there drinking, so you always had to order another dinner. He loved to have dinner with people who might want their portrait painted. Andy was one of those magic people who lit up a room when they walked in. He was endlessly enthusiastic, especially about bright young people. He loved Britain, and that sense of history. He thought we were all a bit grungy, though, that old American idea that we have baths, not showers, and never quite wash ourselves enough. He was fascinated by the British, and visiting Brits were treated like Hollywood royalty. Quite often we'd meet in the morning and give out free copies of *Interview* to all the shops on Madison Avenue, do a bit of shopping, and then take a cab down to the Factory around lunchtime. He would speak to a few people and disappear into the back to start painting. For five years it was a gilded time. I wanted to socially descend, but by that stage Andy had had enough of all that, and wanted to go uptown

and interview princesses. We would go to Studio 54 all the time, and people were always handing Andy drugs. But he wouldn't take them, he'd hand them on to us. It didn't have a liquor license for the first year, but everyone took drugs instead. The socializing was relentless, although it was all about business. Andy was so excited about getting advertisements into the magazine. He really wanted the paper to be thick with advertisements. He would go out to dinner to try and get them. But then when he dictated his diaries to Pat Hackett over the phone every morning, he'd always make things up as he was scared of being boring. He would go to the leather bars, but only as a voyeur. John Richardson and Robert Mapplethorpe went properly.

Mary Harron: In 1975, I'd just arrived in New York, and was working as a cook at a film commune called Total Impact, a very strange place on Fourteenth Street, where one day Legs McNeil came in for lunch. I told him I wanted to be a writer and he said a friend of his, John Holmstrom, was starting a magazine called *Punk*. I thought it was a genius name, as before that people had just used the phrase, "You punk kid." One evening they came to get me from the office, where I was washing the floor, and they took me to CBGB to see the Ramones. It was the first time I'd been there, first time I met Roberta Bayley, who worked on the door, and she let us in for free, and told us Lou Reed was there. Legs and John bounced up to Lou, very confidently, and while he was dismissive, he let us sit there. Sitting with Lou was this tall, dark woman, wearing a black leather jacket, and she had stubble. So I thought, "I guess this is a guy." He said his name was Rachel, in a very deep voice. So this was the first trans person I'd ever met. Lou was answering all these obnoxious questions, but was being very sarcastic. He was being very Lou Reed. You got the whole persona. He was both hostile and entertaining. I was really embarrassed as I'd studied journalism and knew how you ought to conduct an interview, and they were just asking him what he liked at McDonald's. But of course, it was the perfect thing to do. If I'd have asked him anything about the Velvet Underground, he would have just been irritated. We went to eat somewhere afterward. Lou had cheeseburgers but we couldn't afford to eat anything. At one point he got very antagonistic toward Legs, lashing out at him, which I thought was very humiliating. He was being mean to us. Very cutting, very

smart. It was a magical but traumatic night. In the street outside, Legs said, "What an asshole," while John was jumping up and down going, "Now we've got a magazine!"

Legs McNeil: I moved to New York in 1974, when I was eighteen. I'd come to drink beer and get laid. I moved in with John Holmstrom on Twenty-Fourth Street. His previous roommate was arrested for seven counts of rape. New York at the time was extremely intoxicating. It seemed like you could do anything. It was all about saying yes. No one wanted to live there anymore, as it was the end of White Flight. All the white people had moved to the suburbs. Everywhere was deserted. There was still a big division between uptown and downtown, but downtown was really deserted. There was still manufacturing in SoHo. New York at the time seemed like it had possibilities, and nowhere else in America felt like that. It felt like you could do things. I was writing for a small theatrical organization. John was doing cartoons for *Bananas* magazine, which I sometimes wrote for. If I wrote one of his cartoons, we would split the $150. You can buy a lot of beer and cigarettes for $75, which is all I really cared about. The money was usually spent before I got it.

John came up with the idea for the magazine, but I thought it was stupid, to tell you the truth. I thought, why would we want to do a magazine? It just seemed like more homework. But then he said that if we do a magazine people will want to hang out with us, and people will buy us drinks, and that made sense to me. He kinda translated it into my language. He wanted to call it *Teenage News*, which I thought was stupid. It sounded like a classic magazine. I said he should call it *Punk*. He never mentioned the word himself, it was me. I came up with it. He wanted to do a magazine that was rock and roll and comics, so *Punk* seemed appropriate. Plus, we were failed hippies, we couldn't get laid. At the time, the word still had negative, pejorative connotations. It's what everyone on TV said. When Kojak caught the villain, instead of saying, "You fucking asshole," he'd say, "You dirty punk, you're going to the slammer. For life." It was used on television a lot because you couldn't swear. The word was in print a lot but it wasn't in the vernacular. Lenny Kaye and rock writers would use it, but I didn't read those magazines. I thought they were stupid. John read *Creem* a lot, and corresponded with Lester Bangs and those guys. They called Alice Cooper punk of

the year, I think. We decided to call the magazine *Punk* before we even saw the Ramones.

We put Lou Reed on the first cover, and we gave him a second act, not that he'd ever say thank you. He would talk to Holmstrom, but he hated me because I asked the dumbest questions. He wouldn't even look at me. I was an asshole during the interview. I don't blame him. I was a moron. Half the fun was to be confrontational. He was like an old man, you know? Like somebody's father. He was a jerk. And when we interviewed him, he was sitting there with Rachel, the transvestite. John was jumping up and down and screaming, "We got Lou Reed for the cover, we got Lou Reed for the cover." And I said, "Yeah, but did you see that chick he was with, who was really a guy?" That's where my head was at that time.

We knew from the first issue that we were on to something. It was so exciting, and so much fun. It was genuinely funny, too, which we had hoped for. Everybody loved the magazine, but nobody wanted to be called a punk band, because punk hadn't happened yet. The Ramones were pissed off when we called them a punk band—but then the Ramones were always pissed off. The Ramones and the Heartbreakers were playing Sea of Clouds on New Year's Eve, going into 1976, and as I was walking down Houston Street, people were grabbing the magazine out of my hand.

I became famous immediately, and New York City became my city for about a year after the first issue. Anything I wanted. It was great. I was not involved in the business side of the magazine at all, I was just the resident punk. It felt like I'd arrived. I got a big head, like everybody who goes through that. Suddenly you're a somebody. It gave me an extraordinary amount of leverage. I had a lot of fun. In CBGB you also had a lot of great conversations. There weren't fights, we just talked all night. We weren't threatened. It was like a salon. A fun salon where you could drink beer and pick up girls. I thought the scene was going to explode and thought the Ramones would have a radio hit overnight, but that never happened. When the Seventies turned into the Eighties, everybody suddenly hated punk. The Sex Pistols did a lot to help with that. When Sid allegedly killed Nancy in 1979, all the record companies took out ads in the magazines saying don't call it punk, call it new wave.

I eventually left the magazine because I wasn't getting paid. I needed to make a living. I couldn't just glide by on my reputation of being the resident punk anymore. I managed a band for a while but basically, they ended up managing me as I was so drunk. So, I realized I had to start writing again.

Gene Krell: Richard Hell took me to CBGB one night to meet his girlfriend Sable Starr, and Roberta Bayley introduced me to Nicholas Ray, who directed *Rebel Without a Cause*, and *Johnny Guitar*, who was there watching punk bands.

Patti Smith (musician, artist): There was a countermovement of people like me who were dissatisfied with the way rock had been glamorized. People like Tom Verlaine and Richard Hell and Debbie Harry and myself wanted to continue the efforts of bands like the MC5 and Jefferson Airplane. We were merging jazz and politics and poetry and different kinds of performance. It was a cultural revolution.

Roberta Bayley (photographer): I came to New York in April 1974 from London, where I had been living for three or four years. I'd dropped out of college in San Francisco and just moved to London. I was a waitress, a salesperson, things like that. I worked for Malcolm McLaren briefly as I was living in World's End. Vivienne and Malcolm used to come into the vegetarian restaurant I worked in, the Chelsea Nuthouse in Langton Street. I split up with my boyfriend, so I moved to New York. I was briefly a nanny and babysitter, and then met this guy called David Nofsinger, who was a sound engineer for the Rolling Stones. He offered to show me New York and when he asked me what I wanted to do I said I'd like to see the New York Dolls, as I'd never seen them, so we went to see them at Club 82. It was a very strange show because they were in drag, and as I'd never seen them—I thought it was their normal show. David Johansen was wearing a strapless gown, high heels, and a wig. I thought they were really fun. And so I started going to see bands. CBGB was just starting, and I met Richard Hell and we started dating. That was my introduction to CBGB. I got to be a rock's star's girlfriend. They asked me to do the door when Television was playing there with Richard. There were maybe twenty-five people there, but they were

collecting maybe two dollars each. That's how my four-year job at CBGB started. I also saw Television open for Patti Smith at Max's. They really weren't like any other band. I used to wind up people coming into the club, saying you're seeing this amazing band for two dollars and soon it will be fifteen dollars at Madison Square Garden. Everybody was probably ambitious, but nobody looked or talked like they were. No one was saying, "I'm going to make it." It was a crummy club on the Bowery. Below Fourteenth Street the New York Dolls were stars, but not anywhere else.

The first time I met Lou Reed was at a bar called Locale on Waverly Place. I went with Richard and Lisa Robinson to meet Lou and Rachel. I think Richard had a crush on me, although they were married. Lou was pretty charming, but he could turn on a dime. He wasn't held up as an aspirational name. I think *Punk* magazine really helped pull him back up, although I don't really think Legs knew who Lou was. It wasn't as glamorous as people make out now. Everyone just wanted to get out of the place. There wasn't an ambition, just a desire to get out. It was a tiny thing, and only really caught on when the Ramones, Blondie, and the new Television started to draw crowds. I started taking pictures because I didn't want to do the door forever, and luckily I struck up a relationship with *Punk* magazine. I loved that.

This year, Lou Reed organized a kind of rapprochement with Warhol, only he didn't tell him. Having vowed never to work with his friend again, Reed spent several weeks putting words from Warhol's 1975 book The Philosophy of Andy Warhol: From A to B and Back Again *to music. A cassette tape discovered a few years ago at the Andy Warhol Museum in Pittsburgh was found to have contained live recordings that Reed put together from his 1975 tours, with songs from both* Sally Can't Dance *and* Coney Island Baby *on one side, along with a bunch of new songs labeled "Philosophy Songs (From A to B & Back)" on the other. The tape featured Reed sketching out new songs, using phrases from Warhol's "Philosophy" book as raw material for lyrics. One particular song highlighted the phrase "so what"—one of Warhol's favorite expressions—as a dismissive gesture. Other songs reference sex, fame, and drag queens, as well as Warhol's increasingly publicized indifference toward the deaths of two early Factory Superstars, Candy Darling and Eric Emerson.*

It is still not clear why Reed started work on these songs (which were never finished), although further tapes at the Warhol archive document a

series of meetings in 1974 in which Warhol and Reed discussed turning Reed's Berlin *into a Broadway musical. Obviously, that never happened, although in early '75 Warhol was involved in a notorious Broadway flop,* Man on the Moon, *featuring John Phillips from the Mamas and the Papas. In 2017, Laurie Anderson, Reed's widow, said she was unaware of the songs. "He had talked about some things that he had made for Andy," she said, "but they were always in the context of Andy telling him how lazy he was. You know, 'Lou, you're so laaazy.' I think that may have had a little bit to do with the motivation of him saying, like, 'OK, you can write a book; I'll write some songs about your book.'"*

CHAPTER 12

DOWNTOWN
CONFIDENTIAL
1976–1979

"All of the sudden the audiences started getting younger and the spread of the attendance was really wide. I think it's as a result of the records selling more that they started following our careers."
—John Cale

If anyone were in any doubt about the influence of the Velvet Underground, they only need pointing in the direction of the first issue of Punk, *in January 1976, which featured a cartoon of Lou Reed looking like Frankenstein's monster in a leather jacket. Reed became the punk template, and while Richard Hell's haircut was more influential, Reed's general demeanor was the British and American punk benchmark.*

"I knew that Lou had to be our cover story and that we'd deliver a big story that would bring us a lot of attention," says Punk's *former editor John Holmstrom. "The Ramones may have been more punk, but Lou was bigger news. Lou was never 'the godfather of punk,' as he was later labeled; he was a loved/hated New York icon, name-checked by the Dictators in their song 'Two Tub Man': 'I think Lou Reed is a creep,' they sang, and a lot of people agreed."*

Onstage, the Sex Pistols' John Lydon appeared to do a pretty good impression of Lou Reed playing Richard III, while his colleague Sid Vicious couldn't get enough of Lou. "He [Vicious] was all, 'Drugs yeah, it's all about drugs,'" says

Lydon. "Just because he had a Lou Reed record and he believed in the druggy image Lou gave off. Sid's downfall was that he didn't get a chance to meet Lou Reed before he knew what he was doing. He would never have messed with heroin if he had seen what a vacuous fat slob Lou Reed really [became]." The Pistols' manager Malcolm McLaren was also prone to referencing the Velvets' singer. When Vicious died of an overdose, McLaren said, "[How could anyone blame me for his death?] How can anyone say that? God, if Sid could only hear those words. It's like blaming Warhol for Lou Reed's heroin addiction. What are we saying here?" Sid Vicious (born John Ritchie) was actually named after John Lydon's pet hamster, Sid. After the hamster bit Ritchie, he said that "Sid is really vicious!" And so Ritchie was immediately nicknamed Sid Vicious. At the time it was completely ironic, as Sid was anything but Vicious then. As Jon Savage says, "He was goofy, funny, very style-conscious—a Bowie boy. As the Slits' guitarist Viv Albertine says, he was 'kind of sweet really.'" Sid loved his new sobriquet, as he loved the Lou Reed song even more. Lydon had originally called his hamster Sid, after Syd Barrett. He hadn't hated Pink Floyd at all, and only wore his "I hate Pink Floyd" T-shirt for effect. (McLaren also copied the Warhol playbook, building an intriguing army of misfits around the Pistols, which worked wonders until some of them, notably Lydon, started to rebel against him.)

As punk started to develop in the UK, vinyl (or at least the ownership of it) took on enormous importance. In the way that an Englishman can immediately place you when you open your mouth, instantly understanding how you have spent your formative years (George Bernard Shaw said it was impossible for an Englishman to open his mouth without making some other Englishman hate or despise him), so a quick trawl through someone's record collection in 1976/77 told you all you needed to know about them.

The music of 1977 was unusually dense, with a wealth of new sounds competing with the old, as record collections swelled to embrace new albums by the likes of the Clash, the Jam, Talking Heads, Wire, and the Modern Lovers, along with recently venerated records by outliers like the MC5, the Stooges, the New York Dolls, and the VU. Suddenly we were all looking backward as well as forward. One of the records that saw a lot of traction this year was the 1974 Velvet Underground budget compilation that introduced the band to many younger consumers, which vied with an almost sacred new release by John Cale for people's attention. His Animal Justice twelve-inch EP was released toward the end of the year in the aftermath of perhaps his most controversial

performance, a Croydon Greyhound gig that culminated with the beheading of an (already dead) chicken. Cale's band were so outraged they quit, the media used it to frame him as an aging punk warlord, and he wrote a song about the incident, "Chicken Shit," which kicked off the EP. The second track was an incidental version of Chuck Berry's "Memphis," although the third and final song, "Hedda Gabler," inspired by the Ibsen character, was a masterpiece, a track that seemed, unwittingly, to marry the better elements of his wildly varying solo work with a new somber punk aesthetic. One reviewer called it "anthemically atmospheric," another said it had "an odd majesty," and the brooding way the song is delivered makes it patently obvious that what Cale would have benefited from at the time was a stronger producer to amplify this side of his work, a person such as David Bowie perhaps, who was radically repositioning Iggy Pop with The Idiot *and* Lust for Life. *At the time, Iggy was thirty, and while still considered an unnaturally mature age for someone involved in the delivery of transgressive youthful pop, Bowie's patronage added an obvious luster. Cale, five years older, and blurrier in people's minds, seemed more like an angry Sixties relic. That he wasn't anything of the sort reinforces the damaging nature of optics.*

Lou Reed might have seen himself as the bard of New York (the way, he once explained, Joyce had Dublin and Faulkner the South), but during punk he was seen by everyone else as the genre's custodial godfather. For consumers of music papers in the UK and the US, Lou Reed and Iggy Pop were thought to be the quintessential manifestation of punk, in both music and style, with Reed's Rock'n'Roll Animal *persona being the benchmark for anyone wanting to properly come along for the ride. In the UK, the new generation of punks were categorized as ungrateful street urchins, while the CBGB crowd in New York were simply following in Reed's wake. Nobody looked more like a punk than Reed, no one sounded more like one, no one took so many drugs, and no one had such apparent disregard for their audience. He bleached his hair, painted his fingernails black, and wore makeup. He sang about drug addicts, transvestites, and masochists, all of whom he appeared to know. And he rarely wrote a song that involved more than three chords. Oh, and his antisocial and inappropriate behavior resulted in him being regularly accused of being a "jerk," an "asshole," or a "dick," insults he often seemed to enjoy. It was all very well for British punk rockers to cut their hair, start dropping their aitches, and buying leather jackets, but Reed had been doing that for most of his career. Reed hadn't just bought the T-shirt, he owned the factory that made them.*

Lou Reed: It was fun to be in a small club and to be able to look some-body right in the eye and watch them just freak.

Mary Harron: Nobody was really that cool in October '75. There were a few people, but not many. There was no pressure to look a certain way. All you had to do to be a member, was to turn up. I never felt that again anywhere else. There were very few people around, as lots of people thought that bands like the Ramones were just part of an awful scene. It was a cult scene, and sometimes late at night there would only be twenty people at CBGB. Lisa Robinson was there, Lou Reed was there, Warhol had been. It really felt like it was something new. I had rented an apartment in St. Mark's Place, and I didn't really know where to go, so I went back to CBGB. So the second night I went I met Richard Hell. I'd never heard of him, but when I read what he wrote I thought, "Oh my God everyone, here is a genius." I thought these people were so much smarter than anyone else I'd met. I think I used what I knew about the Factory to interpret CBGB for myself. It was New York bohemia, and I could see that there was a direct line back to the Factory. You know, the way people gave themselves names just like they had in the Factory. The Ramones for instance, Johnny Thunders, as well as all the glam rock people. A lot of the girls in '75, '76, before the English punk rock arrived, looked like glam rock chicks, very New York Dolls. The CBGB scene was very much like the Factory scene—New York cool, very articulate and sarcastic. Lester Bangs arrived in New York from Detroit in '76, and he was very excited by the scene. People were starting to act tough and wear black leather, but he thought they were all little lost lambs. He was right. Everyone in CBGB had had some kind of problem in their childhood. They'd had problems at high school or were trying to get away from something. These people were making an art home.

Lou Reed: So often in rock and roll, development is kinda reversed and someone who starts out with something to say loses it and winds up a gibbering idiot. It's disgusting. Back then I thought I'd lost it and I did a bunch of things I was really unhappy with. And I did it all in public and on record and there it is. That's what I did. I just kinda blew it apart because my problem—amongst all the other problems that were going on which you'd have to be deaf, dumb, and blind to miss (i.e., the drugs)—was

that I thought my ability had gone. I thought, it's gone, and I got real upset about it. I thought it had deserted me and it made me really crazy and suicidal, and I just did what a lot of people do about things like that which was more drugs and I got more fucked up to say, the least.

Robert Chalmers (journalist): I saw him on the *Rock and Roll Heart* tour, and I remember his general attitude as being one of: fuck you. For me, contempt for the audience has never been a good look.

Mary Harron: I think I understood the punk movement through the Velvet Underground and Warhol. I'm not sure I would have understood the Ramones had it not been for them. At that point I had heard about Iggy, but I hadn't heard him.

Danny Fields: There was no real rivalry between Lou and Iggy. They were both smart enough to realize that the other one wasn't a threat.

Chris Salewicz: That look that Lou Reed had, with the bleached cropped hair and the leather jacket, was taken up by a lot of French critics, and they were the forefathers of punk. This was in '72, '73, and I always thought [Malcolm] McLaren picked up on that when he went over with the New York Dolls at the end of '73. It was quite obvious at the time. A lot of these guys used to come over to visit the *NME* in London and they all looked like Lou Reed.

Moby: When I was growing up I fetishized New York City. It was the land of Lou Reed and the Velvet Underground, it was where Leonard Cohen wrote "Chelsea Hotel," it was CBGB and all the punk rock clubs. Artists and musicians lived there, and it was cheap and dangerous.

Marco Pirroni: I didn't know how I wanted to play guitar. I wanted to play guitar like Mick Ronson, but then I started to play the Velvets and their songs were easier to play. Even I could work them out, and I could hardly play at all at the time. I could make it sound like the record. That was a big thing. I thought, "I can do this." I hadn't seen the Pistols yet, I don't think they'd even performed yet, and I was thinking, how can I incorporate this into what I want to do, into how I want to play? It

was strange because I had no outlet for it, it was just me at home. I've always thought that Lou Reed was a criminally underrated guitarist. I was just finding my own way.

Proto-punks Susan Ballion (Siouxsie Sioux) and Steven Bailey (soon to be rechristened Steve Severin, taking his name from the Leopold von Sacher-Masoch character in Venus in Furs*) met at a Roxy Music concert at Wembley Arena in October 1975, and immediately, with a bunch of like-minded friends, started following the unsigned Sex Pistols. The* Melody Maker *journalist Caroline Coon dubbed them the "Bromley Contingent," as most came from the Bromley area of southeast London. Berlin, another member of the Bromley Contingent, says that Siouxsie very much modeled herself on the likes of Nico and Patti Smith, while Steve Severin mirrored Lou Reed and John Cale. When, in September '76, they learned that one of the bands scheduled to play the 100 Club Punk Festival, organized by Malcolm McLaren, had dropped out, they hastily convened a group, with Marco Pirroni on guitar and the as-yet unknown Sid Vicious on drums. Two days later, they played a twenty-minute set including an improvised version of "The Lord's Prayer." Fetishized ever since, initially those who were there that night thought it was fun but little else. But it was both the end and the start of something. McLaren certainly understood Warhol's convening power, and could see the attraction as he liked to paint himself as an empowering, controlling Svengali character. The Velvets' influence was felt elsewhere; the Buzzcocks came about in Bolton when Pete McNeish (later Shelley) saw a sign on his college noticeboard written by Howard Devoto (real name Trafford): "Wanted, people to form a group to do a version of 'Sister Ray.'" Shelley says he already knew the Velvets' albums back to front.*

Siouxsie Sioux (singer, musician): We literally formed that night at the 100 Club punk festival, there was a spot free, and we just thought, "All right, we'll just form for the night and that's it"—taking the Warhol [fifteen minutes of] fame thing to its extremity, literally playing for that one show. The irony is that we always distanced ourselves from being a "punk" group and having that sort of label of convenience, we hated having any label of convenience, of being lumped together with everybody else. So, we always distanced ourselves, but with the longevity, the essence and spirit meant what I think punk means in that it sweeps away what's gone before.

Gene Krell: Malcolm loved the fact that while I lived in London, I was obviously from Brooklyn. We were fellow travelers, we worked well together. Malcolm considered himself a revolutionary, and he created an atmosphere, and the clothes became the visual expression of all that. What he despised was the status quo, so he would often express his disdain for Warhol. He said he was happy when Picasso died, and said he disliked Warhol for the same reason, because he became a popular figure. He didn't like the fact that Warhol went around with Jackie Kennedy, for instance. He said he thought Warhol was a spoon-fed bourgeois dilettante, and Malcolm was diametrically opposed to that. But having said that, the commonalities were far greater than the differences. He was more inspired by people like Guy Debord and the Situationists, the idea of urinating in the streets, which obviously Malcolm would never do. In the end he wanted to hang out with Swifty Lazar. This was his methodology. Malcolm loved a polemic, and while he would say these things, when you spoke to him clandestinely, you knew what was really at work. He was interested in the economics.

Marco Pirroni: When I did the 100 Club with the Banshees, we didn't know each other really, and none of us could really play anything, and I think it was Sid who said, "Let's just make a noise like 'Sister Ray.'" I thought, "I know what you mean! Oh my God, no one's ever said that, yes, let's do that. I can do that." So suddenly Siouxsie and the Banshees were doing "Sister Ray," and I understood it all. Let's do this thing like that band the Velvet Underground. Everyone said yeah, that's a good idea, and we did it. By this time, I'd already seen the Subway Sect, and they had all that ostrich guitar which I really liked. And I thought, "This is really Velvets, all that jangly guitar." So, I was thinking that these other people were having the same experience as me. But nothing was ever really said. No one really talked about the Velvets, it was something we all got by osmosis, and we'd all been listening to this stuff in isolation in our rooms at home. It became part of our DNA. It still is.

It was a revelation to discover that there were like-minded people out there. The first time I had an inkling that anything was happening was when I heard something about a band Malcolm was working with. I was walking down Denmark Street looking at guitars, and I saw Vivienne [Westwood] coming toward me wearing Malcolm's black lurex fur coat,

carrying these coffee cups. I asked her what she was doing, because at that point the two worlds of music and fashion, Denmark Street and the Kings Road, they didn't collide in any way, they were completely separate. It was strange to see Vivienne suddenly standing in the other part of my life. She said she was working with Malcolm's band across the road, and said why don't you come and meet them. I was only sixteen, and painfully shy. So I met Steve [Jones] and Glen [Matlock], and Glen I already knew from the shop. I was desperately uncomfortable, but I desperately wanted to be involved. They seemed so much older. They were three or four years older than me which as a teenager is a huge gulf. So I left there, got on the train, and thought, "What is happening?" This band, dressed in clothes from [Westwood's shop] Sex. I hadn't even heard them play. These things just shouldn't fit together, Denmark Street and the Kings Road.

You didn't hear the Velvet Underground on any jukebox, or in clubs, or on sound systems at gigs. There was a tunnel between Tottenham Court Road station down to Denmark Street, and there was a busker down there playing "Sunday Morning." That was the first time I'd ever heard anyone singing a Velvet Underground song. There were only a handful of people who were into this stuff, maybe tens of people. It wasn't even hundreds. I read the music press religiously, all four papers every week—the *NME, Melody Maker, Sounds,* and *Record Mirror.* And there was never a fucking mention of the Velvets in any of them. After a while I didn't even bother looking because I knew it wasn't going to be there.

Siouxsie Sioux: "Venus in Furs" epitomizes what I love about the Velvet Underground.

After the 100 Club gig, Siouxsie and Severin started to try and form an actual band, initially using Simone Thomas, a black girl with peroxide hair—one of the Bromley Contingent who would be asked by the Sex Pistols to accompany them on their infamous appearance on Bill Grundy's TV show Today *in December, when punk was rudely introduced to the British public. She was a classically trained violinist, and one of the original ideas was for their new band to "do" the Velvets. However, the first songs they wrote sounded nothing like them, "and the violin seemed a waste of time," says Severin. When he and*

Siouxsie went through each other's record collections, attempting to assimilate elements of both into a fresh sound, the only album they had in common was John Cale's Fear. *So many early punk bands professed a love of the Velvets. Wire's Colin Newman says that when they started recording, "It had got to be a bit like the Velvet Underground—messy and heavy and sneering." The Undertones' John O'Neill says, "We were such purists about everything. We knew all the* Nuggets *stuff, the New York Dolls, the Velvet Underground."*

Marco Pirroni: Things started to change after the 100 Club, and possibly not until early '77, when the music papers couldn't really ignore punk anymore. *Sounds* went completely punk; John Peel went completely New Wave. They bought into everything. And then people started saying, "Oh, we never liked Robin Trower or Peter Frampton." You fucking liar. I was sort of well-equipped because I had never liked Robin Trower or Peter Frampton. I fucking hated them. So I didn't have to pretend, I didn't have to make things up. I really did know this music, and I really loved the Velvet Underground.

Then when the Ramones started, people started looking toward New York, which was always the great Oz, where everyone wanted to go to. I remember Jordan went to New York, and there was the Dolls, the Ramones, Richard Hell and the original Heartbreakers...Handouts started appearing in the shop [Sex] for Television. There was one which was an A4 photocopied handout with a picture of Venus de Milo and it said Television, with a list of all their songs. I thought that was really cool, and then two weeks later the Pistols did it. "No Feelings," "Submission," and all that. New York at that time still felt exotic, but I knew that scene was over. That whole Warhol thing. I knew about Andy Warhol because I'd been to art school, but I didn't think New York was better than London because those bands seemed older and they didn't look as good. So I thought, "I'm in the right place."

In January '76, Lou Reed was talking to Talking Heads, backstage at one of their early gigs at CBGB. "It's like, cool, you have a chick in the band," he said. "Wonder where you got that idea." Later that night he invited the band*

* When they started playing their signature song "Psycho Killer," the band likened it to a weird mash-up of the Velvet Underground and Otis Redding.

back to his apartment on the Upper East Side. Reed sat on the floor eating an entire tub of Häagen-Dazs ice cream (a quart), and at one point stood up to retrieve the only book on his bookcase, The Physicians' Desk Reference. *He then proceeded to tell them which drugs had been his favorites, and which ones he was taking now. The band's drummer, Chris Frantz, said Reed looked as though he was flicking his way through an L.L. Bean catalog, "Except with pills, pills, pills."*

Jon Savage: During the Seventies, there was a slow accretion of the legend. In 1971, Polydor UK rereleased the first three Velvet Underground albums to critical acclaim and a few more sales. The next year, Lou Reed hit with "Vicious" and "Walk on the Wild Side." David Bowie popularized Warhol, bisexuality, and the Velvets, who were there first, weren't they? The Reed-less Velvets toured, and nobody noticed. In mid-decade, Mercury released the 1969 live set, and Nigel Trevena published the first collection of facts about this almost unknown group. For the Velvet Underground were distinctly ill-exposed. During their lifetime, there were a few record reviews and a few articles by hardcore fans, like Sandy Pearlman and Jonathan Richman, in tiny magazines. Explicitly opposed to the gigantism of the San Franciscan scene—which dominated American pop as it turned into rock during 1968/69—the Velvet Underground were not featured in the dominant media of the time. Out of the mid-Seventies, the story entered our time. Punk brought the Velvet Underground into their own: they were one of the three pre-1976 groups—along with the New York Dolls and the Stooges—that would be admitted to the Pantheon. The group became a rock journalist's touchstone: the subject of discographies, esoteric research, mythmaking in articles by Giovanni Dadamo and Mary Harron. The trickle of Velvet Underground bootlegs became a flood: the "Foggy Notion" and "Cycle Annie" 45's, the Skydog LP, *The Velvet Underground Etc*. This was only natural, as English punk was a fantasy of the Warhol Factory, proletarianized and transposed to London ten years on.

Tracey Emin: I first came to Warhol when I was fifteen, at school. I had to take an art exam, and Andy Warhol and Roy Lichtenstein were the two contemporary artists we were being tested on. But I'm not influenced by Andy Warhol. It's the opposite. What Andy Warhol did is

he invented something completely new. I'm not doing that. It took me ages to work out that I'm not doing anything new. I'm doing something so traditional. What I'm doing is quite old-fashioned, really; I'm not trying to invent anything. I'm just doing what I do in my own little way. When I was younger, I'd go to a show and I'd ask myself, what kind of artist do you want to be: Joseph Beuys or Andy Warhol? And actually, you don't have to be anything.

The clichés about drug pairings were completely accurate. I remember during the punk days (and nights) of '76 and '77, when speed was the drug of choice for many of us rattling up and down the A40 to the Marquee, the Hope and Anchor, the Red Cow, the Roxy, and the Nashville to watch the Sex Pistols, Clash, the Jam, Generation X, and all the other overgrown pub rock bands. Sulfate kept us awake, kept us alert, gave everything an edge. Speed needed to be accompanied by fast music, aggressive music, and the kind of confrontational noise it was OK to belittle. So when we ended up at house parties in parts of London we'd never been to before—on the Dollis Hill borders, in Butler's Wharf, or down in the Ladbroke Grove squats—the Velvet Underground's first two albums were the kind of thing that reflected our drug intake. It made sense to be listening to "Heroin" at four o'clock in the morning in some dingy housing association flat if the alternative was a freezing cold night bus back to Streatham. Alternatively, by the time we were safely back home, in the Victorian terraced houses shared by the kind of people who saw more of each other after dark than they did during the day, it was The Velvet Underground we wanted to hear; the third album we wanted to sink into as we smoked ourselves down.

In April '77 Lou Reed was interviewed by Allan Jones for Melody Maker, *the infamous exchange where he said, "Now I remember why I gave up speaking to journalists. They're a species of foul vermin. I mean, I wouldn't hire people like you to guard my sewer. Journalists are morons. Idiots."*

In the same interview, he also pontificates on the exact cost of heroin a decade after he wrote "I'm Waiting for the Man": "Unintentionally, the Velvets have become something of a specter. Songs like 'Heroin' and 'I'm Waiting for the Man' aren't easily forgotten. You're constantly judged by songs like that. You know, we were rehearsing yesterday—much to everyone's surprise, we do rehearse, it's not as easy as it looks, kids—and we were running through 'I'm Waiting for the Man'... you know, 'Twenty-six dollars...' And I said, 'Hey,

wait a minute! Twenty-six dollars? You can't even get a blow-job for twenty-six dollars these days, let alone some smack...' So we were all saying, 'Jesus Christ, what's the going price these days? Somebody get out on the street and find out. It can't be twenty-six dollars.' You know, we wanted to be authentic. Eventually we decided that the song would have to be classified under folk mystique because we couldn't find out. Anyway, the song isn't outdated. Everything about that song holds true except the price."

Nick Kent: Lou Reed had said in print that he was going to beat me up. But I saw him in Hyde Park soon after and he walked straight past me. He saw me.

Danny Fields: Lou was anything but dismissive, he just didn't suffer fools gladly. He really didn't. When I was looking after the Ramones, I played him an early copy of the first album in my apartment and he laughed all the way through it, he loved it. He was incredibly enthusiastic about the new punk scene.

Fields used to go to the Printing House Gym on Hudson Street with Reed, and they were there one day on the stationary bikes and Fields told him that a friend of his, the DJ and journalist Anita Sarko, was going to interview him in a few days, and could he be nice. "You read all these interviews and he's terrible," Sarko had said. "And I'm petrified." Fields said, "Lou, she's family, so don't be mean. Lou, look at me. Repeat after me. 'She's family.'" Two weeks later Fields bumped into Sarko and asked her how it had gone. She said that Reed had been mean and distant and cold and cynical. "He was everything I feared. A monster. Hostile."

When Fields remonstrated with Reed, he said, "Well, she pressed the record button, so I had to become Lou Reed." It's hardly surprising: if you were an editor and you sent a reporter to interview Reed, or attend a press conference, you'd be disappointed if they didn't come back with some colorful, mean content. Reed had a character to play up to, which people had come to expect. "Snarling, howling, terrifying, and intimidating—that's what people expected from Lou Reed, so that's what he gave them," says Fields. "With friends, he was just Lou."

Robert Chalmers: That's what Bob Dylan used to say: I've got my Bob Dylan mask on.

Chris Difford: I found punk too dangerous. I'd been in gangs before as I'd been a skinhead, and it didn't seem like a genuine gang to me, it just seemed like a reaction, to parenting, to school, to society at that time. When I went to the clubs to see the Clash or the Sex Pistols there was nothing about it that interested me. They were shit. I didn't enjoy the aggression of the audience and it seemed unnecessary to react in that way. I felt uncomfortable. I much preferred the Velvet Underground.

We did our first album with John Cale, so we went all Velvet Underground for fifteen minutes. When Squeeze went to America for the very first time, in 1977, we played Hurrah's, and Andy Warhol, John Cale, and Lou Reed came to our show. Afterward we went back to a warehouse and there were all sorts of scenes going on. There were people having sex in the corner, there were drugs everywhere, and my eyes were wide open. I thought, "What the hell is going on here? This looks like fun. This is the reason I joined a rock and roll band, to see people screwing in the corner of a warehouse." I don't think we were for them, as we were a south London pop band, and we were doing three- and four-minute songs. We didn't really turn the corner into the Velvet Underground world until John Cale produced our first album. He would say to me, "Your lyrics are too sweet, Chris. Why not write a song about being whipped? Or being sexually harassed by a prostitute?" But I said, "That hasn't happened to me yet!" So he told me to use my imagination. And that was fantastic, to be told I could use my imagination like that. He told me to think about what goes through a muscleman's mind before he goes onstage, getting all vibed up, covering himself in oil, taking all these drugs. So, I went home and wrote a song that depicted that. It was a childhood dream that I never thought would come true, to work with one of the Velvet Underground. Our manager Miles Copeland had an agency, and John Cale was signed to it, so we asked him to produce the album. This was the time when he was biting the heads off chickens onstage in Croydon. He came down to the studio to listen to our songs, and I can't say we got on very well at the start. He really didn't like our music and wanted to completely change what we'd done. The twenty-four pop songs we'd recorded for our first album, he dumped them all and made us start again. So we had songs with whipping in the background, a song called "Sex Master." We were young guys making our first album, and it was frightening. But then one day he passed out

and wasn't around for a couple of days, which is when we recorded our first hit, "Take Me I'm Yours." John's early records are amazing records. They were very odd lyrically, but that was what appealed to me. He encouraged me to not just write love songs, and to pursue the obscure.

Valentine Guinness (musician): I went to New York for five weeks during my gap year before I went up to Oxford in 1977, aged eighteen. I spent every day with Andy and Catherine, my sister, who worked for him. I didn't really do anything else, apart from a bit of sightseeing. I was immersed in the whole Factory phenomenon. New York at that time was the height of everything, what with Studio 54 and everything. There seemed to be celebrities everywhere. Catherine, having been Andy's walker for quite a long time, for that period she sort of handed the role over to me. When she couldn't make an event or was too tired, she'd ask me to step in to escort Andy. At that time, he would go to the opening of an envelope. He accepted every invitation, because he absolutely loved standing around at a launch having his picture taken. He loved being the center of attention, and he always had a gaggle of people around him trying to talk to him. He enjoyed being a celebrity. He enjoyed the razzmatazz of it.

By this time, he had stopped trying to be rock and roll, he was in a preppy stage. His uniform was blue Levi's, very often a white jacket, with a checked shirt and brown brogues. He'd toned the whole thing down, so he was almost an establishment figure. He also loved dressing up in black tie. He seemed to be in black tie all the time. I think even Andy was starting to tire of nightclubs.

Peter York met Warhol at a party at Diane von Fürstenberg's gigantic Upper East Side apartment sometime toward the end of the Seventies. He was standing in a corner, minding his own business, and taking stock of the room, when he felt a hand slowly grab his midriff. "Well, this isn't how one usually greets a person, is it," says York. "It was strangely intrusive, as well as being an odd kind of greeting." So, he turned around, but before he could say anything he was confronted by Warhol, holding his outstretched hand. "That wasn't very 'Andy,' the intimate grabby thing," says York, "so I figured he probably wasn't as 'Andy' as everyone made out. There was a warmth to him that he obviously kept hidden as it wasn't very on-message. But then the whole Factory

thing was a mess of contradictions. I spent a day there once and nothing at all happened. And I mean literally nothing. All the freaks had gone and been replaced by people who weren't freakish at all."

Michael Zilkha: I interviewed John Cale for *Interview* in 1977 and that's how we became friends and decided to launch a record label together. So we went into business together with Spy Records. Punk was happening, Mary Harron was bringing us lots of great singles from England, so it seemed like a good idea. John was very druggy, but then lots of artists had similar issues at the time. That's why we eventually broke up the partnership. He was very, very high and wasn't in a good condition. He wasn't easy then, he really wasn't, and had become a junkie. We are great friends now, but that was a different time.

Bobby Gillespie: My relationship with the Velvet Underground started in 1978 when I bought the "Street Hassle" twelve-inch with the original versions of "Venus in Furs" and "I'm Waiting for the Man" on the B-side. Then Gerry McElhone, who would become our manager, had the first album, and we used to listen to it at his mum's house. Then I heard the live *1969* album. In '79 there was still a lot of contemporary music that was interesting. Post-punk. Joy Division. The first two Banshees albums, Wire, Public Image Limited, Echo and the Bunnymen. And the Velvet Underground kind of fitted into that. They had all obviously listened to the Velvet Underground, as they had Can, and that obviously went into the mix when they started making music. Ian McCulloch was very Sterling Morrison. To me they were a new band, not an old one. By 1982, when I'd become bored of contemporary music, I delved back into old music, with the Doors, Arthur Lee's Love, the Byrds, Syd Barrett, and the Velvets. The dark heart of rock and roll. There was a mystery to music then. The Velvets had an aura and a mystique, and there was almost no literature on them. Cale basically gave them an image of evil. He was so fucking stylish. The heavy S&M, amphetamine-fueled, smacky image on the first two records—and it was all in the imagination. Today everything has been exhumed, but back then it was all new. It was the whole thing of being interested in something that no one else was. If you liked the Velvet Underground, then you took speed. Maybe if you were brave you took heroin. You could tell they had a lifestyle

and wasn't around for a couple of days, which is when we recorded our first hit, "Take Me I'm Yours." John's early records are amazing records. They were very odd lyrically, but that was what appealed to me. He encouraged me to not just write love songs, and to pursue the obscure.

Valentine Guinness (musician): I went to New York for five weeks during my gap year before I went up to Oxford in 1977, aged eighteen. I spent every day with Andy and Catherine, my sister, who worked for him. I didn't really do anything else, apart from a bit of sightseeing. I was immersed in the whole Factory phenomenon. New York at that time was the height of everything, what with Studio 54 and everything. There seemed to be celebrities everywhere. Catherine, having been Andy's walker for quite a long time, for that period she sort of handed the role over to me. When she couldn't make an event or was too tired, she'd ask me to step in to escort Andy. At that time, he would go to the opening of an envelope. He accepted every invitation, because he absolutely loved standing around at a launch having his picture taken. He loved being the center of attention, and he always had a gaggle of people around him trying to talk to him. He enjoyed being a celebrity. He enjoyed the razzmatazz of it.

By this time, he had stopped trying to be rock and roll, he was in a preppy stage. His uniform was blue Levi's, very often a white jacket, with a checked shirt and brown brogues. He'd toned the whole thing down, so he was almost an establishment figure. He also loved dressing up in black tie. He seemed to be in black tie all the time. I think even Andy was starting to tire of nightclubs.

Peter York met Warhol at a party at Diane von Fürstenberg's gigantic Upper East Side apartment sometime toward the end of the Seventies. He was standing in a corner, minding his own business, and taking stock of the room, when he felt a hand slowly grab his midriff. "Well, this isn't how one usually greets a person, is it," says York. "It was strangely intrusive, as well as being an odd kind of greeting." So, he turned around, but before he could say anything he was confronted by Warhol, holding his outstretched hand. "That wasn't very 'Andy,' the intimate grabby thing," says York, "so I figured he probably wasn't as 'Andy' as everyone made out. There was a warmth to him that he obviously kept hidden as it wasn't very on-message. But then the whole Factory

thing was a mess of contradictions. I spent a day there once and nothing at all happened. And I mean literally nothing. All the freaks had gone and been replaced by people who weren't freakish at all."

Michael Zilkha: I interviewed John Cale for *Interview* in 1977 and that's how we became friends and decided to launch a record label together. So we went into business together with Spy Records. Punk was happening, Mary Harron was bringing us lots of great singles from England, so it seemed like a good idea. John was very druggy, but then lots of artists had similar issues at the time. That's why we eventually broke up the partnership. He was very, very high and wasn't in a good condition. He wasn't easy then, he really wasn't, and had become a junkie. We are great friends now, but that was a different time.

Bobby Gillespie: My relationship with the Velvet Underground started in 1978 when I bought the "Street Hassle" twelve-inch with the original versions of "Venus in Furs" and "I'm Waiting for the Man" on the B-side. Then Gerry McElhone, who would become our manager, had the first album, and we used to listen to it at his mum's house. Then I heard the live *1969* album. In '79 there was still a lot of contemporary music that was interesting. Post-punk. Joy Division. The first two Banshees albums, Wire, Public Image Limited, Echo and the Bunnymen. And the Velvet Underground kind of fitted into that. They had all obviously listened to the Velvet Underground, as they had Can, and that obviously went into the mix when they started making music. Ian McCulloch was very Sterling Morrison. To me they were a new band, not an old one. By 1982, when I'd become bored of contemporary music, I delved back into old music, with the Doors, Arthur Lee's Love, the Byrds, Syd Barrett, and the Velvets. The dark heart of rock and roll. There was a mystery to music then. The Velvets had an aura and a mystique, and there was almost no literature on them. Cale basically gave them an image of evil. He was so fucking stylish. The heavy S&M, amphetamine-fueled, smacky image on the first two records—and it was all in the imagination. Today everything has been exhumed, but back then it was all new. It was the whole thing of being interested in something that no one else was. If you liked the Velvet Underground, then you took speed. Maybe if you were brave you took heroin. You could tell they had a lifestyle

attached to them. They had to immerse themselves in cult behavior and transgression. It had a sexual allure to me. It was very attractive. Also, learning to play "I'm Waiting for the Man" taught me how to write songs. "Heroin" is just two chords.

Valentine Guinness: Andy was given tickets to the screening of *New York, New York*, the Martin Scorsese film starring Robert De Niro and Liza Minnelli. There was a dinner in the Sherry Netherland Hotel afterward, and I found myself seated next to Liza, and opposite Scorsese. And then Roger Moore suddenly appeared, at the very height of his James Bondness, so it was an extraordinary night. I was so nervous that I nearly spilt a cocktail over Liza Minnelli, and she said, "That really would have ruined your evening, wouldn't it?"

Tony Parsons (journalist, author): This was '77, maybe '78, and I'd just been on tour with Thin Lizzy, who were playing the Eastern Seaboard, and I ended up in New York with the Clash, who were on a promotional tour. My paper, the *NME*, had told me to go up to Manhattan and sit outside Joe Stevens' apartment and wait for him to come home. He was their photographer in New York. They said that if I sat on his doorstep long enough that he'd eventually turn up and he'd be happy to see me. And he did, and he was. He was going to show me around. So he took me down to CBGB on the Bowery, and the moment we get in I spied Lou Reed, and he seemed to take an unnatural interest in me. I was this young, twenty-three-year-old English boy in a leather jacket, fresh meat, and he definitely had eyes for me. I seemed to be his thing. That's where Lou went to pick up boys. In London we were always quite wary of the New York downtown scene because it meant heroin. We were intimidated because of it. It didn't matter how much sex and drugs and rock and roll you'd experienced as a London punk, what you probably hadn't been involved with was heroin. That was really the big league, that was really giving up on life. That was Johnny Thunders, Lou Reed, Iggy Pop. They had come to London almost as the second act of their career, but it felt rather desperate. CBGB felt like Blenheim Palace or the Tower of London, in as much as it felt like a place of historical importance, but it didn't feel like much fun. It felt as though it was over. In the Roxy you'd be having half a lager with the Sex Pistols, or

talking to the Clash or the Jam, but CBGB by this time felt a bit tired. By the time I got there you felt as though you were sifting through the archeological layers of musical history. With Lou Reed trying to get in my pants. The Clash felt the same thing too, felt that CBGB was part of the past, and not the future. Whatever was happening in New York wasn't happening here.

Valentine Guinness: Every day I would go over to the Factory in the afternoon and hang out there and use it as a bit of a base. It was very relaxed and a lot of people didn't seem to be doing all that much. And in the evenings there would be at least three events that we'd all go along to. Sometimes Fred Hughes would come, sometimes Bob Colacello, and sometimes it would just be me, Catherine, and Andy, and often just me and Andy. One night Catherine said that Andy wanted to go to a screening of this movie, but she couldn't face it, so I escorted him. He said, "Gee, I don't know if this movie is going to be any good, it might be a bit boring, a bit silly, it's some sort of science fiction thing, but it's very sweet of you to come along." And it turned out to be *Star Wars*, and we loved it. He was a bit fruity with me, as I was only eighteen at the time. When all his photographs became available online a few years ago, there were some that had been taken of me at his weekend house in Montauk, and I found a picture of a crotch, fully clothed of course, but obviously taken without my permission. It was just a photo of my package. That was the real side of him, as he was very horny and kinky. I had lunch with Andy and Catherine and Victor Hugo, who was [the fashion designer] Halston's partner and one of Andy's assistants. In the taxi afterward, Victor asked if I could accompany him and Andy to do some "art." Catherine put her foot down and said no, although in my naive way I was quite keen. Back in her apartment she said, "When they say art, it means they shit and wank and pee over a canvas and then they sort of rub it in with their feet." That was what they were going off to do after lunch. Andy's persona was very sweet, and he was terribly polite and quiet, but every now and then the undercurrent of this dark, other life peeked through. He was a mixture of kindly uncle and a naughty boy. There was something incredibly childish about him. He liked pushing people to see how far he could go, what would happen. He would make people do things for him, and the thing is, people would,

to entertain him. He obviously had his camera with him all the time, which was something he hid behind, so he didn't have to make too much conversation. He enjoyed bitching about people after he'd left an event in the taxi afterward. The general thing was "gee," "wow." One of the tricks of his success was making everyone feel important. He got everyone to tell him about their dreams and their hopes, and he would always say it sounds so exciting. It was all rubbish really, but people loved it. He wasn't particularly confident around people, so he found a way of dealing with it. But the monosyllabic thing became a bit boring.

Duggie Fields: The last thing I went to in London before lockdown was the Andy Warhol show opening at the Tate Modern. I loved the exhibition as it reminded me of the New York I knew and lived: I went to every Factory except the first one. Whenever I was being given a tour, someone would reintroduce me to Andy's assistant, saying you know Duggie, at which he would look at me and say, "Yeah," as I was thinking "No you don't!" It always felt a privilege to go to the Factory. In the Tate exhibition, they had one of his Oxidation paintings—sheets of copper canvas. I got asked to participate in one of his Oxidation paintings, which involved people pissing on these big copper sheets. I declined, thinking this is literally a piss-take! And now they are in museums all over the world. No regrets though, as I like the story.

Back in the UK it seemed as though every new band no longer wanted to sound like the Sex Pistols, the Ramones, or the Buzzcocks, but rather the more austere and industrial likes of Wire, Pere Ubu, or indeed the Velvet Underground. When Siouxsie and the Banshees released their debut album The Scream *in November 1978, the* NME's *Nick Kent said, "The band sounds like some unique hybrid of the Velvet Underground mated with much of the ingenuity of* Tago Mago-*era Can, if any parallel can be drawn." At the end of his review, he said, "Certainly, the traditional three-piece sound has never been used in a more unorthodox fashion with such stunning results." As New York started to embrace the slickness of the dance floor, so London went black and white again, wallowing in bleak post-punk audacity.*

Valentine Guinness: Warhol never talked about the Sixties. There was a sense that after the shooting he pushed all that darkness away from him.

It was the grim past. He was no longer the polo-necked cool weirdo. The excesses of the old Factory were way behind him, and the Factory I knew was like an estate agent's.

He had a sixth sense about what was good, what was coming. He was very keen on seeing this new band who were supporting Bryan Ferry at the Bottom Line, and it turned out to be Talking Heads. Lou Reed was with us that night, and he liked being rude and standoffish. That was his thing. That was how he managed things. He liked to insult people before they insulted him. Catherine introduced me to him, and he said, "Oh, Valentine Guinness. That sounds like a kind of commercial to me." Not only is it not very funny, but it's also just rude. That was a typical Lou Reed conversation that one would have.

Robert Risko: I was born in western Pennsylvania, about forty-five minutes outside of Pittsburgh. Warhol was probably my parents' age, and he really forged a path for me because on my father's side there is the same nationality, and if you wrote Warhol's father's story that would be my grandfather's story. The Russian peasant farmers coming over, and the fact that he became so ultra-hip was like, yes we can do it! I loved Andy Warhol, loved Pop Art, loved *Interview* magazine, and in 1976, my goal was to work for them. I knew they didn't have illustrators, but I thought I should try. I knocked on the Factory door twice, but was turned away both times, and it wasn't until 1978 when Andy was signing copies of *Interview* on Fire Island, that I finally got to meet him. So I stood in line to meet him, and Halston, who he was with. I told him I really wanted to work for his magazine, and so the following Monday I called the office. I had a one-on-one with Andy and he hired me. Suddenly the gates of heaven were open.

Valentine Guinness: A rich couple would walk into the Factory, and on the floor there would be a large five-foot-by-five-foot screenprint negative of the wife, and underneath Andy and his helpers would push colored sheets around, and the husband and wife would choose what colors they liked. The resulting screenprint would be the colors they had chosen. Thirty thousand dollars was the fee for the portrait done in this way. Anyone could have it done. It was a factory. Some years later I went back with a friend, and paid a visit to the Factory, and Andy

wasn't there. I still thought I owned the place really, and so took my friend back into the bowels of the floor and we found a man doing an Andy Warhol, on the floor on his knees. I introduced myself and he said, "Do you mind if you go away?" He was absolutely appalled that we had seen him do this. But that's the way it worked—Andy didn't do anything as far as I could tell.

Robert Risko: When I first met Andy, he was this stuttering, insecure character, but one time I was up at the Factory, and I heard someone behind me say, "Oh did you go to that party and see what she was wearing?" And I turned around and it was Andy, and he was a completely different person. Then he looked at me, and then started the whole stuttering thing again. Bowie said that Andy was his greatest creation, and he was right. It was a construct. We are basically the same person, at least on my father's side, and I know that personality. Andy could have been my grandfather. He would put on a dumb act to your face but be talking about you behind your back. They are not straightforward. Andy played dumb but he was shrewd underneath.

In 1977 the Museum of Modern Art produced a book entitled 155 Recipes: Conversations with Thirty Contemporary Painters and Sculptors. *Andy Warhol's contribution was Campbell's Milk of Tomato Soup: one can of soup, two cans of milk. Bring to the boil, stir and, serve.*

Nicky Haslam: In 1978, I threw a party for Andy at the Roof Gardens in Kensington when it opened. The invitation read "Nicky Haslam and Regine for Andy Warhol." I liked having top billing. By then he was much more controlled. He had the apartment in Paris, he had the new Factory, he was a celeb. And you don't have the same sort of relationship with celebs that you do with friends. He became more interested in himself rather than his persona. He didn't say "Wow" quite so much. The last time I saw him was when I used to write a gossip column for *Ritz*, which was obviously just a copy of *Interview*, and whenever I was in New York Andy let me write it at the Factory. Which I thought was ironic.

Myra Scheer was an assistant to Ian Schrager and Steve Rubell when they were running Studio 54, from 1979 to 1980. She would start at ten o'clock every

morning and go straight to their office. Often Paul Simon would be there, just hanging out. Together they would go through the newspapers, to see what Broadway show was opening that night and decide what to throw parties for. She would read Rubell's notes from the night before—put this person on the guest list, call that person—which were written on drinks tickets. Then she would go through the call list: eight pages of people Rubell wanted her to invite, such as Mick Jagger and Richard Gere. Whoever answered the phone at Interview *magazine, Scheer would say, "Hi, it's Myra calling for Steve Rubell, for Andy [Warhol]." "Hold on!" She would get put through to Warhol right away. He'd say, "That's fantastic, tell Steve I'll be there." A few months later she started working nights instead, on the door. "Once you got in, if you were on the guest list or comp, you'd come to me," she said. "If you were paying, you'd go to another girl. It was twelve to fifteen dollars to get in, but on a big night like New Year's Eve it was fifty. Sometimes I'd walk the celebrity straight to Steve. He was so excited when Neil Young came in, he made me give him a tour of the club. When Billy Carter, the brother of the president, Jimmy Carter, came in, he was terrified, like a deer in headlights. Steve said, 'Myra, get him to dance!' So I did."*

Sunday, September 23, 1979: in The Andy Warhol Diaries, *the author mentions bumping into Lou Reed in midtown, who tells him that one of his dachshunds has had an operation on his back. Warhol tells him to come down to the Mudd Club with him as they are having a Dead Rock Stars Night. Reed says he will go as himself, but then Warhol tells him he looks too good for that now.*

Allan Jones (journalist): In 1979, I'd gone to see Lou Reed at the Hammersmith Odeon, which even by Lou's standards was a pretty confrontational concert. By the end of the show most of the audience had left. People had been calling out for "Pale Blue Eyes," "Sweet Jane," and "Heroin," and he was intent on playing his new album, *The Bells*, in its entirety. He also left the house lights on, which made the gig quite uncomfortable. The crowd continued calling out for his old songs, and so Lou eventually told us all to fuck off, so lo and behold a lot of people did. As soon as the audience had gone, and there were only a few of us left by then, he started playing "Heroin," "I'm Waiting for the Man," and all the songs they'd been screaming for. The concert ended with his bass player, Ellard "Moose" Boles, singing a half-hour version of "You Keep

Me Hanging On" by the Supremes, although he appeared to only know the chorus. The bass was so loud that it actually made my girlfriend physically sick. It was horrible. As we were leaving, a press officer from Arista Records asked if we wanted to go backstage and meet Lou, so we did. But by the time we got to the backstage bar, we were told that Lou had left with Bowie, and would we like to join them for dinner.

So we went off to the Chelsea Rendezvous just off the Cromwell Road, along with a journalist from *Sounds*, Giovanni Dadamo and his wife. Lou and Bowie were sitting at the head of a long table in the basement, and we were shown to a smaller, adjacent table, along with some other people, including I think Jim Kerr from Simple Minds. Lou and Bowie appeared to be getting on really well, even though they'd had a falling out a couple of years earlier when Lou was recording *Sally Can't Dance*, and David had complained that his diction wasn't clear enough. So they were chatting away, dinner was served, and suddenly there was this kind of explosion, smashing glasses, and Lou was dragging Bowie across the table and bitch slapping him across the face. He was screaming, "Don't you ever say that to me, don't you ever say that to me!" The minders didn't know what to do and just froze. Eventually they were separated and then just burst out laughing and hugged each other.

Five minutes later David was being dragged across the table again, with far more ferocity this time, with Lou screaming, "I told you not to say that!" This time he really went for it and was raining blows on Bowie's head. At this point in his life Lou had been working out quite a lot and was actually quite a powerful man. He was eventually hustled out of the restaurant, while Bowie just sat at the table, head in his hands, elbows on the table, sobbing. I went over to ask him what happened, and he started screaming at me, went berserk and grabbed me. "You're a fucking journalist!" he shouted. So we ended up in a scuffle and it got really unpleasant. On each of the stairs out of the restaurant was a potted plant, and as he walked up them, he kicked each one, and they all came flying back into the restaurant. He later went looking for Lou at his hotel, raging up and down the corridor calling Lou out. Apparently at dinner he had offered to produce another album for Lou as long as he got himself clean and straightened himself out. Which Lou obviously didn't like.

Mary Harron: I went to interview Sterling in '79 and he was a sweet-heart. I was doing a story in Austin, Texas, and I decided to try and track him down, because someone I knew said he lived there. I met him in a bar, and he talked for hours, because nobody had interviewed him for years. He was lovely. Smart, sensitive, an academic. He was doing an MA or something. He was very proud that everyone in the Velvet Underground had been smart. I think he had been wounded by the breakup, as it was like a broken marriage. He was a great guitarist and could have played with other people, but he really enjoyed playing with the Velvets. He gave them stability. He was very happy to talk about the Factory, about the band.

CHAPTER 13

DEAD MONEY

1980–1989

"We found inspiration in the bands we loved—the Velvet Underground, David Bowie, James Brown, Al Green, Otis Redding, Booker T and the MGs, Kool & the Gang, the Stooges, and the psychedelic garage bands of the Sixties."
—Chris Frantz, Talking Heads

Jon Savage: From 1980 onward, the whole period would become part of an established history thanks to books like Andy Warhol and Jean Hackett's *Popism: the Warhol 60's* (1980), Jean Stein and George Plimpton's great *Edie* (1982), and finally Victor Bockris and Gerard Malanga's *Up-tight: The Velvet Underground Story* (1983). Now, we have a positive industry: books from Ultra Violet, Nat Finklestein, biographies of Nico and Warhol, Velvet Underground discographies etc. And the music was picked over until only the bare bones remained. The punks went for the glamorous New York nihilism, with minimalist tendencies, while post-punk groups like Orange Juice and Josef K went for the acoustic quiddities and guitar mantras of the third album. And then, no one had any new ideas for about ten years: as successive generations of indie boyrock groups diluted the Byrds and the Velvet Underground, it became hard to listen to either by the early Nineties.

Everything in pop is overexposed now, isn't it? Each accretion brings a slow shutting down of the Velvet Underground's original strangeness, original promise. Once, they shocked: now, the "shocking" is at the media industry's heart. Once, they sounded like nothing else: now, they sound

like everything else. But should this be regretted? Isn't this inevitable? Isn't it better to know that the Velvet Underground were major liberators?

Monday, August 3, 1981: in The Andy Warhol Diaries, *the author describes walking down Fifth Avenue and going into a record store as "Heroin" was being pumped out of the speakers. He wonders if they only put the record on because they saw him coming. He says it was strange to hear Reed singing, but that the record still sounded good. It took him back. The staff asked him to sign an album. Then he gets wistful: "It's still the original cover with the banana that you can peel the skin off. Does MGM keep reissuing it? I never got any money at all from that record."*

Robert Risko: I went from *Interview* to *Vanity Fair* because they paid, and Andy was legendarily cheap.

Ever mindful of the changing culture, Warhol took a keen interest in the emerging New Romantic scene that was moving from the UK to the US. He also struck up a very public friendship with Duran Duran's Nick Rhodes, a man whom the media liked to say based much of his persona on the artist. In an interview in The Face, *Warhol playfully said, "I love him. I worship him. I masturbate to Duran Duran's videos." Today, Rhodes' appreciation is more measured: "I loved Andy. I often think about him. Now he's become so much larger than life, even more so than he was then. And it's amazing how prophetic his personal vision was. He pretty much invented the twenty-first century, with his imagery and his obsession with fame. He would have loved these reality TV things."*

On Duran's first trip to New York in 1981, Rhodes was asked what he'd most like to do, and having said "Meet Andy Warhol," the next day the band's record company, Capitol, made it happen. When Warhol was taken to their show, he went backstage to meet them. "I told them how great they were. They all wore lots of makeup but they had their girlfriends with them from England, so I guess they're all straight, but it was hard to believe. We went to Studio 54 in their white limo and Steve Rubell was really nice to them. He took them to the booth and gave them drinks."

Nick Rhodes: We arrived in New York in September 1981, and I was a precocious kid from Birmingham, where not an awful lot happened in

the art world. Landing in New York was truly the most exciting thing that had happened to any of us in the band at that point. When we saw the Manhattan skyline, looming and getting larger, it was as though we had arrived in Xanadu. We got off the plane and we got in one of those long limousines; it was terribly uncomfortable but a real thrill. It had a bar in the back. As we got closer to the island there was a sign that said Manhattan left and Long Island right, and as our first gig was at The Spit Club in Long Island, we had to turn right. So we had to stare at the skyline for another three days, which made it worse. But when we eventually arrived the energy was extraordinary. It was another world, and more, even though it was everything we'd seen on TV.

We had a PR girl at Capitol Records who I remember very fondly, called Doreen D'Agostino, who very quickly became known as Doreen Doreen. She was part Dark Angel, and part Bobbi Fleckman from *Spinal Tap*. She asked me what I'd like to do in New York and without thinking I said, "Go up the Empire State Building and meet Andy Warhol. Please." So the next day that's what she organized. I was only joking but she had sorted out the whole thing. First, we went up the tower and then we went to the Factory to meet Andy for lunch. I nearly choked. But we were new, we were quite buzzy, and we were playing the Ritz, and apparently Andy wanted to come and see us play. It was quite an extraordinary thing walking into the Factory as it was just like walking into the movie you'd just been watching. There was Bridget at the desk, there was Fred Hughes, there was Vincent Fremont, and all these characters that somehow, I'd already got to know. They were almost like untouchable movie stars to a nineteen-year-old kid from Hollywood, Birmingham. Anyway, they could not have been more charming, accommodating, and Andy was so funny, too. What a lot of people miss about Andy is the fact that he was razor sharp. You didn't get that unless you knew him. He was hilarious. He was perfectly capable of doing the "Oh, gee" stuff when he didn't want to deal with people, but the real Andy was very different. We hit it off because we just laughed all the time. This was my first time in America, and I didn't know anyone. My address book literally read, mum and dad, Uncle George, Auntie Linda, John Taylor, and Andy Warhol. Andy took me under his wing, and introduced me to not just people, but to Manhattan. The places to go, the restaurants, clubs, the Angelika Cinema, the Empire Diner, the Russian Tea Rooms, Mr. Chow's, whatever. Andy was always

up for an adventure. Any evening, or every evening. I remember one night we started the evening at the Swiss Embassy, some black-tie dinner to which only Andy had been invited. Of course, we weren't in black tie—Andy was wearing his parka, his jeans, and his sneakers—and they had to scramble to create this extra table for us, and we became the focal point. We stayed for an hour and then went downtown to some hip-hop club in the East Village, and I'd never seen anything like it. At the time, Andy was one of the few people to lurch between uptown and downtown and was comfortable with both. He taught me to be curious, which kept him alive. It was his motivation. He was fascinated by human behavior. He was never satisfied with anything but then was sort of satisfied by everything at the same time. Which is reflected in his art—America being both the greatest nation and the worst nation on earth. He wanted to be involved in the edges of everything.

Once when I was visiting New York, and I would call him every time we went, I told him I couldn't go out as I was going to Simon's birthday in Mr. Chow's. So, we turned up and he'd booked a table for two right next to Simon's table. Just him. He obviously bought him a big present. But it was very Andy. Very sweet, very Andy. He had FOMO all his life. He loved going out. Took a camera with him everywhere and encouraged me to do the same. Knew everyone: Basquiat, Keith Haring, Kenny Scharf, Clemente, Julian Schnabel...

Marco Pirroni: When Siobhan Fahey was with Dave Stewart they had tea with Lou Reed in New York. He'd invited them to tea at his apartment in Christopher Street because he thought it was very English. With scones and china. Sylvia Morales was there, and she was literally shaking because she was worried Lou was going to explode. She was so scared of him. He just glared at her, and it was all quite awkward. Then he invited Dave upstairs to look at his studio. Ten minutes later and Dave came down, white as a sheet, looking like he was going to be sick. He was shaking and staring at the floor. He sort of said, Oh, is that the time, we must be going. We've got that thing. And Siobhan is saying, what thing? We don't have a thing. And Dave says we have to go or else we're going to be late. And as soon as they got in the cab, Dave said that Lou Reed had tried to kiss him. He was embarrassed and had to push him off. But they worked together later.

Nick Rhodes: Andy loved our "Girls on Film" video because I guess it was naughty and pop cultural at the same time. He enjoyed the merger of ideas. Sometimes when we used to go out together, he turned to the gang of kids that were with him and said, "Gee, has anyone got any ideas for me today?" And of course, everybody would laugh because he never ran out of ideas. But if anyone came up with something and he liked it, he would take it. That's how he stayed in touch. He was always listening.

Roberta Bayley: I photographed Lou's wedding, when he got married to Sylvia Morales. It was lovely, very traditional, both sets of parents. Lou was wearing a blue suit, Sylvia was wearing her mother's wedding dress. There were probably only ten people there. I was a close friend of Sylvia, but I found Lou a little scary. He could turn and destroy you if he felt like it. He had that kind of skill. I didn't think he would ever do it to me, but you never knew. You didn't want to get on his wrong side. You really didn't.

As the Seventies slowly slipped into the Eighties, Lou Reed started to seriously cut down his excesses, first by curtailing his drug intake, and then by stopping drinking. Chastened by doctors and encouraged by his new muse and partner Sylvia Morales, Old Lou made a New Lou. Sobriety brought fresh perspectives, especially his relationship with the press, and the way in which his past indiscretions were now part of his persona. "You do interviews and what they want to know is, 'Did you and David Bowie fuck a goat in Central Park in 1974?'" he said. In 1980, he entered rehab. His doctor at the time told him he couldn't have another drink, couldn't have another shot of speed, couldn't put anything toxic into his body ever again, or else his liver would explode. While Lou listened to this trailer of mortality, his ex-colleague Nico did not.

Mary Harron: I was living in Paris and I went out one night with Nico, and ended up back at somebody's apartment. She apologized, lifted up her skirt, and shoots up right in front of me. Which I found pretty shocking because she was an icon—she was shooting up in front of me! She liked something I was wearing but then said the saddest thing, she said, "I can't wear any nice clothes because I use drugs." She had been one of the most beautiful women in the world, but she was quite overweight, which was strange because heroin is meant to make you thin. She was

very vulnerable, and frail, and when I interviewed her, she said all kinds of shit. I have guilt about that interview because in hindsight I realize she wasn't really in a good state. You're so selfish when you're young, and all I cared about was the great interview I got. She was saying all these weird things about black people in the street. She was saying that she was sometimes scared of black people. You know, those people who sell those things out in the street, they're so black they're almost blue-black. Crazy shit. So I published everything and afterward she was very upset because she said she never said that. But she probably didn't remember she said it. I thought, "Should you publish things when people are out of their heads and in such a bad state?" The weird thing was, she was very judgmental about people, you know: "She's not very good looking ..." She was a legendary beauty and she was obsessed with beauty... She tended to judge women by their looks. She was in the grips of her addictions, and she never kicked them.

Nico told the writer Chris Bohn in 1981 that she was always a little bit ahead of the curve. "All the people dress the same way now that I was dressing on Marble Index. *Look at the Spandau Ballet, for instance."*

James Young: In 1982, I was about to start at Oxford doing an MPhil in Romantic Literature—Blake, Shelley, Keats, etc. And then an old friend, Alan Wise, appeared, with Nico in tow. They literally knocked on my door. It was just one of those life-changing moments. I dragged my heels a little, and it wasn't an immediate decision to start playing music with Nico, but that's what I did. Alan was her manager and wanted me to be in her band. I wrote to Jesus College and asked them to hold my place for a year. In fact I ended up doing it twice, but stayed with her for six years, until 1988. I said I was involved in a piece of research, which I suppose I was. The reason I did it wasn't because of money, or fame, I think it was more about camaraderie. Not necessarily with Nico, but with this small bunch of misfits driving around Europe in a van. That microcosm becomes a macrocosm, and it becomes your world, and you don't want to leave it. The analogy would be like sailors, at sea with your comrades, your pals, and you miss it when you become a landlubber. Alan Wise said the whole experience was time on board the good ship Nico, and he was right. It was a combination of young guys seeking

adventure and being creative at the same time. And make a little bit of money and get around. Without shooting people or being shot at.

When we met, I was only marginally aware of her work. I'd been into Lou Reed quite a lot, and had spooled back and heard the Velvets, and I know for lots of people they were the bible, but I can't say I was a slavish fan. I knew *Chelsea Girl*, and I knew she had an amazing, strange voice. But I didn't know *The Marble Index* or *Desertshore*. She was very nice when we met, very sweet. She didn't look like a Warhol moon goddess, she was just this lady. She was almost flirtatious, but not in a heavy way. Then she started to commandeer my kitchen, and she wanted to make soup with a bag of dried lentils she'd brought with her in a leather saddlebag. She'd obviously been leading a nomadic existence. She asked me why I didn't have particular spices, so she started taking control of my life and it all started from there. She took over very quickly. She had this Alpha Female thing.

I was really lucky to get a gig. I had no experience, and it was only because of Alan that I got the gig. She'd been playing with a brilliant Manchester group called the Blue Orchids, who had just split up, so she needed musicians to back her, and Alan suggested I'd be useful. It's because I was a piano player, and they tend to be versatile. I didn't have any creative or collaborative relationship with her initially. It was incredibly generous of her to tolerate me, especially as she had worked with the likes of John Cale and Lou Reed.

By this time in her life, Nico's motivations for performing were simple: she needed to perform to get money for drugs.

Nick Kent: I saw Nico in '75, '76 when I was spending a lot of time with the Rolling Stones. She'd put on a lot of weight and I didn't think I'd see her again. She was very ill and was always complaining about being sick. Then in 1983, I happened to be at Island Records in west London, and she was there. She had come to try and get some royalties from her album *The End*. When she was on junk, she was a little girl lost, and she was just wandering around. There was a part of her that was very childlike. She recognized me, and it was clear that she didn't have any money. She wasn't angry or causing a scene, she was just a little lost girl. I obviously gave her my address because about a year later she

turned up at my door. She looked really good, had lost all this weight, was blonde, and looked a bit like she did on the cover of *Chelsea Girl*. She looked fantastic. She told me she was living in Brixton with John Cooper Clarke and a guy called Eric the Ferret. She was with that cast of characters. She had come to see me because she was out of heroin and was desperate. She only had enough to last for eight hours and had come to me to see if I knew anyone who could score for her. She was in that junkie situation. And I didn't, because I was tapering off on methadone. She had the money. She stayed and we had a nice evening although frankly I was surprised she stayed so long because if I had been in her position I would have just left. I remember she kept asking me to play that awful song by Eric Clapton, "Wonderful Tonight." Luckily I didn't. She loved it. I played her the first Smiths record instead, which she really liked. That was the last time I saw Nico.

Robert Chalmers: Alan Wise, her manager, once mischievously remarked that Nico and John Cooper Clarke had one thing in common when they lived together in Brixton: hiding heroin from each other.

James Young: Nico was a very commanding performer, and she could really hold a stage. Often, she had to play in small clubs, which were not really the ideal setting for a woman playing a harmonium. It was quite a subtle thing she was doing, so to be able to make an audience listen you have to have a presence. She inhabited herself so well so therefore she could inhabit a stage. She didn't genuflect or ingratiate herself, she was: this is what you get. You dig it or you don't, and if you don't then fuck off. Some people didn't want to hear the dirges, but most people were respectful. She was oblivious to any puerile heckling.

She was a real artist with real commitment. She became an artist quite late. She was in her thirties when she was making her intrinsically Nico albums, and behind that is an experience of the world, and being among other artists. And the experience of being in Warhol's studio and being with John Cale and Lou Reed and the rest of the Velvets must have had a profound effect on her. And she was admired by some of the greatest songwriters of the period, people like Bob Dylan and Leonard Cohen. And it wasn't just a sexual thing. They liked and respected and encouraged her.

There's an outtake from the D. A. Pennebaker film *Don't Look Back* where Nico is talking to Albert Grossman, Dylan's manager. Dylan is in the background playing his new album, and Nico is in conversation with Grossman. He's telling Nico that Marianne Faithfull is dressing in these cute little schoolgirl outfits, and she says, "Are you saying I should dress like a fool?" And Grossman immediately realizes that this is a different kind of woman, and says she has a good heart, and integrity...and then she says, "That's all I have at the moment." You can feel that she is wanting to make some sort of artistic statement. And that was quite late. She'd done Fellini, she'd been a model, and this was quite a way down the road, so I think you've got to hand it to her. It takes guts. She knew she wasn't going to be a pop chick. She was such an original artist.

As far as Nico was concerned, John Cale's input changed everything. She was about to make *Camera Obscura* for Beggars Banquet, and John came in to produce it. I was blown away by the man's musicality. I'd never experienced that depth of commitment to art before, in anybody. He lived and breathed it, to the point of it becoming exhausting. We were living together in Brixton, and after the studio sessions, he'd get a mix on a cassette tape and he'd be playing it in the taxi on the way back to the flat. You'd have time to grab a beer and a cheap eat and then you'd be back listening to the mix throughout the night. You'd grab an hour's sleep and then it would be back to the studio. It was constant analysis. You could say it was over-excessive to the point of neurosis, but I found it an intensely educative experience. It was like finally doing a post-grad course.

Chris Difford: The first time I met Lou Reed was in a Chinese restaurant in New York and I was petrified. He'd been skiing and had a broken leg. I told him I was a massive fan of his lyrics and he said, "I just want you to know that I'm a massive fan of your lyrics too." I froze. What do you say then?

Bob Gruen: In 1983, Yoko threw a birthday party for John Lennon in the Dakota building. I had just done a job with Warhol as my agency had licensed a photo of Sid Vicious to Andy as he was going to use it as the basis of a picture he was doing for an Australian magazine. He used my picture as the reference and then did a drawing over the top

in different colors. So that night as I stepped into the elevator in the Dakota building, Andy got in too. Now the Dakota opened in the 1870s and it had one of the very first pneumatic elevators. They run on water, and pump water through a series of hydraulic pipes. They can't collapse because there are no cables, but it takes a long time to pump the water. So to get to the seventh floor literally takes seven minutes. So I try to chat up Andy Warhol, you know, Hey, you made a drawing of my picture of Sid Vicious for your magazine. And he goes, "Uh huh." That's great, really nice colors you chose. "Uh huh." So the seven-minute journey was all about me trying to get him to say something other than "Uh huh." But pretty soon I ran out of things to say, you know? But later, upstairs at the table, he's sitting with Keith Haring and Sean Lennon, and they were getting on real fine and making drawings for each other. At one point Andy made a drawing which said, "Andy Loves Sean," and then Sean drew a big heart and wrote "Sean Loves Andy." But when Andy signed his picture "Andy," Sean passed it back and said, "That's just Andy. Write Andy Warhol. Andy could be anybody." I thought that was pretty smart for an eight-year-old. Afterward I said to Yoko that I'd never seen Andy be so animated and verbal and funny with a person, as he was obviously really getting along with Sean. And Yoko said, "That's because he's finally found someone his own age he can talk to."

Keith Haring (artist): Before I knew him, he had been an image to me. He was totally unapproachable. I met him finally through [photographer] Christopher Makos, who brought me to the Factory. At first Andy was very distant. It was difficult for him to be comfortable with people if he didn't know them. Then he came to another exhibition at the Fun Gallery, which was soon after the show at Shafrazi. He was more friendly. We started talking, going out. He wanted them [his diaries] published. That's *why* he kept them. The weirdest thing to me is to see his insecurity. It was all ridiculous, because he had nothing to be insecure about; this was after he'd already safely carved himself a permanent notch in our history, probably the most important notch since Picasso. It's nice going through the diaries, though, because he tells enough of the story that it takes me back to the exact moment, and I can fill in all the rest.

Saturday, September 24, 1983: in The Andy Warhol Diaries, *Andy sees Lou Reed at dinner at Texarkana. He says he looked glum and peculiar, and that his wife—Sylvia—looked more Puerto Rican every time he saw her. "I don't know if Lou is big or not.* Rolling Stone *gave his album four stars—*Legendary Hearts—*but was it a hit?" He then questions Reed's dedication to AA as although he appeared to get sober in 1982, Warhol was under the impression he still drank, and wondered if he went out to drink or just to pick up boys.*

Keith Haring: We talked about trading artworks. He let me look through his prints, and I saw a series of really erotic prints—guys fucking guys and close-ups of dicks. I chose one print of a guy fucking another guy and he said, "I'll make you a painting of it." So Andy took a white canvas and made the same drawing on it, only in real close-up so that it's kind of abstraction, but you can still see what's going on. That was my first Warhol painting. For it, I had to trade him I don't know how many things, because the trade was sort of value for value—and his stuff was very expensive. So his manager, Fred Hughes, arranged all that, because Andy didn't want to be involved in this part of the trade.

Marco Pirroni: I was in New York with Adam Ant and it must have been '84. We were in the hotel with nothing to do, and I looked in the *Village Voice* and saw that Lou Reed was playing at the Bottom Line. He was on in ten minutes and we got a cab down there. It's on a video, *A Night with Lou Reed*, and you can see us in the audience. He was amazing, and played one of these great "I Heard Her Call My Name" solos near the end, which he hadn't really done for ages.

"Uptown is for people who have already done something," said Andy Warhol once. "Downtown is where they're doing something new." By 1984, Warhol lived uptown, but he still loved going downtown, and that year when I visited the city, he was all over it. Like Nicky Haslam said: "Andy, always Andy: symbolic, more New York than the Empire State, more American than the Rockies..." The New York I saw that year was a city that appeared to have been co-opted by Warhol. I went there for two weeks toward the end of the year, and everywhere I went, he was there too. We had been invited by Haoui Montaug to host a party at Danceteria, which was then one of the three most important clubs in the city (Area and Limelight were the others). "We" were Alix Sharkey, Caryn

281

Franklin, and myself, the senior staff at i-D *magazine, and we had started to travel the world, bringing London DJs, dancers, photographers, groups, and "scenesters" to everywhere from Paris, Milan, Berlin, Toronto, and Sydney to Brighton, Manchester, Liverpool, Birmingham, Bristol, and Glasgow. In our heads this was our own bpm-driven version of the EPI, a way for us to publicize our magazine in the time-honored Factory tradition. And now we were in New York, invited by Haoui and Ruth Polksi and accompanied by Jay Strongman, Cindy Palmano, Neville Brody, Nick Trulocke, and Cristian Cotterill. We smugly felt a bit like visiting royalty, as we were swept up by the town's irrepressible demimonde, in the shape of Dianne Brill, Rudolph Pieper, Stephen Sprouse, and, tangentially, Andy. He seemed to be everywhere—having dinner in Odeon (apparently with Jean-Michel Basquiat, but we couldn't see), sitting in a booth with Sting and Billy Idol in Limelight, arriving amid a flutter of paparazzi cameras at Area, on the balcony at the Ritz, for Frankie Goes to Hollywood's New York debut (against the odds, they were good), and, obviously, at Danceteria. Andy was like Zelig, popping up like a clockwork cuckoo. Disappointingly, the only place I didn't see him was at the Chelsea Hotel—which, thankfully, was reassuringly tacky, its hallowed corridors reeking of past indiscretions. We were also slightly disappointed by Andy's lack of curiosity (were we really that boring?), asking only if everyone in London was now shopping at Crolla and wearing patent leather shoes.*

Warhol was a tourist attraction in his own theme park, an attraction of his own making. He seemed to bestow a benign kind of patronage everywhere he went, like a village priest. He was like the alternative mayor of the city, an honorary position he'd earned by dint of just turning up. If anyone deserved a social long-service medal, it was Andy. Each time I saw him he was wearing the same uniform—black jeans, black turtleneck, black trainers, and a black backpack; he looked like a large black match, a magnified stick insect wearing a white candyfloss hat. I later found out that Warhol had mostly stopped doing clubs by this time, but this must have been a particular week—like fashion week, maybe—bookended by enough parties and concerts to keep him interested. What did we know? It was his Disneyland, not ours.

Dianne Brill (socialite, fashion designer, model): I used to sit in my bedroom and read *Interview* magazine. My mother was a society writer in Florida, so she got it on subscription. I opened it up and saw Bob Colacello's diary, and in one day he had five, eight things to do. Every

night. And I thought, what a life that would be. Go to an opening, grab a snack, and then go to that party, that other party, everything. Then an after party, then an after-after party. So I came to New York in 1980, after a brief spell in London. But I eventually got deported. But I soon left for New York. Those were the times when if you had cash in your hand, you could get a sublet, then you got another sublet, until you could finally find an apartment. I was trying to find out who I was, and then I discovered the clubs, and everything opened up, and I became queen of the night. I think I had needed for so many years to feel comfortable and be accepted, and that happened in Manhattan. I suddenly felt like I belonged, and I didn't have to explain myself. We became a tribe. Me, Rudolph [Pieper], Jean-Michel [Basquiat], Andy, Stephen Sprouse, Keith Haring. The writers, the actors, the photographers, the artists, the people with looks. Everyone was an artist in some way. We were so excited with each other. Suddenly we are in some club at 4 a.m. and we are all each other's best friend. We felt free and safe. I started going to Danceteria and I met everyone. I had great party discipline, and I was at every single everything. Every night. There might be six things a night and I would go to them all, even if only for a minute. All downtown. Everything was downtown. I ventured north a bit, but I came from uptown, so I didn't need any of that.

In New York I was already the popular girl at the high school, the queen of the night, the happiest girl in the world to be in the room with all these people. I loved walking into the room. When Andy met me I was exactly what he needed. Not just me, but Keith and Jean-Michel and Kenny [Scharf], Madonna and Haoui Montaug. I think our relationship moved so fast because at that time, '84, he was making all these society portraits, and he thought he could find peace and love with all these WASPS, as he was always the little boy who wanted to be a WASP. The American Dream. But then when he found it, it wasn't for him. He got tired of doing all that shit and started to come downtown again. He needed it, for himself, for his business and for his art and for his soul.

So he really started to hang out downtown, and we started to spend a shit load of time together. And I loved being with him, as it was fun. Uptown wasn't fulfilling for him, so he came back downtown. He gave to us, we gave to him. Walking around in his painted leather jacket. Being

wonderful. Being Andy. My fondest memory of Andy is being with him
and Jean-Michel in Area, when this ridiculous handsome boy came up
to talk. We were talking about the ocean, about a storm, and it became
a deep, heavy conversation about sex, it took a turn, and both Andy and
Jean-Michel were rapt, listening, like "What the fuck." We were all part
of a moment, a New York Moment. Being free, talking about sex in a
way you couldn't really do before, or after...

Anka Radakovich (sex columnist): I met Warhol at the artist Don
Baechler's downtown loft, where I sat on the couch with him and Allen
Ginsberg. We somehow started talking about sex and relationships, with
Ginsberg and I agreeing that you can have good sex with someone you
can't stand, but it's hard to have a good relationship with someone whose
conversation you can't stand. Warhol didn't say a thing, as he sat there
and listened. Then he pulled out a Polaroid camera and asked if he could
take my picture, which I thought was weird, but amusing. Then he said,
"I think fantasy relationships are good, better than real ones."

Dianne Brill: New York was intoxicating in '84 because everyone was
fuckable. In the neighborhoods there was no one who you couldn't
fuck if you wanted to. There was always a possibility. Always a hundred
percent possibility. Even the most awkward, leaning against the wall,
film noir person, that person was still approachable. There was no one
who wouldn't meet your gaze. We were misfits in our previous world,
but together in our new one. Whenever the Brit boys came in, all the
New York girls' radars would go up. New York was a wonderful, sexy
place. You'd walk down the street and a phone would go off in a booth,
and you'd pick it up, and there would be some sexy boy on the end of it.

Jim Radakovich (artist): I met Warhol at an art opening in 1985, and told
him I was an artist, and currently had a one-man show up in the East
Village. He asked if I had a card for it, so I gave him one. A week later,
to my surprise, I popped into the gallery, and there he was, standing
there looking at my show. He saw me, pulled the card out of his pocket,
and asked me for my autograph. Considering that everywhere he went
in New York, people always feverishly shoved things in his face to sign—
Interview magazines, napkins, scraps of paper, soup cans, anything to get

his autograph—his kind gesture showed how much respect he had for other artists. I thought it was generous and was touched by it.

I once asked Haoui if he still saw Lou Reed out and about at night. He looked at me in his rather lugubrious way and said, "Dude, he's now a zombie."

Dianne Brill: Lou Reed was only out and about in a kind of royal way. He was up in Woodstock making bread. Iggy was around a lot more. And Debbie and Chris from Blondie and the Ramone boys and the Beastie Boys. They were like thirteen, hitting me on the ass and running away. This time in the Eighties was all about Madonna doing Haoui Montaug's No Entiendes karaoke show, John Sex, Andy, Karen Finley, with the big can of yams, pouring syrup over her naked body while reciting poetry... Haoui and Anita Sarko brought karaoke to America. Haoui was integral to everything. First, he was the doorman for all the coolest places, so if he wasn't into you, you did not have access. Anyone who fell out with Haoui was really making a mistake. My first in was with Haoui, and without him I wouldn't have been accepted. Getting his approval was everything. We were all so tolerant because we had got used to not being accepted for who we were. We were finally in a community.

Tom Maxwell (journalist): The Velvet Underground album *VU* is the binding agent in a career of releases that differ so dramatically one from another as to be almost artistic reversals. *VU* has the dark majesty of *The Velvet Underground & Nico*, the neurotic strut (if not the head-wrecking dissonance) of *White Light/White Heat*, the tenderness and emotional insight of *The Velvet Underground*, and the pure pop sensibility of *Loaded*. In its ten tracks, *VU* contains refined versions of what the band did well during the four years they lasted. The irony is that the album wasn't released until more than a dozen years after they disbanded. Recorded primarily in 1969, after the ousting of multi-instrumentalist John Cale, and later cannibalized by principal songwriter Lou Reed for his solo career, the recordings that make up *VU* were shelved for sixteen years. They stayed in the MGM vaults, mostly unmixed, until discovered during the process of reissuing the band's catalog in the early Eighties. As a result, VU benefited from much improved audio technology and was released to a world not only better prepared for the Velvet Underground,

but one that had largely absorbed its lessons. The album made a beautiful tombstone for the band's career, at a time when all the members were alive to see it.

Between May and October 1969, the band recorded an album's worth of material in the Record Plant in New York. "That was basically preproduction stuff," Doug Yule once said. "It was done to studio quality but not with that intent. It was all done in the daytime. Which to me is, like, when you're working on an album in the studio—you know it gets dark at like five p.m. This was all done at ten in the morning."

It's not clear that the band had the resources to record releasable "preproduction" material, so I would disagree with Yule on this point. Also, however one believes these recordings fit into the canon, they were definitely intended for release. The proof is that MGM reserved a catalog number, SE-4641, which labels only use for official releases. This is most of the material that makes up *VU*, considered, rightly, to be the great lost Velvet Underground record. The process stretched over several months of desultory sessions, short enough to only allow the tracking of one song per day. What's clear from the recordings—and something that could only have happened in Cale's absence—is the intricate interplay of Reed's and Morrison's guitars. On "I Can't Stand It," they mesh and intertwine and begin to lose individuality in a combination of itchy rhythms and menacing drones, anchored by Yule's steady bass lines.

Meanwhile, the band's relationship with MGM was deteriorating. They didn't believe the label was giving them much support. Conversely, MGM was cleaning house, moving in a direction to get rid of provocative bands as well as acts that weren't selling. The Velvet Underground satisfied both those requirements, so MGM terminated their deal.

The band signed with Atlantic Records almost immediately. Danny Fields has said the label wanted to do a record straightaway, and hoped to rescue the MGM material. That was never going to happen, so the Velvet Underground made what became their fourth album, *Loaded*.

In the Eighties, sensing the band's continued and growing relevance, Polydor Records began reissuing the Velvet Underground's back catalog, and it was then that they discovered boxes of tapes of unissued recordings. "We didn't say we'll just go in and lay down anything and screw them," Moe Tucker said about that time. "There was a sense that it

probably wouldn't be released by them. I think I figured it would just get picked up by the next record company, not realizing that MGM would own it. But when we switched labels, MGM wouldn't give up the tapes."

I remember when VU *arrived in the* i-D *office in Macklin Street, in Covent Garden, we unwrapped it immediately, put it on the deck, closed the door, and turned up the volume. The record player was purposely in the magazine's so-called writing room—the room I shared with my colleague Alix Sharkey, and to which we retreated when we were sick of listening to photographers lying about which celebrities they had access to—as we had snaffled it away from the designers' room late one evening when no one was around. The designers liked to play music in order to set a mood, whereas we played it to know what was going on. Like many journalists at the time who wrote about music, we actually anticipated the YouTube/Spotify generation by thirty years or so: we would play every piece of vinyl as it arrived, often delivering a judgment after only a couple of seconds. If something failed to interest us, it was hoisted off the deck, and flung on a pile to be delivered at some point to Notting Hill's Record & Tape Exchange. Often, someone's reputation or newfound career would be ruined before we got to the chorus, accelerated by a lackluster chord change or superfluous saxophone break. Empathy was considered to be a completely unnecessary quality in our office. Which meant that while we were obviously intrigued by a "new" Velvet Underground record, it was going to be judged by the same standards we held everything to. Perhaps unsurprisingly, we loved it, and VU stayed on the Technics for the rest of the month (much to the designers' annoyance, as they found it "gloomy").*

Tom Maxwell: Once the shelved recordings were discovered in 1984, Reed had reservations about their being issued at all. "They got in touch with me to come out and listen to the tapes," he said. "It sounded pretty good at first and they said I could be involved in the production of it. Then after listening to the whole thing, I said, 'I don't think it should come out.'" He could have felt this way for any number of reasons, but it should be remembered that, by 1985, Reed had recycled most of the songs on *VU* for his solo career, rerecording "I Can't Stand It," "Lisa Says," "Ocean," "Andy's Chest," a retitled "Stephanie Says," and "She's My Best Friend." The shadow of the Velvet Underground might have loomed a little large. In later interviews, both Morrison and Tucker stated that

they made songwriting contributions, but let Reed claim sole authorship to keep the peace.

Because Reed chose not to be involved, Morrison was called in to help assemble two albums' worth of material, *VU* and *Another View,* an album mostly comprised of demos and outtakes. Producer Bill Levenson oversaw the mixing, and once they were cleaned and mixed, he was able to change Lou Reed's mind about their release.

VU came out to a popular culture ready to receive it. Indeed, by the time *VU* was released in 1985 there were dozens of taste-making bands around who owed their careers to the Velvet Underground, with a dozen more who had yet to even form. Benefiting from the advantage of hindsight, Cale makes a return on *VU*, appearing on two songs cut at New York's A&R Studios in February 1968. "Stephanie Says" features his legato viola and bell-toned celeste. "Temptation Inside Your Heart," recorded the next day, features an unedited vocal take, with Reed, Cale, and Morrison joking and laughing in the background in between their vocals. There is no apparent tension in the track at all, even though this would be Cale's next-to-last recording session with the group. *VU* peaked at number 85 on the *Billboard* 200 chart, becoming the band's highest charting release.

In 1986, when Factory Records' Tony Wilson was thinking of a producer to work on the debut album from Happy Mondays, after flicking through his record collection he alighted on John Cale. Wilson was a huge fan of Patti Smith's Horses, *and saw something of Smith's poetic way with words in Shaun Ryder's lyrical surrealism. As the band's manager Phil Saxe considered them to be Manchester's answer to the Velvet Underground, this seemed to make sense. To them, if no one else. Halfway through the first two weeks of recording sessions, they scrapped all the demos and started again, as there appeared to be something of a war of attrition developing between group and producer. According to legend, the sessions involved fistfights, a rumored stabbing, and various drugs of which there were many. Cale was actually trying to get off heroin, which frustrated a band who believed they would be working with a six-star hellraiser. The resulting album,* Squirrel and G-Man Twenty Four Hour Party People Plastic Face Carnt Smile (White Out), *was hardly a classic although Cale did manage to capture their sense of organized chaos. One of the few things both parties seem to remember about the sessions is Cale's*

obsession with tangerines, which he would eat at fifteen-minute intervals. "When John first asked me what the Mondays were like," Wilson said, "'the best way I can describe them, so you know what you're letting yourself in for, John, is scum. They are fucking scum.'" The Mondays' dancer Bez said they found Cale extremely odd: "In the cold light of day, we found him a bit on the strange side, never talking much and constantly stuffing his face with oranges." In the Eighties, the Velvets' influence was everywhere, both in deed and intention. "We were all young men and we just wanted to do what all young men want to do," says Ryder, "have a laugh and a good time. In '84, when we were starting out, the music scene had become really fucking boring. It had all become really controlled, like a shit episode of Top of The Pops. We wanted to bring it back to rock and roll and make it exciting again, like the Rolling Stones, the Sex Pistols, and the Velvet Underground. For us the drugs and the partying were all a part of that. When we were talking to journalists from the NME and stuff, we could have done it like the other bands and talk about what amplifiers we were using but we would have been really fucking bored so we would just roll up a spliff, play pool, and chat about stuff. I really think that having fun with the interviews and the partying reputation helped us to get us where we are." Ryder would make constant references to the Velvets in interviews, which seemed off from a man who allegedly once used a Velvet Underground CD as an ashtray.

John Cale: It was a black mark on me for not being the John Cale they thought they were going to get. But those sessions were full of folly. You know, Bez not being able to stand up straight even when he was sober. Seeing Bez try and play a tambourine was like watching a building collapse. It was very funny, but we got it all done.

Sir Peter Blake (artist): Andy Warhol? Rather sadly, the last time we might have met, there was a dinner at Michael Chow's restaurant and we were right across the room. He was with a separate party, and I was—we were literally across the room—and Michael came over and said, "Andy would really like to meet you," and I said, "Michael, we've met eight times. We've never ever had anything in common. I'm not going to come across." So I stayed at my table and didn't go across. And it was so childish and silly. I mean, looking back, I should have gone across and hugged him and said, "Hello, Andy."

In the summer of 1986, Andy Warhol produced a series of big self-portraits for a show at the Anthony d'Offay Gallery in London. "Some had a camouflage coloring, [and] when he first described it to me, I thought it was unlikely to work," said d'Offay, "but when I saw the first one, I realized it was a stroke of genius. We had enormous press coverage, lots of TV. He came over for five days. It was fantastic. There were security guards and people asking him to sign their underwear." At the private view there was a queue of people waiting for him to sign stuff for them (he wore black, with Billy Boy jewelry), a queue that snaked right out to the street. The artist Cerith Wyn Evans asked Warhol to sign his bus pass, which he duly did. He was funny with the press, too. Asked why he was doing the show, he said, "I've kinda run out of money." Asked why he was doing self-portraits, he said, "I've kinda run out of ideas." At the private view he met the members of a new much-hyped band called Curiosity Killed the Cat. Taking a shine to bass player Nick Thorp, he suggested he direct a pop promo for them. Two weeks later he was directing the video for their first single, "Misfit," in New York. He even made a cameo, aping the cue-card idea from "Subterranean Homesick Blues."

Ben Volpeliere-Pierrot (singer): Andy directed the video, but he used to just appear, say a few things, and then disappear. He fell in love with the bass player, Nick. We gatecrashed the first exhibition he'd had in London for twenty years. We were wandering around and some of the press people said [we should] get in for a photograph with him. He was signing books at the time and so had one of those big pens. He was signing our books when the pictures were being taken, but when he got to Nick he drew a wedding ring on his finger.

Courtney Love: I had been in Alex Cox's *Sid and Nancy*, but I refused to leave Manhattan with nowhere to go, no money, and no future. I just didn't care. I was going to meet Andy Warhol. And? He was going to be mesmerized by my charms—I was a confident kid!—then he'd paint my portrait. And? We'd be best friends—because of said charms. I stuck out my New York couch tour, due to incredible friends, like the great Hal Wilner (and his amazing record collection and trips up to 40 Rock) and lovely Julie Glantz. And, after a time, answering phones at a brothel on Lexington, handing out towels and condoms to the tricks, cleaning up the girls' rooms after. I was always incredibly sad after I worked a shift

there, you would be too. I got so depressed I almost left. But one day somehow, I got the message. I'd been called up to the Factory. "Andy's taken an interest in you," I was told.

Warhol's studio was located on East Forty-Seventh Street, in midtown. Slews of celebrities and artists graced the space, which was where Warhol churned out history-making projects. He put me in his MTV show, where I was introduced by Debbie Harry. When at the Factory, I found Andy's office and went in. He was surprised, I think scared, that there I was! I started by asking him if he would paint me. "Why?" he asked. "Because I'm *amazing*!" I replied (having no clue that Andy did *not paint anyone for free*). He giggled and said to his friend, "What do you think? Should I paint Courtney?" He did not paint me, or even my shoes (he was fond of drawing shoes), but he commissioned a big spread in *Interview*. I think the photographer was Albert Sanchez.

Nick Rhodes: He would always say, I gotta sell a lot of pictures because I've got a lot of mouths to feed. The business of art was everything to him. Being a commercial artist affected everything he ever did. Which is why he was obsessed with being a mechanical artist.

In February 1987, at the age of fifty-eight, and having just shown a series of "Last Supper" paintings in Milan, Warhol went back into hospital, something he vowed he would never do. After the shooting back in 1968, he knew that if he ever went back into a hospital, he would never come out. However, Warhol could no longer postpone gallbladder surgery, and while the operation in New York Hospital was uneventful, he died the following day, the 22nd, from unexpected complications in the recovery process. New York was stunned, the art world incredulous. Bob Colacello told me there was a vast difference in the way his death was perceived on the opposite sides of the Atlantic. In Europe, Andy's death was treated like Picasso's, assuming the art world would never be the same; in America, Warhol's passing was equated to the death of a socialite.

On April 1 almost two thousand people congregated at St. Patrick's Cathedral, New York City, for Warhol's memorial service, an event the artist would have hated to miss. The pews were filled with the righteous, the fashionable, the demimonde and the semimonde. Everyone who was anyone in New York society was there, which is just as it should have been. Among

the famous figures were Halston, Roy Lichtenstein, Liza Minnelli, Calvin Klein, David Hockney, Giorgio di Sant'Angelo, Yoko Ono, Keith Haring, Bianca Jagger, Jean-Michel Basquiat, Andrée Putman, Raquel Welch, Claus von Bülow, Claes Oldenburg, Michael Chow, Jamie Wyeth, Julian Schnabel, Tom Wolfe, Deborah Harry and Chris Stein, Terry Southern, Fran Lebowitz, George Plimpton, Robert Mapplethorpe, Paloma Picasso, Ahmet Ertegun, Stephen Sprouse, Don Johnson, Diane von Fürstenberg, Richard Gere, and Prince and Princess Michael of Greece, even Grace Jones. And of course, there were reminders of the old Factory days in the form of Viva, Gerard Malanga, Isabelle de Fresne, once known as Ultra Violet, and "Baby" Jane Holzer, the original Warhol Girl of the Year, along with Bob Colacello, Fred Hughes, his executor, and Brigid Berlin. Lou Reed and John Cale were also there. The event was so crowded, with people standing shoulder-to-shoulder, it was as if the artist had planned his own funeral, a dizzying crush of fame and phonies. As the mourners ascended the steps of St. Patrick's, they could have easily been mistaken for after-dinner revelers queuing to get into Studio 54 a decade earlier. Only Warhol could have attracted such a crowd.

In his eulogy, the art historian John Richardson likened Warhol to a yurodstvo, a holy fool or "saintly simpleton" common in Slavic and Russian villages, a character who feigns madness and denies the conventions of the human world to be closer to God. Richardson emphasized Warhol's spirituality as the key to his psyche, his almost daily visits to church, his financing of his nephew's education for the priesthood, and his work at a Manhattan church soup kitchen. Referencing the sex and drugs associated with the Factory in the early years, he said Warhol didn't see himself as his brother's keeper, but he "did feel compassion and saved many of his entourage from burnout." There was laughter when some of Warhol's writings were read: "When I die, I don't want to leave any leftovers," went one of the quoted excerpts. "I just want to disappear...although it would be very glamorous to be reincarnated as a big ring on Elizabeth Taylor's finger."

"Someone said that Andy was a skyscraper and when he died the skyline of New York changed," said Yoko Ono, who also gave a eulogy, and who described Warhol as the "mentor" of her fatherless son, Sean Lennon. "But it hasn't changed. Andy is still with us, and he will always be."

Tina Brown said the memorial service was like paging through back issues of Interview. *Brown was not necessarily a fan of the man—she said he was amoral, a manipulative void, a dead star—and yet even she could not help but*

be impressed by the crowd. "The massive turnout of fashion, art, writing, and society was pretty extraordinary. Bianca Jagger looked so pretty and distressed in her little black hat. Andre Leon Talley was there in a bespoke suit as thin as a number two lead pencil with the young Brit fashion assistant Isabella Blow, wearing a couture suit and crazy hat. I couldn't quite take Claus von Bülow going up for communion, but it was full of vignettes in that genre. Andy would have loved it, there is no doubt about that."

The altar was bowered with dogwood trees and forsythia and each pew was decorated with a bouquet of tulips for the morning Mass, highlighted by a soul rendition of "Amazing Grace" by Latasha Spencer. Eventually, the recorded voice of Lou Reed drifted over the crowd: "It's hard to believe Andy's not going to be around. I was hoping he'd turn up and say, 'April Fool!'"

Bebe Buell: AIDS was everywhere by the time he died. Of course, he was terrified he was going to get it, which was ironic because he died in a hospital having his gallbladder out.

Liz Derringer: When he died, I was in total shock. The whole world changed. New York certainly did. I first met him when I was seventeen, and he was always there. If you went to a party, it wasn't a party till Andy showed up. He was our leader, and suddenly we didn't have a leader. You always thought Andy would be somewhere and suddenly he wasn't. He was fun, he liked to dance, spent a lot of time at Danceteria, Studio 54, and then one day he was gone.

Deborah Harry was shocked, too. For her his death was an enormous loss that "changed her life as it changed the art world and the social life of New York City." Afterward she went into mourning and says now that she was actually in that state for at least two years. It was doubly emotional for her because on the same day Andy died, she split up with Chris Stein. "Thirteen years of deep intimacy and creativity with Chris was changing to a different dynamic."

Geraldine Smith: By the time he died, Andy was back with the artists. He'd left all the society people behind and was spending much more time with Jean-Michel Basquiat and Julian Schnabel, the artists. He wanted to get back with the kids. When he died something died with him, because he was a part of New York, a part of the city.

Nick Rhodes: I saw him just a few months before he passed away. I was in LA when I heard the news. Couldn't believe it. I called Fred Hughes, and he was in floods of tears. It was awful. For me it was the loss of a friend, a mentor, and the greatest thinker of his generation.

Duncan Hannah: I went to his funeral, looking around in St. Patrick's, and it was a Who's Who of New York. And I found myself looking for him. I was thinking, Andy must be here. Then I thought, "Wait, no, that's why we're here. There ain't gonna be no more Andy." That hit me hard. I'd seen him about three weeks [before he died]. I was doing something for *Interview*, making drawings that you could put shoes onto. Andy was coming down the stairs looking pretty ghastly, and paler than he usually looked. He looked bad. He asked me what I was doing, and I said I was drawing shoes. He said, "That's your job, right?" We'd been talking about a trade, and he reminded me about how the trade was going to work. I was going to get a portrait of myself, and he would get thirty thousand dollars' worth of my paintings. He had the bug, and wanted work by everybody. You don't turn down a trade with Warhol, even though he'd done one of my friends recently and it hadn't been very good. He was trying to bump me up to a diptych. Then he went and died. Fucker.

Dianne Brill: New York died a little when Andy died. I really don't know why there isn't a statue of him in New York, it's insane. He was so much of his art. He stood alone without his art, and his art stood alone without him. Together, ker-ching.

Robert Risko: People won't admit it, but Andy's death had a huge effect on the city. If Andy appeared someplace during the day or night, then you knew you were in the right place. Restaurant, nightclub, bar. You felt happy if you saw him, sort of like seeing a clown at a circus, a very sleek, adult clown. But when Andy died the city lost its luster. There was no one who could turn New York into that emerald city. Andy was the mayor of munchkinland. He hobnobbed with Jackie O and all the Upper East Side socialites, he was a great crossover person, and was completely uptown and downtown. He reigned King. The King of New York, King of the art deco ruins of the city. When he died, the city got dark. Until *Sex and the City*, and Rudy Giuliani became mayor, and the

city became safer for women to dress in hyped-up miniskirts. The black leather jacket wasn't armor any more, it was a cell phone and a Kate Spade handbag.

Bob Gruen: I don't think his dying changed anything. I mean people come and go all the time. Maybe all the drag queens who hung around him drifted off, but I don't think New York changed. Things were already changing because the corporate world was taking over. It was a time when Madonna could sing a song called "Material Girl" and it could be a number one hit. Yoko Ono had a show in the late Eighties at the Whitney Museum which was a retrospective. She had done work in the Sixties which was very playful. One piece was a canvas on the floor which was a painting to be stepped on, and people would walk on it. I actually went to the opening of that original show, in '67 or '68. It was really fun. There was a gallery in Syracuse where she had a window in the middle of the exhibit that she hadn't been told about. So she made a label that said, "Window to see the sky by." And that became part of the exhibit. But when they did the exhibit in the Whitney, she had the painting to be stepped on but it was bronze. Everything in the exhibition was made out of bronze. When I stepped on it in the Whitney the guard shouted at me, "Don't touch that! You're not allowed to touch it, you're not allowed to step on it." And the window to see the sky by was made of brass, and you couldn't see through it. When I saw Yoko, I told her how disappointed I had been by the new show and she said that was the whole point, that everything in the Eighties had become materialistic. And it's not fun and it is just a thing.

David Bailey: I loved Andy, but then I grew to love lots of the people who swarmed around him. I loved Fred Hughes, Andy's business manager, his brains. He was so erudite and articulate and smooth and charming, he was a wonderful man. As a person I preferred him to Warhol. It was like a non-sexual marriage, and Hughes completed Warhol's circle. Without Fred he probably wouldn't have been as successful as he was.

Nico wasn't at Warhol's funeral, as she was too busy touring in Europe, playing concerts in England, Spain, Austria, Serbia, Germany, Holland, and Belgium. Her addictions had got the better of her, and her life had become little more

than a cycle of opium dependency. For years, heroin had been her accomplice in almost everything she attempted to do.

James Young: I realized Nico had a dependency early on, as the first time she came to my flat she spent half an hour in the bathroom. Her manager spelled it out. As long as she had what she needed, heroin, everything was OK. It's just when she didn't have it that things became problematic. And that could happen at unfortunate moments. I think that if you're addicted to heroin then you should be prescribed heroin, and I wish that had been the case with Nico. She would have lived much longer. It was part of her world. There was always going to be a drug with Nico. She was taking speed as a model to keep her weight down and there was always drugs around. She liked drugs, and they informed her artistic statement. Charlie Parker was another heroin addict, and he used to get distressed when the younger guys thought that if they also took heroin that maybe they could play like him. Taking drugs doesn't make the artists, and it didn't with Nico, but of course there was an interaction. It was the way it was, and I had to accept it or not, so I accepted it. That was Nico's world. She was smoking hash. Heroin. Then methadone after that. And alcohol. She was never sober. Sobriety was not her thing at all. The world was just intolerable for her.

This was because she was a kid in Berlin, and being brought up with a disgusting ideology, and being educated to be a Nazi, and seeing the whole world literally exploding all around her. Berlin on fire. I think that must have affected her as a kid profoundly. The teenager wandering that ruined city, trying to get work, her mother working as a seamstress, being cooped up in a room together. That changes you. That hard, hard reality is going to have a profound effect. The incredible darkness of that period. She used to say that when she was young they moved out of Berlin and went to stay at her grandfather's place. He was a railwayman and he lived ten kilometers outside the city. She said she used to see the trains going by full of Jewish people. And that became part of her nightmares. What does that do to you as a kid? Plus you've been taught that these people are subhuman, and that you are the master race. And being born beautiful and looking like the absolute quintessence of an Aryan goddess, all these things were scrambling in her head. So there is massive guilt there. The perpetrator's guilt. To be around in this post-war

period...Even when I was a little boy, you used to play games and the Germans were always the bad guys. Germans were still the bad guys when I was working with her.

She said she really liked Manchester because it had that kind of Berlin feel. At the time Manchester was being bulldozed and redeveloped and she thought it looked exactly like post-war Berlin. She felt at home among the big gothic buildings.

She briefly mentioned the attack she suffered when she was younger. She said she'd been raped. There have been question marks about it, because it was a court martial, and so there would have been a record of it, and no one can find any record of it. So I don't know. Again, could it be some evolution of her guilt complex? Being a German. She used to say that her father had been killed in a concentration camp, which was just not true. On tour there were protests sometimes, especially in Scandinavia, people outside gigs shouting "Go home, Nazi." And she would say, "My father died in a camp!"

Then of course there was the incident in New York with the actress ... The new generation really come down heavy on Nico because of that. But what do you know about growing up under Hitler? What does that do to your head? That poison, that real poison. It's too easy to dismiss Nico as a racist. There is stuff buried in there, probably, and stuff she was suppressing, with the smack and the booze, and there was a lot of anger in there, especially when she drank. She could get violently angry when she was drunk. And maybe that thing in New York happened at such a moment. When she had booze, she really turned into a monster.

There were times when I thought, "Fucking hell, come on," when we'd run out of smack. Her son would come over, and they'd binge, and then you'd be on tour and suddenly you're in a strange place and she's got a gig to do in the evening and there's nothing. She couldn't do anything straight, and so you were stuck. And that would be infuriating. Trying to find stuff on the street, getting ripped off. Sometimes it was just a drag. I never felt sorry for her, as that's who she was. I just got used to her shooting up in the van. That was her medicine.

Robert Chalmers: One remark that sticks in my mind is John Cooper Clarke saying to me, in quite a casual moment, "Oh, for a while she had her own gaff in Sedgeley Park." That's the area of Salford where Mark E.

Smith [of the Fall] came from, and...not everybody would necessarily aspire to live there. You could say that the Velvet Underground and anywhere else are two different worlds, but it was an odd culture clash to say the least. My school friend Gary, a kid from Didsbury, his father was Nico's landlord. She lived there for a while. I think she was having an affair with someone from Factory Records. I was in his house when he came in one day and said, "That Nico. I went in, and the place was a bloody pigsty. So I told her, get those pots done, woman!" I said, "Did she?" "Aye, of course she did. Place were great when I left."

Danny Fields: I used to speak to Nico on the phone when she would ask me for money for heroin, but there comes a time in any relationship with a junkie where it's your job to come up with a ten-dollar bill. "Oh, Danny, I need some heroin, can you help me?" But the last time I saw her was backstage when she was playing the Squat Theatre on Twenty-Third Street.

In the long dry summer of 1988, having made another attempt to quit heroin for methadone, and having toured Japan with John Cale, Nico went to Ibiza with her son, Ari Delon. On a blisteringly hot day, as the island pulsated with the all-encompassing sound of daytime acid house, she rode off on her bicycle to buy some grass, and was later found by the side of the road, partially paralyzed and unable to speak. Three hospitals turned her away. At a fourth, she was diagnosed with a cerebral hemorrhage, and she died the next day, alone. Many in her Berlin and Manchester circles came to the funeral; but nobody from her New York life attended, or even responded when her manager sent news of her passing. The young couple who found her said that she was lying in the sun beside her bike, clutching a book. It was by Oscar Wilde, with whom Nico shared a birthday.

Chris Salewicz: I knew someone who knew her in Ibiza. She was his next-door neighbor. Then she went off on her bike one day and that was it.

Mary Woronov: She was a nice girl. Only a nice girl would die on a bicycle.

Gene Krell: I was living at the Chelsea Hotel, which seemed appropriate, and I got a call from a friend who asked me if I'd seen the *New York*

Times, but I hadn't as it hadn't come yet. And Nico had just died. I don't know what my initial feelings were, but it all came rushing back, living in Paris and New York, the Portobello Hotel.

James Young: She was kind of funny about Lou, and he was funny about her, about what her people did to his people. There was something there that would never be reconciled. She was much more affectionate toward John Cale. They argued about who was going to go on first when they played together, but that was normal. She got hurt at the end because she didn't understand that John had cleaned up and was trying to protect himself by keeping himself to himself. His commitment to things is absolute. If he was going to be a coke addict he was going to be the world's most monstrous coke addict. And if he was going to be super clean he would be working out every day, playing squash, and he didn't want to be around people taking drugs. She just thought he was being a snob, a maestro in his dressing room. It was self-preservation. It's a pity that they didn't have one last chance to be together without that.

Richard King: John was on a *South Bank Show* and Waldemar Januszczak asked him, on a scale of one to ten, how off your head were you? And John said he'd never been so insulted in his life.

Jessamy Calkin (journalist): In 1988, I took a sabbatical from *Tatler* and started managing the Bad Seeds. I was in a lift in a hotel in New York with the band sound engineer, who was a big Lou Reed fan. The elevator was going down to the lobby and stopped at a floor beneath us. Lo and behold, Lou Reed gets into the lift. He looked incredibly grumpy, but the sound engineer said, "Oh my God, Lou Reed, you're my hero." And Lou Reed said, "Fuck off," before getting out of the lift. And I said to my friend, "Are you really disappointed?" And he said, "No, that's what I was hoping he'd say."

In January 1989, Sire Records released Lou Reed's New York, *an unexpected return to form that used his journalistic prowess to create something of a classic. It wasn't of the street, it was about the street, focusing on Reed's stripped-back poetry and conversational prose (including imagining the death of Donald Trump).* New York *was released at a moment when the city was*

simultaneously grappling with sky-rocketing levels of crime, welfare, crack use, AIDS, homelessness, and racial tension. Consequently, Rolling Stone *called the album "Lou Reed's rock & roll version of* The Bonfire of the Vanities," *the Tom Wolfe book that had been published the year before. For those who had heralded the Velvet Underground in the Sixties, and who had been waiting for Lou Reed to fulfill his transformative potential, the record was greeted as a kind of countercultural redux, not just a return to form, but a genuinely inspired piece of reportage, one that was almost political. I remember being impressed that so many people who had come of age in the Sixties were so beholden to the record. "It's a masterpiece, it's amazing," I remember Tony Elliott telling me, in his house in Vic-Fezensac in south-west France, in the summer of '89. Tony had created* Time Out *magazine in 1968 and was part of a generation that expected radical change as some kind of birthright, a culture of expectancy that affected politics and culture in all its forms. This also resulted in a culture of the disappointed, so to see the likes of Lou Reed—a genuine, copper-bottomed countercultural hero—return in this way was like seeing Che Guevara riding into Wall Street Plaza on a stolen horse. The record helped enormously in altering Reed's cultural standing, although he continued to be belligerent with the press. For him, the concept of the "Beautiful no" wasn't a concept at all.*

Mary Harron: When *New York* came out we were due to film Lou Reed rehearsing for a story on *The Late Show*, but as soon as he saw the crew he shouted, "Get those fucking cameras out of here," even though it had all been arranged. So we had to go through the process of persuading him again. Everyone was terrified, and I was very nervous when we started the interview. But then as soon as I mentioned Delmore Schwartz he warmed up. He became charming. I realized that Lou Reed was one of those people who had to disrupt a situation in order for him to feel comfortable. Because everyone else was so agitated, he relaxed. He took writing and literature very seriously, and if you went in that direction, you'd find a way into the cave. But I had a bit of PTSD after.

Seymour Stein (impresario and entrepreneur): It didn't bother me that some of the records Lou Reed had made before I signed him hadn't been successful. I believed in him. I don't really know how *New York* happened other than that I gave him the space and the time to do what he wanted to. I can't say I inspired Lou, because I don't know that's true,

but I hope I did. I can't say I was in awe of him, but I truly respected him. I showed him my belief, that's all. He had a reputation that was both good and bad, but all I did was give him autonomy, because I knew that's what he needed in order to make a good record.

I let him know how I felt about him. I told him he could do anything he wanted. We both grew up in Brooklyn, we were both Jewish, and we went to high schools that were very close to each other, and we were roughly the same age, and so I thought we had a lot in common. I had a great deal of success with many of my artists, starting as far back as the Ramones, Talking Heads, Madonna, people like that, and most of the people I signed had never made a record before. The only mature artists I signed were Lou Reed and Brian Wilson, because they were both enormously talented, and with Lou I felt a certain kind of closeness because we almost grew up together. He was a special artist, unique. When he was making *New York*, we may have discussed the city, and how we felt about it, and I certainly didn't try to exert any influence over him or the record. If I had suggested he might have been going in the wrong direction he would have said, "So why the fuck did you sign me?" And he would have been right. I let him get on with it. He was tough, but the toughness probably helped him. He had an attitude. There was mutual respect, I think. He was a serious artist who had a mind of his own. Lou could be very nice, and he could be obstinate, but luckily not with me. The reason people liked to be on Sire Records was because we offered freedom. I didn't ask him to play me any music before I signed him—he was Lou Reed. He was a star. He wasn't some bum. He had a strange reputation, but there we are. He was sober when I worked with him. I trusted him. I'm not going to take a bow for those records we made when he signed to Sire. He had talent. I don't know where it came from. I'm not a doctor.

When asked which record he'd bring to a desert island, Bill & Ted *actor Alex Winter chose* New York, *"so I wouldn't be homesick."*

Phil Knox-Roberts (record company executive): I first met Lou with Sylvia in a restaurant in Notting Hill Gate on the day he'd just come back from meeting Václav Havel for the first time. We'd just had great success with *New York*, and he was in a great mood. Pretty much every

time I met him, he was genial. There are so many journalists who have horror stories, but it was the luck of the draw with Lou. I spent a lot of time with him whenever he was over in London. He was once being given the old bloke award at the *Q* Awards, and although he didn't really want to go, he went because I asked him, and Sylvia asked him. He just needed to be persuaded. He could actually be great fun. Nice. But he could be terribly difficult if he chose to. A colleague told me about a dinner he had much later with Lou and Laurie Anderson, as well as Eno, and various Eno types. Lou didn't say a single thing, just glazed over, and when Eno was halfway through one of his rants, just got up and left. Most people's abiding memories of Lou is him being rude and difficult, but not me. When we were promoting *New York*, I took out a silly full-page ad in *Viz* magazine, with a picture of a squid throwing up. And then at the bottom of the page it said, "Lou Reed's *New York*, only six pounds." I had second thoughts and sent it to Sylvia, but they both loved it. That was Lou.

CHAPTER 14

FEAR IS A MAN'S BEST FRIEND

1990–1999

> "As a New Yorker you can't help but be proud of the fact that so much music and culture started here. Punk, jazz, hip-hop, and house started here. George Gershwin debuted 'Rhapsody in Blue' here; the Velvet Underground are from New York."
> —*Moby*

On January 20, 1990, Rachel Humphries died of AIDS at the age of thirty-seven, at St. Clare's Hospital, New York. She was buried in the gigantic pauper burial site at Potter's Fields, on Hart Island, in Long Island Sound, just east of the Bronx. It remains perhaps the single largest burial ground in the US for people with AIDS. Since their breakup in 1977, Lou Reed had rarely mentioned her to anyone. He was eight years clean, still happy with Sylvia Morales, and enjoying a creative renaissance.

Just a year after New York, *Lou Reed now produced another mesmeric record, this one a duet with John Cale.* Songs for Drella *was released in April 1990, a song cycle in honor of their mentor, Andy Warhol ("Drella" being a contraction of Dracula and Cinderella invented for him by Factory Superstar Ondine). The songs focused on their friend's interpersonal relations and experiences: Warhol's first-person perspective, third-person narratives chronicling events and affairs, and first-person commentaries by Reed and Cale themselves. The record memorializes the era with sassy affection, walking you*

through Warhol's life with the eyes of people who had been on both sides of the glass. Here, there is journalistic poetry, contextualizing a period that they themselves were also responsible for, a period that was already morphing into a different sphere of influence, while acknowledging all that had gone before.

The same year, Reed visited Czechoslovakia, months after the country was freed from Soviet rule. He had been sent by Rolling Stone *to interview the writer and dissident Václav Havel, who, by then, was the country's president (and who had already made Frank Zappa its "Special Ambassador to the West on Trade, Culture, and Tourism"). His interview revealed the enormous impact that Reed's work with the Velvet Underground had had on an entire nation during a pivotal moment in its history. After the Soviet Union took control of Czechoslovakia and turned it into one of its many satellite states in 1968, the Czech art world obviously receded. Music was censored, busking became illegal, and any music broadcast on the radio was heavily censored. Only the most banal pop was permitted, while musicians were not allowed to write songs with English lyrics or to sport long hair. Thirty-two-year-old Hável was a widely published writer in '68. Before the Soviet occupation he had enjoyed a career as a respected playwright and a poet, and the year before had traveled to New York, where he heard the music of the Velvet Underground for the first time. Walking by a record shop in Greenwich Village he heard the* White Light/White Heat *album. Keen to buy something unknown and unobtainable in his country, he bought the record, which became one of his favorite possessions. He said that while he wasn't any kind of expert, he could tell their music was special. Special, and important.*

Richard King: It was John who introduced Jeff Buckley to "Hallelulah."

Leonard Cohen's "Hallelujah" was originally released on his 1984 album Various Positions, *a glacial, underproduced dirge that almost willfully disguised its exquisite melody. In John Cale's hands, it would become a modern masterpiece, something that would have fitted perfectly on* Paris 1919. *He first heard the song while attending one of Cohen's gigs at New York's Beacon Theatre in 1990. "I was really an admirer of his poetry, it never let you down," he says. "There's a timelessness to it." He didn't decide to record it, however, until the French magazine* Les Inrockuptibles *asked him to contribute to* I'm Your Fan, *a Cohen tribute album released a year later; Cale called Cohen and asked him to send him the lyrics, which he promptly did, all fifteen verses. "It was a*

long roll of fax paper. And then I choose whichever ones were really me," says Cale. "Some of them were religious and coming out of my mouth would have been a little difficult to believe. I choose the cheeky ones." Ten years later, his version was chosen to appear in DreamWorks' smash computer-animation film Shrek, *prompting a tsunami of identikit cover versions by the likes of Rufus Wainwright and Jeff Buckley. It would soon be covered three hundred times, causing Cohen to, rather ungraciously, say, "I don't want to hear any more new versions of 'Hallelujah'! Let's put an embargo on that!"*

John Cale was probably more famous around this time than he had been for fifteen years, which suddenly made him commercially appealing, particularly in the world of fashion.

Fashion designers have a habit of resorting to cheap tricks when the chips are down—i.e., when the economic outlook is bleak, when their profile is dipping, or when they've run out of ideas. For instance, whenever you see a model wearing tartan on a catwalk, this doesn't mean they're surfing some kind of soothsaying zeitgeist, it means they've reached in the bottom drawer in order to recycle a hoary old favorite. One of the more entertaining clichés is the use of unlikely celebrities as runway models, using architects, sportsmen, celebrity chefs, old pop stars, and vintage Hollywood stars to wear the clothes instead of gaunt teenage waifs with twenty-six-inch waists. One of the first designers to recycle bold-faced names was Rei Kawakubo, the stern-faced designer of the Japanese brand Comme des Garçons. Since the Eighties she has made an occasional habit of using the famous in her Paris menswear shows, including John Waters, David Sedaris, Julian Sands, Jean-Michel Basquiat, Gary Oldman, John Malkovich, Cerith Wyn Evans, Kanye West, Alexander McQueen, Jared Leto, Francesco Clemente, Dennis Hopper, Frank Ocean, Matt Dillon, and Robert Rauschenberg. They're also the kind of men you wouldn't be surprised to see in a Wes Anderson movie. In 1990, it was the turn of John Cale to grace the Comme des Garçons catwalk, cruising down the runway in black duster coats and big boots, his Barry Humphries wedge giving him a regal, almost Shakespearean air. Reassuringly, he found the experience something of a chore. "The fashion world lingo is peculiarly its own," he said. "You never saw so many adjectives in the employ of a primary color."

When I saw Cale coming down the catwalk in Paris that season, I was reminded of his rather intense beauty. You can spend hours reading the increasing number of books about the Velvet Underground and Andy Warhol and never read anything about Cale's innate good looks. He has always been

an extremely handsome man, blessed with a seemingly permanent and rather sinister haughty expression, excellent bone structure, and a fine head of hair. He has also aged well, which, considering the vast number of narcotics he has fed through his body, is its own kind of miracle.

But then sex had always swirled around the Velvet Underground.

Sometime during 1991, Jon Savage went on a pilgrimage. In the mid-Seventies, he'd read John Rechy's City of Night *in a kind of frenzy. Written in the pace and rhythm of early rock and roll,* City of Night *became central to Savage's mental map of Los Angeles. Years later, he'd drive around MacArthur Park and Pershing Square looking for the ghosts of Chuck, Skipper, Miss Destiny.*

Rechy lived in Los Feliz, at the foothills of Griffith Park. In 1955, Nicholas Ray shot the climactic scenes of Rebel Without a Cause *at the park's Observatory: hidden in the film's love triangle—James Dean, Natalie Wood, and Sal Mineo— was an explicit homosexual subtext, "which Mineo lived and died out," says Savage. In 1966, Rechy made the park the star of his second novel,* Numbers, *as Johnny Rio cruises its hidden glades to the sound of "Wild Thing," "Summer in the City," and the Standells' "Dirty Water."*

When Savage and Rechy met, they discussed the fact that what was once taboo, hidden, right at the edge, was now at the heart of pop culture. What had happened?

"When Rechy first wrote what would become City of Night, *in the late Fifties, homosexuality (let alone hustling, drag queens, and drug taking), was just not talked about," wrote Savage afterward. "Much of the Fifties existed in order to edit out of history the freedoms of wartime: a renewed, McCarthyite puritanism drove homosexuality further underground with the inevitable psychic consequences. By the mid-to-late Sixties, there were all sorts of exposé! books, but not then: just a few coded, discreet novels (like James Barr's* Quatrefoil), *which would usually end in suicide or death."*

Jon Savage: Before the full industrialization of media and of pop, there was an edge of the world, and Rechy was falling off it. Now that the leather queen is a pop video staple, now that trannies are high fashion, now that it may be possible for the outcast to gain access to the mainstream and thus lose his outcast status, it's hard to imagine the sheer desperation of being cast out in the late Fifties/early Sixties, with no way in, no way never ever.

The question "What is Pop?" is an ideological battleground. If "Pop is dead," who is pronouncing the death sentence? Not those of us who still have much to gain from it. The Eighties insistence—post *The Great Rock'n'Roll Swindle*—on Pop as Industry, Pop as Process, Pop as Hyper-Capitalism is, of course, an important part of the picture, but not all of it, never ever. I'd rather talk about the idea of pop as an enfranchising process—imperfect but powerful: in [the critic] Dave Marsh's words, providing "a voice and a face for the dispossessed." Let us celebrate those who have contributed to this ongoing process, to these hard-won freedoms.

And he was talking about the Velvet Underground.

Richard King: I remember in '92 John had just been to see Abel Ferrara's *Bad Lieutenant,* and he said, "That's too much. That's extreme."

In 1992, James Young's extraordinary book Nico, Songs They Never Play on the Radio *was published, which detailed their working life together, and became an instant classic. It was harsh, honest, funny, unrelenting, and often coruscating.*

James Young: I was quite unprepared for the attention the book got, as I thought it would be such a marginal thing when the book was published at the start of the Nineties. I thought, no one's heard of Nico, and it wasn't about the so-called glamorous Warhol years. It was the other end of things. I just thought the book would disappear, and then my phone just became red hot. I should have realized that anything associated with the Warhol world is electrifyingly interesting to people, and it continues to be that way. I think we still live in Andy Warhol's world, more than ever, really.

The Velvet Underground's unlikely reunion had a very protracted birth. It began in 1987 when both Lou Reed and John Cale started talking at Warhol's memorial service in New York. They hadn't spoken in a while, but their combined grief brought them together. First there was Songs for Drella *and a brief promotional tour, then at a Brooklyn gig in December '89 they were joined onstage by Moe Tucker, for an encore of "Pale Blue Eyes." But whenever*

a journalist would inquire if they were getting back together, Reed would say something like, "I don't believe in high school reunions." Then, just a few months later, the four original members were invited to the small French town of Jouy-en-Josas for the opening of an Andy Warhol retrospective. Cale and Reed were scheduled to play a set of songs from Songs for Drella, but the presence of Tucker and Sterling Morrison caused those present to think that something remarkable might happen.

And it did, even though Reed kept shutting it down. "You'll never get the four of us together on one stage again," he said at a press conference at the French event. "Ever. The Velvet Underground is history." Then, hours before the event, Reed agreed to a meal with Cale, Tucker, and Morrison. Not only was this the first time they had all been together since 1968, when Cale was kicked out of the group, it was a moment of reckoning. Fifteen minutes before Reed and Cale were due onstage, Reed suggested inviting Morrison and Tucker onstage to play "Pale Blue Eyes." When it was carefully pointed out that it had actually been recorded after Cale left, they opted to play "Heroin" instead. Lou Reed's biographer Victor Bockris said afterward it was like people who suddenly remembered they once had great sex. Three years later, they all decided to get back in bed together, embarking on a European tour in Edinburgh on June 1, 1993, which included a performance at Glastonbury, and with Cale singing most of the songs Nico had originally performed. As well as headlining (with Luna as the opening act), the Velvets performed as supporting act for five dates on U2's Zoo TV tour. The European reunion tour was a huge success, and so a series of US tour dates was proposed, as was an MTV Unplugged album. But then Cale and Reed fell out again, breaking up the band once more. Cale had suggested they write new material, that they should "remythologize" the band rather than demythologize it, but he was overruled by Reed, who thought he was doing the rest of the band a favor by appearing with them and didn't want to confuse his own release schedule by allowing the Velvet Underground to produce new records. As it was, the band refused to call it a reunion, preferring "continuum." Perhaps predictably—they had all moved so far away from where they were in 1968—the concerts were disappointing, with Reed tending to use Cale, Morrison, and Tucker simply as another backing band. What had begun with great promise turned out to be ill-fated, short-lived, and acrimonious. Richard Williams says he had no interest in seeing a regrouped Velvet Underground, and there were many who felt the same. Lightning was never going to strike twice.

Anthony DeCurtis (author, critic): When it came to think about an American tour and the "Unplugged" show, Cale finally couldn't stand it, and that was the end of that.

Richard King: I was born in Newport, in South Wales. I'm an only child, and my parents were both teachers. My father was from Chepstow, but my mother was from Garnant in the Amman Valley. She and John Cale are cousins and are both only children. John's daughter Eden is also an only child. So there have only ever been four of us on that side of the family. So when I started piano lessons I was given a piano case which had Joan Davies, my mother's name, crossed out, then John Cale and his name crossed out. And then mine. I was six. I also played the violin and the viola, as they were the instruments in the family. My mother was always in touch with John's mother and father, but John was obviously in America. For my fourth birthday I had a Mickey Mouse T-shirt, a present from John. That was about the only contact I had with him until I was a teenager, when he started to reconnect with the family. Fundamentally because he was now straight. But his name was always mentioned. We have this thing called *Sul y Blodau* or Flowering Sunday in the chapel in West Wales, the same day as Palm Sunday, and it's the day when all the graves are tended to and dressed with fresh flowers, and my mother would do that religiously, and would always do John's grandparents' graves as well. We would sometimes go and visit his mother in a nursing home. In 1981, John married Risé [Irushalmi], and as soon as they had Eden, he was very much back in touch. Becoming a parent suddenly made him very aware of family, and that was the moment he started recording in Wales.

In '92 he invited me to New York, my first trip to America. We got the bus to Madison Square Garden, and then got a cab to John's place in Greenwich Village. It was snowing so it looked like the cover of *The Freewheelin' Bob Dylan*. As soon as we put our bags down John said we were going out to dinner. We walked a couple of blocks to this brownstone, and the concierge waved us in. We headed to the elevator, and John pressed P, which I realized was probably for Penthouse. So we got out at the top, and walked down this long corridor to a solitary door. A figure leaned out of the open door and grunted. It was Lou Reed. John said, "This is my cousin Richard, and this is Lou, this is

Sterling, and this is Moe." That day they had got back together for the reunion. You could see the Chrysler Building from his apartment, which was illuminated. It was snowing and through the speakers came this incredibly scratchy version of "All Tomorrow's Parties," and it was a recording of their first rehearsal earlier in the day. Lou was talking about guitar pickups, as you would expect. I was glad I had jet lag as I couldn't really understand why I was having dinner with the Velvet Underground. They were reminiscing but they weren't showing any emotion. Sometime later I went to see them play at Wembley, and the band loved the fact that John spoke to my mother in Welsh, although I think Lou was a bit grumpy about that.

Paul McGuinness (entertainment manager, TV producer): The Velvet Underground opened for U2 in 1993, so they came on tour with us, although they clearly all hated each other. There were various disputes about transport and hotels, and they were not very good at managing themselves. They didn't like the status of underdog, being an opening act. We were very nice to them, transported them, fed them, and looked after them. Cale was the one I liked, and he was a very nice man, he was good fun to be with. He came up to me backstage one day and said, "Where's Lou?" And I thought, "Oh fuck, Lou's gone. Lou's flounced. He's left the tour." And I said, "I think he's in his dressing room." And Cale said, "No. I don't care where Lou is. Where's the loo?"

Michael Zilkha: Why on earth would they open for U2? I can't imagine them opening for anyone.

Chris Thomas: When they re-formed, John wanted me to produce the live album, which got up Lou's nose. That's why they fell out.

Mary Harron: One of my great regrets is not going to see Sterling when I had the opportunity, when I was researching *I Shot Andy Warhol* and he was living upstate. I had no idea he was sick. He had cancer.

Margaret Moser (journalist): On the night of May 17, 1979, Sterling Morrison and John Cale stood in a La Quinta Inn motel room in Austin, Texas, grinning at one another like a couple of streetwise Cheshire cats.

It was the second time the former bandmates had gotten to visit with each other in a month; Cale had returned to play the Armadillo World Headquarters less than four weeks after his first Austin show. It was also the second time they were seeing one another since 1969, when Sterling delivered the news to Cale that he was no longer in the band he had cofounded, the Velvet Underground.

At the time, ex-members of the Velvet Underground were not hanging out together, and in those heady days of punk and New Wave, the VU were gods. Until the night in 1979 when he walked onstage with John Cale's band and played "Pablo Picasso," few Austinites realized that VU guitarist Sterling Morrison lived in town. Although they continued to make critically acclaimed music, by the late Sixties, Morrison's heart was no longer in the band. During the Velvets 1969 tour of Texas, he applied to graduate school at the University of Texas and left the band. While working on his doctorate in medieval studies, he was a TA and enjoyed the pre-*Slacker* Austin lifestyle, playing in the local band the Bizarros and hanging out with his pals. There was little about his unassuming demeanor to suggest that only a handful of years before, Sterling Morrison had been in one of the most notorious rock and roll bands ever.

Joe Kruppa (teacher): When the Velvet Underground played the Vulcan Gas Company [Austin, 1969], I was teaching Literature & Electronic Media [at the University of Texas]. I wanted someone from the Velvet Underground, preferably Lou Reed, to come to class [as a guest speaker]. Reed agreed to do it. Lou was in a pissy mood that day. Snarling, he talked about Warhol and the Velvet Underground.

Sterling came to the class too. The next year I was sitting on the committee that decided teaching assistantships. I was reading through a big stack and came to one that said, "Holmes S. Morrison." It didn't register. I started reading it, and where it said, "Past Experience" he wrote something like, "For the past six years I've been involved with a professional musical organization touring and recording for Verve Records."

Holy shit. I couldn't believe it was Sterling applying. He had a fairly decent but unconventional academic background. I knew he would not be rated very highly [by the committee], so I gave him the highest rating I could and went to bat for him. He got the TA-ship.

Bill Bentley (journalist): I met him in 1975. I used to go to the Cedar Door. I overheard this guy at the bar talking about Frank Zappa, and put two and two together: He had to be Sterling. So I asked, "Are you Sterling?" He looked at me bug-eyed and said, "Who wants to know?" That's how we met. By accident.

After that I asked him to do an interview with me for the *Austin Sun*, where I was music editor. I thought it was fascinating that no one had heard from him since he came to UT. He liked the story, so we [began] hanging out. I was playing with the Bizarros and thought Sterling would be the perfect person to join us. The Bizarros played a kind of twisted, blues-based bar rock. Getting Sterling in was strange because, as he told me once, the VU never played any R&B or blues, that Lou said he would fine the players if he heard any blues licks in the Velvets' music—[Lou had a] thing about needing only two chords. Sterling came from a whole different side of rock and roll.

He was a Yankee to the bone and proud of it. Austin was love, peace, and understanding, and that's not what Sterling was about. We'd take Sterling to parties and bet on how quickly he could clear a room.

I had a really painful falling out with Sterling. We were close, and I felt responsible for getting Sterling back into music. But you could only go so far into his feelings, and then there would be a wall. There came a point in the Bizarros when Ike and Speedy Sparks decided that [guitarist] Bill Campbell's playing was more in tune with the Bizarros. Rightly or wrongly, they decided to get rid of Sterling. We had a band vote, and I lost. He didn't talk to me for five years. He was a man of contradictions. I don't think he ever figured out his place. If you look at the history of the Velvets, Lou Reed went on to great things, John Cale did, even Moe went on to make records. But besides the Bizarros and a few guest stints, he never found a place in music again. And he wanted to. Look at his English department career, it took him fourteen or fifteen years to get his PhD and he never became an English professor though I know he wanted to.

John Cale: Sterling's relationship with Austin is a mystery to me. But I appreciate it because he went right back into academia and was well-suited for it. One of the things I said at his funeral was that I didn't realize how much I really depended on him to spill the beans intellectually. He

was someone you could call up with the craziest theory and he'd come back with a rational response that was better thought-out.

Lou Reed: There is no one who was more perfectly made for being a tugboat captain. There was nothing he couldn't master.

Bill Bentley: He ended up working tugboats to make a living because he'd been a TA so long at UT they wouldn't let him do it anymore. He eventually got his captain's license. He knew that's not what he was meant to do with his life but that's how it ended up.

John Cale: Long ago Lou had sent Sterling to tell me I was out. [Lou didn't] have the guts to do it himself. And Sterling resented that. In the middle of the [reunion] tour in Lausanne, Switzerland, the resentment all burst out again. There was a stage situation where Lou's guitar tech was on Sterling's side of the stage. Whatever Sterling was doing, he had to make room for the tech to run out there and plug in Lou's guitar. There were different guitars for every song practically. A party was organized by U2 on a boat on a lake. It was a steamer; it chugged around the lake and stopped in the middle for everyone to swim in the afternoon. It was fun. But for some reason Lou hadn't gotten up in time and was the last one aboard. The fact that everyone was there ahead of him lit a bomb under him, and he didn't let anyone forget it throughout the day. Sterling was having a great time. When we got off the boat, Lou didn't talk to the band for the rest of the day. The whole thing started up onstage again. Sterling that night in the bar was livid. Things lurking for years just came out. All the chickens came home to roost.

Moe Tucker: We knew something was wrong, but we had no idea it was terminal, for God's sake. I had seen him a month before the museum show, and the difference in his physical appearance was shocking. John and I happened to be having tea together when we saw him across the lobby. Both of us were like, "Oh, God..." Just a month.

John Cale: After the reunion tour, I was to do some music at the Warhol Museum for Andy Warhol's *Eat/Kiss* and invited Moe and Sterling to play. While he was in Pittsburgh, he went to Carnegie-Mellon Hospital.

He couldn't sit or stand for long. [Morrison's wife] Martha said he was coming back to Poughkeepsie. I really didn't know what he was doing; I knew he was in Houston. I really didn't [understand] how much of a problem it was until Martha took him to her GP and the tests came back. I went up to see him after he had some treatments in Buffalo. It was shocking to see. He was very emaciated but determined to get to play the *Eat/Kiss* music at an upcoming festival. We were focused on getting Sterling in shape to go to it. As soon as I saw him, I knew there was some serious difficulty.

We did the festival without him. When I came back, I got a call that said I better go up and see Sterling. That was the last time I saw him. He was aware of what was around him but couldn't communicate very well. I wanted him to know what kind of an influence he'd had on me, so I got a chance to tell him.

Moe Tucker: I never contemplated the cause of his cancer, but I thought of the ship channel. He was older and wiser, gave up smoking, jogged… always popping vitamins. I'd laugh at him and say, "Sterl, put that shit down. Have a cigarette." He was real proud that he had not become a pot-bellied, dumpy older person. So him getting that sick that quickly was a shock.

Lou Reed: When I found out he was sick, he was already hospitalized. I was truly shocked. Sterl had never been sick a day in his life. I saw him two days before he died. I remember him as funny, confident, large, and brilliant, surely the toughest of us all. A warrior. Sometimes he infuriated me, but he was overall a king.

John Cale: I thought it was the right thing to do, dedicating my book *What's Welsh for Zen* to Sterling. I think everyone discovers things after a person is gone. In my case, it happened while I was working on [the song that became] "Some Friends." That realization caught me by surprise. I was writing *Walking on Locusts*. There was a string piece I'd written for Julian Schnabel's movie, the flattest piece of music I've ever made, no structure or profile. And I kept working it over and over again, and all of a sudden these lyrics started coming out. It was involuntary, but I realized quickly what they were about. It had this solitary effect,

suddenly there was something in the back of your mind you weren't talking about but really felt. That was how Sterling's personality affected me. Much later.

Lou Reed: No, I didn't attend his funeral. I dedicated a song to him from the stage of the Rock and Roll Hall of Fame—I wanted his name to be heard on TV and to the crowds watching the show. I wanted to play "Sweet Jane" for him one last time. Sterl could do almost anything. His guitar style was unique and mirrored the innate talents of this wondrous man. I loved him deeply.

Sterling Morrison died on August 30, 1995, of non-Hodgkin's lymphoma.

Lou Reed: Sterling was a really big guy. He covered a lot of ground, he got a lot of life into his fifty-three years. He and I were the same age, for Chrissakes. We went to college together. Knew each other for a long time, and Maureen knew him longer than I did. Jesus, how is it possible? Guy worked out, never sick a day in his life. Literally. He fucking jogged.

Mary Harron: I hadn't seen John Cale for a while, but I asked him to score *I Shot Andy Warhol*. Lou Reed had already said we couldn't use any Velvet Underground songs in the movie because he hated Valerie Solanos, so I asked John, who actually wasn't speaking to Lou at that point anyway. Everything he wrote was so European, and elegiac, and tragic. So I had to ask him to make it more American. Some of his strings were just too dark. John goes into tragic European pretty easily.

Mick Brown: When Mary Harron's film *I Shot Andy Warhol* came out in 1996, I went to the US to interview some of his old Superstars for the *Telegraph*. They were all living in California at that point—Viva, Joe Dallesandro, and Holly Woodlawn. Holly was charming. She lived just off Sunset Boulevard, just near the old Riot House. When I turned up at her apartment, he/she was completely dressed up, and asked me where I'd like to go. So, we went to the Chateau Marmont. As we walked into the bar, she slipped her arm in mine. Joe Dallesandro on the other hand was surly, embittered, and semi-impoverished. He was living in a motel. Chuck E., the guy from the Rickie Lee Jones song, lived two doors

down from him. We went to a Dunkin' Donuts, and Joe told me his sad and sorrowful story. There was a tragic moment when he called his agent and had to explain to the receptionist who he was. Viva was very entertaining. She lived in the Valley, and we went out to a restaurant there, a rather quiet place. She had a very loud voice, and when she said, "All Andy wanted to talk about was guys' penis size," the entire restaurant turned around to look at us.

In his piece, Brown wrote: "Ten years ago, in 1986, Holly Woodlawn had dinner with Warhol in New York, 'and it was the first time he opened up for more than ten minutes in all the time I'd known him. We went upstairs and we were talking for two hours. He was really funny. He was like a little gossipy queen. He said he wanted to manage me and stuff, and then he died.' By candlelight, you could see the shadow under the panstick, the dark half-moons under her eyes. She was 50. She should wear glasses, she said, but doesn't. She can't see things close up. 'But from a distance,' she breathed, 'everything looks glamorous.'"

Gillian McCain (poet, journalist): Growing up in a small town, I had never got into Patti Smith as I thought she was a native Ethiopian singer. So I never listened to *Radio Ethiopia*. Then I saw the underarm hair on *Easter* and thought, "No, I don't like hippies." I even avoided the Velvets' *Live at Max's Kansas City* because I thought, "What cool things could possibly come from Kansas City?" But ever since I first visited New York with my parents when I was eleven, my goal was to live there. I moved in 1986 from New Brunswick, Canada, when I was twenty-one, to go to NYU. When I moved, I remember feeling a little sad that I'd missed the heyday, you know, but it was fantastic. All the myths were wrong, as everyone was so friendly. It was pretty easy to meet people as they were so engaging. The East Village was buzzing, and the city was still vibrant. I was out every night, to the Tunnel, the World, Danceteria was still just going. We'd go to Holiday Cocktail Lounge on St. Mark's Place, the 7b Horseshoe bar, and all the dive bars. And of course the Ritz. I went to see Nick Cave, Leonard Cohen, the Butthole Surfers, Cocteau Twins. I met Legs McNeil, who was collaborating on a book project with Dee Dee Ramone, and we became fast friends. Legs was getting so much material that I thought the story was bigger than just

the Ramones. He was interviewing Richard Hell and Danny Fields and all these great people. I kept going through the transcripts saying, the story is so much bigger! You gotta talk about Max's. And in the end, he asked me to do *Please Kill Me* with him, which came out in '96. It was such a great experience because he knew everyone, so everyone said yes to being interviewed. So it was an education. Richard Hell was a bit intimidating, as was Cyrinda Foxe, although the biggest disappointment was meeting all the Warhol people. Gerard Malanga and Billy Name were great, but when we took Ultra Violet out for dinner she was all about, "Well, I invented punk," so you have to let them go with it for a while. Lots of them just didn't have very good stories. We got great stories out of people as it felt as though the culture was changing, and that maybe something was ending. Times Square was already becoming like Disney. They were celebrating a time when people felt free. They weren't worried about offending people.

Reeves Gabrels (musician): On January 9, 1997, David Bowie celebrated his fiftieth birthday with a special concert at New York's Madison Square Garden. He was joined onstage by several special guests including the Pixies' Frank Black, Smashing Pumpkin Billy Corgan, Dave Grohl and the Foo Fighters, Lou Reed, Robert Smith of the Cure, and Sonic Youth. "I have no idea where I'm going from here," he said onstage, "but I promise I won't bore you." That night I had to teach Lou Reed how to play "Queen Bitch" for David's fiftieth birthday party, and unbeknownst to me David had set up a live feed so everyone else could hear. Lou predictably put me through the wringer, shouting at me, telling me all the things I was doing wrong, telling me I was playing in the wrong key, but after that he became like my mad old uncle. "Hey, call me anytime, I don't sleep, I'm always up."

CHAPTER 15

ALL TOMORROW'S PARTIES

2000–2013

"The Exploding Plastic Inevitable's sophisticated yet brutal mixture of film, art, music, fashion, and mediation revealed roiling emotions that were too much for the pop culture of the time, but its influence has been as vast as it is uncontested. The EPI now seems like a basic blueprint for the multimedia synaesthesia of 21st-century pop culture—a vision for the future that came to pass."
—Jon Savage

In the summer of 2001, when the Strokes' debut album Is This It *started to insert itself into our lives, the band (with their vintage leather jackets, skinny ties, and jutting model cheekbones) were naturally treated as the Next Big Thing. Heralded by the press as "the forefathers of a bold new era in rock," "the greatest rock band since the Rolling Stones," and "the second coming of the Velvet Underground," the band had nowhere to go but out of style. Before they did, though, they managed to convince the herded masses that their brilliantly delivered fusion of Sixties and Seventies downtown pop—Television, the Ramones, Blondie, Talking Heads, Richard Hell, the Velvets, etc.—was genuinely transgressive. Frontman Julian Casablancas managed to perform a fair-to-middling impersonation of Lou Reed's vocal techniques, while the band's wiry guitar lines gave the whole package a nice urban sheen. "We were worried*

about putting out the album, because we thought we'd get busted." Casablancas said he wanted to make the band sound as futuristic as possible. He wanted the Strokes to sound like "a band from the past that took a time trip to the future to make their record." As well as admitting they modeled "Last Nite" on Tom Petty's "American Girl," they also "ripped off" bass parts from the Cure. "There are some bass lines on our first album that were one hundred percent ripped off from the Cure," said bassist Nikolai Fraiture years later. Weirdly, the band decided to leave the album title's question mark off the cover as they didn't think it aesthetically looked right. The Strokes officially met Lou Reed when Filter *magazine arranged a grip-and-grin between them in 2004. When Reed was asked, "Didn't Andy manage the Velvet Underground in the beginning?" (didn't these boys know anything?), he scratched his head and replied, "All that meant was that we were affiliated with him. We would stand there onstage, dressed all in black, with black glasses, and he would project movies onto us—slides and films—and we would stand there and play. He was a genius. I often ask myself, when I'm writing something or working on something, 'What would Andy do?'" The Strokes smiled and looked around at each other as if to say, "Dude, we say the same thing about you."*

The band's only misstep was the original inclusion of the song "New York City Cops" ("they ain't too smart"), which they sensibly chose to replace with a newly recorded song, "When It Started," after the "valiant response" of the city's police department during the 9/11 terrorist attacks.

Ed Vulliamy: It's 2001, 9/11, and I go to New York to interview John Cale for the *Observer*. He said something I'll never forget: "Hundreds of people running past my door making no sound." Only a musician would have an aural memory of 9/11.

The 9/11 attacks changed New York forever, and the psychological effects were manifest immediately. As grief and anger gave way to a tacit understanding that the world had changed forever, Manhattan had changed too. Afterward the streets were never quite as busy, the bars never quite as noisy, the energy never quite as urgent. The city had been moving that way anyway. By the Noughties, Manhattan had become an island co-opted by Realtors, so much so that even the liminal parts of the East Village had become so gentrified that it was often difficult to see any signifying elements of the city at all. The buildings got taller as the city got duller. Artists and musicians had to move to Brooklyn

to find anywhere they could afford to live, while the housing market had taken an airbrush to the dividing line between uptown and downtown. Fourteenth Street was now an historical partition. There had been a drift uptown, as though old money was somehow more reliable than the new. Fashionistas were tiring of SoHo, principally because it looked like an urban regeneration theme park, one that was being copied everywhere from Chicago to San Francisco. A friend of mine who worked in the film business at the time said the city had become even more hierarchical. "You have the money up here," he said, raising his hand up to his head. "Then just under the money you have opera, then the theater, and then some way below that you have film." And the music? "You need to go over a bridge for the music."

Entertainment became available on tap, accessible to a smart phone generation which could now experience the Velvet Underground any way they wanted, in exactly the same way they could consume the Beatles, Emmett Grogan, or Mark Kostabi, long tail or short. The future had arrived, and it was full of the past. Especially in New York, which had started to feel like a city full of echoes. Sure, there was a constant stream of beautiful, clever new buildings, and an endless supply of gargantuan retail cathedrals, but culturally the city was fighting a losing battle with Williamsburg, Red Hook, and even Los Angeles.

Not that the city ever lost its heritage, or its ability to own its cultural IP. One must never forget that this is still the city of two million opinions. And sometimes those opinions are so similar, so uniform, that the whispers become a roar; one you can hear echoing between the buildings on Fifth Avenue. Having a cocktail with a marketing leviathan one night, as George Bush was leaving office, I heard the town's palpable disgust with its then government articulated thus: "Our town is a stand-alone, kinda," said my friend, his voice rising to fill the silence of the bar. "And here in Manhattan, we want to be our own country. We'll take Brooklyn and Queens with us but we wanna separate ourselves from America. We're richer, we're smarter, and we're funnier."

When Nora Ephron moved to the Upper West Side, she said that after a few weeks she couldn't imagine living anywhere else. She began, in her own words, "to make a religion of my neighborhood" and became an evangelist for the area, obsessing about every retail detail.

New Yorkers will forever be defined by their resilience and sense of humor. For years I had three New Yorker cartoons stuck on my office pinboard, cartoons that sum up the three fundamental characteristics of your average New Yorker: the work ethic, the self-centeredness, and the ability to be brutally

honest when the occasion demands. *The first features two guys in a bar (*New Yorker *cartoons always feature guys in bars); one says to the other: "Basically I like to keep the coffee buzz going until the martini buzz kicks in." The second shows a man behind his desk trying to find a lunch slot for the person on the other end of the phone: "How about never?" he says, hopefully. The third shows a couple walking along a windswept Hamptons beach, with the woman saying to her friend: "I do think your problems are serious, Richard. They're just not very interesting."*

In New York, often you don't need to speak to a person to know what their opinion is. Once, as I walked along West Forty-Fourth Street on my way to the theater, a tall, white, shaven-headed endomorph crossed the street, dressed in standard-issue three-quarter-length khaki shorts, baseball boots, and a T-shirt that proudly proclaimed, "Do I look like a fucking people person?"

A sentiment that could have been invented for Lou Reed.

Mick Brown: I only interviewed Lou Reed once, but it was enough. I'd spoken to Bob Ezrin about Lou and he said if I was meeting him that I should wear armor. He told me he was a tough one to warm up. I told him that it should be fine, and he said, "I don't think so." I'd gone to New York to interview him for the *Telegraph* in 2007. I'd arranged to meet him at 4 p.m. at his favorite café in Greenwich Village. Fifteen minutes later he walked through the door, sat down, and studiously ignored me for twenty minutes. I nodded, he refused to shake my hand, and said, "The interview will begin when you turn on the tape recorder." Then he proceeded to have a twenty-minute phone conversation. After that he engaged the waiter in conversation for another ten minutes. He was ghosting me in order to unsettle me. He used to say that his idea of hell was meeting an English journalist, and here it was, displayed writ large. Then his manager arrived, and he talked to him. By the time we ordered food I was beginning to feel like a very unnecessary component in the whole process. Then he turned to me, gave me a querulous expression as if to say, What are you waiting for? When we started talking, he was incredibly difficult, especially when talking about the Velvet Underground. The whole experience was grudging. He wasn't interested in accommodating me. It had obviously become his default position, to be hostile. It was his defense mechanism. He was slightly more animated when talking about Warhol, saying how much he'd admired him, but

he only began to warm up when I mentioned he was a fan of "You're So Fine" by the Falcons, the old R&B doo-wop record, with the great Robert Ward guitar solo. He responded because he then realized I knew what I was talking about. Then we talked about Doc Pomus, Delmore Schwartz, William Burroughs, Allen Ginsberg, and Hubert Selby—whom I'd met in LA. He became most animated when I mentioned he'd become a student of the Tibetan Buddhist teacher Yongey Mingyur Rinpoche, who I knew a certain bit about. The carapace of studied cool, hostility, and indifference just vanished, and he was like a different person. We parted on very good terms and agreed to meet when he was next in London. Then I made the mistake of writing the piece and I never heard from him again. I have to say that, regardless of his fascination for it, he was probably the least Buddhist person I've ever met. He was difficult, obfuscating like crazy. I think he had Joni Mitchell syndrome, and felt that he was recognized and appreciated for the wrong reasons.

Barbara Charone (publicist): Lou had a love/hate relationship with the press. They loved him; he hated them. He liked to make people feel ill at ease, which is the worst thing you can do.

Bobby Gillespie: It's narcissism with all the rock journalists who want the Lou Reed confrontation. I read one recently when this guy was saying he went head-to-head with Lou Reed. I just thought, you want to be Lester Bangs. Wankers. Lou Reed liked Lester Bangs because he respected him. He was his moral conscience. They flatter themselves.

Francis Whately (director): We were making a series called *The Seven Ages of Rock*, and I was given a film called "Art Rock," which looked at Peter Gabriel's Genesis, Syd Barrett's Pink Floyd, the Velvet Underground, David Bowie, and Roxy Music. So we interviewed John Cale and Lou Reed, and I was rather worried about interviewing Lou because I'd heard the stories. I was a British journalist, so I was concerned. So we were in New York, and I thought that if he's accepted an interview, then surely he's going to play ball. So he arrived, looking cool in a red T-shirt and a leather jacket. Very friendly. And I start asking him questions. And he doesn't really want to know, and one question after another goes past with him either nodding or saying, "I don't know," or "I can't answer

that." I mentioned that David Bowie was obviously influenced by the Velvet Underground, and he says, "Was he?" Not knowing that he was playing with me, I reminded him that Ken Pitt, Bowie's manager, had brought back an acetate of the first Velvet Underground album from New York, and that it was probably the first copy to arrive in the UK. Bowie treasured it all his life. He studied it, and actually made a version of "Venus in Furs," which was "Little Toy Soldier," where a girl called Sadie, who dressed up in men's clothes, was beaten by this little toy soldier in an act of masochism. I think Lou Reed perhaps genuinely didn't know this, and asked how he could get a copy. I said that I'd got a copy, and he asked if he could have it. I said I'd give it to him if we made a deal. I said that if you answer my next question in anything like an appropriate manner, then I'll send it to you. And he said, "This is not a hostage situation. Free America. Free America. Free America." But at least it had broken the ice. Things were easier from then onwards. I think his motivation for behaving like this was to separate the wheat from the chaff. I think he wanted to engage with someone who had done their homework, who knew what they were talking about, and who didn't ask the same boring questions. And I think I had done exactly what he had feared. I fell into the trap, and became exactly the kind of vermin he was anticipating. But when I got on to the subject of *Berlin*, he became quite different. His eyes lit up. He was about to bring it to Britain and he became very engaged. I think his thing was, "I'm Lou Reed, and you're going to have to work very hard to get anything out of me." My cameraman, who was American, perhaps thought I had got what I deserved. Even Tony Visconti, who used to do t'ai chi with Lou Reed, said that sometimes Lou could just be an asshole. And they were very good friends, so I guess it depended on what day you got Lou Reed.

Robert Chalmers: As a journalist, people ask if you're apprehensive before going into an interview, and in my experience the answer—for most people who have done it for a bit—is very generally no. I wasn't nervous of meeting Lou Reed at all. I admired the work; I mean I knew of his reputation for being a bit of a handful. I interviewed him at the May Fair Hotel in London when *Magic and Loss* came out, I can't pretend that he wasn't difficult. I had been sent by the *Independent*. When I went to the suite there were other people around...various press people. There was a

guy stacking CDs who I assumed was some kind of junior administrative assistant from Warner Bros. He warned me to be careful what I said to "Mr. Reed" and in particular to avoid asking "inappropriate questions."

At which point I couldn't help myself, and I said, "By inappropriate, do you mean something like, 'Where's Rachel?'" It transpired, when Reed eventually turned up, twenty minutes late, slightly more punctual than you would expect, that this guy was not some junior aide but was actually quite close to him. The two of them then went off into a quiet huddle in the next room, after which Reed appeared in an even worse mood than his reputation might have presaged. Which meant that he was tersely monosyllabic, and very hostile in terms of his body language. He was wearing what I remember thinking looked like a Seventies north Manchester car coat, and he didn't take it off.

After about three and a half minutes I said, "You know what, if you don't enjoy doing this sort of thing, here's an idea: don't do it." At which point there was a sort of swirl of faux suede, and he was gone. One PR was close to tears by this point. Apparently, they called the *Independent* and asked if they could send a more amenable journalist. Which they did. I would prefer not to say who that was. [Giles Smith— *Ed.*] I didn't read what they wrote for the sake of my karma, if you know what I mean.

That incident was purely the result of my own stupidity and an inability to keep my dumb sarcastic yap shut. I have never sought confrontation in interviews, simply because, in my experience, it doesn't work. Especially with tricky subjects like Reed, or James Brown or Hunter S. Thompson. There's no point stirring it with these people. I've only once embarked on a mission to destroy, and that was with Lord Archer. But Lou Reed—as I say, largely thanks to me, was just impossible. He was never going to go the full ninety minutes, not with me.

As a general rule I think that he especially didn't like British journalists, because...it's a generalization, but often they don't necessarily show great artists the degree of reverence they are perhaps used to in the United States. We're not deferential enough. And there are a lot of American interviewees who don't like being talked to like normal people.

But I repeat, I got off to a catastrophic start of my own making. If I can risk a dead metaphor, I managed to torpedo my own boat before I'd even cast off. It was a spectacular fuck-up. But...in general terms...

could an artist be British and hold themselves in such elevated regard as Lou Reed? Well, there are a few. Morrissey—for all his ability to self-deprecate—springs to mind. Another point is that Reed, as you know, has said that when he sees a recording device, he has to "become" that uncooperative person. Which is interesting if true. Most musicians in my experience tend to get on OK with other musicians, but some—like Reed, anecdotally—didn't even get on with their pickup bands. But Lou Reed wasn't easy with fellow professionals. He played the Isle of Man once and treated the promoter and the other musicians with shall we say not the deepest respect. His rider included certain specific years of an obscure sophisticated Italian white wine, and a humidor with two or three Cuban cigars, to be ready for him when he came offstage. He was such a pain to deal with from start to finish that on the final night the promoter left early, having trousered the Montecristos. He told me: "Can you imagine the look on his face when he opened the humidor only to find a packet of ten Embassy Regal?"

The only positive thing I can really take from the experience is that recently I wrote a chapter for Erica Heller's book *One Last Lunch* in which a number of writers imagined a lunch with a dead person. The contributors included Rain Pryor, Erica herself on her father Joe, and Kirk Douglas, who himself died just after it came out. In that I tried to imagine the scenario from Reed's point of view, and doing that I think brought me far closer to understanding him that anything I have been exposed to in terms of being in the same room, or listening to his music, even.

Otherwise the consequences were not great. That incident ignited a feud with an editor I otherwise like, who accused, and still accuses, me of having done it deliberately, which is absolutely untrue. A Radio One DJ played a Lou Reed track on his show and said, "This song actually lasts forty-five seconds longer than Robert Chalmers' interview with Lou Reed."

Moe Tucker: Many journalists who tried to interview Lou came unarmed with any knowledge. They didn't like him very much, because he didn't like them, and I don't blame him, actually. But, my personal opinion, I don't blame them [either]. I do think that Lou sometimes went a bit overboard in deriding them.

In 2010, when Moe Tucker was filmed expressing her fury over the Obama administration at a Tea Party rally in Tifton, Georgia, she robustly defended her right to politically do anything she damned well liked. "Anyone who thinks I'm crazy about Sarah Palin, Bush, etc., has made quite the presumption," Tucker told the Riverfront Times *music blog. "I have voted Democrat all my life, until I started listening to what Obama was promising and started wondering how the hell will this utopian dreamland be paid for? For those who actually believe that their taxes won't go up in order to pay for all this insanity: good luck!" When she was pressed on her involvement with the Tea Party, she said, "I'm not 'involved' with the local movement. I went to the first Tea Party in June or July of 2009 because it was within striking distance, and I wanted to be counted." She concluded by saying how amazed she was that her interview was so widely criticized: "I'm stunned that so many people who call themselves liberal yet are completely intolerant. I thought liberals loved everyone: the poor, the immigrant, the gays, the handicapped, the minorities, dogs, cats, all eye colors, all hair colors! Peace, love, bull! You disagree and you're immediately called a fool, a Nazi, a racist. That's pretty fucked up! I would never judge someone based on their political views. Their honesty, integrity, kindness to others, generosity? Yes. Politics? No!"*

Moe Tucker: No country can provide all things for all citizens. There comes a point where it just isn't possible, and it's proven to be a failure everywhere it's been tried. I am not oblivious to the plight of the poor, but I don't see any reason/sense to the idea that everyone has to have everything, especially when the economy is so bad. I see that philosophy as merely a ploy to control.

Singing against apartheid and for Tibetan freedom, working with Amnesty International and standing with Occupy Wall Street, Lou Reed became more political the older he got. Over the years he became someone whose focus on personal freedoms moved to a wider grasp of the political world, something he had largely ignored in his fiery pomp. He became engaged, passionate, and far more generous with his time than many. He defended human rights and decried attacks on artistic freedom. "It's one thing to read about things. [But it's something else] when someone's sitting right in front of you telling and articulating some of these gruesome, unbelievable things that happen to people who do things that we take for granted every day," he explained before an Amnesty

International Conspiracy of Hope concert in the mid-Eighties. "I mean, some of the records that I've made? I would be rotting in jail for the last ten years."

However, he reserved his most acute anger for journalists. Elvis Costello once said that while he didn't really listen to Lou Reed's records, "I never miss an interview with him." Why would he? Reed had created a particular way of dealing with his critics, and after a while they expected it. There is a litany of stories involving the testiness of Lou Reed in interview situations. Confronted by another journalist armed with less than celebratory questions, Reed could get angry.

Chris Difford: Johnny Depp organized a sea-chantey evening, and I was one of the singers along with Lou Reed and Suzanne Vega and various other people. Lou was very sober by this point, and very focused. We were in Dublin one night and he rewrote the entire lyrics to a song from scratch. We were all astounded. He was very kind to be around. As one gets older there is less to write about, which I think happened with Lou, as he became obsessed with the sound of things, with technology. So I peeled away from him toward the end.

Bobby Gillespie: We were playing a festival in Benicàssim in Spain a few years ago, and Lou was playing too. After our set we were quite toasted. I didn't know he was in the dressing room next to ours, and it was just a partition between our room and his, like they do at these festivals. It's just a big tent. And I walk right into him. He's wearing a tight red T-shirt and shorts. I said, "Thank you for all the great music, and all the inspiration." And he looked at me and said, curtly, "Thank you." Then silence. I said, "I bet everyone says that to you." He said, "Not everybody," and then disappeared back into his dressing room. Tense.

Lizzy Goodman (journalist): It's almost impossible to upstage a real rock star. Part of the fun of going to splashy bold-name attended rock events—like the listening party of the Metallica Lou Reed collaboration album *Lulu*, held at the Steven Kasher gallery in Chelsea—is watching very famous celebrities act like giddy touristy school kids around rockers like Lars Ulrich and Lou Reed. So imagine my surprise when, about an hour into the event, someone showed up who turned everyone's head: John McEnroe.

Full disclosure: I am a tennis dork. Like, I follow all those ATP dudes on Twitter and am actually genuinely compelled by tweets about training regimens and fantasy football teams and charity events they are supporting. So it's not surprising that I would wig out upon seeing the tennis legend in person. But it is surprising that Lou Reed would. (Reed didn't swoon or anything but he smiled a lot, which for him counts as effusive.)

There was a secret back space behind the bar where all the bold names were stashed and periodically one or two of them would emerge and mill around. Cocktail waitress girls would shout descriptions of the hors d'oeuvres (stuffed figs or little pieces of rare steak served on plates so overloaded with floral garnish they looked like funeral arrangements) into their ears because the record was being played so loudly no one could hear anything else. The hoi polloi, elite enough to have gotten into this party to begin with, were therefore not inclined to stare at the main attractions just because, hey, that's Lou Fucking Reed wearing bizarre space age basketball shoes and sampling a stuffed fig. But of course, there were some superfans in the house and Lars or Lou or Kirk would take a few pics with them, then go shuffling back into the secret special room.

When McEnroe showed up in his blazer and skull T-shirt the seas parted. He marched right up to Reed, around whom there had formed a little radius of attention, and they embraced. He then proceeded to act much more like a normal human than any other famous person there, which of course is the coolest thing a celeb can do. He hit the bar in the front, had a beer, took about seven hundred photos with a bunch of people who five minutes ago were acting like they were doing due diligence at an office cocktail party but were now suddenly flushed with fandom. Had another beer. Looked bored and agitated by all the attention. Then split.

Francis Whately: Bowie told me that he thought the Metallica album was the best thing Lou Reed had ever done. It had been panned by everyone else, and maybe this was Bowie being mischievous himself, but I think he genuinely thought it was true, because Lou Reed was doing what Lou Reed did best when he was collaborating with someone who you wouldn't expect and doing something quite unique.

Judd Apatow told Roger Daltrey he went to a Lou Reed concert, and it was so loud his ears didn't stop ringing for twenty-five years. "And I saw him somewhere,

and I said to him, 'I saw you, and my ears have rung for twenty-five years,'
thinking he'd laugh, and he just looked at me." "Yeah, that was Lou," said Daltrey.

Stanley Buchthal (film producer): I first met Lou back in 1978 with Clive
Davis. I was having dinner with Clive in a downtown restaurant in New
York and Lou was at the next table with Rachel, his transgender lover,
with the red nails, the lipstick, and the boobs. Then I financed the filming
of *Berlin* in St. Ann's Warehouse in Brooklyn in 2008. Everyone who was
anyone came. Bono. Patti Smith. Julian Schnabel. It was a cause célèbre.
It was the first time he had played the full album live in over thirty years.

Then I properly got to know him when Lou started coming to
Mustique about five years before he died. He used to come with Bice
Curiger, who runs our Van Gogh Foundation in Arles. That's where we
used to hang out. The only reason he stopped coming is because he
had a dog and they wouldn't let it in. But he loved the place, and would
hang out with Basil from Basil's Bar all the time. He had a thing with
Mick Jagger, though, who obviously has a house on the island. He never
resolved it, because I think he was always jealous of Mick. I'd call him
up and say, "It's Mick's birthday and we're going over to the house..."
And he'd say, "Well I don't know." He wanted to go, but he wanted to be
begged. You always had to beg the guy.

Courtney Love: Lou was a grumpy old man. He was mean, that was his
thing. Grumpy. The work was great, but the man not so much.

Stanley Buchthal: Lou didn't get rich until he died. He made millions,
but he didn't make tens of millions. He came to Mustique, but then he
never rented, he was always a guest.

Valentine Guinness: I met Lou Reed on holiday once in Mustique and he
couldn't have been nicer. I saw him in the aisle in the small, unprepos-
sessing supermarket behind Basil's Bar. He was there with his wife,
Laurie Anderson, and since meeting her he seemed to have changed a
lot. So I sent a message to the house he was staying at, and invited him
to our house. So Laurie and him came over for a drink, and I thought
they were both clean and serene, Lou and Laurie, but my parents said
they would offer champagne anyway. They politely turned it down, but

when they saw that my wife was drinking white wine, they both asked if they could have some. "Is there white wine?" Then my wife took out a packet of Marlboro, and they said, "Oh my God, are we allowed to smoke?" He was very sweet, told great stories, whilst knocking back the white wine and smoking like fury.

Mark Cecil (financier): I used to see Lou Reed on Mustique all the time, but he was always very polite and proper. Nothing like the Lou Reed of repute. He went to the beach every day and always stayed in the shade. He didn't go out or socialize at all.

Stanley Buchthal: Then he got ill, and he had a liver issue. He needed a new one. He knew that Maja [Hoffman, Stanley's wife] had a lot of connections, so we had him go see a Russian Jewish healer in Fuschl, Austria, several times, to cleanse him. So we had a relationship with him, but I have to tell you, he was parsimonious. In fifteen years he never once paid for a meal. You know how artists are. He called me up once and said, there's a dinner, are you guys coming? And I said, "Lou, I'm not coming. You've never paid for dinner once!" He sent a limousine to pick us up that night, but only because I called him out. We had a lot of mutual friends, but I wouldn't put up with his bullshit. Lou was a cantankerous character, you know? He was totally talented. But he knew what he wanted. He would ask you an opinion, and I would ask him why he bothered asking. He wasn't going to listen to you. Bowie transcended things, but Lou didn't. Lou never would have made a record with Bing Crosby. Lou wasn't that experimental. He didn't go out of his zone.

Chris Stein (musician): The last time I saw Bowie was the summer of 2013, upstate. We were talking about Lou Reed, which was ironic in retrospect as this was just after he had the liver transplant. We were saying how we were concerned about him and all that stuff.

Stanley Buchthal: Maja had underwritten a performance Lou was giving of *Berlin* in Lyon, with his entire orchestra, backing singers, everything. I wasn't an insignificant thing to do. We said he could stay at our place, and I can't tell you the number of calls I had regarding his bullshit. This

wasn't right, that wasn't right. That's how he operated. And I'd say, am I talking to a two-year-old? But it's Lou, so you put up with it. You take the rattle away. He complained like an old Jewish housewife. He was in a cab. His back was hurting. He had to get back to the hotel to change. Everything was a problem. So I invite him to our chateau for lunch, and after waiting and waiting, he eventually turned up two hours late. Then he turns up, and sees that our house is actually really beautiful, and he says, why didn't you tell me? And I said, I wasn't pitching you to come, Lou. And he walks round the garden and he's still complaining. So now I get him a massage, and afterward he says, you know what, I can now perform tonight. He had actually been thinking about bailing on us. That's how his brain worked. That was Lou. Another time we're at this huge five-hundred-person fundraising dinner in the Hamptons, and I have to take him into the kitchen to get a steak before everyone else is eating as he says he's diabetic and isn't going to make it. He'd been waiting four hours and we still hadn't sat down to eat, but he needed some food. Otherwise he was going to die, apparently. So I found him some food. He had to have some food. There was always a story with Lou.

Bobby Gillespie: Nick Cave told me he was out at dinner with Hal Willner and Lou in New York. Nick was talking about a particular medication he'd been on, to cure hepatitis, and Lou said he'd taken the same drug a while ago. Lou said it had made him grouchy, irritable, depressed, angry. And Hal says, "But Lou, you're like that all the time."

Young Kim (author): I met Gene Krell when I was at law school in NYU, in 1995. He used to go out with Nico, had worked with Malcolm [McLaren] and was now running a department in Barney's on Madison Avenue. As I was wandering around the store looking for a summer suit, he jumped out at me and told me he liked my coat. We hit it off and it was like an introduction into a new world. He knew Vivienne Westwood, knew everybody. I had never met anyone randomly before, only through controlled circumstances or friends, but when I got home, I decided to call him up. I thought if he sounds crazy on his answer machine I won't leave a message, but if he sounds normal, I will. So, I called the number, and the message was weird, some message about the American government spying on people. I thought, this guy's crazy,

so I threw away his number. Then I saw a picture of him in *Paper* magazine, and I thought then he must matter. So, I went running back to Barney's. He introduced me to so many people—he introduced me to Bill Cunningham, took me to Suzanne Bartsch's wedding, threw me a birthday party at the Tunnel. He was my first entry into this world. He was very close to Ronnie Cooke and Jonathan Newhouse from Condé Nast, and as they were expanding into Asia, and as Gene had lived in Japan, and knew Korea, they asked him to launch Korean *Vogue*. Gene knew everyone, literally everyone. The world he introduced me to was far more interesting than law school. I left law school and tried to get a job in the fashion industry. I ended up working with Ian Schrager in the hotel business and the fashion designer Victoria Bartlett. I did that for ten months before going to fashion school in Paris. London was really happening at the time with Cool Britannia, Eurostar had just opened, and so I started visiting the city. I soon met Joe Corre and Serena Rees from Agent Provocateur, and lots of other people in London. Then Gene got me invited to a Vivienne Westwood fashion show, and I was then asked to come to the after-party dinner. And that's where I met Malcolm. I saw him from across the room, and he was talking to Joe. When Joe walked away, he was standing on his own, and he looked like a wonderful fun person, so I went right up to him and said, "I've always wanted to meet you." I don't know where that came from because it wasn't true. It was a lie. It just came out of my mouth. I knew he was associated with punk, but I didn't know much more than that. At the time he was working with the Polish government, trying to make Warsaw hip. He gave me his card, which was one of those cards from Smythson with just his name on it. He was hanging out with Tom Binns and Max Vadukal and people like that. And that was it. He became the first man I slept with.

Life changed drastically and I was exposed to so many people and so many things. There was craziness, too, as Malcolm was very damaged. He was sweet but he could be irrational. He would say something was blue when it was pink. He knew about architecture, fashion, music, wine, everything cultural and political. He knew a lot. For me it was a second education. We started to see Lou Reed and Laurie Anderson at art events, and I guess we started having dinner with them. The first dinner was at the Kitchen Club in Nolita, which has gone now, which Lou

and Laurie liked to go to. They brought along their dog, a small terrier called Lolabelle. She was a very sweet woman, kind of adorable. She managed him very well. I remember that he spent hours doing t'ai chi every day. They were quite attached to the dog. Lou was very particular about his food, and it had to be cooked a certain way. It had to contain certain vegetables. He didn't drink, he'd cleaned up, that kind of thing. He loved Malcolm's *Fans* album, and his version of "Madame Butterfly," and he talked about that a lot. Then I made the mistake of telling him my favorite album was the banana album. He said, "That was forty years ago!" He was quite angry. I remember I told David Foster that once and he was horrified. But then he was MOR.

Later Alanna Heiss, who created the Museum of Modern Art's PS1, organized a screening of Malcolm's film *Paris, Capital of the XXIst Century*. Lou and Laurie came to that, but this was quite near the end of his life. Laurie was asking Malcolm about his clothes, as he was wearing Thom Browne. There was a sale of his clothes at Bergdorf's, and when Lou heard there was a sale he shouted across the room, "A sale? A sale. You say there's a sale?" And then Malcolm started calling him "a mean old Jew." And Lou said, "What did you say? Did you call me a mean old Jew?" Malcolm couldn't really drink, and he was a cheap date. But Laurie really loved Malcolm's Thom Browne trousers.

Tony Visconti: I moved back to New York from London and started seeing Lou socially. I was still in awe of him. We had a mutual friend in Mick Rock, the photographer. Lou and Mick were always kind of seen together in those days. I'd see him occasionally and he would dismiss me and walk away.

He was very difficult to get close to. He was well known as being a curmudgeon. He just didn't take kindly to people in those days. I think he was overly protective of himself. He put the barriers up, socially. But when I was speaking to David Bowie about how it was hard to find a t'ai chi teacher as good as the one I had in London, he said, "Why don't you speak to Lou? Lou studies t'ai chi." I said, "OK, that'll be interesting." All I had to do was mention those two words: t'ai chi. Lou just opened up like a flower and said, "Wow, I didn't know you were interested in that. I have a great teacher and his name is Master Ren Guang-Yi."

Laurie Anderson first met Lou Reed, in Munich in 1992, as they were both playing in John Zorn's Kristallnacht Festival commemorating the Night of Broken Glass in 1938, which marked the start of the Holocaust. She was surprised he didn't have a British accent; all along she had through the Velvet Underground were an English band. Finally, Reed had met a lover who was easily his intellectual and artistic equal. In many respects she was probably his superior, as she was a genuine hyphenate: performance artist, singer, inventor, film director, writer, musician (people said she had the ability to turn things into avant-garde gold). When Reed asked her out, she said, "Yes! Absolutely! I'm on tour, but when I get back—let's see, about four months from now—let's definitely get together." Their first date was comically apposite: the Audio Engineering Convention in New York (they arranged to meet in the microphones section). It was a bit like "Perfect Day," as the convention turned into coffee, then a movie, dinner, a walk, and then home. Reed had met his soul mate, and from that moment on they spent most of their time together. When asked about their relationship, she sounded like one of Reed's lyrics: "[He] was my best friend and he was also the person I admire most in this world." They did the things that couples often do: made up silly jokes, tried to stop smoking, bought a (piano-playing) dog, sang to each other in elevators, saw plays and exhibitions, and collaborated on a daily basis. Sensibly, they shared a house that was separate from their own places. Saliently, she said that he completely understood that pain and beauty are often intertwined, and that this had energized him. She tended to accompany him as often as she could: once, at a particularly fractious record company meeting in London, with the European label boss, Reed was just about to explode when Anderson gently brushed her husband's arm and said, "Lou, don't do that. He's one of the good guys..."

Nick Kent: It's hard to know where the center was in Reed's life. I guess in later life Laurie Anderson provided it. Apart from that, I think he was someone who struggled. He saw the ugly side of life, and he was able to write about it. Whether you call what he did slumming or voyeurism, and both criticisms are accurate, he also managed to embed himself in his subject matter to the point it got into his skin. He wasn't a tourist.

Bobby Gillespie: Laurie Anderson says Lou spent his career veering between folk and rock and roll.

Stanley Buchthal: Laurie was his creative counterpart. She had a career, she wasn't at home, cooking and waiting for him to come back from work. She had her own career, and they became a definable couple. She was a normal person.

Mick Brown: My old agent used to say that no one could understand the relationship between Laurie Anderson and Lou Reed, as it was like sunshine and rain. She was the embodiment of charm and loveliness and Lou was a misanthrope. Although I don't think he behaved so badly when he was with people he considered his peers. Peter Gabriel told me he thought Lou was a great person.

Barney Hoskyns: In 1992, I had one of those hideous Lou Reed interviews that so many have suffered. I was interviewing him for *Vogue*, and the experience left a fairly nasty taste in my mouth in the sense that he did not disappoint. He was vile, as vile as we know he could be. Then I interviewed him in 1996 for *Mojo*, and I did what David Fricke had advised me to do, which was put up with forty-five minutes of unusable bullshit about amplifiers and sound techniques. After that he appeared to be so exhausted that he quite happily answered all my questions and it turned into a really good interview. I think I kind of passed the test. I approached him a few years later for a glam project I was involved with, with Todd Haynes, and I expected him to tell me to fuck off, but he obviously took me seriously enough to talk to me again.

I actually think he was psychologically sadistic. He enjoyed belittling interviewers, making them feel small, and I don't think that's a credit to him. There was no need to do that. But having got him onside, for at least an hour in my second interview with him, he did engage with me. What I do remember is that Laurie Anderson stopped by, because they were going out to something afterward, and she was so charming, and so nice and grounded, and not the kind of person who took any pleasure in making people feel uncomfortable...that when they started interacting, I thought, well, he can't be all bad. She was clearly such a good person. She could tolerate Lou Reed. It's like that line from "Perfect Day" where he talks about forgetting himself, and thinking he was someone else, someone good.

Lou Reed: When I went to college most people were listening to various kinds of folk music, whereas I was in a rock and roll band. Lyrically, I don't think there was too much else apart from Dylan and the Velvets that was engaging that part of your head. That's why, in a sense, it was so easy to do. It was like uncharted waters. Which made it so absurd to be told you were doing something shocking, with *Howl* and *Naked Lunch* and *Last Exit to Brooklyn* already out. There was such a narrow-minded view of what a song could be. And I'd have to sit there with people saying, "Don't you feel guilty for glamorizing heroin, for all the people who've shot up drugs because of you?" It's one thing tweaking the nose of the bourgeoisie, but really...and then to go to Czechoslovakia and Václav Havel shows you a book of *hand-printed* Velvet Underground lyrics which would have put you in jail if you'd been caught with it. The point is, I wanted those songs really to be about something that you could go back to thirty years later. And in fact you can: they're not trapped in the Sixties, they're not locked into that zeitgeist.

Stanley Buchthal: He loved Julian Schnabel, and had a deep artistic connection with him. Schnabel was actually with him when he died. Lou and Laurie had a house in the Springs of East Hampton, and Lou died underwater, in the pool. He didn't drown, he just died, because his transplant from the Cleveland Clinic hadn't worked. He only lasted five or six months. His stinger came out toward the end.

Tony Visconti: It wasn't the transplant that killed him. He had liver cancer and they thought at the time it was only in the liver. Viruses are so, so tiny and they can hide somewhere. Just a few cells can jump from the liver into another organ. That happens a lot. They didn't detect it. It was undetected for months. He was cancer-free. That's what the blood test had shown. In the last couple of months, it just came back and took over. It was too late even though he got the liver of some young person. I think the cancer just spread to other parts of his body. He went very quickly.

Richard King: After a while John [Cale] really started to look like my mother. She always had a black bob and they have similar noses.

By dint of his relative anonymity, by the end of the second decade of the twenty-first century, John Cale had become a kind of countercultural Yoda, the wise old Welshman of Sixties noise rock, a genuine iconoclast who, while everyone else was looking elsewhere, quietly got on with being completely disruptive. He looks back upon those times with benign eyes. By the time of Todd Haynes's affectionate documentary, released in 2021, Cale was full of forgiveness.

"It's made me appreciate the personalities and the disparate confluences we laid bare in the Factory and through the development of what would become the Velvet Underground. They came from all over the world and opened this Welsh boy's eyes to the rest of mankind beyond the European experience. It took all these characters to fuel the furnaces. It's important for everyone to understand the entirety of this band, warts and all, but most importantly the organic nature of its honesty. If there had been a blueprint, we didn't want to know. Carving our own distorted path was far more important than trying to be the next big thing. Without the competitiveness that grew out of our fierce desire to bend and ultimately break rock and roll, we'd have been just another Sixties band."

Lou Reed appeared to have made peace with himself by the time he died, and had certainly made peace with the demons that had haunted him since puberty. Not that he thought any less of himself, of course.

One of my favorite stories about Reed involves one of his managers back in the Eighties. The manager was looking for a PR to handle a forthcoming European tour, and spoke to a particularly prominent publicist based in London.

"I'd love to work on Lou's campaign," said the publicist. "I mean, he's such a great songwriter, and he writes about urban depravity better than anyone else in the business. In fact, I'd say he was the best songwriter in New York."

"Don't you ever say that to Lou," the manager shot back. "He thinks he's the best songwriter in the world."

By the time I finally got to meet him, he had reached such an exalted level in the rock and roll firmament that most people in the industry had forgiven his indulgences. Anything that Reed did that would have traditionally been seen as untoward behavior in any other star was considered, by the end of the Noughties, as "Just Lou being Lou."

Of course, "Just Lou being Lou" obviously traditionally contained its own complications, although when we invited him to appear at the GQ Men of the Year Awards in 2013, the complications revolved around his ill-health rather than any outrageous demands or riders.

The awards had been started because, as well as attempting to produce what we wanted to be the best magazine in the world, we also tried to build our very own ecosystem around the brand, trying to give it its very own halo.

Ever keen to keep us on our toes and perhaps more than a little irritated at having never been invited, there are some who thought we created the Men of the Year Awards simply in order to have a party. Although I have to say the awards dinner certainly managed to create its own celebrity microclimate—a place where you might find Amy Schumer swapping punch lines with David Walliams, or Pharrell Williams comparing backhands with Andy Murray. And while we obviously knew that the collective power of the extraordinary people in the room (try Rose McGowan, Eddie Redmayne, Emma Watson, Benedict Cumberbatch, Jay Z, U2, Prince Charles, Jeff Goldblum, Keith Richards, Samuel L. Jackson, Beyoncé, Chadwick Boseman, Sir Michael Caine, Madonna, and Led Zeppelin—who reformed just to attend the awards—for size) added to the luster of the celebration as well as the very idea of the thing itself, we liked to think that the awards remained a reflection of achievement, a way to acknowledge success in everything from literature to sport and from comedy to architecture and back again, applauding supermodels, design icons, photographers, film directors (somewhere, perhaps in some strange, shadowy parallel universe, Martin Scorsese's speech is drawing slowly to a close), chefs, entrepreneurs, and Olympians (standing ovations being wholeheartedly encouraged).

We always went out of our way to celebrate the iconic too, those who have climbed the mountains time and again and whose interstellar status can sometimes be taken for granted—Ray Davies, Little Richard, Tom Wolfe, Iggy Pop, Burt Bacharach, Nick Hornby, John Barry, Salman Rushdie, Elton John, Anish Kapoor, and Tony Bennett, for instance—and those who actually helped shape the lives of those in our constituency. The two people I was obsessed with getting to the awards were Van Morrison and Lou Reed, legendarily two of the most "difficult" people in the music business. As it was, they both turned out to be absolute pussycats, who couldn't have been more charming to work with. Maybe they had both softened over the years, or maybe it was simply because of the way we treated them. After all, if there's one thing that the famous hate more than anything else, it's being outside their comfort zone.

Lou Reed's final interview was with Farida Khelfa in Rolling Stone, *of all places, published on November 8. "Sounds are the inexplicable," he said, enigmatic to the last. "Sound is like light. What is light? What is sound? And*

yet we have these astonishing ears and we know when something is coming close to us without seeing it. Little Will the dog has ears that are six hundred times better than me, he can hear things blocks and blocks away. But what is sound? Sound is more than just noise, and ordered sound is music.

"There is a sound you hear in your head: it's your nerves, or your blood running. It's kind of amazing to hear that."

Danny Fields: The last time I saw Lou was on a panel in the store that had been built on the site of CBGB. He was standing up and telling people to stop talking. He was having his liver problem at the time. Laurie was there, like the person on the prow of a ship, looking out for him. She was there for the reinvention of Lou, supporting him, making a structure in which he could exist. She was very sharing. She knew what she had. His life must have changed so much, as he became so conservative and well-behaved. Because the stories that Sylvia used to tell me were, "what?" You know, picking up drag queens to come home with him and shit on his face. He really did that. Lou wasn't playing. You don't ask a drag queen to shit on your face as a front. That's going quite far. That's not an affectation. He was on the wild side. Far gone. Maybe he wanted to horrify people. Because he really did those things.

We hugged that night. I really hope someone has a picture of it.

Jimmy Page: In 2013, I went to a talk with Lou Reed and Mick Rock when they did the *Transformer* book together. Lou had been ill, and he was fragile but he was lucid. He was repairing. Whenever he talked about Andy that night he was full of gratitude, and you could see it surfacing a lot.

Bob Gruen: The last time I saw him was at a Mick Rock book event, two weeks before he died, and he was really friendly. He came up and shook my hand and gave a good eyeball. It was a goodbye, basically. So we ended on a good note. Which was great because I like to get along with people, and he spent his life trying not to get along with people.

CBGB officially closed on October 15, 2006, after thirty-two years, following the loss of a deal to renew the lease with the landlords. The final concert was headlined by Patti Smith. Two years later the New York annex of the Rock

and Roll Hall of Fame opened in Mercer Street, in SoHo. In contrast to the Hall of Fame in Cleveland, the annex focused almost exclusively on New York itself, and featured a 1957 Chevy owned by Bruce Springsteen, some teenage correspondence between Paul Simon and Art Garfunkel, one of Bob Dylan's harmonicas, and the oversized suit worn by David Byrne in Stop Making Sense. *When I visited it not long after it opened, as far as I could see, the only exhibit worth mentioning was one of the old urinals from the famous Bowery club. It had been plonked down outside the lavatories almost as an afterthought. The annex was closed barely a year later. In 2013, CBGB's legendary bathroom was re-created for the* PUNK: Chaos to Couture *exhibition at the Metropolitan Museum of Art. At the time the Dangerous Minds website said that "the shithole at CBGBs was punk rock's Petri dish, spawning a virus that would radiate outward and forward into the future, changing pop culture forever. Rock and roll's DNA was retooled in the stool garden. For the sake of accuracy, the bathroom's floor should be soaking wet, the toilets overflowing with shit and piss and shards of broken beer bottles everywhere."*

Duncan Hannah: The last time I saw him was at the screening of the documentary about Ginger Baker, *Beware of Mr. Baker*, at the Film Forum in 2012. I went to the john after the movie, and in front of me was this old lady, this shabby old character, stooped and all dressed in black, in Reeboks and an ugly leather jacket, shuffling along at a really slow pace. I wanted to pass in front of her, but I thought it would be impolite. She very slowly trudged into the men's room, into a stall. I went into the stall next to her because I was intrigued. It was Lou Reed. And he was taking ages to piss. He obviously had prostate problems. I pissed away mightily next to him, thinking haha. It all came back to me. Isn't life funny. "Hey Lou, remember me? I'll take you up on that now. Want me to shit in your mouth?"

When Reed had a liver transplant a few months before his death, The Onion *ran a satirical piece about King Lou: "It's really hard to get along with Lou—one minute he's your best friend and the next he's outright abusive," said the vital organ, describing its ongoing collaboration with the former Velvet Underground frontman as "strained at best." "He just has this way of making you feel completely inadequate. I can tell he doesn't respect me at all. In fact, I'm pretty sure he's already thinking about replacing me."*

Alan Edwards (publicist): I was introduced to Lou Reed back in the day and his response was nothing if not predictable. "Fuck off," he said, and walked off in the other direction. He was everything I'd been led to believe he was, which, in one sense, was reassuring, if a little bruising. Then a few decades later I was representing him when he was asked to get involved with Dylan's Men of the Year Awards. On the night, we were in the elevator in the Royal Opera House, in Covent Garden in London, going up to the reception, and I started telling Lou what was about to happen, and who he was about to meet. As I was telling him this, he looked at me intently and said, in rather too loud a voice, "Who are you?" Ray Davies was also in the elevator and I could tell he was about to burst out laughing, or wet himself. "I'm your PR," I said, as this was the only legitimate response the question warranted. As we stepped out of the elevator, I immediately tried to win him back. There was roughly a hundred yards between the elevator and the start of the reception line, and I needed to get Lou back onside before we reached it. So I started talking about his first solo album, a record I actually love, with as much enthusiasm and insider knowledge as I could muster. We were following all these A-listers into the party, all these scantily clad models and Hollywood legends and there was I, trying to win over the most cantankerous man in rock and roll. Then it was almost as though he flicked an internal switch, as he was suddenly back in the room. I had a hundred yards to change my relationship with my client, and I managed to do it. As soon as we got to the start of the line, he was charm personified. But that was Lou. He was quixotic, temperamental, and often downright rude, but it was all a test, a way to protect himself from the outside world. Because there were parts of the outside world he didn't like at all. There were others in the Velvets who could be a bit like that, I think. But you can forgive them, you could forgive Lou, because what they had, no one else had. They had genuine talent, original talent, the kind of talent it's impossible to replicate, in any day or age.

Ed Vulliamy: Joanna Coles [the writer] walked out on him because he was so rude to her.

Richard King: When Lou died Caitlin Moran was straight on Twitter saying all these journalists had their Lou Reed stories about how awful he was. But maybe Lou thought they were all dicks.

Jenni Muldaur (singer): At first, I didn't know about the illness that Lou had, that ended up taking his life. But Laurie really took me under her wing, and made me a part of everything, and I was with Lou a lot in the last ten years of his life. We used to be neighbors in East Hampton, and it was great to have the nature experience with these people. We'd go on walks and really get to be in nature together. I'd always think to myself, that's Lou Reed swatting a fly, or that's Lou Reed whipping cream. That was really special. We had these really domestic experiences out there. Toward the end, when we were out on the beach, he would say, "Do you know how lucky we are?" Because he knew he was not going to be here. To watch that beautiful transformation from a kind of a cocky rock star, who wasn't kind or patient, to being this really deeply spiritual, grounded person, was amazing. During the last year he was really on a higher plane. He was really tuned in to the important things in life. It was a very beautiful thing to witness. When you're at the end of your life you really get to see what's important.

I called him my platonic soul mate. He was like a big brother to me. He looked out for me. We were two peas in a pod, and hung out all the time. When Laurie was on tour he'd take me with him to premieres, or to see U2. That night they played a few bars of "Perfect Day" and he had tears streaming down his face. He was always amazed that he had made an impression on people. He had a humility that was deeply touching. He wanted to live. He had battled so much…

Laurie would be traveling so when he was sick, I was with him a lot. I went with him to Cleveland to see his doctor. For the last five years I was with him when he was not well. We would go get a massage. Six months before he passed, we went to this Moroccan place in Tribeca where there were these different pools, and he looked at me and said, "You know what's happening?" That was how he dealt with mortality. I looked at him with my eyes and said, "I know. And I'm here and I love you." He was vulnerable. He used to cry because he was old and vulnerable. He would look at you and you'd know how he felt. He wanted to live. He wanted to be here to experience more. And it kind of catapulted him into this higher state of being. He had a Tibetan teacher, and he had his t'ai chi and he kinda tuned in to that stuff. And I wish somehow he could have got a better liver.

During that period, I witnessed some bad Lou behavior. He did not suffer fools, but if you were one of the twenty people he could suffer, he was great. I saw him be rude to a couple of people, but toward the end he didn't even do that. I saw him once be rude to a waiter. And I looked at him in a disapproving way, and he looked at me and said, "I can't help myself." It was very cute.

I would say, "You know what, Laurie's a saint, as she puts up with so much." He could be impossible. This was what I loved about Laurie. He'd bring in some weird lamp or something he'd bought, and he'd say, "Laurie, I got this lamp. Do you like it? Do you like it?" And then she would just change the subject. "Shall we paint this wall this color?" She could completely disagree with something you're saying but instead of being combative, she would say something like, "Oh, why do you think that?" It was a great way to defuse things. The last thing I saw Lou do was an event with Mick Rock in New York. We stopped there on our way out to Long Island. I sang with him on tour, but what I had with Lou I never had with anyone else. I literally felt like he was my best friend. We were so connected. We'd be at a movie and as soon as it was finished, he'd say, "Let's go to another movie." In those last couple of years, he really didn't want to be alone. He thought it was amazing that I could book restaurants near movie theaters. I said, it's just a little planning, Lou. Weirdly, he would always want to drive out to his place on Long Island on Friday at 4 p.m. I would say, maybe the only reason to be a rock star is not having to sit in rush-hour traffic. We could leave on Thursday night! Being his friend was a completely joyful experience. We were barely ever at odds. We had a connection that was about eating, movies, the theater. His connection with Hal Willner was really profound as well. He really loved doo-wop. He grew up on it. I would start singing an old doo-wop song or Phil Spector song and he would say, "How did you know I was just thinking of that?"

Two nights before Lou died, Hal Willner and I went round to see him and his caretaker Jim was there. And Hal curated the music for the evening. When he had the liver thing, he was very yellow. So we played this most beautiful music, Nina Simone, holding his hand. It was an incredible night. Lou had a tear running down his cheek and he said, "You'll have to forgive me, I'm highly susceptible to beauty."

I miss him every day. Lou and Laurie were a very special couple. I'm not going to lie, there was some tension, but they worked together.

And Laurie really did the most beautiful funeral at the Apollo. Laurie is incredible, and Lou loved her madly.

Laurie Anderson was unsurprisingly eloquent about her husband's passing. She said that as meditators, they had prepared for the moment—and how to move the energy in the body up from the belly and into the heart and out through the head. She says she had never seen an expression as full of wonder as Reed's as he died. She said his hands were doing the water-flowing 21-form of t'ai chi, and that his eyes were wide open. "I was holding in my arms the person I loved most in the world and talking to him as he died. His heart stopped. He wasn't afraid. I had gotten to walk with him to the end of the world." She said that life—"so beautiful, painful, and dazzling"—does not get better than that. "And death? I believe that the purpose of death is the release of love."

David Bowie: Lou was a master.

The fulsome outpourings of love and appreciation were perhaps a little surprising, and there appeared to be far more respect for Lou Reed in death than perhaps there had been while he was alive. There was also maybe a sense that a large part of the past, a part we all took for granted, was gone forever. "His work and that of the Velvets was a big reason I moved to New York and I don't think I'm alone there," said David Byrne, immediately after Reed's passing. "We wanted to be in a city that nurtured and fed that kind of talent."

Bob Gruen: After he died lots of people started to say how lovely he was as a guy, and that he only kept up this defense to protect himself from other people. I said, "Well, it worked with me."

CHAPTER 16

THE AFTERMATH

2013–2023

"Lou Reed was one of the few men I've ever met who could cry."
—Laurie Anderson

Bono (singer, musician, activist): Lou Reed made music out of noise. The noise of the city. Big trucks clattering over potholes; the heavy breathing of subways, the rumble in the ground; the white noise of Wall Street; the pink noise of the old Times Square. The winking neon of downtown, its massage and tattoo parlors, its bars and diners, the whores and hoardings that make up the life of the big city.

New York City was to Lou Reed what Dublin was to James Joyce, the complete universe of his writing. He didn't need to stray out of it for material, there was more than enough there for his love and his hate songs. The city he devoted his life to was his muse more than any other. Until Laurie Anderson came into his life, you could be forgiven for thinking that Lou had no other love than the noise of New York City. If he thought people could be stupid, he thought New Yorkers were the smartest of them.

His deadpan humor was easily misunderstood as rudeness, and Lou delighted in that misunderstanding. For the purposes of the hotel register, his pseudonym was once Raymond Chandler. I asked him what he liked about the noir genius of the detective story. "Biting humor and succinctness," he replied. I asked him for an example: "'That blonde is about as beautiful as a split lip.' It doesn't get better than that." He laughed loudly.

Lou exemplified the idea of art as the discovery of beauty in unexpected places. One of his most famous songs, "Perfect Day," is made even more perfect by being about a heroin addict walking through the park in the warm sun, completely separate from the problems that brought him his addiction. It's been sung by all manner of earnest voices, including mine and children's choirs, since it was written in 1972. It never fails to give me some kind of extra ache as they sing the last line, "You're going to reap just what you sow," oblivious of the icy chill suggested.

We know that turning pain into beauty is the mark of a great artist and we understand defiance is at the heart of romance, but we are mystified by how Lou Reed's songs are so airborne. Helium-filled metal balloons, never weighed down by their subject matter, humor always around the corner from vitriol. Magic and loss, indeed. Lou Reed was an alchemist, turning base metals into gold, heavy metal into songs as disciplined as if they came from the Brill Building—which they did, because that is the world where Lou got his start.

Lou was born out of two influences that can't be underestimated. One: the talents of his bandmates in the Velvet Underground, who then influenced pretty much every group that had a foot in the Seventies. (Witness our own "Running to Stand Still" for red-handed proof.) U2 were beyond ourselves with delight when the Velvets re-formed to play some select dates in the early Nineties, including some with us. "Pale Blue Eyes" is perfection in pop.

Two: the short-story writer Delmore Schwartz. Lou would return to this subject a few times with me and got me to read *In Dreams Begin Responsibilities*. (I did and they do.) He also got me a collection of essays, *The Ego Is Always at the Wheel*. (It is and I know.) I got him a collection of Seamus Heaney poems. Our last conversation was a simple thanks.

The music is eternal. It will keep being made even without him.

It's too easy to think of Lou Reed as a wild creature who put songs about heroin in the pop charts, like some decadent lounge lizard from the Andy Warhol Factory. This couldn't have been further from the truth. He was thoughtful, meditative, and extremely disciplined. Before the hepatitis that he caught as a drug user returned, Lou was in top physical condition. T'ai chi was what he credited for his lithe physicality and clear complexion. This is how I will remember him, a still figure in the eye of a metallic hurricane, an artist pulling strange shapes out

of the formless void that is pop culture, a songwriter pulling melodies out of the dissonance of what Yeats called "this filthy modern tide," and, yes, pop's truly great poker face—with so much comedy dancing around those piercing eyes.

Bobby Gillespie: Lou Reed created a character. You think of Lou Reed, you think of the cover of *Street Hassle.* A punk who goes to heavy leather bars. Taking methadone. Talking back to the cops. High-fiving Hispanic guys. Someone who came up from the sewers of New York City. And it was a character that people grew to love, and believe in. Obviously, he's a lot more nuanced than that, but it worked. Nico was the eternal beauty, the martyr. The doomed romantic. The ancient European songstress. Gothic. Singing hymn-like dirges of existential despair. You can see how people could identify with her. But Cale's character was different and more difficult because he moved around a lot.

Robert Chalmers: In this age of cancel culture, I don't think he'd be especially happy with "I Wanna Be Black," what with shooting twenty feet of jism and all that. It hasn't worn particularly well.

Richard Williams: The importance of the band and those first two albums would be difficult to overestimate. It took four or five years for the influence to become explicit, but eventually they suffused almost everything. It colored me in a very profound way, not always benefi-cially. It's a tricky thing to say, but they legitimized and encouraged a discussion of the darker areas of life in popular music. Which is fine, it's good. "I'm Waiting for the Man," "Venus in Furs," "Sister Ray," they're great songs that deal with transgressive subjects. But this became an obsession for a generation of musicians and their listeners. Once they get into everybody's hands, they can be damaging. The title of Nick Kent's book, *The Dark Stuff,* was an indication. It's much better, I think, when life is a balance, and on the whole, I'd prefer to have slightly more light than dark. Of course, the darkness is always there, and the Velvets expressed it brilliantly, as a group of artists. It was extraordinary to do that, at a time when it ran so much against the grain of the culture. Of course, whether it's Lou Reed, or Charles Bukowski, or George Grosz, there's a very powerful journalistic side to this, noting things down,

and transcribing them into songs or great art. I certainly wouldn't argue against them doing what they did, not at all, not for a minute. It's the use to which others put it that sometimes worries me. Of course, it's much easier not to say this.

Barney Hoskyns: I remember that when he died, the editors at the *Word* were approached to go on the radio and talk about him, and no one would because they all hated him so much.

When Lou died, the New Statesman's *Kate Mossman wrote a funny piece along the same lines, saying that the very same journalists who had queued up to write obituaries of Captain Beefheart—"because everyone believed they were the one to have figured out the golden ratio that made him great"—turned down the opportunity to eulogize Lou, "fielding the calls from Radio 4 or ITV all day, as when the envelope is passed round in the office in honor of the colleague no one particularly likes." Mossman said that to anyone given the task of finding out what made him tick as a musician and who really had to deal with him, he could be one of the coldest, most humorless, arrogant, and—worse—boring characters rock and roll has ever seen. She recounted the story of when Reed was forced to take a Ryanair flight to a gig in Ireland because no other company flew there. She said the thought of Reed on Ryanair was "just too sweet to bear." Mossman cut him some slack—"Anyone who received electroconvulsive therapy for 'suspected' homosexuality in his teenage years is probably allowed to be grumpy forever"—but was pretty merciless, suggesting that his perpetually bad mood might have been the result of spending a lifetime harking after former glories. Her final point was telling:*

> Reed made a huge contribution to the direction of twentieth-century music: he was at the heart of a schism that has been at its center since the mid-Sixties, between people who believe pop should be Art—with a capital A—and those who think it ought to be lower-case.
>
> His studied charmlessness was revolutionary: it made ordinary people, who could hardly play their instruments, think they, too, could become pop stars. And they did: music went from something you had to be able to sing and dance to, to something you heard leaning up against a wall, and that's where a lot of it stayed.

Bebe Buell: Lou Reed was like a father figure to me, as he was to lots of other people. He was so sweet and nice. He once said I must have had a womb of a goddess to produce such a beautiful child as Liv. He was poetic. The last time I saw Lou was in a café in the Village. He had his little dog with him, which they let him take inside. He was a charmer to the end. I was with my mother and my daughter Liv, and he said, "The apple doesn't fall far from the tree." Two months later he was dead. If I'd known, I would have stayed right there in the café forever.

"Musically, Lou Reed was profoundly important, but there was another component to his public persona that cannot be overlooked," said Michael Stipe. "He was the first queer icon of the twenty-first century, thirty years before it even began. As early as the late Sixties, Lou proclaimed with beautifully confusing candidness a much more twenty-first-century understanding of a fluid, moving sexuality. He saw beyond—and lived outside—a society locked into a simplistic straight/gay binary division. Through his public persona, his art and music, he boldly refused labels, very publicly mixing things up and providing a "Whoa, that's possible?" avenue of sexual exploration and identity examination, all with whip-smart nonchalance. He was indefinable, he was other, he was outside of society. He spearheaded a new cool, and he did not care if you "got it or not."

Nick Kent: I can relate to Reed because I come from a middle-class family, like Reed did. He talks about the street and the sound of the street, but he was slumming. And I was slumming. We chose to stay, but the fact is that when things got really, really bad, we could go back to our middle-class parents and dry out. Most street people don't have that option. Maybe that's what makes the Velvet Underground's music so attractive. Reed was an outsider everywhere. There is a part of him that is homosexual but there is also another part of him that craves to be married and to have a relationship with a woman. There wasn't one place where he felt truly comfortable; even when he put on his leather jacket and his dark glasses, it was an image, but that was the image he felt most comfortable promoting. If you want to know the real Lou Reed, he is the grumpy guy sitting by himself in a room reading a book. With a notebook by his side in case he gets any ideas. That's him. That's what David Bowie was like toward the end of his life, a man sitting in a room reading a book

with a notebook by his side. Bob Dylan the same. But Reed was a very strange man, a very complicated man. It's like the W. B. Yeats line, the center is not holding.

"There will never, ever be a Lou Reed Night on X-Factor*," said Danny Baker. "This, more than anything, will be his legacy."*

Chris Difford: The Velvet Underground are an essential part of the kit. If you haven't listened to them and haven't immersed yourself in the beauty of the songs, you haven't come very far.

Duncan Hannah: The Velvets were a huge influence on everything for years and years, and you saw them everywhere in Echo and the Bunnymen and the Jesus and Mary Chain, and they keep coming back in new guises. Fuck, they were amazing. They were the template. They were a new bohemia, like it probably was with Wyndham Lewis in Montparnasse. They were the best.

Chris Difford: They were fashionless.

In 2018, Julian Casablancas, the frontman of both the Voidz and the Strokes, spent an interview with New York *magazine espousing the talents of Ariel Pink. "Everyone knows David Bowie now, but I bet he was pretty underground in the Seventies. I think Ariel Pink will be one of the best-remembered artists of this generation and now nobody in the mainstream knows him. My mission is the same as it's been from day one, which is to try to make something that has artistic value and bring it to the mainstream. Nothing about that has changed. I strive to build a world where the Velvet Underground would be more popular than the Rolling Stones. Or where Ariel Pink is as popular as Ed Sheeran."*

Mary Harron: Anyone I can think of who stayed famous, celebrity famous, really, really wanted it. They wanted it so much they could put up with the weirdness of living with their famous self, having to always be "Salvador Dali" or "Andy" or "Madonna" or "Patti Smith." I think that Lou Reed wanted to be "Lou Reed" but John Cale didn't really want to be "John Cale"—or didn't want to enough.

Ed Vulliamy: Cale has always had an extraordinary attachment to a country he left as a young man. He almost felt guilty about leaving. When he did an EP called *E is Missing*, about Ezra Pound, it's about being a traitor, and I think he felt some kind of traitor's relationship with Wales. But he loves the country, and he has an umbilical cord. I've known him for twenty years, and everything that first drew me to his music has bloomed since I've known him. Any serious writer has to be seriously perfectionist about language, punctuation, paragraphs, tensions, everything. I think it was his attention to micro-detail that attracted me so much. Obsessive sounds derogatory, but that's what he is. He has ears like a coyote. John Cale is better now than he was when he was in the Velvet Underground, but then why shouldn't he be? If you are a restless innovator, then you remain one. He does, to this day. With Cale you never know what you're going to get. He is generally underappreciated, but then so was Schubert. I hope he is remembered as one of the great musicians produced by this country in the second half of the twentieth century. He should be spoken about in the same breath as Schoenberg, Janacek, Stockhausen, and John Cage, although he'll probably be remembered as the viola player in the Velvet Underground.

Soon after Reed's death, Rostam Batmanglij of Vampire Weekend tweeted that he was "maybe the first out songwriter," an allusion to his purported bisexuality. This encouraged Mark Joseph Stern to write a piece for Slate, *entitled "Was Lou Reed the First Out Rock Star?," in which he asserted that "Reed's biographers, and many of his fans, often take his bisexuality as a given." Chris Roberts, author of* Lou Reed: The Stories Behind the Songs, *describes the singer as "a bisexual Factory burnout," a "bisexual speed freak," and a "bisexual student of Dostoevsky." Some obituaries, too, mentioned his bisexuality without explanation or qualification. But during his lifetime, Reed was perpetually evasive on the topic of his own sexuality. In an infamous "interview-cum-confrontation" with Lester Bangs (a journalist Reed had a love/ hate relationship with, but someone he ultimately respected), Reed waxed cryptic about the matter, saying: "The notion that everybody's bisexual is a very popular line right now, but I think its validity is limited. I could say something like if in any way my album helps people decide who or what they are, then I will feel I have accomplished something in my life. But I don't feel that way at all...You can't listen to a record and say, 'Oh that really turned me onto*

gay life, I'm gonna be gay.' A lot of people will have one or two experiences, and that'll be it. Things may not change one iota…By the time a kid reaches puberty they've been determined. Guys walking around in makeup is just fun. Why shouldn't men be able to put on makeup and have fun like women have?"

In 2021 Todd Haynes produced a long-overdue documentary about the Velvet Underground, and in interviews supporting its launch suggested that the word "queer" now applied to the band. "It's tricky," Haynes told Dazed. "It's remarkable how insufficient the word 'queer' is to describe this time, given the advancements in gay culture and LGBTQ+ identity. When the word 'queer' came into usage more in the Eighties and Nineties and around gay activism, different people have different definitions of how 'queer' became a term appropriated by gay people, when, of course, it was always a derogatory term for gay people used by straight people. But it still feels way after this time. What I think it tried to do was talk about a more transgressive, gay sensibility that felt outside of conventional norms. And so it really was trying to find a word—a politically active word, even—for what a certain kind of gay culture or gay perspective was. Which is true to this period. Andy Warhol called it pop. Susan Sontag called it camp. Baudelaire called it dandy. They're different but have a relationship to each other. It definitely felt important about the story of this band, and the series of rejections to the rest of the world…People who were not gay in their sexual practice also just assumed this to be their outlook. One way this was expressed was going to the West Coast and going, 'Ugh. The hippies are so conventional and uptight and bourgeois'—and, as we would say today, heteronormative. Maureen Tucker and John Cale felt that way."

To Amy Taubin in Film Forum, Haynes said, "One priority for me in the film was to emphasize the queerness that defined the Factory in contradistinction to hippie counterculture at large. That's really important to the work that they were doing, the sensibility they were describing, and the opposition they represented even to such a robust youth culture defined by rebellion and innovation. It infused the music, the art, and the atmosphere."

In 2017, a Canadian student body claimed that "Walk on the Wild Side" contains transphobic lyrics. The Guelph Central Student Association, a group at the University of Guelph in Ontario, apologized for including the song on a playlist at a campus event. In an apology published on Facebook but subsequently removed, the group said: "We now know the lyrics to this song are hurtful to our friends in the trans community and we'd like to unreservedly apologize for this error in judgment." Reed's friends were unconvinced. "I don't

know if Lou would be cracking up about this or crying because it's just too stupid," Hal Willner told the Guardian. *"The song was a love song to all the people he knew and to New York City by a man who supported the community and the city his whole life." The Guelph student group promised to be "more mindful in our music selection during any events we hold" and added: "If there are students or members of the campus community who overheard the song in our playlist and were hurt by its inclusion and you'd like to talk with us about it and how we can do better, we welcome that." Obligated to explain exactly what about the lyrics was so offensive, they said the lyrics "appeared to be problematic" because they suggested trans people are "wild." Holly Woodlawn, the trans actress mentioned in the song, was thrilled with "Walk on the Wild Side." "Lou Reed made me immortal," she said.*

Nick Kent: John Cale knew what was going on. Just look at his track record. He went from the Velvet Underground to producing the Stooges' first record, then he produced Nico, recorded with John Cage, with Nick Drake, produced Patti Smith's *Horses*. And some of his records are better than Lou Reed's, especially in the Seventies. He wrote better songs, and he was a fundamentally good person.

Jude Rogers (journalist): As a child, I learned piano and violin, but I often saw them as means to help me bash out TV theme tunes, or go to local orchestras and hit boys on the head with my bow. The music itself I found dreary. It was about discipline, control, and composure, about getting me to sit down, shut up, and behave. It was the sound of the world as it was, fettered and strict, not the world as it could be, all rowdy and free. In my late teens, I was living parallel musical lives: an indie kid on one hand, a reluctant fiddler on the other. I rarely practiced, preferring to hide in my room with Supergrass cassingles and *Select* magazines. My violin teacher Don, a sharp old stick of eighty-four, started giving me music that was wild and unruly: Shostakovich concertos, Bartok polkas, Monti's mad gypsy music. At first this felt wrong, but I started enjoying myself. My resin-covered violin became my own Flying V. It's this I remember as the orchestra's bows move over the strings; as the choir work through their complicated harmonies. Opening my eyes to music with more rock and roll spirit had helped me look at other classical music differently. I remember my music lessons

winding up before I went to university and being genuinely sad. I went to Don's house for tea, where he talked about other old pupils. One had written a symphony as a teenager and gone to New York. He'd ended up in a group called the Velours or the Velvets, and his name was John Cale.

"When discussing John Cale with a musical heathen, one defaults to the obvious— bass and viola in the Velvet Underground, one of those bands which changed the sound of sound," said Ed Vulliamy in a BBC podcast in 2019. "However, what Cale proceeded to do, post Velvets, is even more intriguing. Restless innovation, no two performances ever the same. Take 'Half Past France,' on the album Paris 1919, *which is not about the Treaty of Versailles, more the exhausted ennui across Europe after World War One. On the record the song is subdued, ethereal. By the time it reached Cardiff Coal Exchange in 2010, it had been orchestrated by Cale to sound like an oratorio by Janáček. At the Roundhouse in 2016, 'Half Past France' was an electronic symphony. And in Brooklyn two years later, Cale tore his own song apart, then reconstructed the shards into something rightly terrifying for the times we live in."*

Ed Vulliamy: I saw him play the Cardiff Coal Exchange. He addressed the crowd in Welsh. I took my daughter, who was then only nine, and the guy next to me turned round and said, to both of us, in a broad Welsh accent, "He's ours."

David Bailey: As for Andy, well I loved him. For me, Warhol's greatest achievement was his electric chair picture, and if I had to choose one to own, that would be it. Glamorizing it was a very clever way of showing how awful it was. The thing about Andy was that if you asked him a question he would answer it with another question. I knew he had all these scars from being shot by Valerie Solanas, but he wouldn't show them to me. He said, "Gee, Bailey, you don't want to see those, as I look like a Dior dress." I said, "What do you mean?" He said, "Well, actually I've got more stitches in me than a Dior dress…"

Andy was actually quite a funny man and used to say some great things. I remember we were driving along one day, in the Hamptons, traveling up to his beach house, and I asked him about his car crash silkscreens. "It wasn't the idea of the accident that appealed to me," he said. "I was just thinking about, well…it all started with buttons. I always

wanted to know who invented the button, or who was the person who first thought of making buttons, and then I thought of all the people who worked on the pyramids—I wondered what happened to them, why aren't they around? I always thought it would be easier to do a painting of people who die in car crashes because sometimes you don't know who they are."

And what do you say to that?

Danny Fields: Warhol validated fame. And after a while he didn't need any more fame.

Francis Whately: I had been to the Warhol Tate exhibition in 1971 with my father when I was six. It had the turquoise Marilyn as the poster, which I think is now the most expensive painting in the world. I was fascinated with him from that moment on, and then when Bowie sang that song about him, I realized that he was a very important part of the culture. I don't think any other artist has had the ability to discuss the world in the way in which he has. The narrative I wanted to tell with my films was that Warhol told you everything you needed to know about America. About race, celebrity, fashion, art, the art market...through the lens of Warhol. I can't think of another artist you can do that with in the twentieth century, or indeed any other century. He is ripe for endless reappraisal because he touched so many areas of culture. For instance, when he was asked who the most famous person in the world was, he didn't say Einstein, he said Chairman Mao, because everyone in China had a copy of his book. It was explained to him that they were given the books, and that they hadn't bought them. This didn't seem to matter a jot to him, because he saw Mao as an icon of the twentieth century, just as he did Marilyn. He anticipated the way in which we live today.

He was a catholic generalist in both senses. Like Bowie, there appeared to be very little he wasn't interested in, whether it's the men on the moon, or the great series of sporting heroes he did, indigenous Americans, pop stars, or people who hadn't ever been recognized because all they were was mangled features in a newspaper having been run over or in some appalling car accident. I think he genuinely did want to give a voice to the voiceless, while at the same time being a voyeur. I think he's always seen as this great exploiter, and I think he could be

very cold, and it was my job to try and determine whether he was really as unpleasant as some people have stated, or actually that was an act, and there were two Warhols—the artist persona he gave to everyone, and then the real Warhol which was actually quite sensitive and who was actually interested in homelessness, working in a soup kitchen at the end of his life, etc. There is quite a lot of cynicism about him working in a soup kitchen, but he did it a few more times than most celebrities in America. And the fact that so many people who had been in his employ still worship him suggests that he was perhaps not as unpleasant as other people have painted him to be. Either time has mellowed them, or maybe time has made them realize that some of his peccadilloes might be neutered by the enormous contribution he made, and that the longer time goes on, the greater we realize what that contribution was.

Bob Colacello: I have never had more people email me, text me, or stop me in the street, people I know, people I don't know, wanting to talk about Andy. In terms of Andy's popularity, I don't see it as ever having waned. It seems I get constant requests to talk about Andy Warhol. But once you're connected to Andy you can never be disconnected. We're like the low-rent Bloomsbury Group, I mean the number of memoirs and biographies written about Virginia Woolf's husband's boyfriend. Andy created a world, a little tribe, a family, that goes back to the Sixties, that goes back to Gerald Malanga, to Bridget Polk, to Viva, to Edie Sedgwick, to Lou Reed, the Velvet Underground.

What I didn't like about the Netflix series *The Andy Warhol Diaries* is that it made Andy out to be the saddest person who ever lived, who never once laughed. Andy Warhol was the Oscar Wilde of the Factory, not the Virginia Woolf. Basically, everything Andy did had an element of comedy. The big criticism of his work, especially in the US as opposed to Europe, was: Campbell's soup, is that a joke? Mao painted green, is that a joke? And yes, on one level it's a joke, but Andy was dead serious about what he did, too. The film seemed to have forgotten about this whole thing called camp, which was very much at the center of Andy's aesthetic and mentality. In Susan Sontag's *Notes on Camp*, Andy was one of the prime examples. In that sense it was very homosexual rather than in any activist, political sense, which the documentary seems to sort of hold against Andy and all of us for not being activists. But we didn't

feel like we needed to be activists of any sort. Maybe we were lucky because we were in a bubble in New York, and everywhere we went people were very nonchalant about whether we were gay, straight, or otherwise. It was a very tolerant, free atmosphere, and Lou Reed and the Velvet Underground were part of that aesthetic. Lou Reed might have become political later, but not originally. Being a conservative Republican, or voting for Ronald Reagan, was beyond the pale. After Vietnam and Watergate, by 1974 there was no reason to protest, there really wasn't. You couldn't protest against Gerald Ford, and Jimmy Carter was thought of as some kind of saint. So it was a time to dance, and then disco came along and everybody loved disco. You could dance alone, with a group, with a boy, with a girl. Nobody cared. And the Velvet Underground were the precursors of that attitude. "Lonesome Cowboy Bill," that was about all these good-looking cowboys in New York—you know, were they really gay, or fooling around because there were no women around.

It was a task, but I read the Blake Gopnick book on Andy. Gopnick comes across as a straight guy trying to prove he's really cool about homosexuality. He was all wrong for it. I met with him before he wrote a sample chapter, as I was asked by Wayne Lawson, who used to be at *Vanity Fair*, if I could help him. So I met him but after five minutes I knew he was all wrong for Andy. He's too intellectual. I thought the book was really boring, and missed the point. It was very off-kilter. Instead of saying that Andy's colors were influenced by Matisse, he uses the word colorways. Why? Every time it popped up I circled it. Next, we'll be talking about people of colorways.

He tries to contradict me and John Richardson about the importance of Andy's belief. Like all secular intellectuals he was trying to downplay the significance of religion. Andy's connection to his religious upbringing was strong, which was half Roman Catholic, half Russian Orthodox, and originally called the Uniate Catholic Church. They recognized the Pope, but retained the Eastern Rite mass, which was said in Slavonic. It was a very particular mix of West and East.

The Last Supper is Andy's great last series. Those are very strongly felt paintings. They're very emotional. They're masterpieces. I came to the realization that Andy was making religious art for a secular culture. He was making icons in the Greek definition of the word, which is objects

of worship. Not celebrities. And Marilyn, Elvis, Jackie, and Liz were all secular saints. People worshipped them, people had visions of Elvis in parking lots in Memphis. The hammer and sickle, the dollar sign, these are things we worship. But he was making them for his time. That was part of why they had such widespread appeal. People worshipped Mao.

Dianne Brill: *The Andy Warhol Diaries* documentary was made by Ryan Murphy, and it was not the Andy I knew. Murphy obviously has an agenda, the effect of what he is saying was that every queer man ends up old, alone, and fat. He did it with the Halston movie and with the Warhol documentary. I was there, and I can tell you that Andy was not alone and sad. He was alone and queer and happy. He was creative and fabulous and inspired. Everything was going very well for him. He was not on a downward spiral. They misunderstood: Andy's voice wasn't sad, Andy's voice came from being a socially awkward child. He had to learn how to socialize. How to express himself. How to be free. And he did. He learned it. He got it. He was comfortable in his own skin. He always had a delay with other people who were more socially skilled. He would often do this little stutter thing, which I always found very interesting. Like his brain was working faster than his mouth. And it was. Andy was smart, funny, he was a hell of a lot of fun. And even if he was just saying, "Gee…" or "Great" all night, that was public. We were actually talking. He learned how to control people around him with this persona that he created. It wasn't fake, it was based on who he was and his experience as a child, how awkward he was. He found a new way of expressing himself, like we all did. He was just a little more interesting than most.

Francis Whately: Amy Taubin knew Warhol and appeared in some of the early films, and she understood him for what he was. She knew he was obsessed with his legacy. The key thing was how he could live after he had died. Here was an artist who understood how important his legacy would be, and so a huge amount of his life was devoted to how he would be received after he died. He wasn't just recording events as they were, but he was ensuring that the work he produced would be forever valuable, forever insightful about the culture he was trying to articulate. He ensured he wasn't a figment of society; he was in fact the

soothsayer of the twentieth century. He is the person we will continue to look back on and discover more about. He understood how important it was to be talked about after you've gone. Bowie did the same. Despite his humiliation in 1971 when he met Warhol, Bowie still recognized that Warhol had a huge amount to offer him, and of all the influences in Bowie's life, I think Andy Warhol remains the most pronounced throughout. And I don't think it's discussed enough. They were both so curious. I remember Bowie emailing me once about women's football, and how fascinating it was. This is the guy who was also interested in Arcade Fire and Spongebob. In that way he is very like Warhol because there was no part of the culture that didn't intrigue him. You can only keep a certain amount of people in your Rolodex, after which it becomes untenable to keep in touch with everyone you've met and liked. So the idea that he would give up on some of the musicians he'd worked with was completely understandable. Warhol was the same. He moved on and moved on. It was time management.

Lou Reed: I couldn't have been a luckier guy. I can't think of anything I'd have enjoyed more than meeting John, running into Sterl on the subway, hooking up with Maureen, and being with Andy Warhol. What an unimaginably great time!

Francis Whately: He is an absolutely huge artist. You can't imagine what rock and roll would have become without the Velvet Underground and you can't imagine the Velvet Underground without Lou Reed. He was light-years ahead of everyone else. But I think Lou Reed was a far more damaged person than either Bowie or Warhol, and therefore he was working with a smaller capacity. Bowie and Warhol made a lot of mistakes, but they managed to get past them and move on, and I think that when Reed did something that wasn't received in the way he thought was appropriate, he found it hard. I think it would be almost impossible not to be damaged by what his parents put him through when he was a teenager.

On May 9, 2022, at Christie's in New York, Warhol's 1964 Shot Sage Blue Marilyn *was sold for $170 million ($195 million with fees), making it the second most expensive work ever to sell at auction and the priciest piece of*

twentieth-century art. The buyer, who was present at the auction, was Larry Gagosian. This almost unbelievable sum was actually below market expectations, as the painting was estimated at $200 million (while there were some who thought it may have beaten the extraordinary record-breaking outlier, Leonardo da Vinci's Salvator Mundi *[painted circa 1500], which sold for $450 million in 2017). "This sale demonstrates the pervasive power of Andy Warhol as well as the lasting legacy that he continues to leave behind in the art world, popular culture, and society," said Alex Rotter, Christie's chairman of twentieth- and twenty-first-century art. "When we think of the most iconic images of art history," said Johanna Flaum, head of post-war and contemporary art at the auction house, "we think of paintings like Da Vinci's 'Mona Lisa' and Botticelli's 'The Birth of Venus' and Picasso's 'Les Demoiselles d'Avignon.' This is of that same lineage—it's that iconic image from the second half of the twentieth century. And, in a very Warholian way, has been reproduced endlessly."*

Richard Williams: Lou Reed was extraordinary. I think *The Raven* is a fantastic piece of work. Terrifying, but brilliant and very disciplined. So is *New York*. And *Metal Machine Music,* and its offshoots and derivatives... what a fantastic art gesture. Can you imagine the faces of the RCA executives when he gave them that record? John Cale, when you go and see him nowadays you see an evening of great, important music. And Nico, what a great body of work. She was a serious artist, and she believed in what she was doing. All three of them were serious artists, and in different ways they had peripheral aspects to their lives that could be easily amplified. So if you went to interview Lou Reed and you asked him stupid questions you'd get something which you'd write up as an interview with a fascinating but surly, rude, and uncooperative person. If you asked him if he was on heroin when he wrote "Heroin," then you knew what sort of reaction you were going to get. But if you asked him a question about Ornette Coleman or Don Cherry, you'd get a really good response. With John Cale it was easy for people to find elements of his performative character that could be exaggerated. And the same with Nico, because we all fell in love with the strangeness of her—you know, "another cooler Dietrich for another cooler generation," as John Wilcock brilliantly wrote in the *East Village Other* after seeing the Exploding Plastic Inevitable in 1966. Once you'd read that, how could you not be desperate to hear and see it for yourself?

Gene Krell: People reduced Nico to a stereotype, which was so cruel.

I have interviewed enough celebrities to know that, from the moment we meet, there is often a kind of war of attrition between us. Because they are famous, they have usually created a self—a self that is not completely them, but curiously it is not not them either. Which is what the journalist and profile writer Thomas B. Morgan said back in the mid-Sixties: "Most better-known people tend toward an elegant solution of what they, or their advisers, call 'the image problem,'" he said. "Over time, deliberately, they create a public self for the likes of me to interview, observe, and double-check. This self is a tested consumer item of proven value, a sophisticated invention, refined, polished, distilled, and certified OK in scores, perhaps hundreds of engagements with journalists, audiences, friends, family, and lovers. It is the commingling of an image and a personality, or what I've decided to call an Impersonality."

These days, impersonalities have become so successful that it's nigh impossible to tell the difference between what is real and what is mediated. Often, because they are always "on," some celebrities treat their impersonality as their real identity, their real character. And, as a lot of famous people long ago decided that fame was the only way to diminish, if not completely banish, their past, they are completely happy with this.

And, oddly, often we are, too. It's debatable whether Lou Reed was.

Mary Harron: My feeling about the importance of the Velvet Underground and their significance has not diminished at all. I haven't outgrown them. What I learned from them when I was young was so essential in how I look at the world. The things that I like are the same ones I found in them. I like things that are minimalist, unsentimental, dark, drily funny, things that are not self-indulgent. I like things that have a toughness about them. I like art, genre, and pop culture. I like the Velvet Underground. They laid out that territory for many, many people.

Legs McNeil: I'm sure someone's having fun somewhere, but's it's not really fun, is it? There's always someone doing something in Buttfuck, Arizona. But just walking down the street was fun in the Seventies. You just thought anything could happen. I used to go into bars and wait for people to walk by so they could pay. There was a bar on the Bowery that had huge windows, and I used to sit there and drink expensive beers

waiting for someone with an American Express card. I was a cheap little hustler. I stopped drinking in 1988 because I had to. It was awful, but I had to do it. I had to go to church basements for ten years. But it worked.

In the summer of 2022, Moe Tucker's Facebook page was full of endorsements for the ultra-conservative Supreme Court Justice Clarence Thomas. She reposted a Senate-sponsored message encouraging people to support him: "1 MILLION PEOPLE. That's how many are calling for Justice Clarence Thomas to be IMPEACHED and removed from office for siding with LIFE. We need to make sure we stand by Clarence Thomas and have his back to protect the integrity of the bench and the Constitution. Stand with Justice Thomas..." A disappointment to many, this was another example of Tucker refusing to toe any party line. When Tucker had expressed doubts about the Obama presidency over a decade earlier, she was decried by people in their thousands, and yet as Alexis Petridis pointed out in the Guardian, *"The Velvet Underground's music doesn't express a single political view; we assume they're left-wing liberals because they sang about drugs and sex and transvestites, but they could just as easily be radical right-wing libertarians." Tucker continues to be vocal, offering contrary opinions on immigration, border control, cashless bail, critical race theory, Alexandria Ocasio-Cortez, Joe Biden, and the Disney Company as well as abortion.*

Robert Chalmers: To use Bob Dylan's phrase, she's gone out beyond where the trams stop. You read her stuff on Facebook and think, this woman needs help.

Moe Tucker: Anyone who knows me knows that I'm not a fool, a racist, a Nazi. Anyone who knows me knows I'm afraid of flying, afraid of bugs, but not afraid to say what I think.

Danny Fields: Nico went through so much. She'd been there and done it, spending the Fifties modeling for all those big German brands. Sparkling and twinkling in her plaid skirt. She knew she was in the band because of her spectacular presence, but it was a chance to play music with Lou and John. She was committed. The uglification of her beauty was something that enhanced her decline. She let her teeth get bad, her skin, her body. She was saying, what's left of me is what I am. Let me get rid of this thing that you are dazzled by. The facade. I have a heart.

Gene Krell: I was taking Nico to the airport to return to Paris. We both knew we would not see each other for some time. Knowing my favorite song of hers was "Femme Fatale," she began to sing as we approached the terminal. I never saw her again, making the moment that much more special. Nico knew I had nothing to gain from our relationship other than my respect and love for her. I never wrote a book, never capitalized on our relationship. All I remember is Narita airport in '76. We were still close but I cannot say this with any degree of confidence.

James Young: I keep coming across commentators saying that Ornette Coleman had suggested a particular approach to the harmonium, of playing the melody in the left hand instead of the right (the reverse of the usual keyboard method). But there's no evidence for this. Ornette had no recollection of meeting Nico or discussing this. People like to invoke cool artists like Ornette in the hope that it will confer some extra dimension of the avant-garde...but Nico doesn't need that. She created her own sound. The way she approached her harmonium was to play repeated simple alternating notes in the right hand (a "drone") with the melody "underneath" in the left. Where would she have encountered that kind of sound? The Velvets, of course. For me, Nico's music is a distillation of the Velvet Underground's aesthetic, derived from her lived experience. She also liked Terry Riley...again repetition, "minimalism," as a mesmeric drone layer of sound. When I first started working with her, she used to say, "Play like Terry Riley...you know, da-doo, da-doo..."

Cale talked about Nico as being a European classical artist, and I think he's probably closer there, as she doesn't really fit any genre. She was unique as she had a self-invented milieu. You can't imitate it as you'll look like an idiot. A number of contemporary female artists do name-check her, but not many people try and copy her. Why would you?

Gene Krell: When I had the association with Nico it turned pretty volatile. Dark clouds gathered, and our relationship was like a Greek tragedy at times, almost Shakespearean. Time wore us down, although it had its wonderful moments, too. She had this beautiful photo that she loved, taken in Morocco. On the back of it she wrote the song "Purple Lips," because at one time I actually had purple lips, and she captured it. I read an interview where she was asked about the song, and she says, "Yeah,

I wrote that for Sid Vicious." Now I'm laughing but at the time I was so enraged. That was the foundation of our relationship. Much later I was working at Bleecker Bob's [record store] and Nico rang up and said, "Is my little husband there?" She said she was in New York and wanted to come and see me. And in a moment I now regret, I left, as after all those years I didn't know what I would say to her. I was so angry.

Danny Fields: Warhol and Nico were extra-planetary.

Nick Rhodes: The internet would have been Andy's ultimate dream, but I don't think he would have been able to ever leave the house.

Bebe Buell: Andy would have created the digital *Mona Lisa* if he was still alive.

Nick Rhodes: The reason people thought he was a fake? The usual—jealousy. He was very successful and made a lot of money and a lot of people didn't like that.

Deborah Harry says Warhol was the master of blurred lines, between art and commerce, between serious and playful, and probably between uptown and downtown, too, juggling the conventions of marketing, mass production, branding, popular culture, advertising, and even celebrity. "He was serious about his work," she says, "but he approached it with a sense of humor." She is still amazed that she became acquainted with him, still giddy with the notion that she, along with Chris Stein, would be invited into his world, encouraged to attend his parties and private dinners. "He didn't eat much; he'd often cover up his plate with a napkin and take it with him and leave it on a ledge somewhere for a hungry street person... One of his great skills was that he was a very, very good listener. He would sit there and suck all of it in. His curiosity was endless."

Lou Reed: If you play the [Velvets'] albums chronologically they cover the growth of us as people from here to there, and in there is a tale for everybody in case they want to know what they can do to survive the scenes. If you line the songs up and play them, you should be able to relate and not feel alone—I think it's important that people don't feel alone.

In the summer of 2022, at Viv Guinness's rather wonderful Festival of Writing and Ideas at Borris, in County Carlow, in Ireland, Laurie Anderson performed two ad-hoc one-woman shows in the festival's beautiful garden marquees. The artist spent the weekend beaming, spreading goodwill with a constant stream of seemingly benevolent, infectious, and almost certainly involuntary smiles. Every casual question, every incidental encounter, and every cupcake and mug of tea was met with what appeared to be sheer delight. In fact, I'm not sure I've ever seen someone smile so continuously. Before her first performance, her smile capered onstage accompanied by an oversized tartan duster coat, flat shoes, and short spiky hair. She told all of us in the audience that we were going to be playing a game. And so the star-studded crowd—including war correspondent Ed Vulliamy, Pulitzer Prize-winning poet Paul Muldoon, TV polymath Alan Yentob, film director Nick Broomfield, journalist Mary Fitzgerald, and former president of Ireland Mary Robinson—were asked to think of a word and to repeat it carefully into a roving microphone brandished by Fiachna Ó Braonáin of the Hothouse Flowers. The words—"effervescence," "Elizabethan," "infidel," "cheese," etc.—were then fed through a computer and spat out again accompanied by electronic drones, building into a roundelay about the end of the world. So it wasn't a game at all, but rather a benignly chaotic performative piece which we had all willingly contributed to. While I'm sure she had done this many times before, the joy which it so obviously brought her made her seem like the kindest, most generous person any of us had ever met. The yin, perhaps, to her late husband's yang. At dinner afterward she was charming, funny, and generous with her time and anecdotes. At one point she told a lovely story about her blind dog, who had been completely destabilized by her affliction, scared to walk to her feeding bowls or venture outside Anderson's apartment. Becoming blind had basically frozen her. Anderson's dog trainer suggested she teach her dog to play the piano, in order to try and encourage her to become more playful. Anderson did just that. "Music saved her life," she said, "which is the same for a lot of musicians."

Jon Savage: So what did the Velvets do? They helped to enfranchise women as instrumentalists in pop groups, as opposed to featured singers (although they had one of those as well, and what a strange tale that is); introduced a whole strain of contemporary American classic music to a wider market; wrote some wonderful, enduring songs; laid down a marker which no art-pop group has since been able to ignore. Without

the Velvet Underground I would never have: visited New York; read Delmore Schwartz; heard La Monte Young and Terry Riley; perhaps even become a writer. The Velvet Underground stand at the point where the archaic, immediately post-war culture of repression and exposé! meet the full implications of the Sixties: sexual freedom, social mobility, pop as the motor of the culture industries. If tragedy stalks their story, it's because they, and many others at the same time, were exploring uncharted waters. Now that we think we know everything about pop, it is easy to tie up their story into a neat package: this omits any account of the group's courage, which is the reckless courage of all those who, both then and now, refuse to be content with the world as it seems.

In August 2022, John Cale released the largely self-recorded "Night Crawling," a highly evocative and atmospheric single that reimagined the singer with David Bowie in New York in the midseventies, bouncing from bar to bar in a kind of downtown fug. The music was almost incidental—nostalgic without being cloying, with Cale's sonorous tenor taking us on a guided tour of the past. "There was this period around the mid-to-late seventies when David and I would run into each other in NY," said Cale. "There was plenty of talk about getting some work done but of course we'd end up running the streets, sometimes until we couldn't keep a thought in our heads, let alone actually get a song together. One night we managed to meet up for a benefit concert where I taught him a viola part so we could perform together. When I wrote 'Night Crawling,' it was a reflective moment of particular times. That kind of NYC that held art in its grip, strong enough to keep it safe and dangerous enough to keep it interesting. I always figured we'd have another go at the two of us recording together, this time without the interference of being perpetually off our heads. The thing about creating music is the ability to divine a thought or feeling even when reality says it's a logical impossibility."

The song was an unlikely echo of Cale's backstory, a narrative that he resolutely refused to exploit.

Nevertheless, the narrative remains.

Gillian McCain: Kids can't really afford to live in New York anymore. I go to Williamsburg, and I don't get it. I still love New York, and it's still my favorite city in the world, but I just don't get culture anymore. I mean, can you imagine growing up with a phone in your hand all the

time? The Sixties and Seventies in New York, even the Eighties, was a golden age. It was golden. It was also such a small scene, as everyone kinda knew everyone. Golden. If you ask me who the most important people are, it's simple: Danny Fields, as he is the thread from the Warhol days right through to the Ramones. Danny, the Velvet Underground, the Ramones, that's about it. Golden.

Legs McNeil: What's New York like today? I don't know as I don't live there anymore, so I don't feel I'm entitled to have an opinion.

Richard Hell: Things always change, and New York teaches you that.

Dianne Brill: The city is opening up again like you haven't seen for years. People are so hungry to be fun and nice and enjoy themselves. The vibe is amazing. I really think something has happened. New York is back. I thought it was going to go back to what it was like before, which was a little dry. But these little places are bubbling up and people are going from table to table, and talking, talking. It's like, Oh my God, it's life again. Everything's getting better.

POSTSCRIPT

Garnant today feels like a very lost place indeed. The former rural mining village sits on the edge of the Brecon Beacons National Park, which makes for an extraordinarily stark contrast. As you descend the Black Mountain (Y Mynydd Du) on the western high ground, you feel as though you're in the closing clifftop scenes of The Italian Job, *but in only a few minutes you're in a South Wales ghost village, where people appear to no longer roam. Here in Carmarthenshire, the rural landscape hasn't changed much since John Cale left in the early 1960s, but the urban environment is almost unrecognizable.*

As you enter the village, scooting by a Turkish barber and a bronzing shop, you find yourself in a sea of gray pebbledash, with rows and rows of the small, terraced houses built to house the long-gone mining labor force, now punctuated by Chinese takeaways, fish bars, and the dilapidated Workmen's Hall and Institute. Proud space like this was "the physical manifestation of the urge for communal self-improvement and the egalitarian spirit of working toward the shared purpose of better conditions and livelihoods characteristic of the mining industry," Richard King writes in Brittle With Relics, *his personal history of Wales.*

The Institute last opened its doors in 1972.

In many respects Garnant feels like one of those small towns you come across when you drive west in the States, along Route 66, where the road is surrounded on each side by a dozen or so buildings, with a gas station, a grocer's, and the odd convenience store. But there is no western glamour here. No melodramatic setting sun. And no moving bodies. No bodies at all. In fact, it is a sorry sight, the only movement being the occasional mobility

scooter or local county bus (driven by young men in mirrored sunglasses). It is poor, and any sense of community is certainly well hidden. The old open-cast mine, which once extracted two thousand tons of coal per week, is now the site of the Garnant Park golf club. (The internet has often tested my credulity, although a Carmarthenshire website I found while researching the area before my visit tested it a little more: "Here at Day Out With The Kids we've found 287 fun things to do in Garnant for you and the family to discover, including indoor and soft play areas, beaches and museums and art galleries.")

The local cemetery, Hên Bethel, standing alone on a hillside, is where Cale's family are buried. Today it consists of a graveyard, a long-closed chapel, and a bunch of derelict stables. It is the oldest chapel in the Amman Valley, although that honor is certainly not reflected by its disrepair. Like the village it once served, Hên Bethel is a monument to different times. It has echoes, too, with locals mentioning a ghostly top-hatted figure who stalks the cemetery, and of organ music being played in the chapel after dark, even though it never contained one.

This is the place John Cale escaped in the early Sixties, on his way to reinventing the decade, though one wonders what kind of launchpad would be needed today. Not only is the past always a different country, but they did things differently there.

ACKNOWLEDGMENTS

Firstly, thank you as always to Sarah, Edie, and Georgia, for their constant and often unrestrained support. Thank you also to Gordon Wise and Jonny Geller, and the man with the most withering eye roll in the industry, the great Lee Brackstone. And of course, I would like to thank the following 170 people for, in one way or another, wittingly or not, helping to deliver this book: Brett Anderson, Laurie Anderson, Ron Asheton, David Bailey, Lester Bangs, Devendra Banhart, Kat Bawden, Roberta Bayley, Bill Bentley, Alex Bilmes, Rodney Bingenheimer, Leee Black Childers, Victor Bockris, Michael Bonner, Bono, David Bowie, Dianne Brill, Mick Brown, Tina Brown, Stanley Buchthal, Bebe Buell, David Byrne, John Cale, Jessamy Calkin, Alan Cavanagh, Dave Cavanagh, Nick Cave, Mark Cecil, Murray Chalmers, Robert Chalmers, Barbara Charone, Jarvis Cocker, Bob Colacello, Alice Cooper, Jayne County, Sara Cox, David Dalton, Ray Davies, David Dawson, Anthony DeCurtis, Rob Dickens, Chris Difford, Alan Edwards, Mark Ellen, Tracey Emin, Syd Fablo (*Rock Salted*), Bryan Ferry, Danny Fields, Duggie Fields, Ciara Finan, Tony Fletcher, Ian Fortnam, Bobby Gillespie, Lizzy Goodman, Martin Green, Jason Gross (in particular for his help with the Robert Quine material), Bob Gruen, Catherine Guinness, Valentine Guinness, Duncan Hannah, Keith Haring, Mary Harron, Bob Harris, Deborah Harry, Nicky Haslam (stop smoking!), Viola Hayden, Todd Haynes, Richard Hell, Tom Hibbert, Baby Jane Holzer, Barney Hoskyns, Mick Jagger, Allan Jones, Edie Jones, Georgia Jones, Steve Jones, Lenny Kaye, Caleb Kennedy, Nick Kent, Young Kim, Richard King, Tony King, Phil Knox-Roberts,

Gene Krell, Joe Kruppa, Hanif Kureishi, Oliver Landemain, Andrew Loog Oldham, Courtney Love, John Lydon, Tom Maxwell, Gillian McCain, Paul McGuinness, Stuart McGurk, Alastair McKay, Kembrew McLeod, Legs McNeil, Lucinda McNeile, Moby, Sterling Morrison, Margaret Moser, Regine Moylett, Jenni Muldour, Kris Needs, Stevie Nicks, Nico, Jimmy Page, Tony Parsons, Tom Pinnock, Marco Pirroni, George Plimpton, Pooce, Iggy Pop, Robert Quine, Anka Radakovich, Jim Radakovich, Gary Raymond, Lou Reed, John Reid, Nick Rhodes, Jonathan Richman, Robert Risko, Chris Roberts, Mick Rock, Jude Rogers, Henry Rollins, Laurence Romance, Paul Rothchild, Scarlett Sabet, Jon Savage, Edie Sedgwick, Charles Shaar Murray, Siouxsie Sioux, Geraldine Smith, Patti Smith, Chris Stein, the completely wonderful Mandy Stein, Seymour Stein, Michael Stipe, Sophie Storey, Chris Sullivan, Chris Thomas, Sherill Tippins, Moe Tucker, Kurt Vile, Tony Visconti, Ben Volpeliere-Pierrot, Sarah Walter, my contacts at the Andy Warhol Foundation, Sue Webster, Francis Whately, Richard Williams, Ellen Willis, Alex Winter, James Wolcott, Mary Woronov, Peter York, Jan Younghusband, Doug Yule, Tony Zanetta, and Michael Zilkha.

I interviewed people all over the world, from London, Brighton, and Northampton, to New York, Los Angeles and Houston, from Manchester, Paris and Hay-on-Wye, to Brooklyn, East Hampton, and Montauk, from Carlow, Mustique, and Westchester, to West Sussex, Tokyo, Seattle, and the Cotswolds.

I'd especially like to offer my huge thanks to Kimberley Jones from the *Austin Chronicle*, for allowing me to use some material from Margaret Moser's 2000 piece, *Velvet Underdog*. Margaret was a journalist, historian, and, back in the day, a self-confessed groupie. She is perhaps best known for being the director of the Austin Music Awards. Some people take forever to get back to you, and sometimes don't get back at all, but Kimberley was swift, and particular, asking that we make sure Margaret's work was properly acknowledged. Kimberley, I can't thank you enough.

I'd also like to pay proper thanks to John Robinson, for allowing me to use various edits from his magnificent special edition of *Uncut* devoted to the Velvet Underground, which was published in 2021. The magazine is a testament to the fact that half a century after they ceased to exist in any form, our fascination for the Velvets remains undiminished. It was

published just as I was embarking on this project, and it very quickly became an invaluable source. John also helped me enormously with Jonathan Richman, which also came from the special edition.

In particular, I'd like to thank Ian Fortnam for allowing me to quote from his marvelous Lou Reed interview in *Classic Rock* magazine, one of the best I've read. One of the reasons Ian got such a good interview is because he didn't treat Reed like a schmuck. "I was determined to have a good experience with him, because I didn't want to have my appreciation of his talent tarnished in any way by blundering into a personal confrontation," says Ian. "And I thought the best way to avoid winding him up, which I was more than aware was an incredibly easy thing to do, was to treat him with the level of respect that both he and I thought he deserved."

Thank you also to everyone for agreeing to speak to me, sharing their stories, and granting me permission to reproduce or use their material. Every effort has been made to contact all copyright holders. Where it appropriately fitted the narrative, I have occasionally adapted material from previous projects (David Bowie being a case in point). As with any project like this, whether in print or on film, the knitting together of contemporary and archive material for a prismatic narrative is a delicate, and potentially hazardous process, especially when presented with so many ways in which to interpret the material, and particularly when using material from people who are no longer around. The fundamental aim must always be veracity, because without that, then all you're doing is creating an alternative fiction. I was particularly mindful of using quotes by Lou Reed which might have been delivered in his default defensive mode, and which reverted to type. I didn't need Lou Reed to paint a picture of the generic Lou Reed, as so many biographies had successfully done that before. After having spent more than a year speaking to people who knew Lou in a more personal capacity than many journalists, it was evident that the persona he built was so successful it actually became a genuine caricature, and the "striking" characteristics he exhibited so well were exaggerated by journalists on a pretty regular basis. They used Reed's knee-jerk responses to create both comic and grotesque portraits that, while often hugely entertaining, only tell a portion of his bizarre and complex story. I was also mindful of misrepresenting Nico, or using quotes she may have given while overly medicated. Odd thing: I spoke

to over two dozen people who knew Nico, or who had met her in some capacity, and none of them could resist mimicking her voice, even when they were being affectionate. It was obviously too good an opportunity to miss, and, judging from the way in which all the impersonations were so similar, she was obviously easy to copy. The trick, I soon learned, was to pronounce everything in an almost comic German accent, very low, and very slow. I think Tony King probably did the best one, although Duncan Hannah's and Mary Woronov's were pretty good too.

BIBLIOGRAPHY

Air Mail, Aspen, the *Austin Chronicle,* BBC, bryanferry.com, Daily Beast, the *Daily Telegraph, Details, East Village Eye, Electronic Sound, Esquire,* the *Evening Standard,* the *Face, Fader, Far Out, Filter,* the *Financial Times, Flood, Fondata, Frieze, GQ,* the *Guardian, High Times, i-D,* the *Independent, Interview, Lab Mag,* Longreads, the *Los Angeles Times, Melody Maker, Modern Drummer,* the *Modern Review, Mojo,* the *Nation, New Style, New York,* the *New York Times,* the *New Yorker, NME,* PBS, *Q,* The Quietus, Radio 2, *Record Collector, Ritz,* Rock's Back Pages, *Rolling Stone,* the *San Francisco Chronicle,* The Scene, *Screw, 16, Skin Two, Smart, Sounds, Spin, Street Life,* the *Sunday Times, Talk, Time Out, The Times, Trouser Press, Uncut, Vanity Fair, Vibe,* Vice, *Vogue,* the *Wall Street Journal,* the *Washington Post, Zig-Zag*

Joe Ambrose, *Chelsea Hotel Manhattan* (Headpress), 2007.

Jennifer Otter Bickerdike, *You Are Beautiful and You Are Alone: The Biography of Nico* (Faber & Faber), 2021.

Victor Bockris, *Lou Reed: The Biography* (Hutchinson), 1994.

Victor Bockris, *Warhol* (Muller), 1989.

Victor Bockris and John Cale, *What's Welsh for Zen? The Autobiography of John Cale* (Bloomsbury), 1999.

Victor Bockris and Gerard Malanga, *Up-tight: The Velvet Underground Story* (Omnibus), 1983.

Tina Brown, *The Vanity Fair Diaries* (Weidenfeld & Nicolson), 2017.

Brett Calliwood, *The Stooges: Head On—A Journey Through the Michigan Underground* (Music Press), 2008.

Jarvis Cocker, *Good Pop, Bad Pop: An Inventory* (Jonathan Cape), 2022.

Bob Colacello, *Holy Terror: Andy Warhol Close Up* (HarperCollins), 1990.

Arthur C. Danto, *Andy Warhol* (Yale University Press), 2009.

Anthony DeCurtis, *Lou Reed: A Life* (John Murray), 2017.

Jim DeRogatis, *The Velvet Underground: An Illustrated History of a Walk on the Wild Side* (Voyageur Press), 2009.

Nat Finkelstein, *Andy Warhol: The Factory Years* (Canongate), 1999.

Glenn Frankel, *Shooting Midnight Cowboy: Art, Sex, Loneliness, Liberation, and the Making of a Dark Classic* (Farrar, Straus & Giroux), 2021.

Chris Frantz, *Remain in Love* (White Rabbit), 2020.

Blake Gopnik, *Warhol* (Penguin) 2021.

Pat Hackett (ed.), *The Andy Warhol Diaries* (Warner Books), 1989.

Debbie Harry, *Face It* (HarperCollins), 2019.

Nicky Haslam, *The Impatient Pen* (Zuleika), 2019.

Clinton Heylin, *All Yesterday's Parties: The Velvet Underground in Print 1966-1971* (Da Capo), 2005.

Clinton Heylin, *Babylon's Burning: From Punk to Grunge* (Penguin), 2007.

Peter Hogan, *The Dead Straight Guide to the Velvet Underground and Lou Reed* (Red Planet), 2017.

John Holmstrom and Bridget Hurd, *The Best of Punk Magazine* (HarperCollins), 2013.

Steve Jones, *Lonely Boy* (Penguin), 2016.

Richard King, *Brittle With Relics: A History of Wales 1962-1997* (Faber & Faber), 2022.

Sam Knight, *The Premonitions Bureau* (Faber & Faber), 2022.

Johan Kugelberg (ed.), *The Velvet Underground: New York Art* (Rizzoli), 2009.

Greil Marcus (ed.), *Stranded* (Knopf), 1979.

David McCabe, *A Year in the Life of Andy Warhol* (Phaidon), 2003.

Kembrew McLeod, *The Downtown Pop Underground* (Abrams Press), 2018.

José Esteban Muñoz, Jennifer Doyle, Jonathan Flatley, *Pop Out: Queer Warhol* (Duke University Press), 1996.

Lou Reed, *I'll Be Your Mirror* (Faber & Faber), 2019.

Lou Reed, *The Last Interview* (Melville House), 2015.

Mark Rozzo, *Everybody Thought We Were Crazy* (Ecco), 2022.

Jon Savage, *The England's Dreaming Tapes* (Faber & Faber), 2009.

Jon Savage, *1966: The Year the Decade Exploded* (Faber & Faber), 2015.

Anthony Scaduto, *Mick Jagger* (WH Allen), 1974.

Howard Sounes, *Down the Highway: The Life of Bob Dylan* (Doubleday), 2001.

Peter Stanfield, *Pin-Ups 1972: Third Generation Rock'n'Roll* (Reaktion), 2022.

Bob Stanley, *Yeah Yeah Yeah: The Story of Modern Pop* (Faber & Faber), 2013.

Jean Stein and George Plimpton (eds), *Edie: The Life and Times of Andy Warhol's Superstar* (Jonathan Cape), 1982.

Sherill Tippins, *Inside the Dream Palace: The Life and Times of New York's Legendary Chelsea Hotel* (Simon & Schuster), 2013.

Ultra Violet, *Famous For 15 Minutes: My Years with Andy Warhol* (Harcourt Brace Jovanovich), 1988.

Richie Unterberger, *White Light/White Heat: The Velvet Underground Day-By-Day* (Jawbone), 2009.

Ed Vulliamy, *When Words Fail* (Granta), 2018.

Mick Wall, *Lou Reed: The Life* (Orion), 2013.

Andy Warhol, *Andy Warhol's Exposures* (Hutchinson), 1999.

Andy Warhol, *"Giant" Size* (Phaidon), 2008.

Andy Warhol and Pat Hackett, *POPism* (Penguin), 1980.

James Wolcott, *Critical Mass: Four Decades of Essays, Reviews, Hand Grenades, and Hurrahs* (Doubleday), 2013.

Tom Wolfe, *The New Journalism* (Harper & Row), 1973.

Tom Wolfe, *The Purple Decades* (Farrar, Straus & Giroux), 1982.

Mary Woronov, *Swimming Underground* (Serpent's Tail), 1995.

James Young, *Songs They Never Play on the Radio* (Bloomsbury), 1992.

INDEX